PROFESSIONAL
PAINTED
FINISHES

INA BROSSEAU MARX

ALLEN MARX ROBERT MARX

WHITNEY LIBRARY OF DESIGN

WATSON-GUPTILL PUBLICATIONS

NEW YORK

To Cornelia Guest, our editor

First there was an idea;
then there was a book;
and, in between, there was
enthusiasm, intelligence,
patience, and skill.

All photography by Nick Simone, unless otherwise noted.
All demonstration photographs of glazing, marbling, and graining conceived and
executed by Ina Brosseau Marx and Robert Marx, unless otherwise noted.
All commissioned work rendered by Ina Brosseau Marx, Robert Marx, or decorative
painters who have studied at The Finishing School.
All line art by Marca Cameron.
Trompe l'oeil rendering by Ina Brosseau Marx.

First published 1991 in New York by Watson-Guptill Publications,
a division of BPI Communications, Inc.,
1515 Broadway, New York, NY 10036

Library of Congress Cataloging-in-Publication Data

Marx, Ina Brosseau, 1929–
Professional painted finishes : a guide to the art and business of
decorative painting / Ina Brosseau Marx, Allen Marx, and Robert Marx.
p. cm.
Includes index.
ISBN 0-8230-4418-1
1. Painting, Industrial—Technique. 2. Paint materials.
3. Finishes and finishing—Technique. 4. Color decoration and
ornament. I. Marx, Allen, 1922– . II. Marx, Robert, 1956– .
III. Title
NK2175.M37 1991
667'.9—dc20 90-49594
 CIP
 r90

Printed in Malaysia

First Printing, 1991

8 9 / 97 96

Editor: Cornelia Guest
Designer: Jay Anning
Production Manager: Ellen Greene
Set in 11/13 Stempel Garamond Light

ACKNOWLEDGMENTS

We would like to thank

Cornelia Guest, for her vision, superb editing, and understanding of our philosophy and methods

Nick Simone, not only for his exceptional photographic skills, but also for his upbeat attitude and accommodating nature

Jay Anning, our designer, for his excellent judgment and taste

Ellen Greene, our production manager, for her unerring eye and helpful suggestions

Our dedicated staff, headed by Patricia Quinn Donovan and including Susan Annarumma, Lori Barnaby, Marca Cameron, Deborah Menkins, and Nina Perez, all of whom gave their utmost in cooperation and hard work

Our thousands of students, without whom there could be no enjoyment in teaching

Those hundreds of students who submitted well-done, imaginative work (most of which, because of space limitations, could not be included in this book)

Julia Moore, for her guidance in the initial phase of this project

Stephen Wolf, for believing in us early on, and for continuing to be an invaluable resource for us and our students

Peggy Kennedy, who so kindly shared her interior design expertise

Howard Zucker, whose columns over the years have been a valuable source of information

Robert Jaeger, Bernard Lee, Peter Mattson, Robert Hund, Ken Charbonneau, Marsha Pike, and Joy Luke for sharing their knowledge about woods, marbles, and color

Marilyn Ludwig of the National Paint and Coatings Association (NPCA) and Deborah Belcher Chaiko of Benjamin Moore & Co., for their valuable information and ever-ready availability

James Cook Embree, for his helpfulness with overseas information

The late Isabel O'Neil, who introduced us to the painted finish and ended up becoming a close friend

Most of all, our wonderful family: the late Pauline Brosseau; the Marxes—Michele, Mitchell and Penelope, Russell and Cheryl, Eric and Sue—for both their specific contributions (such as providing the title and helping with word processing, consulting, and research) and for their overall support and understanding; and Lincoln Endelman and Ray Brosseau for being so generous with their expertise.

CONTENTS

PART THREE
PROFESSIONAL PRACTICE 239

APPENDIX 273

FOREWORD

The resurgence of interest in glazing, marbling, and other decorative painted finishes continues to grow and expand. After several decades of "less is more," we are seeing a craving for a sense of detail in our lives. This is reflected in the return of architectural embellishments and in the treatment of all decorative surfaces. Fabrics, wall-coverings, and painted surfaces all reveal complex layering of color, design, and texture. No longer satisfied with solid color, architects, designers, and consumers are discovering the elegant surface treatments that decorative painting can provide. Glazing and other techniques impart a richness and depth of color that cannot be achieved with conventional methods of paint application.

Here at last is the book for which many of us have long waited. While the text has been geared to those who might wish to pursue a career as professional decorative painters, beginners and professionals alike will find the format and writing to be clear, direct, and easily understandable.

This complete and comprehensive guide is truly reflective of the authors, Ina, Allen, and Robert Marx. Enormous effort has been taken to ensure that the instructions are clear, the photographs top quality, and the information complete. More important, the authors teach the readers to become thinking decorative painters, to understand the analysis behind the techniques, enabling them to create beautiful and varied paint finishes. Emphasis is placed on understanding naturally occurring materials, such as marble and wood, which the painter may wish to simulate.

The same philosophy and approach have been used successfully since 1983 by the Marxes at The Finishing School in Great Neck, New York, where they offer one-day classes in special painting techniques. Students include home-owners, painting contractors, interior designers, and historic preservationists. Those who have attended the school are always impressed with the carefully organized sessions, which enable them to achieve highly professional results in an amazingly short time. This is possible because the Marxes have brought many traditional techniques up to date. Effects that might have taken days, perhaps even weeks, can now be achieved in hours by utilizing today's faster-drying paint products, protective coatings between layers, and easily obtainable tools.

In addition to being the founders and directors of The Finishing School, the Marxes have been invited to lecture and to conduct demonstrations for the National Decorating Products Association, the Painting and Decorating Contractors of America, the National Trust for Historic Preservation, the Cooper-Hewitt Museum, the Smithsonian Institution, and many others. One highlight of their professional career has been the renovation and restoration of the headquarters of the National Paint and Coatings Association in Washington, D.C. A true showcase for the paint industry, this former mansion features examples of glazing, marbling, graining, and gilding throughout.

The Marxes are also conservators of painted and gilded objects. Their restorations are in the permanent collections of the Metropolitan Museum of Art, Yale University's Garvan Collection, the Cooper-Hewitt Museum, the New-York Historical Society, and prominent private collectors.

In the following pages, learn and explore the fascinating, exhilarating, and quite possibly profitable world of decorative painting.

KENNETH X. CHARBONNEAU
Color and Merchandising Manager
Benjamin Moore & Co.

PROFESSIONAL
PAINTED
FINISHES

INTRODUCTION

In the last few years there has been a renaissance in the decorative arts—especially in the painted finish. Designers and homeowners are championing texture, detail, originality: personal touches that signal a renewed reverence for fine craftsmanship. The explosive revival in the centuries-old art of faux finishing is not surprising. From *faux marbre* columns to elaborate trompe l'oeil murals, faux finishes offer an exciting and dramatic way to redecorate. Faux can make small spaces appear larger, bring texture to a flat surface, disguise unsightly or damaged areas, and match existing decorations. It also can add a refreshing sense of humor and whimsy; faux often indicates that the owner is not taking himself or herself too seriously. And, should the owner tire of one finish, another can easily be painted over the first.

To meet the huge demand for specialty finishes, painters and designers are rapidly expanding their repertoires. Workshops, courses, and schools have attracted professionals and do-it-yourselfers, both of whom desire to create a luxurious new world, often at a fraction of the cost of real marble, stone, or wood.

After gaining international renown as conservators in the painted finish, we founded The Finishing School in Great Neck, New York, in 1983. Today the school is considered among America's foremost schools for teaching painted finishes. With that reputation has come a constant demand for lectures, workshops, and seminars, as well as consultations. Articles about the school have appeared in numerous magazines and newspapers.

Part of the reason our school has been so successful is the structure of our classes. Unlike schools that require months of study, we offer one-day classes, during which several techniques are mastered. The results achieved with these techniques are of professional caliber—despite the facts that (1) the materials used are inexpensive and available at most paint and hardware stores, and (2) the methods can be learned in a day by anyone—even a person with no previous artistic training.

A large percentage of our students are professional painters, interior designers, and architects hoping to expand their repertoires to meet the demands of their clients. They have found that their businesses have benefited greatly. Other students have included investment bankers, flight attendants, accountants, violin makers, and a chimpanzee trainer. Many of these amateurs, with their varied backgrounds, have started—and succeeded in—their own businesses using our methods. Whether they come to us for commercial or personal reasons, our students leave with professional skills and attitudes. They approach decorative painting with confidence, and practice high standards of discrimination and craftsmanship. They understand that their reputation is paramount, and that every project must be completed to the client's and their satisfaction.

The key to our students' success, we feel, is our approach to teaching. We believe that everyone is born with natural artistic ability and a sense of balance and design. Whether these innate abilities are nurtured or not determines the extent to which the person develops into what society calls an "artist." As mentioned, our methods require no previous artistic training or experience. We find, in fact, that untrained people can be some of our best students because they have no preconceived notions and approach the painted finish with a fresh, untainted perspective. On the other hand, students "trained" in faux are sometimes the hardest to teach; they bring to school a repertoire of "patterns" that they automatically use instead of really analyzing the substances they are rendering.

We do not believe in the conventional idea or concept of talent: that it is innate; that some have it and some do not. Our belief is that what the world calls talented people are those who in reality have worked hard in creative and disciplined ways to hone their abilities.

The brain directs the hands. We stress concepts as well as practical knowledge. Instead of simply addressing questions about technique, we deal with a larger group of questions about how a natural substance looks and why it looks that way before we teach how to simulate it. Only after understanding how substances may or may not look can you achieve a realistic simulation. This awareness of the reality of a substance affects every aspect of the processes that follow, including perhaps the most difficult decision: knowing when to stop.

We also teach our students to understand the technical properties of their media. We convey the reasoning behind our recommended choices so that the students later will be able to make choices of their own with confidence. Only by knowing the media can a decorative painter have the freedom and flexibility to do superior work.

The ability to meticulously render exact copies of natural substances does not necessarily result in good faux. Our aim is not simply to reproduce nature, but to create art. Marble from a quarry varies: some is wonderful; some, unpleasant. The same is true of decorative painted reproductions. To achieve excellence in faux requires making value judgments about what can be eliminated or rearranged to enhance the painted surface, while still capturing the unique qualities of the original substance. A well-designed faux surface has asymmetrical balance and a repetition of colors in some form. The eye moves over it easily; there are no distracting focal points. By making these artistic discriminations, we are able to create faux that often seems to improve on nature.

The best decorative painting balances spontaneous rendering within the framework of analytical and aesthetic evaluation. The process itself is like true jazz improvising; to paraphrase Charlie Parker: harmony, style, and technique are learned and then forgotten at the moment of creativity. Art, being more tangible, can be changed during and after the creative process. The goal was stated perfectly by Mai-mai-sze Luch'ai in *The Way of Chinese Painting*, published in 1679:

> You must first learn to observe the rules faithfully; afterwards modify them according to your intelligence and capacity. The end of all method is to seem to have no method.

THE HISTORY OF THE PAINTED FINISH

Throughout history, painted finishes have gone in and out of vogue. Paint has covered surfaces in many diverse ways—it has been used for communication and narration, decoration, protection and preservation, camouflage, unification of different elements, and simulation of other materials. Out of fashion in the 1950s and 1960s, today the painted surface is back, more popular than ever—perhaps in response to the monotonous white walls favored by Modernists for the past decades. From abstract rag-rolled surfaces to the most realistic marbling, painted finishes have become firmly established in the forefront of late twentieth-century design—and from the look of it, will continue to be a prominent design element in the next century, too.

MARBLING

The first known use of paint to convey the illusion of marble traces back to the Mycenaeans, an ancient Aegean civilization who, over four thousand years ago, marbled their pottery. Some two thousand years later, marbling was used in Pompeii to frame murals and painted ornaments on walls, mimicking the real marble used in more formal, costly interiors.

The appreciation of the wit and style needed to render marbles and other painted finishes blossomed in Europe in the Renaissance—when real marbles were accessible but marbling was a specialty—and carried over into later periods as well. Marbling also became popular among architects as a substitute for real marble when load-bearing walls and bases provided inadequate support. All over Europe, church decoration from the thirteenth century on exhibits marbling that was done not only to simulate more costly materials, but also to supply the formality and grandeur of real marble to architecture that could not support its weight. Fifteenth- and sixteenth-century examples, like Saint Peter's in Rome and the Sistine Chapel in the Vatican, have a preponderance of painted marble to solve the problems posed by insufficient architectural support for real marble. Michelangelo even went so far as to simulate marble sculpture in paint in the Sistine Chapel.

All over England, Europe, and Scandinavia during the Baroque period of the sixteenth through early eighteenth centuries, illusionistic renderings of marbles were accompanied by illusionistic renderings of space as well. Because of the appreciation of monumental and sumptuous spaces during this period, it became very popular to dissolve whole walls and ceilings in private residences with painted illusions of life-sized figures set in full-scale architecturally correct spaces. Among the best marbling done in this tradition was that executed by the Italian painter Paolo Veronese (1528–1588) and his artists on trompe l'oeil architectural elements such as doors and door frames, panels, and pilasters. Their work can be seen today at the Villa Barbaro in Maser, Italy.

In the mid-eighteenth century the artifacts and architectural decoration that were unearthed at Herculaneum and Pompeii were the principal stimuli for a renewed interest in antiquity—and for the eventual emergence of the neoclassical movement in the decorative arts, which strongly influenced interior decoration, furnishings, and ornament. For example, excavated ancient Roman pottery that combined clays of different colors to suggest the veining of a hard stone inspired the marbled ware and agate ware of eighteenth-century Wedgwood and Staffordshire china. The English architect Robert Adam (1728–1792) was largely responsible for broadening the scope of painted finishes during this period. In addition to marbling, he painted grisaille (painting in shades of gray to resemble classic dimensional decoration), classic designs after Pompeii, and pale-colored wall and ceiling ornaments.

In eighteenth-century England, Europe, and Scandinavia, both rustic and formal interiors began to integrate architecture and furnishings. In France, specific decorative schemes for entire rooms were devised, making furniture—veneered or painted to resemble marbles and woods (called *faux marbre* and *faux bois*)—part of the decor; walls in stately residences were matched with painted furniture of great sophistication. At the same time, according to Peter Thornton in *Authentic Decor—The Domestic Interior 1620–1920*, the French middle class actually preferred painted marble on fireplaces and woodwork to real marble, whose cold formality, they believed, rightfully belonged only in grand settings.

During the Regency period of the early nineteenth century in England, painted finishes were much desired and produced. Among the more popular renditions of the period were tabletops that replicated in paint the specimen marble tabletops that Napoleon had brought back from his Italian campaigns. The real and painted versions showed pieces of different marbles separated by black or white marble bands and centered, often, with pieces of malachite and lapis lazuli. Regency painted furniture and objects were so much the fashion of the day that detailed instruction for painting furniture appeared in diverse publications: Sheraton's *Cabinet*

Directory of 1803 and Whittock's *The Decorative Painter and Glazier's Guide* of 1827, to name two.

Compared to the fine decoration of the Regency years, the decoration of the mid-nineteenth-century Victorian era in England was more crude and garish. Except for a vernacular tradition of marbling for pub decor, hand-done marbling was losing its appeal.

In North America, the earliest recorded use of marbling—called *deceit*—was in the early eighteenth century in the then-capital of Virginia, Williamsburg. However, aside from its use in some public buildings and affluent homes, marbling was not used extensively in North America until the early nineteenth century—and then mostly in Southern interior decoration, where architectural marbling was used in mansions until the outbreak of the Civil War in 1861.

In the Northern states there was a relative lack of interest in architectural marbling; however, marbling *was* popular in floor decoration. As far back as the early 1700s, floor boards in the North were painted to resemble black and white squares of marble (a small area of original marbling of this type is now preserved at the Van Cortland Manor house in Tarrytown, New York). In addition, floor cloths made of canvas and painted with intricate marble patterns were popular in the North all through the eighteenth and nineteenth centuries.

By the nineteenth century, the tradition of marbling in the United States had become rather pedestrian except for that done in the magnificent summer mansions—called cottages—in Newport, Rhode Island. Although real marble was everywhere (one mansion owner bought his own marble quarry; another installed in his home over seven million dollars worth of marble), marbling was done throughout these mansions as well for both decorative and practical purposes.

GRAINING

Graining—painting surfaces to resemble woods—dates back as far as marbling. As marbling was used to simulate rare and expensive marbles, graining was used to turn common woods into more rare species. However, except for brief periods in certain cultures, graining has not usually been considered as fashionable as marbling. The main exception was in the United States, where graining became far more popular than marbling.

Realistic graining was done as far back as the third and fourth dynasties in Egypt (2780–2565 B.C.) on funerary statues, walls, and furnishings. Because of the difficulty and expense of obtaining woods in ancient Egypt, wood was highly valued. It is no surprise that

the grainer's skill was in demand.

For long periods after that, there are no records of much significant graining being done elsewhere. Because most other cultures were able to get enough woods for their needs—or used other solutions—there was little interest in simulating woods in paint. In Renaissance Italy, for example, artisans met the challenge of the lack of fine cabinet woods for architectural elements and furnishings not with graining, but with a method of covering poor wood and poor construction with layers of gesso—basically a calcium carbonate and glue mixture—and then painting and gilding the surfaces. Graining first became popular in Europe in the second half of the seventeeth century as a simulation of the then-fashionable veneering, where finer, often tropic woods were laminated onto more sturdy wood furnishings (made of readily available woods such as oak).

Although not a painted finish, *decor bois*—graining and trompe l'oeil on porcelain and faience—was a short-lived, but charming, addition to the use of graining in the decorative arts during the 1770s. It was produced mainly by one firm, the Nidervillier pottery and porcelain factory in Lorraine, France. Their ware simulated strongly grained wood in two tones of brown, on which sepia or crimson-colored scenes of everyday life or classic ruins were painted as if they were prints pinned onto the wood. The warmth and simplicity of graining for *decor bois* and some of the furnishings of this period mimicked the "reverse chic" of Marie Antoinette playing at being a milkmaid.

The use of fine woods and cabinetry in France during the eighteenth century kept the need for graining to a minimum. Little *faux bois* was done until the early nineteenth century, when Napoleon's use of mahogany veneers stimulated painted imitations.

While some decorative graining was done in England in the late eighteenth century (we restored six painted satinwood wheel-back Adam chairs), most of the graining of that period is found on the interiors of English wood cabinets.

Throughout the nineteenth century, the use of tropical woods like rosewood, mahogany, and satinwood became popular in England—especially veneered in handsome patterns on furniture. Because these woods were expensive and rare, graining again became fashionable. The vogue that made formal painted furniture as accepted as real mahogany in English homes was transported to North America in the early part of the nineteenth century (we restored a *circa* 1910 window bench from Duncan Phyfe's workshop that showed maple grained with acid to simulate mahogany;

the piece is now in the Metropolitan Museum of Art). Painted mahogany, particularly the crotch figure, was used extensively on the woodwork of fine houses of the early and middle nineteenth century—always with the regional variations of the area.

In addition to this early nineteenth-century formal and realistic graining to simulate fine woods and handsome veneering, a folk style of graining was popular in North America. This style emerged in the seventeenth century with the influx of English, Dutch, and German settlers. Unable to afford more expensive woods, these settlers made furniture from soft pine and then used their native painting techniques to decorate and protect it. Among the better-known graining techniques that developed were those of the German communities like the Pennsylvania Dutch.

In early nineteenth-century North America itinerant painters traveled from town to town "decorating" (the term used then to cover all types of painting). These painters painted everything from portraits of ship's captains to fanciful graining and marbling on walls and floors for their wives. Unfortunately, most of the work of these traveling painters has been stripped off or covered with paint or wallpaper. One painter whose work has been preserved is Moses Eaton, whose box of exuberantly patterned samples is in the collection of the Museum of American Folk Art in New York City.

By the beginning of the second quarter of the nineteenth century, practically every small town and village in North America had decorative painters who would grain local carpenter-made furniture for from fifty cents to a dollar. At the same time, mass production of painted (mostly grained) furniture had begun. The painted decoration on this furniture imitated the fine woods and bronze inlays of the cabinetwork being made at the time for the more affluent strata of society. For example, chairs made in Connecticut by Lambert Hitchcock from 1825 to 1850 had simulated bronze ornaments, made with bronzing powders and stencils, over grained underlayers. These chairs sold for $1.50 at the time, and 100 were made in a day. Corey's, a six-story factory in Portland, Maine, flooded the country with grained furniture. Still-extant Corey chairs turn up intermittently—some with the same mass-produced, although hand-painted, wood grain as seen on a chair in the furniture collection at Yale University.

During this same period (from approximately 1820 to 1850), the joy of painting—working with a combination of very responsive media, a wide range of colors, and patterns based on real wood grains—inspired many craftspeople to go beyond realistic graining. Their work, called country or primitive graining today, exhibits such imaginatively designed surfaces and unusual blends of color that much of it is highly prized as art.

GLAZING

Although marbling and graining have been represented in all periods of the decorative arts—along with many fewer instances of faux renditions of almost every other recognizable natural material (e.g., the faux red-tortoise-shell finish on American highboys in the Metropolitan and Winterthur Museums)—painted finishes that were not based on real materials were done worldwide, also. The simplest to the more visually complicated encompassed glazing: laying a translucent film of color over another colored surface.

Although oils, the principal ingredient in glazes prior to modern times, were used as far back as the fourth century B.C. for medicinal purposes, they were not used as glazing components until the twelfth century A.D., when glazes made from nut oils and varnishes were developed in Italy. Among the first uses of glazes was in applying yellow oil and varnish glazes over tin to simulate gold. This led, in the fifteenth century, to the more commonplace practice of shading painted and gilded altarpieces with glazes, as seen in Giovanni Bellini's Frari altarpiece, where the gilding is toned with a richly colored oil glaze. (Bellini's atelier also used glazes on furniture.)

In the early fifteenth century, the Flemish brothers Van Eyck developed oil painting (making use of pigments ground in oil), lifting the purely decorative functions of glazes into the more rarified atmosphere of fine art. Happily, though, the uses of glazes to create beautiful nuances of color remained in the decorative arts as well, as the richly colored wall panels and furnishings of all periods attest.

An important painted finish—japanning—emerged in the seventeenth century and was practiced for centuries all over England, Europe, Scandinavia, and North America. It evolved from oriental lacquer—a hard, highly polished finish the likes of which had never been seen before that time outside of the Orient. From the seventeenth century onward, paint and tinted shellac or varnish imitations of lacquer's handsome sheened finish were developed by decorative painters all over the western world. Craftsmen like Gerhard Dagly in Germany and Giles Grenday in England applied japanning onto important pieces of furniture—the colors of which ranged from the German cream through the English sealing-wax red to dark green, navy blue,

and black. Decorations were often built up on the japanned surfaces of all sorts of objects and furnishings.

Popular variations of japanning developed, including toleware (japanning on tinware), decoupage (an art form in which prints are glued on a painted surface and then varnished), and *Vernis Martin* (a style developed in France using a varnish containing garlic and, often, gold dust). These finishes were so admired during the late seventeenth through early nineteenth centuries that from early on ladies of leisure practiced them on all kinds of furnishings and objects. The well-known English book by Stalker and Parker, *Treatise of Japanning and Varnishing*, published in 1688, was designed principally for amateurs. Although there was a brief eclipse in interest during the early eighteenth century, japanning resurfaced in the 1740s, and *The Ladies Amusement or the Whole Art of Japanning Made Easy*, a late eighteenth-century book filled with chinoiserie designs, kept the craze alive into the nineteenth century—again, among nonprofessionals. Penwork, a variation of japanning in black and white done primarily in England in the late eighteenth and early nineteenth centuries, was almost wholly an amateur pursuit.

In the early nineteenth century, a bronzey-gray-green painted finish was popular in countries as diverse as France, Russia, the United States, and Spain. Based on imitations of verdigris, a natural finish that develops on bronze when it is exposed to the elements, this finish became fashionable again in the 1980s.

LATER DEVELOPMENTS

By the later nineteenth century in both North America and England, most house painters included graining, glazing, and marbling among their offerings to churches and theaters as well as to private residences. These painters often used mechanical means to achieve their results. Graining was applied with transfer papers, stencil graining plates, and Gransorbian (a photo-graining paper with an absorbent surface in relief) in all types and lengths of wood. This resulted in quite realistic, although often repetitive, graining and led to a decline in personal skills, which undoubtedly hastened the demise of fine decorative painting after this period.

At the turn of the century and later, hand-painted marbling and graining were still being done in houses like Lyndhurst, in Tarrytown, New York, and The Breakers, in Newport, Rhode Island. During the 1920s and 1930s elaborate mansions still called for this type of work; however, the prime demand for these techniques was in motion pictures. Movie studios required marblers, grainers, and glazers to create movie sets.

(Fifty years later we received a commission in this tradition when we glazed a ladies' phaeton that was used as the main prop for the movie "Heaven's Gate.")

In the mid-twentieth century painted finishes fell out of favor under the Bauhaus influence of minimalist decor—white, white, and more white—and also as a result of the period's rigid ideas concerning ornamentalism: none.

THE PAINTED SURFACE TODAY

Since the 1970s there has been a revival of interest worldwide in painted finishes. Reasons for this renaissance are as diverse as those who desire these finishes—from the craving for accurate restoration of older houses and their furnishings to the fancy for the most avant-garde visual effects. In between these two extremes of tradition and fashion lie a whole range of practical purposes—using painted finishes to solve problems with space, architecture, design, color, and light.

Painted finishes were used so often in historic interiors that accurate restoration calls for these finishes to be restored or recreated. Through the expertise of government agencies in many countries—like the National Trust for Historic Preservation in the United States and the Royal Oak Society in Great Britain—and the knowledge and dedication of local historical societies, a wealth of documentation of original pigments has been accumulated. In addition, schools such as ours offer training in the skills needed for application and restoration of painted finishes.

Contemporary painted finishes exhibit an unlimited range of colors and patterns. Styles have changed—what may have been considered bad taste (clashing colors and bold patterns) in the past is now accepted as commonplace. As previously unknown materials and paint techniques are developed, art historians of the next century will be able to describe more and more new combinations of visual effects. For example, even though glazes now can be used to create almost unlimited colors and patterns, when new products—such as the recently developed interference paints—are combined with glazes, a totally new dimension of color saturation and depth is possible. New marbles that are being quarried and brought to view will inspire both realistic and impressionistic decorative finishes; even the finishing process on real marbles may suggest painted finishes that have not been done before. Novel finishing techniques on real woods will influence the coloration of graining. The future will see an evolution of greater originality in all phases of decorative painting.

HOW TO USE THIS BOOK

In order to get the most benefit possible from this book, we urge you to read (and reread) it, regardless of which specific technique(s) you plan to do.

The first section of the book—*Basics*—covers material that is relevant to all painted finishes. Since so many essentials of decorative painting overlap, we have grouped common elements to avoid repetition in the text. In this section you will find important information on media, tools, rendering methods, surface preparation, finish coats, color, and design.

The second section—*Techniques*—covers the three major decorative painting types: glazing, marbling, and graining. Each chapter provides both an overview of media, tools, and applications, and detailed step-by-step illustrated instructions for rendering specific finishes.

The presentation of visual demonstrations in these chapters reflects the differences in how we teach each painting type. Glazing techniques are relatively simple to learn, and the instructional photographs support this. In general, to execute a glazing technique requires knowing which tool to use, how it is used, and how the final effect should look. The challenges in glazing are to find interesting and creative applications of these simple techniques and to execute your choices evenly over large surfaces.

Marbling differs from glazing in several ways. First, while glazing techniques usually involve manipulating one coat of paint (the glaze coat) over another (the base coat), most marbling techniques require two or more layers. The pattern in each of these layers is reworked constantly, according to your aesthetic evaluation. In marbling, for example, a small shift of line or the sparking up of a texture can make a tremendous difference. Second, marbling is replicating a real substance, so authenticity of your rendering is an essential factor in creating a believable surface.

Because of the specific nature of marbling, we have presented the visual instruction in two ways: (1) a series of photographs demonstrating the technique in process,

and (2) a final sample that illustrates the finished effect. The in-process series was shot live and photographed close up to show the process itself. These demonstrations are similar to those we give our students in class. The final samples, on the other hand, demonstrate the finished work one should strive to achieve on the job. Both use the same techniques. We also have included color chips of the paints we used in these techniques (mostly Benjamin Moore alkyd interior house paints); the colors can be matched if the actual paint specified is unavailable in your area.

Graining combines elements of glazing and marbling. Like marbling, graining is generally multilayered. However, with some exceptions (such as burl and applied heartgrain), graining layers are rendered in a similar method to glazing: removal techniques are used over the entire surface. The main difference between glazing and graining is that wood has predictable characteristics. This allows almost every wood to be broken down into distinct layers: pore-structure layer, figure layer, crossfire layer, and toning layer. Although every wood does not contain all of these layers, this approach facilitates analysis and replication.

The final section of the book is *Professional Practice.* In it you will find information on setting up a business and working with clients, as well as business specifics on estimating, writing a letter of agreement, and the decorative painting process, from conception to completion. These chapters are designed not only for decorative painters, but also for those who supervise and/or hire them. The more common knowledge that all parties involved in a decorative painting project have, the more satisfactory the final results will be. Even if you are not involved in a professional situation, there is much information in the final section that can help make any project go more smoothly.

The glossary and list of sources in the appendix will help you with any unfamiliar terms and with locating the tools and media you need to do the job.

PART ONE
BASICS

MEDIA

Every stage of a decorative painting project, from priming to protective coating, involves the application and/or manipulation of some type of media. The main functions of paint media are the same today as they were centuries ago: to protect a surface (from water, dirt, heat, and cold) while making it clean and hiding what is underneath. However, in past centuries painters formulated their own paints, glazes, and finishes, which led to an intimate understanding of how various raw materials affected both the process and the product. These days painters are able to obtain products for everything that can be done to a surface, including cleaning, priming, base-coating, glazing, and finish-coating. Among each group of media there are many variations in solvency, drying time, sheen, consistency, and quality. The following approach to understanding modern media should provide you with a basis for making intelligent choices.

COMPONENTS OF MEDIA

The word *media* is the plural form of *medium*, which refers to a substance used by artists—the liquid part of either a formula or a thinning agent. Most media is a combination of two or more components. Having a general idea of the properties and the amounts of the components that are in a mixed medium will help pinpoint what adjustments are needed to make it work for you in different situations. The basic components of paint and glaze media are pigments and vehicles.

PIGMENTS

A pigment is an organic or inorganic solid that adds color and body to a medium. Pigment is ground up and put into a liquid to make a paint. The pigment does not dissolve, but remains suspended in the vehicle (which is why paints must always be stirred). Pigments vary in their opacity, density, hiding power, permanence, and cost. (Recently, a group of pigments called interference colors has been developed to produce iridescent paints.)

VEHICLES

The vehicle is the liquid that carries the pigments and all the other ingredients that make up a formula, such as binders, resins, thinners, solvents, and driers. Vehicles help the pigment particles to bond to each other and to the surface that they are coating, accelerate the drying process, and provide durability.

SOLVENTS AND THINNERS

Solvents are evaporating or volatile liquids that are both part of the vehicle formulas and available individually. They allow you to have more control of your formulas—by reducing or increasing evaporation and aiding penetration—and to remove solvent-related films. Paint thinner, denatured alcohol, and water are the most commonly used solvents in decorative painting.

Solvents are termed thinners when they are used to reduce paint and finish viscosity so that the liquids may be spread in a thin film, thereby appearing less opaque. They may also be used for cleanup. Functions of the commonly used solvents and thinners follow:

Paint thinner. Also known as mineral spirits and white spirit, paint thinner is distilled from crude petroleum oils. It has the identical thinning properties of turpentine but is less toxic and less expensive. Paint thinner is used with alkyd paints and other paint-thinner-soluble products. Buy the best grade: that labeled "100 percent government-approved mineral spirits."

Water. Water is the solvent for latex and acrylic paints (when they are wet) and other water-soluble products.

Denatured alcohol. Also called solvent alcohol or denatured solvent, denatured alcohol is ethyl alcohol that has been made unfit for drinking by the addition of poisonous materials. It is the solvent for shellac and dried latex and acrylic paints.

Turpentine. Distilled from pine tree sap or oleoresins, turpentine is a solvent for alkyd paints and other paint-thinner-soluble products. Turpentine has been largely replaced in industry and studio use by paint thinner.

Naphtha. Also known as benzine (not benzene), this petroleum-distillate solvent evaporates very quickly, making it a useful solvent for speeding drying times.

Kerosene. After paint thinner, kerosene is the most useful of the petroleum distillates. It is used to slow the drying time of media (see page 70). Kerosene either can be added to paint and glaze formulas (replacing an equal amount of paint thinner) or can be coated on a surface prior to glazing.

SOLUBILITY

To understand how media work, you must understand the concept of solubility. This defines what solvent may be added to a particular medium. The most basic

aspect of any medium is the correct solvent that can be used to thin it, as virtually all paint and most other media used in decorative painting are thinned to some degree. More than one can of paint has been ruined because someone inadvertently added the wrong solvent; for example, water to alkyd paint or paint thinner to latex paint. The proper solvent for a paint can usually be found on the label of the can in the directions for thinning and cleaning brushes. The media listed in the chart on page 14 are grouped according to their solvent.

Understanding the role that solvents play in paint chemistry not only allows you to perform the necessary tasks of thinning down media and cleaning brushes, but also allows you to experiment with new combinations of materials that share common solvent bases to adjust color or to change properties. For example, with an alkyd paint you can shift the color with japan paint or artists' oil, speed up drying time by adding japan drier, or slow the drying time by using glazing media.

Solubility is also a factor in alternating layers of different solubilities and/or interlayering. The aim of alternating solvents is to lock each layer in, offering protection from subsequent coats and enabling you to obtain visual effects of great depth. To combine layers of materials, observe the correct solvent base for each and do not permit two layers having the same solvent base to touch one another.

Interlayering is using an isolating layer of a different solubility between two layers of the same solubility; for example, using a shellac isolating film between two alkyd marbling layers. Some media, such as tempera (see *Serpentine*, page 120), Marglaze (a formula developed by Ina Marx, see page 181), and watercolors (see *Country Graining*, page 233), must have an isolating layer to protect even thoroughly dry layers from being removed by subsequent layers.

Sometimes an isolating layer is used between layers when it is not absolutely necessary. For example,

• to create a sheened surface on which to work;

• to allow a top layer to be manipulated and/or removed without damaging lower layers; and

• to shorten the time in which the next layer can be applied. For example, an alkyd marbling layer might need six to twelve hours drying time before another alkyd layer could be applied over it. However, the first layer could be covered safely with shellac after two to three hours, and the next alkyd layer could be applied over the shellac forty-five minutes later. Note: When "pushing" the time between layers, keep a running

parallel sample of all steps to prevent problems (see *Sample-making*, pages 253–57).

Whenever possible, we use shellac as an isolating layer for the following reasons:

• It can be thinned to make a very sheer coating (we use one part three-pound cut shellac to one part denatured alcohol).

• It dries quickly, often enabling you to apply the next layer after forty-five minutes.

• It can be removed with alcohol (we use a cotton swab for removal), which permits adjustment of a previously painted layer.

• It has good bonding properties, even over fresh paint.

• It has only a slight yellowing effect—which is usually not objectionable. (We use a water-based acrylic-type finish when an absolutely clear isolating layer is required. Be careful to keep this type of finish intact since it has a tendency to peel, taking with it under- and overlayers.)

Shellac can be used to isolate paint-thinner-soluble paints as well as casein, gouache, tempera, and watercolor. Since latex and acrylic paints become alcohol-soluble when dry, with these paints it is more appropriate to use a latex acrylic finish or water-soluble medium than shellac. However, with care you can also use shellac over these paints. Do not overbrush with shellac and always test it on parallel samples to make sure the shellac will not remove or crack the previous paint layer.

PAINTING AND GLAZING MEDIA

The media used in decorative painting can be paint-thinner-soluble, water-soluble, or alcohol-soluble. Specific formulas for glazing, marbling, and graining media are given in the techniques section of this book. However, a general understanding of the commonly used media will enable you to make appropriate substitutions should they be dictated by your situation (for example, if you are working in a poorly ventilated area, you may want to consider substituting water-soluble paints for paint-thinner-soluble ones).

Certain substances are soluble in several solvents. For example, powdered pigments are generally soluble in paint thinner, alcohol, and water. They can be used in any technique, but are particularly useful in graining media. Powdered pigments are inexpensive and store well; however, they are somewhat unwieldy. They can be useful as a supplement or back-up media.

PAINT-THINNER-SOLUBLE MEDIA

The majority of our work is done with paint-thinner-soluble media—in fact, alkyd interior house paints, glazing media, and japan paints form the basis for most of the glazes and paints used in this book. Paint-thinner-soluble media are easy to work with, give consistently good results, and are readily available in most areas. However, they are more toxic than water-soluble media, and environmental legislation may restrict sales of certain media in specific regions. The paint-thinner-soluble media most commonly used in decorative painting are the following:

Alkyd interior primers and house paints. These paints, which are often erroneously called oil-based, are composed of pigments and synthetic resins suspended in linseed (or some other) oil. They come in various sheens—flat, satin, semigloss, and gloss—and take from twelve to twenty-four hours to dry completely. They are commonly used as prime coats and base coats, and in decorative media. We use and recommend alkyd interior house paints because:

- they are widely available in a complete range of premixed colors;

- they are relatively inexpensive; and

- they are versatile.

Flat alkyd paints have a higher percentage of solvents than sheened alkyd paints, and, as a result, are being regulated out of existence (although water-reducible alkyds are being developed).

Japan paints. These paints are saturated, pure pigments ground in driers and varnishes. They dry within a few hours to a matte finish, and can be used both as flat base coats and in decorative media. Japan paints are excellent for decorative painting either used by themselves or to tint other paints. Although their color range is limited compared to interior house paints, their colors are more intense and include important and sometimes hard-to-find dark and earth colors.

Artists' oil colors (in tubes). These traditional fine-art media are made of pigments mixed with oil (usually linseed). They dry to a semigloss sheen. The colors are very saturated, which makes the paints useful in decorative media. However, because of the paints' high oil content, they take a long time to dry (sometimes days). Because these paints are expensive and slow-drying, we prefer to use japan paints.

Stains. These are used in graining media. Two forms of stain are available: (1) the more commonly used nonpenetrating (or masking) stains, the solids of which are used to make graining media; and (2) penetrating stains, which are used directly from the can as a toner. Nonpenetrating stains have a high pigment content and are an excellent choice for formulating graining media because they already come in realistic wood colors (see *Graining*, pages 174–238, for stain/glaze formulas). Penetrating stains contain little (if any) solids and are formulated with transparent aniline dyes. Because they are designed to soak into wood, they do not dry quickly and remain tacky for a long time. Once they are no longer wet, they must be protected with a layer of shellac.

Asphaltum. This is a coal-tar derivative that adds depth and translucence to glazes. It dates back to ancient Egypt, where it was used in the mummification process (in the 1930s a number of Egyptian mummies were ground up to acquire the asphaltum). It is used in decorative media, particularly Marglaze (see page 181). Note: Asphaltum must always be isolated with shellac.

Glazing media. These are premixed and range from thick and opaque (usually off-white) to thin and translucent (usually blue-gray). They add to a formula translucence, flow, and the ability to hold a pattern (megilp). Glazing medium is combined with equal parts of paint thinner to form a vehicle used in many decorative-painting techniques. Drying times and sheens vary; they can be adjusted to suit your needs (see *Glazing*, pages 72–73 for glaze formulas).

Boiled linseed oil. This plant derivative is used as part of paint and glaze formulas. It is used in decorative media and also to extend drying time. Be sure to test linseed oil on a sample before using it on the job; often it may yellow unacceptably. In addition, it must be thoroughly dry before it is covered with a finish coat or cracking may develop.

Finishes. These are natural and synthetic resins dissolved in vehicles to form protective coatings. They are available in various sheens and drying times (see *Finish Coats*, pages 41–47). They are used as protective coats and to form translucent glazes (such as Marglaze, see page 181).

Driers. Also known as siccatives, these are metallic salts that are mixed with media to speed drying. The two most common types are cobalt and japan. When using

driers, start with only a little bit (1 to 2 percent of the formula) as they are quite strong and may cause the paint to crack.

WATER-SOLUBLE MEDIA

Water-soluble media are most commonly used in graining (see pages 182 and 233–38). However, because they are less toxic than paint-thinner-soluble media, they are becoming increasingly popular as media for other decorative painting. The most commonly used water-soluble media are the following:

Latex interior house paint. These paints come in various sheens and dry within a few hours. They frequently are used in decorative media; however, they generally do not give as smooth a texture as alkyd paints. We use them primarily as a first layer when a second layer must be applied on the same day.

Acrylic paints. These paints are made of pigment suspended in an acrylic resin. They are similar in chemistry to latex paints; however, they are of a higher grade. Many people use acrylics for decorative painting and murals. Acrylics have two main advantages: (1) they dry quickly, and (2) they do not need an isolating coat before subsequent layers are applied.

Casein. Although this paint was originally made of pigment suspended in a medium of glycerin and milk curds, we prefer to use soy-based casein. Frequently used in decorative media, casein always must be isolated with an interim shellac layer as it remains water-soluble even when completely dry.

Tempera. This paint has pigment suspended in an egg-oil emulsion. Like casein, tempera remains water-soluble even when completely dry and thus must be isolated with an interim shellac layer. It is used as a component of decorative media.

Gouache. This paint is similar to watercolor; however, it has more white pigment, giving it greater opacity. Used in decorative media, it, too, must be isolated with an interim shellac layer as it remains water-soluble even when completely dry.

Artists' watercolors (in tubes). These paints are made of pigments combined with a binder, such as gum arabic; a moisturizer, such as glycerin; and a wetting agent, such as ox gall. Like casein, tempera, and gouache, when they are used in decorative media, artists' tube watercolors must be isolated with an interim shellac

layer as they remain water-soluble even when completely dry.

Latex acrylic finishes. Often called water-borne finishes, these nonyellowing and quick-drying finishes can be used as glazing media and as finishes. We prefer to use paint-thinner-soluble finishes because of their added translucence and working times. However, latex acrylic finishes are good if a second layer is desired in the same day. These finishes are also appropriate instead of shellac for use over dry latex and acrylic paints.

ALCOHOL-SOLUBLE MEDIA

Be careful when checking media labels for alcohol-solubility: alcohol is listed under various names, including denatured alcohol, solvent alcohol, or denatured solvent. The most commonly used alcohol-soluble media in decorative painting is shellac, which can be used as an isolating media or a finish coat (see page 41).

Shellac. Shellac is the secretion of the tropical "lac" bug, dissolved in alcohol. It is available in three colors: clear, opaque white, and orange (for some reason, clear shellac is called white shellac, so check labels carefully). Shellac is used primarily as an isolating layer over paint-thinner- and water-soluble paints (except for latexes and acrylics). The shellac we use most often is three-pound cut (three pounds of solids to one gallon of alcohol), mixed with up to one part of alcohol (in other words, one part of liquid shellac to one part of alcohol). Since alcohol is hygroscopic (absorbs moisture from the air), keep shellac cans tightly closed and observe the date on the can to prevent drying problems and "bloom"—a bluish white haze that can appear in a film.

Aniline powders. These are dyes that can be used to tint shellac, allowing an isolating layer to add toning and depth. They are relatively expensive; however, a little goes a long way.

CONSISTENCY

To a large extent the final effect of any decorative painting is dependent on the consistency of the media. Media consistency is simply the ratio of solids, binders, and solvents to one another. Consistency affects both the process (how media move and flow) and the result (how the rendition looks). Whenever you are not getting the decorative effect you would like, suspect your media's consistency first.

There are two ways to arrive at a correct consistency. By far the most common is to add the appropriate solvent when a medium is too thick. The other is to allow the excess solvent in a too-thin mixture to evaporate (or to add more pigment).

When adjusting media, analyze your problems and what options will solve them the best. For example, to make an overly opaque alkyd glaze more translucent you would add glazing liquid in addition to paint thinner so that drying is retarded and body is maintained. You would not add more pigment, because your overly opaque glaze already has an overabundance of pigment solids.

In this book we present formulas that have been successful for us and our students over the years; nonetheless, you must be alert to conditions that may require you to make adjustments when you least expect it. Factors such as how the surface was prepared (was a primer used?), the conditions under which you are working (is an air-conditioning vent drying your glaze?), the size of the area you are working on (can you retard the drying of your glaze?), and the plane of your working area (did you prepare your sample vertically?) can affect media consistency.

MEDIA AND THEIR SOLVENTS

Knowledge of media and their solvents is important for the "layering concept" (choose an isolating coat with a different solvent from the prior coat); thinning (use the solvent specified on the media label); and cleaning brushes and tools (use the solvent specified on the media label).

The following lists group media by their solubility. Media of the same solubility may be combined with one another, while media of different solubilities may be interlayered.

Paint thinner and turpentine
- alkyd interior housepaints
- alkyd primer-sealer-undercoater
- artists' oil tube colors
- japan paints
- most stains (check label)
- most glazing mediums (check label)
- most finishes (check label)
- linseed oil (boiled)
- asphaltum and asphaltum mixtures
- driers (cobalt and japan)
- flatting oil
- most powdered pigments (check label)
- most waxes
- size (fast and slow)
- kerosene
- naptha

Water
- latex housepaints (while liquid)
- latex primer-sealer-undercoater
- acrylic paints (while liquid)
- casein
- gouache
- artists' tube watercolors
- poster paints
- showcard paints
- tempera
- distemper media (made with beer, apple cider, or similar substance)
- india ink (while wet)
- most powdered pigments (check label)
- glue sizes (e.g., rabbit-skin, fish)
- latex/acrylic finishes (while liquid)

Denatured alcohol*
- latex housepaints (when dry)
- acrylic paints (when dry)
- shellac
- latex/acrylic finishes (when dry)
- most aniline powders (check label)
- most powdered pigments (check label)
- india ink (when dry)

Lacquer thinner
- lacquer

Toluene, Xylene, Benzene, Benzine (Naphtha), and Acetone
- specialized uses

*Alcohol has the potential for dissolving paint-thinner-soluble and water-soluble materials. Be alert to possible damaging effects when using it, and always test it on a sample before using it on the job.

HEALTH, SAFETY, AND ENVIRONMENTAL CONCERNS

Decorative painters generally work with paints and solvents that are considered relatively safe. However, continued exposure to any paint or solvent is stressful to the body and can lead to respiratory, skin, kidney, liver, brain, and nervous-system problems, as well as allergies. With proper precautions these risks can be significantly reduced.

Chemical contaminants enter the body by inhalation, ingestion, absorption, or invasion of a cut or abrasion. Accordingly, special care in working with paints and solvents should be taken by pregnant women (especially in the first trimester) because of the transfer of trace substances between mother and fetus. Other groups whose immune systems are more vulnerable to toxicity from paints and solvents include smokers and people with allergies or respiratory, kidney, or liver diseases.

By following a few simple suggestions, you can assure that your work area will be as safe as possible.

PROVIDING PROPER VENTILATION

Many of the media used by decorative painters give off potentially harmful fumes—some of which are odorless. Therefore, it is essential that your workspace be properly ventilated. To obtain adequate ventilation or air exchange, work with as many windows and doors open as possible. If necessary, set up an exhaust fan in such a way that it removes the contaminated air from the work area without drawing it past workers. For example, if you are glazing a wall from left to right, place the fan in a window on the left side of the room.

If it is impossible to get good ventilation and/or the fume concentration is high, wear a respirator. Make sure that it fits snugly, with no gaps between the seal and your skin. Also, check the label of the filtration system to see that it is the proper system for filtering toxic odors. If you are sanding or doing other activities that saturate the air with particles, you should wear a dust mask; however, be aware that these masks do not block chemical contaminants.

Used rags and cheesecloth are a major source of fumes in a studio and on the job. Keep these in a covered container and dispose of them frequently.

Fumes also escape from open containers of solvent. Keep covers on those containers you are not using to prevent the liquids from evaporating into the air.

AVOIDING INGESTION OF TOXINS

You should not eat or drink while working, and you should always wash your hands thoroughly after painting. Never put a brush or tool in or near your mouth.

MINIMIZING ABSORPTION OF TOXINS

We use gloves to minimize absorption of harmful materials through the skin. Vinyl gloves will not dissolve when exposed to paint thinner, are inexpensive, and are readily available through pharmacies. They can be doubled up for especially messy jobs (we have occasionally worn three pairs of gloves). While recent reports indicate that latex gloves give the best protection, we have found that latex gloves tear too easily to make them practical for decorative painting.

If you do get a solvent on your skin, wash it off immediately. Even though you may not feel any damage being done, many chemicals can enter your system through your skin. It is not necessary for there to be a cut or abrasion for a toxin to get through.

Whenever possible, you should substitute a less harmful material for a toxic one (for example, use paint thinner rather than turpentine). Also, if you get a rash or other reaction when using a particular substance, try using a replacement.

FIRE SAFETY

Many paints and solvents are flammable. Check labels on all products you use for any flammability warnings, and make it a practice never to smoke in your work area—or to work near any open flame. If you are using linseed oil and other materials with a low flash point, wet the dirty rags with water before discarding them to prevent fires due to spontaneous combustion.

ENVIRONMENTAL CONCERNS

We heartily applaud new environmental regulations that limit the amount of volatile organic compounds (VOC) in paints and finishes. Although at times these regulations have been inconvenient, reformulated products are increasingly available and substitutes can always be found with a little experimentation.

We also recommend recycling your materials when possible and disposing of them conscientiously. We recycle paint thinner for cleaning brushes and tools by letting the solids settle to the bottom and reusing the top (liquid) portion. When the paint thinner becomes too dirty to use, we dispose of it (along with unusable paints) through our community's disposal program.

TOOLS

There is an entire range of tools that can be used in decorative painting, from a piece of potato to a $400 stipple brush. When students first come to our school, many are surprised that we use so few specialized brushes and tools. Most of our techniques, including the ones in this book, are done with everyday items such as cheesecloth, plastic, cardboard, sponges, and simple artists' brushes. Certainly, fancy brushes and tools are nice to have and do have a place (especially in graining, where check-rollers and floggers are useful). However, we believe that the brain is the most valuable tool, so we emphasize the variety of effects that can be achieved with ordinary tools.

Become familiar with the effects you get using specific tools in various ways. Then, when you have an idea to try or see a substance you wish to simulate, you will have an entire repertoire of visual textures from which to choose. In addition, keep your eyes open for new potential tools among both everyday items and tools used by other industries.

TOOLS FOR MANIPULATIONS

Tools may be used in many different ways. They may be stroked, dragged, twirled, or rolled; laid on, pounced on, or pressed in; or used to spatter, whisk, blend, fuse, or print. Also try using tools both flat or on edge, as well as both wet and dry. Many tools can be used as they are, while others can be cut, torn, or notched—or crumpled, pleated, wadded, or poufed. Find ways to make tools work for you.

Choose tools based on how their unique qualities can be used to execute desired effects. Try to think of what the tool needs to do in as specific terms as possible. For example, to apply long, narrow veins precisely where you want them, you need a brush with long flexible bristles that allow a good paint flow and control; a #0, #1, or #2 artists' script liner brush or sword striper would be a good choice. However, for washy veins and drifts, a feather or a larger artists' brush would be a better choice. A stiff-bristled brush is needed to pull and thin out paint when whisking, while a brush with softer bristles is needed when blending to remove brush marks. The chart on page 22 shows how different tools can be used in similar ways. Do not be afraid to experiment with these or any other tools.

Most of the tools you will be needing are well-known items. The tools we use most are brushes, cheesecloth, paper, plastic, chamois, sponges, feathers, and an assortment of removal tools. In addition, for graining we use some specially designed tools.

BRUSHES

Brushes are available through art stores and paint suppliers in a multitude of shapes, sizes, and qualities. In addition to those brushes designed for artists and house-painters, there are brushes specifically designed for decorative painters. We use both bristle and foam brushes, depending on the technique.

Brushes perform according to the type, quality, length, and shape of their bristles, as well as their amount of flagging (splittling of each bristle's end). We have found that the following are sufficient for most work:

Artists' script liner brushes (mainly #0, #1, and #2). These thin, long-bristled brushes are used for fine lining and controlled placement of small amounts of paint. They are ideal for any applied technique where specific placement of media is desired, as well as for minor corrections of both applied and removal textures. The long bristles of these brushes retain and feed media nicely, and also provide the flexibility needed to render intricate effects (short bristles do not perform these functions).

¼-inch (60 mm) flat soft-bristled artists' brush. This brush is good for applying larger amounts of paint. We prefer soft bristles to stiff bristles because they allow us to blend media together more effectively.

Flogger. Sometimes known as a dragger/flogger, this wide, long-bristled brush is either dragged with its broad side against the surface to produce a soft, relatively even linear strie texture (see pages 93–94) or "slapped" to produce a porelike texture in a process called flogging (see page 184).

Blending brush. This tool is brushed with light pressure in different directions to blend media, soften texture, and feather out paints. The best blenders are made of badger hair, for water media, and hog bristle, for oil media. However, with care, any soft-bristled brush can give satisfactory results. Blending brushes are particularly useful for softening the sharp edges of crossfire (see pages 195–204).

Stiff-bristled brushes. These brushes are whisked through wet media to create porelike lines and create channels (soft bristles do not have enough spring for whisking).

Fan brush. This fan-shaped brush is used for both applying and removing media. It can be charged with

media and pulled on a surface to create fine lines or pressed onto wet media to leave unusual configurations. It can be used as it is or it can be combed through to get more defined groups of bristles.

Stencil and glue brushes. We twirl these round, flat-ended brushes on the surface to apply or remove media to form knots. The brushes can be used as they are, or with clumps of outer or center bristles cut out.

Sword stripers. These thin brushes with long, tapering bristles are valuable for applying long, thin lines of media. They are ideal for applying veins.

Mottlers. These flat-ended brushes are stroked, dabbed, or twisted on surfaces to produce the subtle crossfires found in many woods. There are different kinds of mottlers, including straight, fan, and wavy.

Wallpaper-smoothing brush. This stiff-bristled, 12-inch-wide (30-cm-wide) brush can be used as is, cut into pieces, or with clumps of bristles cut out and the brush then wrapped with cheesecloth. It is dragged on a glaze surface to produce either soft or more sharply edged striés.

Liner and lettering brush. Also known as a fresco brush, this long-bristled brush can be stroked, rolled, and/or twirled across a glazed surface to create variations of color.

Stipple brushes. We use these wide brushes with long, closely packed clumps of bristles to remove glaze. The brushes can be pounced, dragged, or twisted on the surface. A stipple brush evens out glazes, either to create a sheer, translucent coat or in conjunction with other decorative techniques. Stipple brushes come in various sizes (from 1 × 4 inches [25 × 100 mm] to 7 × 9 inches [18 × 23 cm]) and are quite expensive.

Foam brushes. We use foam brushes for many applications, including applying media over an entire surface, applying lines and dabs of media, and applying horizontal finish coats. These brushes hold a lot of media and are inexpensive. Although many brands are not supposed to be used with shellac as it can cause the foam to disintegrate, we often do so on small- and medium-sized surfaces. Foam brushes are available in 1- to 4-inch (25 to 100 mm) widths.

Toothbrushes. Toothbrushes are widely used to spatter media (see page 185). Their bristles are flicked with a finger or comb to distribute dots of media on the surface. (Note: A regular brush with its bristles cut short can also be used.) The quality of the spatter texture can be controlled by the consistency of the media, the amount of media off-loaded from the toothbrush before spattering, the distance from the work at which the toothbrush is held, and the speed at which the media is flicked over the surface.

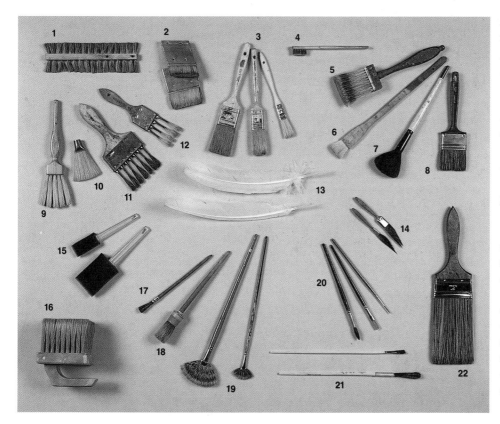

Brushes and feathers used in decorative painting: (1) two-sided grainer; (2) two mottlers; (3) three stiff-bristled brushes; (4) tooth-brush; (5) badger-hair blending brush; (6) bake wash brush; (7) mop; (8) hog-bristle blending brush; (9) walnut grainer; (10) hand grainer; (11) seven-part movable pipe grainer; (12) four-part pipe grainer; (13) two turkey feathers, cut and uncut; (14) two sword stripers; (15) two foam brushes; (16) stipple brush; (17) glue brush; (18) stencil brush; (19) two fan brushes; (20) three artists' brushes: hog-bristle brush, ox-hair brush, and script liner brush; (21) two liner and lettering brushes; (22) dragger/flogger.

CHEESECLOTH

Cheesecloth is a cloth with a rather open weave, usually made of cotton, but also available in synthetic fabrics.

Many types of cheesecloth are sold in supermarkets and auto-supply stores. The most inconvenient, uneconomical way to buy cheesecloth is in the supermarket packages of yard-long lengths; the weave is so open that the absorbency of the cheesecloth is minimal. Another type of cheesecloth has a very close weave; however, before use it must be washed to remove a size that otherwise hinders absorption. A cotton waste-type of cheesecloth is also unsatisfactory because it lacks absorbency.

We used to work with sixty-yard bolts of cheesecloth, which required our cutting the bolt up into pieces and then washing them to remove the size. We are most pleased with our current cheesecloth; it is cut for convenience, washed for absorbency, and packaged in a tight roll of 100 pieces, which is more than enough for glazing a very large room (see *Sources* in the appendix for ordering information).

Cheesecloth is a good tool for creating basic soft mottles, striés, and other glazing textures. It is also used to reduce the amount of glaze before and during certain decorative manipulations. It is poufed or crumpled and then dabbed, dragged, or rolled across a surface.

In certain cases, cheesecloth is too fragile for the job, and other cloths must be substituted. For example, for a very rough stucco surface, washed cloth diapers or a cut-up, well-washed damask tablecloth wear better.

If you cannot get cheesecloth, poufed or crumpled stockinette or muttoncloth may be used. However, these fabrics are heavier and less absorbent than cheesecloth, and because they are knitted rather than woven, they leave more of a textured imprint.

PAPER

Paper is one of the decorative painter's most useful tools. It can be used in many different ways: for removing glaze to create a texture, for creating hard-edged striés, for reserving a lower layer in chunklike shapes, and for blotting up glaze or paint to create lighter areas or crossfire (see page 195).

Many different types of paper are used in decorative painting. Newspaper is a standard removal tool; it can be crumpled, pleated, or kept flat to remove paint or glaze from a surface in general or specific patterns (see *Rag-rolling*, page 94, and *Straight Grain with Crossfire*, page 195). Most newspapers absorb in a similar way because of their fiber content. However, some papers produce quite different results. The *Manchester Guardian*, for example, is a crisp, thin English paper that produces a very fine texture. Newspaper can also be torn into breccia shapes (see page 141) and used to reserve lower paint layers in marbling techniques (although we prefer to use the paper that comes around rolls of sterile cotton).

Crumpled facial tissue can also be used to remove media. The tissue is stroked across the surface, leaving little texture. This makes tissue a good tool for techniques that require a smooth imprint (such as mahogany, see pages 226–30). Tissue can also be gently blotted or dabbed on a surface to remove excess media without leaving a texture. Although paper napkins and towels can also be dabbed on the surface to absorb media, these papers leave an imprint. These are used when a heavier blotting or break-up of texture is required.

Cardboard or oak tag (see pages 104–106) can be cut, torn, or notched to create removal tools for scraping paint or glaze off a surface. These tools are useful for creating striés and for rendering stripes in certain woods. After cardboard or oak tag is cut, the edge is pulled along the surface; the resultant pattern is determined by the irregularities in the edge and the amount of pressure used by the painter. Torn edges give many stripes of varying widths, shades, and depths; cut edges create designs and patterns; and notched edges remove glaze in graphic stripes similar to those achieved with a cut squeegee.

PLASTIC

Although many types of plastic are suitable for glazing, we usually use one-mil plastic dropcloths, either 9 × 12 feet (2¾ × 3½ meters) or 10 × 25 feet (3 × 6½ meters) in size. We generally cut the plastic into pieces, but we have used it full size when doing large flat wall surfaces.

Plastic is an interesting removal tool. Because it does not absorb the media, its imprints tend to be strong in texture. It can be crumpled, pleated, or left flat (the more crumpled it is, the finer the resultant texture will be), and then rolled, dabbed, or pressed on the glaze-coated surface. We also have a technique in which we lay plastic on the surface and then manipulate it with our fingers (see *Removal with Laid-on Plastic*, page 88).

CHAMOIS

Chamois is another good removal tool. Before use it must be wet with water and then wrung out (always wet any natural material before using it). It is then

wadded and crumpled and pressed or rolled on a glazed surface to completely or partially remove the glaze. When chamois is rolled on a surface, it leaves a somewhat broader texture than that achieved with fabric, paper, or plastic. Chamois can also be formed into specific shapes, such as stones or lozenges, and pressed against a glazed surface to leave an imprint.

Real chamois skin (from Alpine goats) has become difficult to locate. Today, the thin leather from sheepskin is more widely used. Frankly, we prefer it; this "chamois" is thinner than the real chamois skin and, since it is not cured with fish oils (as is real chamois), it is not slimy when wet.

SPONGES

Sponges can be used in various techniques to either dab media onto a surface, manipulate media on a surface, or remove media from a surface. We use both marine (natural) sponges and synthetic sponges, depending on the technique. All sponges must be wet with water and then wrung out before being used.

The two types of marine sponge that are commonly available are sea grass and sea wool. Sea grass has tubelike openings at the edges while sea wool has smaller, solid protrusions. We recommend getting both, as they each deposit paint differently. Marine sponges apply paint in specific patterns, so take care to make the texture as even as possible to avoid a blotchy look. We use whole and cut marine sponges for rendering granites (see *Granite*, pages 113–15) and in certain marbling and country graining techniques (see *Travertine*, pages 107–109, and *Applied Country Graining*, page 235). They can also be used to remove glaze, creating a "pebbly" texture.

The synthetic sponges we use are cellulose, not foam, and they have a flat surface, rather than one that is ridged or patterned. The ones we prefer have various-sized oval openings on the surface. These sponges are ideal for printing paint onto a surface, particularly when an entire surface needs to be covered with a stonelike texture (see *Serpentine Marbles*, pages 120–36). In addition, the sharp edges of these sponges can be pulled across a wet glazed surface to produce fine lines of varying widths for glazing, marbling, and graining.

FEATHERS

We use turkey feathers in both marbling and country graining techniques. In marbling, feathers are both stroked and laid on the surface to apply veins and drifts (see *Yellow Sienna*, pages 166–69). In country graining, feathers are cut short on one side and then pushed or "chopped" on the surface to remove media in a particular pattern (see *Feather Manipulations*, page 237). Feathers may also be placed on a surface and flipped from one side to another to create a pattern, and the tip can be used to paint fine lines.

OTHER REMOVAL TOOLS

Steel or bronze wool. Both steel and bronze wool, which come in fine through coarse grades, can be dragged through glaze (usually more than once) to produce varying degrees of rough, broken striés and pore structures, depending on the grade used; however, steel wool will bleed a gray color when used with paint-thinner-soluble media, while bronze wool will not. (Bleeding may or may not be desirable.)

Stucco roller. This plastic-looped roller can be dragged across a glazed surface to produce fine, sharp-edged striés or rolled through glaze to create small repetitive markings.

Nylon pot scrubber. This kitchen item is dragged on an edge through glaze to produce fine strié or grain lines (see *Zebrawood*, pages 190–91). The many types of pot scrubbers each produce a different linear pattern.

Squeegees. These window-washing tools can be used to obtain custom graphic stripes and plaids (see pages 95–98). Their edges are notched out with a cutting tool and then dragged through glaze to create sharp-edged striés. The cut-out notches leave glaze on the surface while the "teeth" pull glaze completely off the base coat.

Vegetables. Solid vegetables, like potatoes, can be cut into shapes and dabbed, twisted, or stamped on a surface to remove or print media (see *Rasotica*, pages 116–19). Stemmed vegetables like broccoli or cauliflower can be used to apply or remove paint in interesting patterns.

Cork. The edge of a cork can be pulled through glaze to render lines or knots, or the end of the cork can be stamped on the surface to apply or remove media.

Glazing Putty. Traditionally used to produce country graining, this putty is formed into balls or long rolls and dabbed and pressed on a surface to manipulate the media (see page 238). It is available in two types—vinyl water-based and linseed-oil-based, each producing different results.

Erasers, beveled. Useful in creating veining and medullary rays (see pages 192–94), erasers can be pulled through wet glaze to expose pure base coat or through almost-dry glazes to create an unusual texture.

Stump or wipe-out tool. These rolled-paper or rubber tools are stroked on the surface to remove excess media.

Cotton. Wads of dampened sterile cotton can be dabbed, whisked, and/or rolled on a surface to apply spurts of color or to subtly whisk and fuse paints. Cotton's softness and nonpatterned fiber formation provide subtle results when cotton is used to apply or remove media.

Cotton swabs. These tools are very useful as they are absorbent, small, and easy to control. Some uses include thinning lines that are too wide, imparting varied line quality, blotting up excess media, making channels, and opening up dense areas.

GRAINING TOOLS

Although graining can be done with regular decorative-painting tools, there are a number of special tools that will facilitate your work. (These tools are discussed in depth in the chapter on graining, pages 174–238.)

Pipe grainer. Also known as a pipe overgrainer, this tool is comprised of a series of small brushes (sometimes adjustable) set on a handle. The pipe grainer applies individual parallel lines of media; it is charged with media and stroked along the surface to create straight-grain lines (see *Brazilian Rosewood*, pages 212–13). This tool can be used as it is, or its brushes can be combed through to separate the bristles (which results in even finer lines). If you cannot find a pipe grainer, you can make your own quite easily by combining a number of small artists' brushes (see page 213).

Check-roller. This tool is made up of a series of separated thin metal disks threaded on a bar. As paint is applied to the tool, it is rolled down the surface to produce the fine, broken pore structure found in American oak (see pages 210–11).

Graining heel. Also known as a rocker, this rubber-and-wood tool is pulled and rocked on a surface to quickly and mechanically produce heartgrain patterns (see page

Tools used for removal techniques: (1) three rubber graining combs; (2) check roller; (3) heel; (4) four rubber graining combs; (5) torn cardboard square; (6) notched cardboard square; (7) two rubber window-washing squeegees; (8) cotton swabs; (9) four steel graining combs; (10) wallpaper-smoothing brush; (11) pink eraser; (12) green rubber eraser; (13) rubber mucilage-bottle top; (14) stump; (15) two-sided wipe-out tool; (16) two kitchen pot scrubbers; (17) bronze and steel wool; (18) looped plastic roller.

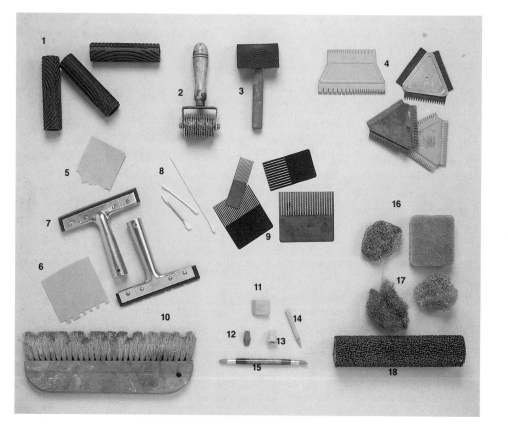

206). These patterns are particularly effective when combined with pore structures, straight grains, and overglazes.

Graining rollers. These rubber tools are rolled or pulled down a surface to create particular wood-grain patterns. Rollers are available in various patterns including broader-scale heartgrain and sycamore (see pages 200–201).

Rubber graining combs. These combs are pulled and/or twisted on a surface to produce sharp-edged straight-grain lines. Different styles are available, including graduated combs and triangular combs with three different sizes of teeth.

Steel graining combs. These combs are pulled and/or twisted through media to create grain lines. They can be used as they are or wrapped in fabric or a cut balloon (the wrapped combs produce subtly textured straight-grain patterns). In addition, alternate teeth can be bent up to change the pattern.

Hair combs. These combs are useful for combing through brushes to open them up into clumps of bristles. Combs also may be pulled across short-bristled brushes to flick off spattering media.

TOOLS FOR APPLYING PAINTS OR GLAZES

There is another group of tools that, while not actually part of the decorative manipulations, are fundamental to any project. These include the brushes and rollers used to apply primers, base coats, glazes, and finishes.

House-painting brushes come in many shapes, sizes, bristle compositions, and grades. A good paint store can help you choose the right brushes, as well as give information on how to use them. Professional-quality brushes will give better and quicker results. We generally use 3- to 4-inch (80 to 100 mm) brushes.

Rollers—a napped pile or foam sleeve covering a rolling metal cylinder called a cage—are often used to apply primers and base coats. They come in various widths, naps, and compositions, and are used in conjunction with a metal tray for holding media (disposable plastic tray liners are also available to facilitate cleaning the tray). Using a good-quality roller sleeve with the correct nap will give good coverage, reduce "pebbling," and leave fewer fibers. (Hint: Keep loose fibers to a minimum by first wrapping the roller cover with masking tape and then removing the tape.) We use foam rollers to apply glazes.

Coatings of thin, quick-drying materials such as

shellacs and water-soluble finishes can be applied with lamb's-wool applicators. (These are usually used on floors and walls.)

CLEANING TOOLS

With care, brushes and tools can last for a long time. The general cleaning procedure for bristled brushes is as follows:

1. Off-load as much paint or glaze as possible from the brush by wiping it with a paper towel or against newspaper.

2. Using the correct solvent, rinse and wipe off as much of the remaining media as possible. You can often use some almost-clean solvent (for example, used paint thinner with the solids settled on the bottom) as a first rinse, using fresh solvent as an optional final rinse. Do not let brushes sit in solvent, especially up to the ferrule (the metal band that holds the bristles). The brushes will lose their shape and the bristles will loosen.

3. Wash the brush with brown soap or dish detergent and warm water. Note: Since soap may be harsh on bristles, clean any "extra special" brushes with products scientifically formulated to clean brushes (see *Sources* in the appendix).

4. Coat the bristles with brown soap (or other cleaner) and use your fingers to shape the bristles into their original shape.

5. Hang the brush by a hook or lay it out to dry.

6. When the brush is dry, flick out any dried soap (away from your face, as the soap contains lye) and wrap the brush in its original wrapper or in brown paper.

There are products available that will remove dried paint-thinner-soluble and water-soluble media from brushes and tools (alcohol-soluble media usually stays alcohol-soluble). Hand cleaner often works well.

Follow the correct cleaning procedure for your tool. Foam brushes may be cleaned with the proper solvent and squeezed dry. Chamois and sponges should be swished in the correct solvent and then washed with brown soap and water. Feathers should be swished in the proper solvent and laid out to dry. Squeegees, check-rollers, graining heels, and rubber graining combs should be scrubbed with a toothbrush and solvent, then rinsed with water and set out to dry. Be careful never to leave a rubber tool sitting in paint thinner, or it will swell.

TOOLS AND THEIR EFFECTS

Removal Tools That Produce Overall Nondirectional Textures

Cheesecloth, poufed or crumpled: basic soft mottles, striés, and other glazing textures.

Stockinette or muttoncloth, poufed or crumpled: similar to cheesecloth effects, but more textured.

Stipple brush: subtle glaze effects.

Newspaper, plastic, plastic wrap, tissue paper, fabric, and household wipe, crumpled, pleated, or left flat: quick, overall subtle to broad textures.

Chamois, wet with water and wrung out, then wadded or crumpled: completely or partially removes glaze, or can be rolled to create a textured effect.

Marine sponge, wet with water and wrung out: even pebbly texture.

Feather, bristles cut short on one side: traditional country-graining patterns.

Removal Tools That Produce Directional Textures

Facial tissue, crumpled: smooth texture.

Flogger: relatively even, soft striés and/or porelike texture.

Wallpaper-smoothing brush, as is, or with bristles cut shorter (with or without clumps cut out) and wrapped in cheesecloth: soft or more defined striés.

Fan brush, as is, or combed through: fine, sharply defined lines.

Synthetic sponge, wet with water and wrung out: fine, sharply defined striés of varying widths.

Cardboard or oak tag, torn, cut, or notched: stripes, designs, patterns, and hard-edged striés.

Steel or bronze wool, as is, or torn into smaller pieces: varying degrees of rough, broken striés and pore structures. Steel wool bleeds gray when used with paint-thinner-soluble media.

Stucco roller sleeve, as is, or cut into smaller pieces: fine, sharply defined stripes or pits of base color.

Nylon pot scrubber: strongly defined thin striés.

Squeegee, notched: custom graphic stripes and plaids.

Graining heel: heartgrain patterns.

Graining rollers: various patterns including broader-scaled V-grains and sycamore.

Rubber graining combs: sharply defined grain lines.

Steel graining comb, as is, or wrapped in fabric or a balloon: defined or subtly textured straight-grain patterns.

Erasers (beveled and other) and cork: exposes pure base coat or gives a subtly textured effect.

Tools That Apply Media and Solvents

Artists' script liner brushes (mainly #0, #1, and #2): specifically placed lines.

Liner and lettering (fresco) brush: broad manipulated lines.

Sword striper brush: long thin lines.

Foam brush: overall application; broad lines; "dabs" of color.

Feather, as is, or combed through: The tip applies fine lines; the broad edge can make washy veins and drifts.

Pipe overgrainer, pipe grainer, or overgrainer: individual parallel lines of paint.

Marine sponge, wet with water and wrung out (can be cut into smaller pieces): broad-textured pattern.

Synthetic sponge, wet with water and wrung out: textured pattern.

Cotton, wadded and wet with 1–1 mixture: spurts of color with great subtlety and variation of depth.

Toothbrush or bristle brush cut straight across: specks of media spattered on the surface.

Check roller: the specific pore structure found in American oak.

Tools That Adjust Texture or Alter Quality

Facial tissue, crumpled or left flat: blots or dabs excess media without leaving a texture.

Paper napkins and paper towels, crumpled or pleated: blots and breaks up media, leaving a heavy texture.

Cotton, wadded and wet with 1-1 mixture: subtly whisks and fuses paints.

Cotton swab, as is, or wet with 1-1 mixture: thins wide lines, varies line quality, blots up excess media.

Blending brush: softens textures and feathers out media.

Stiff-bristled brush: whisks lines and creates channels.

Wipe-out tool or stump: corrects irregularities in linear removal techniques.

Miscellaneous

Paper from rolls of sterile cotton (or similar paper), torn and wet with water: reserves a base coat or subsequent layer(s).

Stencil or glue brush, as is, or with clumps of bristles cut out: applies and removes knots.

Vegetables, cut up: Solid vegetables can remove or print media; textured vegetables can apply paint in patterns.

Cork, as is, or cut up: prints media; removes lines or knots.

Glazing putty, in balls or long snakelike shapes: country graining patterns.

Mottlers: subtle crossfires.

Hair comb: combed through brushes to divide them into clumps of bristles.

SETTING UP A WORKSPACE

Regardless of whether you are a solo practitioner or run a large firm, you will need a workspace or studio. This work area should be efficiently and pleasantly set up, and should include health and safety features such as ventilation and exhaust systems and a fire extinguisher. Even though you may not have an ideal workspace, try to incorporate as many of the following features as possible:

- many windows to ventilate and to let in good light for working and matching colors

- adequate artificial lighting

- electrical outlets, including enough so that fixtures with different types of lighting can be set up for color testing

- air conditioning, heating, and exhaust systems

- a fire extinguisher

- floor-to-ceiling storage for supplies and samples (use the master supply list on page 268 for reference)

- a worktable (a collapsible table 3 × 6 feet [1 × 2 meters] is ideal)

- a desk

- portable chairs

- a telephone

- file cabinets

- a paper cutter

- large trash containers

- a utility sink with hot and cold running water

- open storage around the sink

- a hanging bar for oak-tag samples

- a drying rack for holding flat samples

- vertical surfaces for preparing vertical samples

- amenities such as a radio and a comfortable chair

You will also need the following supplies:

- gloves

- a respirator

- empty cans with lids (quart and gallon)

- buckets

- aprons

- stir sticks

- 8- or 9-ounce (250 or 280 ml) paper and foam cups

- laundry soap

- hand cleaner

- paper towels

- paper napkins

- cheesecloth

- natural sponges

- dropcloths

- newspaper

RENDERING A PAINTED FINISH

Painted finishes fit into three broad categories: original effects, replication of other painted surfaces, and exact simulations of real substances. The requirements for rendering them are the same: to determine what colors and media should be used in what sequence. The more knowledgeable you become about color, media, tools, and techniques, the more quickly you will be able to make satisfying, efficient choices for your particular renderings—whether they require one layer or several.

APPLIED AND REMOVAL CONCEPTS AND TECHNIQUES

There are only two types of manipulations possible for decorative painters: media can be applied to a surface with a brush or a tool and left there (the applied technique), or media can be applied to a surface with a brush or a tool and, while the media remains wet, be removed to expose some or all of the underlayer (the removal technique). By thinking of any decorative-painting project in terms of applied or removal techniques, you will be able to break down all techniques, from simple lines through complicated visual effects, into one or more layers of paint applications. If you have captured the essential colors and visual textures, these layers will "read" as the real substances, painted surfaces, or original finishes you have been attempting to render.

APPLIED TECHNIQUES

In applied techniques, tools are used to apply media to the surface. These techniques give you precise control over the placement and quality of your lines, masses, and colors, which makes the techniques appropriate for marbling, graining, and other finishes requiring exact positioning of media. The most commonly used tools are brushes of all types, sponges (natural and synthetic), and other printing materials.

Surfaces rendered with applied techniques can exhibit both hard-edged and blended color, depending on the method used. Any surface that will accept the media may be used; however, if the technique involves manipulation, avoid matte surfaces, as they absorb media and may make your manipulation more difficult.

A large variety of brushes is available for applied painting, from those that have a very few bristles and create a hairline (as in certain veined marbling) all the way to six-inch (15¼ cm) wall-painting brushes that allow you to make broad textures. With all brushes you control both the specific placement of the lines and the

line quality. Tools that print when charged with media—the synthetic sponges used for rendering serpentine marbles, for example—are used in applied methods to provide color and texture that appear to have the randomness obtainable with removal methods, yet have been carefully positioned.

Most liquid media may be used for applied techniques; however, the media must be thin enough to flow yet thick enough to retain an applied line without spreading. To test for media consistency, paint a line on your surface; the line should remain intact in the shape and place where you put it.

When using applied techniques, apply less medium than with removal techniques, as too much media may make the surface look opaque and scumbled. Remember, too, that you can always add more media where and when desired. (In addition to simply applying media, you may also pounce or spatter solvents on for decorative effects.)

One of the big advantages of applied techniques is that they allow you to pause mid-technique, enabling you to paint at your own speed. Their main disadvantage is that they often require a higher degree of skill with brushes and control over the media than removal methods.

REMOVAL TECHNIQUES

Removal methods enable you to quickly and easily produce subtle through elaborate visual textures, as well as color variations ranging from pure base coat through pure media color. Removal techniques are used for all glazing, most graining, and some marbling. Surfaces rendered in these techniques may exhibit

• translucent through opaque color;

• complicated color combinations;

• visual texture;

• a nonmechanical, hand-done look; and

• a thin ridge of media along one edge.

In preparation for removal techniques, the surface is usually coated with a sheened base coat to prevent absorption. One exception is for removal country graining, where a matte base coat is used.

All liquid media may be used for removal techniques. The media must be thin enough to flow, yet heavy enough to take an imprint without closing up. To test for proper consistency, draw a finger or brush handle

through the media; the resulting channel should remain open without showing raised opaque edges (except in techniques where these edges are desired).

A wide variety of tools can be used for removal techniques, including cheesecloth, feathers, sponges (natural and synthetic), plastic, fabric, paper, chamois, rubber, and vegetables. In addition, certain brushes, such as stipple brushes, floggers, and pounce brushes, may be used. When using these tools, factor in the difference in scale of each one and how it relates to the room size. Tools are applied with varied pressure and movement to wet media. Solvents may be spattered or pounced on the media for decorative effects.

When using removal techniques, remove more medium than seems necessary. You cannot remove the media when it is dry, but you always can add more.

Although removal techniques often appear broadly done and even a little crude because of the out-of-scale tools used by some painters (such as a fingertip wrapped in cheesecloth for veining), they can be quite sophisticated. Some renditions even look much better done in removal methods than when done in applied methods. For example, mahogany, whether straight-grain or crotch-figure, often appears rather labored and garish when it is rendered with each stroke laid on (applied). But if you use removal methods to render mahogany, the results will have the great depth of color and dramatic areas of light and dark apparent in the real wood.

The main disadvantage to removal techniques is that you must work while the media are wet, which means you often cannot stop working mid-technique. In addition, you may get some undesirable visual effects because of the relatively random nature of the manipulations.

SELECTING THE APPROPRIATE TECHNIQUE

In order to determine whether removal or applied techniques are more appropriate, focus on the specific qualities of texture and pattern that you want. The choice is often obvious; a softly textured wall would likely be a removal glazing technique, while applied techniques would most likely be used for a marble with specific vein placement and little texture.

Sometimes the context dictates technique choice. For example, in this book we show a removal technique for zebrawood. However, if you wanted more control of line placement in a small piece of zebrawood inlay, you might choose to apply every line with a fine brush before toning.

During this initial evaluation, it is not important to determine which specific applied or removal tool will be used. Those will be determined while you experiment on samples. Both techniques involve the interaction of color in some fashion, the consistency of the media, and various tools to create their effects. In addition, both techniques can work in conjunction with each other. For example, fine lines and shading can be applied to a rendition done with removal techniques to help clarify it (see *Rasotica*, pages 116–19). In contrast, paint that has been applied as lines of veining can be thinned down in places with a cotton swab to mimic the natural changes in vein width seen in many marbles.

Your own skills, standards, and confidence level may determine which method you choose for any individual project. If you are a rather slow worker, removal techniques (which must be done while the media stays wet) are still possible if you break large areas up into smaller units that you can render separately so that each unit is a small manageable project.

When developing decorative finishes—for our school curricula or for architects and interior designers—we usually consider removal techniques first. This is because we have found over the years that the majority of people can create complicated color and visual effects more easily and quickly with removal techniques than with applied ones. Removal techniques involve a partially random physical manipulation of media rather than conscious artistic control of it. When using applied techniques people often tend to apply too much media and then try too hard to direct it; the results are usually overly opaque, contrived, and poorly rendered.

Where we have used applied methods in this book we have made a deliberate effort in as many instructions as possible to capture some of the spontaneous quality of removal methods by selecting manipulations or tools that encourage random, rather than patterned, placement. (Examples of this are the use of torn papers in the Verde Issorie and Rosso Verona instructions on pages 124–26 and 140–43.) Even with those finishes where each line must be applied with rather precise placement and the line quality itself is important (as in certain Italian marbles), we have introduced ways of achieving a nonpatterned natural look.

SELECTING A BASE COAT

The color you select for your base coat directly relates to whether you choose an applied or removal technique for your rendering. The serpentine marbles are an example of how different techniques affect the choice of base coats. We use a white base coat and a removal technique for Verde Antico (see pages 133–36), and an

applied technique on a black base coat for all the other serpentines. The numerous, fine light-green markings found in Verde Antico would be impractical to apply individually with a brush. Accordingly, we use two removal glaze layers (first light green, then dark green) over a white base coat to give "sparkle." The white base coat also enables us to create inlay patterns.

In contrast, for the other serpentines no removal techniques seemed adequate to give blends of opaque color (as in Verde Aver, pages 121–23), crisply defined overall texture of opaque paint (as in Verde Issorie, pages 124–26), and specific placement of the veining network (as in Tinos green, pages 127–29). We chose a black base coat because black is present in all these marbles (in varying degrees) and could therefore be included in the rendering without having to be added during the marbling layers, which would disturb the purity of the greens and whites.

Here are some guidelines for choosing base coats:

- When replicating natural substances like marbles or woods, try to determine the most pervasive color. This might appear clearly visible in some places, but most often it is veiled by other colors, seeming to be "underneath" everything.

- In general, base coats for renderings of natural substances should be somewhat lighter and brighter than you might originally think; it is easy to darken and dull the colors with subsequent layers of glazes.

- Choose a base coat that is appropriate to the parameters of the project. For example, an exquisite tabletop done with five layers of glazes over a white base coat has great depth. If you want a similar depth of color in an entire room where the budget allows for only two layers, you must use a darker base coat.

- If possible, try more than one base-coat color in your sample-making. Paint several boards with each color, writing the respective paint number on the back of each board. You can save any boards you do not use, building up a supply of dry, prepared sample boards.

CHOOSING SUBSEQUENT LAYERS

Because base coats take so long to dry, it is easier to experiment with the colors and textures of the layers that go over base coats than with the base coats themselves. When choosing these subsequent layers, consider the following:

- Except for simple glazing, decorative painting techniques are multilayered. The separate layers may or may not have more than one color within any particular layer. To determine whether colors should be combined in one layer, consider whether the colors can blend or fuse together (as in many marbles) or must remain as separate and distinct layers (as in most graining).

- When developing different layers, start by establishing a broad, overall texture and then get increasingly more specific. This not only gives you something to work with (so you are not faced with a blank canvas), but also can save time. Often a few layers that do not call for much aesthetic evaluation can be done more quickly than a very detailed layer where every line is specifically placed.

- When replicating a natural substance, look for darker, more opaque areas for indications of the color to be used for translucent toning.

PREPARATION OF SURFACE

How a surface is prepared prior to a decorative painting treatment has a profound impact on the outcome of the project, affecting both appearance and durability. There are entire books (see *Bibliography*) devoted to the various aspects of preparing surfaces. These books examine the large varieties of surfaces, conditions, materials, and methods involved in laying on paint. This chapter concentrates on the aspects of surface preparation that directly affect decorative painting, providing the basic concepts along with applicable technical information.

Four steps are involved in proper surface preparation: surface stabilization, surface filling and prepriming, priming, and base-coat application.

SURFACE STABILIZATION

All surfaces have similar preparation requirements; namely, that they be stable, clean, and free of loose material. All loose material, such as flaking and peeling paint, should be removed with a scraper and/or wire brush. If this is not done, subsequent paint layers will peel off as well. Common reasons for peeling paint include the following:

Water damage. Before painting a water-damaged surface, be sure that the problem has been corrected and that the surface is completely dry.

Paint applied over sheened surfaces that were not rough enough to bond with the paint. Examples of such surfaces include high-gloss paint, Formica or plastic, and, most commonly, woodwork that had been shellacked or varnished. The proper corrective procedure is first to remove all paint (not just the loose paint) down to the problem layer; otherwise the peeling will continue over time. This can be done by scraping, sanding, using a heat gun, or stripping. The exposed sheened layer should then be abraded so that the primer coat can bond with it (see *Providing "Tooth," page 28*).

Calcimine. In older houses (those built before 1930), calcimine (or whitewash) was often used on both ceilings and walls. When repainting these walls you are apt to encounter two problems: (1) it will be hard to develop a permanent bond between the primer and the calcimined surface, and (2) the calcimine will be extremely difficult to remove. Some paint dealers claim that alkyd primers will bond with a calcimined surface; however, we have not had good luck with them (some special primers, such as XIM, will improve the chance of bonding success). An expensive, but sure solution, is

to install a new surface, such as roofers' fiberglass gauze netting set in a drywall topping (skim coating). Another expensive remedy is to frame the room and install ½-inch (12 mm) dry walls. (Note: These same procedures are applicable to a badly cracked ceiling.)

The only other reason for stripping paint prior to decorative painting is to expose the contours of paint-encrusted moldings or carving. Paint that is tightly bonded to the surface does not have to be stripped before decorative painting.

If you are considering stripping a surface, prepare yourself for hard work. The process is very time-consuming, particularly on carved surfaces where many layers of paint have filled in the depths of the carvings. Stripping is also messy and often potentially toxic; proper ventilation and a good respirator are mandatory. The toxicity problem has been lessened recently by the introduction of two new products: Safety Stripper (made by 3M), a traditional stripper with a greatly reduced toxic-chemical content; and Peel-Away, a specially formulated low-toxicity chemical paste used with a fibrous laminated cloth. With the Peel-Away method, you apply the paste to the surface and then cover it with the fibrous cloth. This treatment liquefies all the paint coats down to the raw wood. When the cloth is removed, the old paint layers and paste come off. Although many coats of paint can be removed using this method, Peel-Away has two disadvantages: (1) it cannot be used on composition plaster, and (2) it is more expensive than conventional liquid strippers.

When preparing surfaces of furniture, objects, or architectural elements constructed with more than one piece of wood, make sure that all joints are tight and secure. If the joinery repair is not done before painting, the ensuing movement of the joints will fracture the new paint coat.

SURFACE FILLING AND PREPRIMING

The final appearance of a painted surface is affected by how well each step in the preparation process is done. If the substrate (the surface under the paint coat) is not properly prepared, the uncorrected defects will mar the final effect.

FILLING CRACKS AND HOLES

After removing flaking paint, you must lightly sand the sharp edges of previous paint coats with 120- and 220-grit sandpaper to blend them into the surrounding

surface. Fill any holes or cracks with vinyl spackle or wood filler (do not use plastic wood). One of our favorite fillers is an acrylic modeling paste (available from artists' supplies stores). When filling a damaged area, you must study and match the surrounding area so that the repaired area has the same texture. Be careful not to overfill any areas; telltale bumps will appear in your finished work (a slight overfilling is acceptable if it will be sanded down level with the surrounding surface).

If a crack is too shallow, the filling material will not stay in place when the area is sanded. These shallow cracks should be deepened with a sharp knife (such as a putty knife or special tool sold for this purpose) so that a wedge is created to better hold the filling material.

When you are considering how perfect a prepared surface should look, you must take into account the decorative painting technique you will be using and the resultant investment in time and money. If you are working with a limited budget, there are glazing techniques you can use that will adequately mask tiny cracks and lumps in the wall. On the other hand, if the commission is to create a lacquered wall, surface preparation must be perfect and will entail hours and hours of labor.

When preparing a floor constructed of floor boards, do not use filler in the spaces between the boards. The movement caused by people walking on the floor would crack the filler and subsequent paint coats. For hundreds of years floors have been painted over unfilled floor boards of many different widths. If you want a seamless floor, you have two main options: (1) you could lay an entirely new floor of the type of linoleum that is specially treated to accept paint, or (2) you could lay plywood or Masonite as an over-floor (extra-large sizes of plywood may be custom-ordered from a lumber yard).

CLEANING THE SURFACE

Prior to priming a surface, you must remove all dust with a soft vacuum attachment and/or dry cloths. Do not use anything wet to remove dust; it will smear and become difficult to remove. After dusting, wash off any leftover dirt with any good household powder or liquid (Spic 'n Span, for example). With a wall, start cleaning at the bottom and work upwards. This reduces the chance of streaking. Pay special attention to surfaces with any of the following:

Wax. Remove all traces of wax from the surface with naphtha (benzine).

Rust. Remove rust with scrapers, steel wool, emery paper, or a rust-removal solvent. Next, go over the area with a tack cloth. Finally, coat the surface with a rust preventative.

Repairs. Spackle filling damaged areas is usually more absorbent than the surface surrounding it. Spackled areas should be primed several times before the entire wall is primed so that the absorption will be equalized.

Gesso. Old gesso does not strip off except with extensive, laborious sanding. It is usually applied thicker than layers of primers and paint. If the gesso has come off in pieces, one treatment is to glue these pieces back in place and treat the surface as a cracked one. Be aware, however, that when a gesso surface begins cracking in one area, it is likely that damage will develop in other areas, regardless of any repairs you make.

Knots. Knots that can be seen in previously painted surfaces, as well as those appearing on raw wood, should be coated with well-stirred aluminum paint. The pigment in aluminum paint is ground into flat plate shapes, and when aluminum paint dries these pigment plates lie flat, sealing the surface and blocking any sap from marring the painted surface. This protection will last for years.

Mildew Mildew is caused by spores that develop because of lack of sunlight and too much moisture. It must be treated and removed prior to painting. The possible treatments for mildew are (1) to move a portable object into the sunlight or under artificial sunlight created with a sun lamp or strong light bulb; (2) to wash the mildewed areas with household bleach and let it dry thoroughly; and (3) to hang a porous bag of moisture-absorbent crystals in the mildewed area. In addition, paint additives to prevent mildew are available for use in mildew-prone environments.

PROVIDING "TOOTH"

It is important that each coat of paint you apply grabs or bonds to the preceding applications. This bonding process is referred to by painters as either "tooth" or "purchase." Establishing tooth is particularly important on a sheened surface. The two most common ways of ensuring this bonding are (1) to rough up the original surface, after cleaning it, by dry-sanding it with 80- or 120-grit sandpaper or (2) to apply a chemical product such as Wil-Bond or Liquid Sandpaper. The chemical method softens the existing coat for a period of time (usually about thirty minutes), allowing the new coat to "dry into" (bond to) the former coat. Chemical

softening and bonding is especially useful on carved surfaces where dry-sanding is difficult. However, these liquid substances give off potentially harmful fumes; wear a good respirator if you use them (see *Health, Safety, and Environmental Concerns*, page 15).

Bonding can be affected by usage. The recommended methods of securing a strong bond between paint coats is particularly essential on stairs and in commercial traffic areas and entrances.

PRIMING

Primers are designed to seal surfaces to ensure equal absorption of subsequent paint layers and to reduce the amount of more costly paints that will be needed. With proper priming, different surfaces (e.g., dry wall, raw wood, plaster, and Masonite) will all accept the base coat and subsequent coats in the same way, and the final surfaces will appear identical.

PRIMER TYPES

There is a wide variety of primers—each designed to solve specific problems. These included water-soluble (latex) primers, paint-thinner-soluble (alkyd) primers, and alcohol-soluble primers (shellac and shellac variations). Manufacturers also specify whether primers are for interior or exterior use. Use primers as directed; interior products will not stand up to adverse weather conditions and exterior products may be toxic if used inside.

Each type of primer has certain advantages. Latex primer dries quickly and, as long as it remains wet, can be cleaned up with water. Alkyd primers go on smoothly and seal better than latex, further reducing absorbency. We do not recommend using alcohol-soluble primers on interiors because they give a patchy appearance; however, they are useful for outside use as they contain a fungicide that helps protect the surface.

Drying times of these primers vary from thirty minutes to twenty-four hours. Some primers are made to be applied on glossy surfaces (with these, do not dull the surface by sanding or chemically abrading). Most knowledgeable paint dealers can give guidance on the best product to use for a specific job (another source for answers for technical questions is your local chapter of the Painting and Decorating Contractors Association [PDCA]). Be sure to test the recommended product in your sample-making procedure before using it on a job.

TINTING A PRIMER

Tinting your primer may allow you to eliminate one extra base coat. (Tinting your primer is more necessary with dark-colored paints than with light-colored ones because the lighter colors contain more titanium white, which has good hiding powers.) To tint a primer, add enough of the dark-value base coat to the primer to turn the white primer into a medium-dark value (both primer and base coat must be of the same solvency). If the primer is paint-thinner-soluble, we prefer to use japan colors, because they are strongly color-saturated. Do not use commercial tint colors; they are not potent enough to darken a primer, and, in addition, may cause drying problems if too much is used.

APPLYING PRIMERS

Apply primers to large surfaces with napped rollers and to smaller surfaces with foam or bristle brushes. We use foam brushes for coating raw wood with alkyd primers.

After the primer has dried (check the drying time on the label), you may notice that raised fibers have appeared (this happens most often over raw wood). Sand these fibers down with 220-grit sandpaper. Be careful not to sand too long or too vigorously or you may sand through the primer coat and expose the raw wood. After sanding, go over the area with a tack cloth to remove any residue.

Instructions for priming varied surfaces follow. Note: For all these surfaces, the number of primer coats required depends on the absorbency of the surface (how much sealing is needed), the nature of the primer (its covering power), and the color of the surface to be primed (dark or light). In most cases, one or two coats are sufficient. To test whether you need more, apply a small amount of paint to an inconspicuous area to see if it dries evenly and hides the previous surface color. In general, faster-drying primers do not provide as heavy a priming coat as slower-drying ones.

Unpainted wood and new dry wall. Apply one or two coats of primer.

Previously painted surfaces. Rough up the surface to be primed with 80- or 120-grit sandpaper. Do a quick sanding (one or two broad passes) to create scratches that will give the subsequent coat something to grab, or use a chemical bonding product. Prime.

Previously stained and varnished surfaces. If the surface is waxed, remove the wax with naphtha. Rough up the surface with 120-grit sandpaper or 00 steel wool. Wipe with alcohol. Prime.

Asphalt tile. Remove wax with naphtha and prime.

Shiny plastic, Formica, ceramic tiles, and glass. There are special primers (XIM, for example) that are

formulated for use on shiny surfaces. When using these, do not sand the surface prior to applying the primer as this will hurt rather than help the bond. Also, take care when painting over a glass surface to ensure that an accident cannot result from the glass being obscured.

Metal. Remove rust and apply a rust preventative. Prime with a special metal primer.

Concrete. Test for dampness by placing a rubber bath mat on the concrete for three to four days. If the concrete remains dry, proceed with a recommended primer. If the concrete becomes damp, correct the condition causing the dampness before applying the primer.

Floorcloths. If the floorcloth is to be rolled up for storage or transportation, it should be primed with a latex primer, which is more elastic and flexible than other primers. Use as many coats as needed to fill the interstices between the weave. (Note: water-soluble media should be used for the paint and finish coats.)

Canvas to be adhered to a wall or ceiling. When priming a canvas to be adhered to a surface, apply a latex primer to both sides. Latex is flexible and elastic, so the movement of the canvas will have less effect on the paint surface. On the underside, because latex dries alcohol-soluble, the water-soluble adhesive used to mount the canvas will not affect the bond to the surface. We have heard several cases of canvas warping and stretching because the painter neglected to prime the canvas back. If you are dealing with mounted canvas for the first time, we suggest that you prepare and mount a sample before starting the job to test your materials, paint coats, and mounting adhesive.

Paper (e.g., oak tag for samples). Apply a coat of paint-thinner-soluble primer-sealer-undercoat. Do not use latex primers; the paper will curl.

BASE-COAT APPLICATION

After you have primed your surface, you are ready to apply paint layers, the first of which is the base coat.

TOOLS

To apply alkyd, japan, or other paint-thinner-soluble paints, use oxhair or foam brushes. Use nylon or foam brushes to apply latex, acrylic, or other water-soluble paints. For large surfaces, use either the appropriate brush or a napped roller, being aware that a skillfully brushed wall will have a smoother surface than a rolled one, but that applying paint with a roller is usually more efficient.

STRAINING PAINT

Before applying any paint, you should strain it to remove any lumps of dried paint or impurities. Stretch cut sections of sheer scarves, curtains, or panty hose over a container (we use an empty paint can) and secure the cloth with a rubber band so that it has a little slack (a dip in the center). Then pour the paint through the cloth. Be careful that the cloth is not pulled too tautly, or when you pour the paint through it, the liquid will run over the sides of the container before it has been able to strain through the mesh.

PAINTING PROCEDURES

Applying a base coat is much like house painting. The number of coats you will require depends on the condition of the surface, whether the surface has been primed, and whether one coat of paint will adequately cover any colors or patterns on the surface. If there is showthrough, you will need another coat. The following instructions apply to both paint-thinner-soluble and water-soluble paints.

1. Stir the paint thoroughly

2. Pour the desired amount of paint into another container.

3. Add a small amount of solvent, a little at a time, testing the paint on a sample board until the applied paint is smooth and level, showing no ropiness due to brush marks. The solvent for alkyd paint is paint thinner; for latex, water. When adding solvent, stir continually and thoroughly.

4. Load a brush half way up and apply an even paint coat to your surface.

5. Even after you have added solvents to produce the correct consistency, you may see minor brush marks on the painted surface. These can be eliminated by barely touching the brush to the surface when painting the final strokes.

6. Let the base coat dry.

You should not need to sand the base-coated surface if you follow the above instructions. In any case, latex and acrylic paints do not sand well. Alkyd sheened paints must be allowed to dry for at least twenty-four hours. (Note: Poor surface preparation may cause the base coat to lift and crinkle even after a twenty-four-hour waiting period.)

While you are waiting for coats to dry, clean your brushes (see page 21) or wrap them tightly in plastic wrap to keep air from drying them.

PREPARATION OF SURFACES

Surface	Prepriming	Priming	Base coat
Unpainted wood; new dry wall	1. Remove dust with a soft brush, by hand, or with a vacuum-cleaner. 2. Repair any damaged areas by filling them in with spackle or modeling paste, sanding the surface level with 120- or 220-grit sandpaper, removing sanding dust with a tack cloth, and spot-priming several times (as needed). 3. Rough up the surface with 80- or 120-grit sandpaper. 4. Dust with a tack cloth. 5. Seal any knots with aluminum paint.	1. Apply alkyd or latex primer. 3. When the surface is dry, sand it with 120- or 220-grit sandpaper. 4. Remove sanding dust with a tack cloth.	Alkyd recommended; latex acceptable.
Previously painted	1. Dust with a duster. 2. Remove dirt with a damp soap pad or good household cleaner. Wipe clean with a slightly damp cloth. 3. Fill in any damaged areas with spackle or modeling paste; sand the surface level with 120- or 220-grit sandpaper; remove sanding dust with a tack cloth; and spot-prime the repaired areas several times (as needed). 4. Rough up the surface with 80- or 120-grit sandpaper. 5. Dust with a tack cloth.	Apply alkyd or latex primer.	Alkyd recommended; latex acceptable.
Previously stained and finished	1. Remove dirt with a damp soap pad. 2. Remove wax with naphtha. 3. Let the surface dry and wipe off stain with alcohol. 4. Rough up the surface with 80- or 120-grit sandpaper 5. Dust with a tack cloth.	Apply alkyd or latex primer.	Alkyd recommended; latex acceptable.
Shiny plastic, ceramic, glass	Clean with alcohol and tissue paper. Do not sand; leave shiny.	Apply primers designed to bond to shiny surfaces.	Alkyd recommended; latex acceptable.
Metal	1. Remove rust with an emory cloth or 00 steel wool. 2. Wipe the surface with a tack cloth. 3. Apply a rust preventative.	Apply a special metal primer.	Alkyd recommended; latex acceptable.
Floorcloths (canvas)	None	Apply latex primer as needed to fill the interstices between the weave.	Latex paint (for its elasticity).
Wall or ceiling canvas	Apply latex primer to the back of canvas to seal it from water-soluble adhesive.	Prime the front of the canvas with latex primer.	Latex paint (for its elasticity).
Paper (e.g., oak tag)	None	Prime the shiny side as desired with an alkyd primer.	Alkyd paint (*not* latex) is applied to the shiny side.

DESIGNING AND ORGANIZING THE SURFACE

Many times, after determining the treatments for particular surfaces, you have no further design decisions to make. For example, a room rendered entirely with rag-rolled walls requires no surface organization. However, before you can begin painting any finish that requires a designed surface, you must determine the scale and pattern of the design, measure and mark the surface, select the order of rendering, and tape the surface.

DETERMINING THE SCALE OF THE RENDERING

The scale of a painted finish interrelates with its pattern and its proportion in relation to its setting. Although natural substances are rendered most often in actual scale, their scale can be expanded for stylistic reasons (this is especially effective in contemporary settings). When determining scale, keep in mind the following essential considerations:

How the viewing distance affects the scale of the rendering. Distance can have an important influence on the effect of your rendering. Marbling that looks just right on a cornice molding 14 feet (4¼ meters) from the floor will look slightly crude on a chair rail; graining that is beautifully subtle on eye-level panels will no doubt fade out on a cornice that is 12 feet (3½ meters) away. Surfaces that are close to the viewer—such as a tabletop—must be designed and executed more carefully than one viewed from a distance.

How believable your rendering will appear. The nearer the size of your renderings approaches that of the real, the more believable your work will appear. Do not miniaturize a faux rendering to fit a small area—your work will lose credibility.

How the direction of the rendering—veins in marble or grain in wood, for example—enhances or detracts from the space. The scale of the vertical, horizontal, or diagonal units can be chosen to enhance a space. In a room with a low ceiling, for example, vertical graining would give the impression of more height as long as the scale of the stripes was not too broad.

BREAKING UP THE SURFACE

Surfaces may be broken up in many ways. Consider first whether you want to follow the divisions of an actual substructure or create your own divisions.

If there is an actual joined structure underlying the surface you are painting, you may follow the partitions of the natural joints. This not only enhances the initial realism of your faux, but maintains the work if the joints open up over time, as they often do. For example, if you were graining a door, you would paint the stiles (the vertical members), the rails (the horizontal members), the moldings, and the panels as separate pieces. If you were marbling a fireplace, you would paint the lintel (the horizontal member) and the posts (the vertical members) as separate pieces (incidentally, in real marble fireplaces mitered joints [joints angled at 45 degrees] are used only when thin, flat facings of marble are glued to a backing; solid marble is butt-joined).

If you would like your rendition to look as if it is constructed of joined pieces, but there is no real joinery underneath the paint, examine real architectural elements, furnishings, or objects to determine how to break up the surface. Separate units can be placed adjacent to each other in many ways. For example, a floor of painted marble squares can be rendered as pieces butted directly adjacent to one another or with simulated grout strips between the pieces.

If you would like to render faux substances in elaborate patterns, investigate the many possibilities that are used in real veneering. Veneers are thin layers of woods, stones, or marbles that have been cut from larger pieces and then laminated onto a sturdy substructure for use in paneling, doors, and other architectural elements and furnishings. Veneer patterns include:

Book matches. Also called mirror images, these are veneers cut from consecutive leaves of wood or slabs of marble, butt-joined against the same figure to give the impression that the pattern is reflected. If you join your hands as if in prayer and then open them outwards while keeping your thumbs attached, you can get the idea of a book match.

Quarter matches. These are double book matches with the same section of the figure butt-joined.

Parquetry. This is a pattern of repetitive geometric designs. The word is taken from the French word for floor patterns, *parquet.*

Crossbanding. Often used as a border, crossbanding is veneers of linear bandings (as from malachite) or straight grains (as from woods) cut into 1- to 2½-inch (25 to 63 mm) strips.

Stringing. These are ⅛-inch-thick (3-mm-thick) strips of veneer set as inlay.

Pictorial scenes and florals. These are scenes made from carefully chosen highly figured pieces of wood or marble. In marbles these patterns are known by the Italian term, *pietra dure* (hard stones); in woods they are known as marquetry.

Arabesques. These patterns are characterized by elaborately interlaced strips, creating all-over designs.

MEASURING THE SURFACE

Once you have decided how to organize your surfaces, measure and mark them to facilitate your painting. Use accurate measuring tools—rulers, T-squares, protractors, and sharply pointed hard-lead pencils. Follow the age-old carpenters' axiom: measure twice, but cut once (in your case, measure twice and mark once). If the end of your ruler is awkward to use, you can still obtain a precise measurement by starting your measurement from the 1-inch (3 cm) marking. Be sure, however, to add an extra inch (3 cm) at the other end; for example, the measuring of a 6-inch (15 cm) line would read 7 inches (18 cm) on the ruler using this method.

We often use a simpler method for measuring, particularly when fractions are involved. This method uses strips of newspaper, or other paper, to measure the entire width of a section. Fold the strip in halves, or whatever segments are required; then transfer these fold-line markings to the surface you are measuring. Pencil lines are acceptable only if they will be painted over completely or can be erased or removed with the proper solvent (most often paint thinner). Otherwise stick small pieces of painters' tape (see page 35) wherever you wish to place a pencil mark and mark on the tape; the tapes can be lifted off later when they are no longer needed.

MEASURING ARCHITECTURAL ELEMENTS

When measuring architectural elements, adjust your method to suit the particular element. For example, if you are rendering design units on a wall, measure the wall from the center out to either side; this keeps the design symmetrical. Check ceiling and floor lines with a level prior to measuring any horizontal units. Adjust any lines that are not level.

Rotundas and other very large floor-to-ceiling spaces having no corners present measurement and painting problems if they are not broken into smaller units. Design these surfaces with separate long panels or repetitive blocks, adapting the method given on pages 38–39.

Sometimes floor designs look better when a doorway is used as a key to measuring. For example, you might

Miter joint

Butt joint

Quarter-matched veneer with miter joints, crossbanding, and stringing.

Solid wood panel construction.

make use of a doorway when you wish to have all the diamonds in your design line up along the floor of a long, narrow corridor whose doorway opening leads off one side of a foyer. Other times the center of the floor area is used as a starting point—as when measuring the floor for a checkerboard design in a square entry where the front door is centered on the wall.

THE ORDER OF RENDERING

You must next select in which order to render your surface. Try to think through all the processes so that you can work in the most efficient way possible. The following factors will affect the order:

- Individual pieces that are directly adjacent to each other cannot be painted at the same time. The exception to this is when the adjacent surfaces are on different planes, such as the top and sides of a table or two walls that form an outer right angle.

- You can apply tape to some media, such as the glaze used in Malachite (see pages 104–106), without first applying an isolating layer. This allows you to glaze a section adjacent to one you have just finished by simply taping over the completed section. Other media, such as Marglaze (see page 181), require you to apply an isolating layer over each completed section before moving on to the next one.

- It is usually more efficient to take each taped-off section, including the first protective layer, through completion to avoid constant retaping (a floor would always be done in this manner to leave dry places on which to walk and work). However, for an especially difficult technique you might prefer to paint or glaze each layer over the entire surface before moving on to the next.

Panel door, showing the order of rendering. Although the door has six stages, sections 1 and 2, 3 and 4, and 5 and 6 each can be done at the same time. (Note: Even though sections 1 and 2, and 3 and 4 do touch each other at the tips of the miter joints, with care these sections can safely be done at the same time, especially if the mitered areas are done first.)

RENDERING JOINERY

There are two fundamental principles that affect the order of rendering joinery:

1. Individual pieces that are not adjacent to one another can be done at the same time.

2. When rendering a series of straight boards, choose the order so that the ends of the boards being glazed or painted always abut boards that have not yet been done. This is to prevent media that is pulled down during a stroke from damaging boards that are already done.

In addition, the following factors can influence the working sequence:

The degree of precision desired. Although we usually tape off all boards, in more casual situations where precisely delineated boards are not required (e.g., in some country graining), many boards can be done at a time.

The size and profile of the moldings around the panels. All four sides of many carved and/or mitered moldings around a panel often can be done at the same time without the result looking sloppy or imprecise. In addition, certain moldings around panels are easy to do at the same time as the adjacent stile or rail.

Personal preference. Different people have different opinions as to what order is easiest and looks best. For example, some people prefer working on door panels first, feeling that they are easy to isolate and clean off, while other people leave the door panels for last to minimize the potential for damage on these visually important elements.

There are a number of different ways to handle the mechanics of rendering individual wood pieces:

- You can wipe clean the edges of individual boards with cheesecloth or a cloth (this is usually not appropriate for a formal application).

- You can use the pattern rendered on one board to form the edge of the adjacent boards. For example, in the door on page 34, glaze would be applied over all of the stiles and rails. Pulling through a tool on the rails (4) would form the top and bottom edges of the short stiles (2), while graining the long stiles (6) would form the ends of the rails (4). This technique also is best suited for casual situations, although it can look quite convincing if skillfully executed.

- You can tape off individual boards, glaze them, and then isolate them with shellac. This gives crisp, well-defined boards and allows adjacent boards to be rendered without retaping. "Sensitive" media, such as Marglaze (see page 181), require this approach, as even minute seepage will damage unprotected work.

- You can tape off individual boards without isolating them. Many times tape can be placed over already-glazed boards so that adjacent boards can be glazed. This saves a step, but requires extra taping time.

TAPING

After measuring and marking your surface and determining the order of rendering, you must tape the surface to divide it into sections and/or to reserve an underlayer for design or simulation purposes. Prior to choosing the tapes you will need, you should analyze the functions they must perform. In addition to the two mentioned, consider such requirements as achieving crisp edges with no seepage or fuzziness on straight or curved lines, and obtaining neat joints at corners and angles. Areas that are not to be rendered at all must be isolated with tape before any work is started.

The use of tapes of all kinds has become an integral part of almost all decorative painting processes. A wide range of adhesives, backings, and widths are available. Base your choice on the stability of the surface being taped and the suitability of the tape for the job. Look for tapes that do not damage the surface, that remove easily, and that leave little, if any, residue.

When choosing a tape, consider how thick it is. Although thicker tapes often are wider as well and can offer broad coverage, they will collect more paint along the edge than thinner tapes. Then, when the tape is removed, an unwanted ridge of paint is left. Before applying any tape to your surface, test first in an inconspicuous area whether the tape will damage the surface.

TYPES OF TAPE

The tapes most commonly used by decorative painters are painters' tape and masking tape—both available from paint and hardware supply stores. In addition, there are various special-purpose tapes that also are useful.

Painters' Tape

Painters' tape comes in 2-inch to 6-inch (50 to 150 mm) widths, with half to one third of the width of the tape lightly gummed on one side. This tape has much less tack than masking tape of the same width and is used both for protection and to mark off a straight edge. Painters' tape often can be used on newly painted surfaces if they have dried to the touch. The tape has two main disadvantages: (1) it is stiff and therefore difficult to tape to carved or sharply contoured surfaces, and (2) it cannot be taped to itself (it cannot be overlapped).

Masking Tape

Masking tape is readily available in widths from ⅛ inch to 3 inches (3 to 80 mm), with the larger widths having the most tack. It is an excellent tape for protecting stable surfaces (such as metal, hardware, Formica, and painted surfaces that are tightly bonded in all layers). Masking tape is an all-purpose tape; however, it should be tested carefully; we have found a tremendous difference among brands in the amount of tack and overall quality.

You can buy an inexpensive, lightweight, portable taping machine that simultaneously lays masking tape and attaches 1- to 2-foot-long (30- to 60-cm-long) masking paper to the tape. These machines help to provide extra protection during rendering.

Special-Purpose Tapes

Among the many special-purpose masking tapes are the following:

Quick-release tapes. These are tapes with an adhesive that is formulated so that it will not damage delicate surfaces; the tape releases safely and easily from surfaces such as freshly coated paints, multicoated painted

Correct tape position to place the connecting V on the surface.

Incorrect tape position—the V will not be on the surface.

surfaces, and foil wall-covering. When you apply paint next to this tape, you can obtain a sharp, clean edge.

Freezer tape. This tape also is safe on most surfaces. It is available at stores where supplies for freezing foods are sold.

Long-release tapes. These are tapes that can be left on the surface for extended times. They have an adhesive that is formulated to remain on a substrate for up to seven days after application without damaging the surface, tearing, or leaving a residue—a particularly useful factor in decorative painting since many projects are done over a few days' time. (The commonly available masking tape must not be left on a surface for more than 24 hours or it may damage the paint coat and/or be difficult to remove.)

Transparent (office-type) tape. Transparent tape comes in ½-inch to 1-inch (12 to 25 mm) widths. Although it can be useful in giving sharp edges in relatively small applications, it can be unwieldy on larger jobs since it has a tendency to curl back and stick to itself.

Chart and map tapes. These are very thin, flexible tapes that can be bent to form curves. They are available in widths of ¹⁄₆₄ to ⅛ inch (½ to 3 mm). They are sold in art and drafting supply stores.

APPLYING TAPE

Apply tape by rolling out 1 or 2 feet (30 to 60 cm) at a time, following the contour of the surface. Stretching the tape slightly can help create a straight line, although overstretching should be avoided because of the possibility of the tape snapping back to its original position, resulting in an uneven line (edge).

If a long line is called for, mark the wall with a light pencil every few feet to indicate where the tape should go, or use the method mentioned on page 33 of applying small pieces of tape on which to make pencil marks. Another alternative on an installation that has many repetitive markings is to devise a system using templates (see pages 38–39).

Press the tapes down on their edges only; pressure in the middle of the tape is unnecessary and may cause damage to the surface. The secret to achieving a sharp painted edge is to use the correct tape and to burnish the edges well (rub them down securely). Always burnish the edges of any tape prior to crossing over it with a second layer; otherwise seepage will occur under the area of double layering. Small pieces of cut plastic credit cards (or strong fingernails) make suitable burnishers.

A common problem occurs when you apply tape to a rendered surface in preparation for treating an adjacent area. If you are not careful, the tape can extend into the unpainted area. Then, when you remove the tape, a thin sliver of solid base coat is revealed (this happens most often in corners). To prevent this from happening, allow the merest fraction of an inch of the painted surface to show at the edge of the tape.

Taping that is treated casually, or is delegated to unsupervised, inexperienced assistants, can make the finished result look incorrect or untidy. The initial taping is especially critical because it becomes the reference for later layers, which will follow these original lines. This lesson hit home in a recent show house when our students were called upon to marble the baseboards of four flights of a stairway. Picture a dozen eager men and women trying to apply tape to an uneven surface while a steady parade of equipment-laden workers squeezed past them. Unfortunately, the inadequacies of the taping done by several inexperienced students, and the scope of the touch-up required, were not revealed until after the final finish coat had been applied and the tape was removed.

When taping moldings and walls, tape as close as possible to the line where they meet. When old, damaged, or textured walls (stucco, for example) are involved, try to fabricate as straight a line as possible rather than follow every imperfection. If another painter is doing the base-coating for you in a color different from the adjacent surfaces, emphasize in your specifications that the taping and edges of color must be correctly placed or you will be unable to work on those surfaces.

Tape can also be used to quickly and effectively design and reserve bands of inlay (see *Verde Antico*, pages 133–36).

REMOVING TAPE

Tape should be removed from a surface as soon as possible after painting. Pull it from the surface at a thirty- to sixty-degree angle using moderate pressure and speed. Overly fast removal causes splintering (the tape will tear in long, thin pieces), and overly slow removal can leave adhesive residue, which you may be able to remove with acetone, lacquer thinner, or, sometimes, paint thinner. If you are removing residue, first test your solvents in an inconspicuous area to determine whether they will damage the surface.

Paint seepage also can be treated (although the best treatment is prevention). Rub the surface with the correct solvent on a cotton swab, or hold a single-edge razor blade totally perpendicular to the surface and "tickle" the offending paint off the surface little by little.

ORGANIZING THE TROMPE L'OEIL SURFACE

Although all marbling and graining may be thought of as trompe l'oeil (fool the eye), the term is reserved, usually, for illusions of dimensional surfaces with strong highlights and shadows. In decorative painting, trompe l'oeil is most successful when the shadows are not too far away from the flat plane of your rendering. Good examples of this are raised or recessed moldings with beveled butt or mitered joints. The crisper the angle of the change in plane, the more it will catch the light and cast a shadow. Dimensional panels, and doors with panels, are especially adapted to simulations with trompe l'oeil.

When planning, measuring, and taping the surface for trompe l'oeil blocks and molded edges on woodwork, consider the direction of the light source. The classic light source comes from the upper left, throwing shadows on the right and below. Highlights always appear on the areas that are directly in the path of the light.

Trompe l'oeil architectural rendering. Highlights and shadows drawn in with black and white charcoal give the rendering a three-dimensional quality.

MEASURING AND TAPING PAINTED BLOCKS

While coordinating a large installation of painted stone, we innovated a quick and accurate method for measuring and taping stone blocks.

Tools

templates cut from wooden paint stirrers (or other thin wood)
rolls of ⅛-inch (3 mm) tape
a pencil
a single-edged razor blade
a level
⅛-inch-wide (3-mm-wide) felt marker (optional)

Technique

1. Determine the size of the blocks.

2. Cut the stir sticks. At least two pieces should be cut to the height of the block (mark these "L" for length), and at least two pieces should be cut to one-half the width of each block (mark these "W" for width).

3. Measure the place where two courses of blocks will meet and, using a level, lightly pencil in a small horizontal line. Floors, ceilings, or moldings should not be used as references because even little deviations from a level plane would be disturbing when the wall is completed.

4. Run ⅛-inch (3 mm) tape slightly above or below the line, and then erase the pencil line. (An alternate method is to completely cover the line with the tape and erase it after glazing.)

5. Place the sticks marked L against the tape line and hold them in position with two short pieces of ⅛-inch (3 mm) tape. This gives the correct spacing for the next horizontal line.

6. Run a roll of ⅛-inch (3 mm) tape along the end of the template sticks, stretching the tape very slightly.

7. Continue the process of measuring with the template sticks and taping until all of the horizontal tapes are in place.

8. Burnish all of the horizontal tapes.

9. Find the center of the wall and, again using the level, mark a few horizontal tapes so that a vertical exactly 90 degrees from the horizontals can be taped.

10. Tape the center vertical line and, using the sticks marked W, tape the verticals on the entire wall. Do not burnish the vertical tapes at this time because some of them will be removed.

11. Cut out every other vertical tape, repeating the same pattern on every other horizontal row. Note how the razor blade is placed on the horizontal tape and the tape is pulled taut against it to make a sharp cut.

12. Now burnish the edges of the remaining vertical tapes. If you stop the taping at this point, when the glazing is completed and the tapes removed, your surface will have the appearance of a grouted stone wall.

13. (Optional) If you would like to render trompe l'oeil dimensional stones, mark with the pencil one acute angle along every horizontal tape where it is to the left of the top of every vertical tape. Mark another acute angle at the bottom of every vertical tape. The angles should open about the same amount as the width of the tape (in this case, ⅛ inch [3 mm]). Next, cut out each angle with a razor blade. After the blocks have been glazed, use a felt tip marker to draw in lines simulating shadows. Note: Left-handed people will usually find it easier to have the light source come from the upper right when doing the lining. The miters would then be in the upper left and lower right corners of each block.

Right: Burnishing tape edges to prevent seepage. Far right: Seepage that resulted from improper or no burnishing.

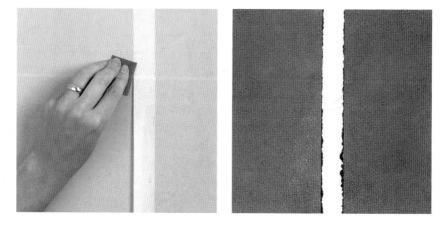

Template sticks are used to help measure and tape the surface to create horizontal lines. Note how the rolls of ⅛-inch (3 mm) tape are allowed to hang, assuring continuity of the horizontal line. These horizontal tapes are burnished before vertical tapes are applied.

Next, vertical tapes are applied to the wall from top to bottom. They are not burnished at this stage.

Every other vertical tape is cut to create a block effect, with the same pattern repeated on every other horizontal row Note how the razor blade is placed on the horizontal tape and the tape is pulled taut against it to make a sharp cut. When the rows have been completed, the vertical tapes are burnished.

Acute angles are cut with a razor blade along every horizontal tape where it is to the left of every vertical tape, and at the bottom of every vertical tape. Marker lines are added later to create a beveled effect.

GEOMETRIC FLOOR DESIGNS

1. Measure and mark the floor.

2. Apply painters' tape around alternate squares. As can be seen in figure 1, the tapes encroach onto the squares that are in between, thereby reducing their size.

3. Base-coat the fully exposed squares. Let the paint dry.

4. When the base coat is dry, render the base-coated areas as seen in figure 2. Let the paint dry.

5. Follow one of the following two procedures: (1) Peel off the painters' tape and then tape back over the edges of the dried rendered squares (as shown in figures 3 and 4); do not isolate the squares with shellac; or (2) shellac the dried rendered squares and let the shellac dry (it is not necessary to tape back over the edges of the finished squares—in fact, it may do some harm if the shellac is not completely cured); then peel off the painters' tape. (Note: If you use a water-soluble finish instead of shellac, be careful when peeling off the painters' tape—the finish becomes a plastic film that bonds to your paint; both paint and tape may come off together when you remove the tape.)

6. Render the remaining squares. Let the paint dry.

7. Either (1) peel off the painters' tape; or (2) shellac the dried rendered squares and let the shellac dry; then peel off the painters' tape.

8. When the surface is dry, apply finish coats as desired. A finished floor, rendered in Verde Antico and a white drift and mottled marble, is shown in figure 5.

1

2

3

4

5

FINISH COATS

Finish coats are the final layers that are applied to a surface after all other painting is completed and has dried. Over the years many types of finish coats have been employed. While there has been an evolution in the development of finish coats, there is still no perfect one; they all have advantages and disadvantages.

TYPES OF FINISH

The most commonly used finishes—and the ones specified in the technique section of this book—are paint-thinner-soluble and water-soluble finishes (using latex acrylic materials). These finishes are often called *varnishes*; however, this term technically is reserved for long-drying finishes made from natural resins derived from living or fossilized trees.

Both paint-thinner-soluble and water-soluble finishes come in sheens ranging from flat to glossy. The best way to decide which brand of finish to use is to research and try various types. The satin gloss from one company may be better than that from another, but the first company's gloss may not be as good as that from a third company.

You also may want to experiment with tinting your finish coats. Both paint-thinner-soluble and water-soluble finish coats may be tinted with any media of the same solubility. Experiment by adding a little tint at a time, as adding more tint than can dissolve in the finish will result in streaking.

WATER-SOLUBLE FINISHES

Water-soluble finishes dry quickly (in one to two hours) and cure to a hard finish with little or no yellowing. They are nonodorous and easy to clean up. However, they do not give as flawless a finish as paint-thinner-soluble finishes, and they tend to be more expensive. In addition, they are usually thinner than paint-thinner-soluble varnishes, which will require you to apply more coats to adequately cover paint texture. They also add a strong bluish film over dark colors, making them inappropriate for many dark surfaces.

Used extensively for protecting stained wood floors, the best water-soluble finishes contain special cross-linkers (hardeners). Although numerous water-soluble finishes have been developed recently by paint manufacturers, these do not seem to have the same degree of durability as those produced for use on commercial floors.

PAINT-THINNER-SOLUBLE FINISHES

Two main types of paint-thinner-soluble finishes are available: quick-drying (one-to-two hours or four-to-six hours) and slow-drying (twenty-four to forty-eight hours). The slower-drying finishes provide the best surfaces, as your brush strokes will level out on horizontal surfaces and you can brush out sags on a vertical surface; however, many layers of these finishes can take up to six months to fully cure.

All paint-thinner-soluble finishes dry to a very hard surface; however, surfaces finished with polyurethane products tend to scratch and need to be redone sooner than other paint-thinner- or water-soluble finishes. In addition, if polyurethanes are applied too thickly, they have a hard, plastic sheen. Wipe-on polyurethane, which requires many coats, has a softer sheen.

The main disadvantage to paint-thinner-soluble finishes is that they will yellow your surface. In addition, they give off noxious fumes and require good ventilation in your workspace. They are more difficult to clean up than water-soluble finishes; however, they are also less expensive.

SPECIALIZED FINISHES

The following finishes are appropriate for specific situations; however, their use as decorative-painting finish coats is not widespread today.

Shellac. This is substance made by dissolving stick-lac in alcohol (see page 13). Shellac does not yellow as much as paint-thinner-soluble finishes and has the added benefit of always being removable (again, using alcohol). The main disadvantage of shellac as a finish coat is that it is soft and can be marred by heat, water, and alcohol. Antique restorers use thinned shellac in a technique called French-polishing because, while the shellac is not durable, it can be built up and rubbed down to a shiny, deep, warm finish that is still totally removable—a "must" for renewing finish coats on antiques. Another plus for restorers is that they can use dried, packaged shellac flakes (ranging in color from dark red-browns to paler, honey colors) to mix their own shellac finish coats. Shellac also makes a good finish coat for frames.

Marine varnishes (spar varnishes). These varnishes are available in quick-drying and overnight-drying types. They are strong and durable, being especially weather-resistant. However, they have a strong yellowing effect.

Tung oil varnishes. Gymnasiums use these varnishes. While they are very strong, they are also very yellow.

Bar-top varnish. This is a strong, yellowing varnish that resists alcohol and water. It is appropriate in bars to hold up against spilled drinks and constant mopping with wet rags.

Nitrocellulose spray lacquer. In the 1920s nitrocellulose spray lacquer (which is soluble with lacquer thinner) was developed in France. This lacquer is still used extensively today for commercial finishes. While lacquers for brushing have been developed since then, we believe that they dry too quickly for good manual application. Good spray equipment is expensive, however, and if you are not fully trained and experienced in spray techniques, you risk exposure to serious toxicity.

SELECTING THE RIGHT FINISH

Before choosing a finish coat for a project, analyze the commission to determine its specific requirements. Then try to find the finish that best suits your needs. There is no perfect finish—and similar types can differ widely, depending on the manufacturer. Before buying a finish, check the label on the can. On it you will find the solvent, the degree of sheen, cleaning instructions, drying times, coverages, temperature restrictions, and special instructions for product use (for example, there are fire-retardant finishes that should be used when finish-coating a fireplace). Before using a finish, or for that matter any media, always read its label carefully. A number of finish coats, for example, cannot be used over shellac (one of our students ruined a beautifully marbled table by using such a finish coat).

Make all decisions regarding finish coats in the early stages of planning—not after you have completed the decorative painting. For the benefit of both the client and the decorative painter, samples that are submitted must be finish-coated exactly as they will be on the actual job. This prevents wasted time, spoiled work, and bad feelings. In our opinion, decorative painting that is not finish-coated where appropriate damages a painter's reputation; it is better not to undertake any renderings that, because of lack of time or money, cannot be finish-coated properly for wear and aesthetics.

To determine what media should be used, how they should be applied, and how they should be polished, consider the following factors:

- the protection required for the projected wear

- the type of sheen desired, based on aesthetic and practical considerations

- whether an existing surface is being matched

- whether the surface is in poor condition

- whether a nonyellowing finish is required

- drying time constraints

- budgetary constraints

The number of finish coats you need will depend on the finishing treatment you select (see pages 45–47).

SELECTING MEDIA

In selecting the right media for a particular job, take into consideration the media's durability, appropriateness, degree of yellowing, and drying time.

Durability
When determining the strength of finish coat to apply, consider the type of use and the amount of exposure to damage the surface will have. For example, a painted floor in a heavily trafficked area needs more and stronger protective coats than does a picture frame that is dusted only occasionally.

The strongest and most durable finish coats (both paint-thinner- and water-soluble) are those termed "gloss." To reduce gloss in a finish, manufacturers add substances such as mica, silica, wax, and talc, which also reduce the strength of the finish. (We have, on occasion, used the top part of an unstirred and unstrained satin or semigloss paint-thinner-soluble finish when gloss was unavailable; each time the finish dried hard and glossy.) If you want a strong finish that is not glossy, apply gloss finishes first for strength and follow with a finish coat with a lower sheen.

Appropriateness
Certain situations demand a particular sheen. For example, flat or satin sheens are appropriate for historic and "country" settings, as well as on older, distressed, textured, and subtly rendered surfaces. High-gloss sheens usually are suitable for modern settings, as well as on formal furniture of all periods. Other factors that would dictate a particular sheen include the following:

- whether an existing sheen of a real or painted surface must be matched (baseboards marbled to match a real marble fireplace, for example)

- whether the rendering requires a sheen to foster the illusion of a natural substance (this includes all marbling and most graining)

- the presence of surface imperfections. (Scratches, poor repairs, bulges, and depressions will be accented by a

SELECTING A FINISH COAT

There is no perfect finish. When choosing a finish coat to use for a project, first consult the following list of advantages and disadvantages. For more specifics, examine the label on the finish coat can, which will list the solvent, degree of sheen, cleaning instructions, drying time, coverages, temperature restrictions, and other suggestions and restrictions. Never use a finish coat without first reading the label carefully.

Product	Advantages	Disadvantages
Water-soluble finishes; drying time: 1 to 2 hours	• nonyellowing • nonodorous • easy to clean up with water • quick-drying (allows layering after 2 hours) • cures to a hard finish (especially those with cross-linkers)	• more expensive than paint-thinner-soluble finishes • nonreversible • tendency to bubble • brush strokes dry into finish
Paint-thinner-soluble finishes; drying time: 1 to 2 hours	• quick-drying (allows layering after 2 hours) • cures quickly to very hard finish • less expensive than water-soluble finishes	• yellows • often bubbles upon application (although bubbles may settle into the final surface) • strong odor, requiring good ventilation • cleanup more difficult than with water-soluble finishes • more toxic than water-soluble finishes
Paint-thinner-soluble finishes; drying time: 24 to 48 hours (petroleum product)	• on a horizontal surface, brush marks disappear due to leveling • on a vertical surface, sags can be brushed out • less expensive than water-soluble finishes	• yellows • strong odor, requiring good ventilation • cleanup more difficult than with water-soluble finishes • more toxic than water-soluble finishes • when layered, takes a long time to fully cure (up to 6 months)
Paint-thinner-soluble finishes; drying time: 4 to 6 hours (polyurethane-synthetic product)	• on a horizontal surface, brush marks disappear due to leveling • on a vertical surface, sags can be brushed out • less expensive than water-soluble finishes • cures quickly to a hard finish	• yellows • strong odor, requiring good ventilation • cleanup more difficult than with water-soluble finishes • more toxic than water-soluble finishes • tendency to scratch; needs redoing sooner than water-soluble floor finishes
Shellac	• reversible • gives a warm, deep look • can be rubbed down	• soft • can be marred by alcohol
Marine varnishes (spar varnishes)	• strong and weather-resistant	• strong yellowing effect
Tung oil varnishes	• very strong	• very yellow
Bartop varnishes	• very strong • resists water and alcohol	• very yellow

high-gloss finish. Imperfections on a horizontal surface—or a vertical surface with a strong raking light—are especially bothersome. Poorly applied brush strokes, scratches from abrasives, and dust particles that have settled on the surface are several problems that may be annoying on a vertical surface, but scream for attention on a horizontal one)

- lighting strength and placement—a factor that is often overlooked (for example, the "bounce" from strong artificial or natural light reflecting off a glossy surface can be disturbing).

Yellowing

Finish coats vary widely in the degree of yellowing (more gently called ambering) they add to a surface when they are applied, immediately after they have dried, and over time. The effects of this yellowing on colors used in the technique layers can differ greatly. White and light colors (pastels) are affected more than are blacks and dark colors. Painted finishes with colors that are compatible with a yellow tint (painted Yellow Sienna marble, for one) often achieve more depth from the extra toning these yellowing finish layers provide.

Paint-thinner-soluble finish coats are all yellowing to some degree due to the oil and alkyd resins present. The common remedy for this—adding a touch of blue artists' oil tube color—may turn the yellow tinge in some colors to a green one (which may be preferable to yellow in certain cases). For some renditions of compatible coloring a touch of white artists' oil tube color may help. During the sample-making process, it is essential that you test the yellowing impact of your finish coats.

Water-soluble finishes, which dry with little or no yellowing, offer a viable solution to many yellowing problems. The main problem with water-soluble finishes is the strong blue film they add to dark colors (black turns navy blue, for example). Because of this trait, you should use paint-thinner-soluble finishes for dark surfaces. A word of caution: Make sure paint-thinner-soluble renderings are completely dry before covering them with water-soluble finish or they may yellow the finish from underneath.

Drying Time

Finishes vary widely in the times they take to dry. Quick-drying finishes can dry in as little as one hour; others can take twenty-four hours or more. Check the label on the can for drying times.

When selecting a finish coat, consider as well the curing time to final hardness. Some twelve- to twenty-four-hour paint-thinner-soluble finishes may seem dry to the touch after one day, but will still show an impression from an object, like a lamp, for as long as six months after the finish was applied. On the other hand, our students tell us of kitchen counters that were subjected to hard use almost immediately after quick-drying finish coats had dried and showed no marks. Many quick-drying finish coats were intended to be used as floor finishes and, therefore, have been formulated to cure quickly to permit the floor to be walked on without being scuffed.

There are three major factors to consider concerning drying time when selecting a finish:

Leveling. Ideally, finish coats should be smooth and level, with no pits or bumps. Depending on the size and prominence of your work, leveling may be unimportant or very important.

Longer-drying finishes (those requiring twelve to twenty-four hours to dry) allow brush marks to even out and air bubbles to evaporate. These finishes also give you more time to make corrections. You will be able to check if any missed areas ("holidays") have occurred or, on vertical surfaces, to brush out any sagging or "curtaining" before the finish dries. Portable lights are valuable to help you examine vertical surfaces from the side, not head on, enabling you to find defects before the finish has dried.

Quick-drying finishes sometimes leave brush marks and "pimples" (caused by the finish drying before the air bubbles can dissolve). While in most cases these bumps can be sanded out, they sometimes leave tiny holes in the finish. Paint levelers may be added to quick-drying finishes to reduce the amount of bubbles.

Dust Control. Dust has been the major problem for varnishers for centuries. It follows that the longer a finish is wet, the more dust accumulates on the surface. In addition, insects and other particles in the air (such as gold leaf and sawdust) can also stick to the surface. There are several ways to minimize this dust problem:

- Create as dust-free an environment as is feasible.

- Use an infrared light bulb to attract dust away from the finished surface.

- Employ a "pick-stick" to remove dust and particles. In the eighteenth century this was made by putting rosin on the end of a stick. A folded piece of masking tape (sticky side out) can be used as a modern pick-stick.

- Choose a quick-drying finish that leaves less time for dust to settle on the surface.

Available Time. The drying time of a finish coat can greatly affect your work schedule. It is possible to apply many layers (up to seven) of quick-drying finish coats—those requiring one to two hours to dry—in one day. The same build-up could take two or three weeks to achieve with twelve- to forty-eight-hour finishes. The added travel time you are apt to incur by using slow-drying finishes can add considerably to your fee, not to mention the inconvenience for all parties.

APPLICATION TOOLS AND METHODS

In addition to selecting the best finish media for a project, you must decide which tools and methods to use for the most effective application. Ask the following questions:

- How large is the surface to be protected?

- Is it a vertical or horizontal surface?

- What is the consistency of the media?

- Are there difficult areas to be reached (because of height or obstructions)?

The tools most commonly used for applying finish coats include the following:

Cage and roller. This tool is a wire framework with a handle. The framework accommodates roller sleeves that are made in various depths and materials (e.g., Orlon, foam, lamb's wool). They usually leave an orange-peel texture. Use a cage and roller for large, flat surfaces.

Foam brushes, ox-hair brushes, and bristle brushes. Experiment to find out which type works best for you and the finish coats you are applying. Foam brushes often leave a trail of air bubbles after them (if this happens, go over the area again lightly with a dry brush). A good bristle brush usually will apply a finish well (unless it is too thick, in which case a ropey look will appear), but the brush will be time-consuming to clean. Brushes are good tools to use for small or difficult-to-reach areas.

Lamb's wool or foam applicators. These applicators are smaller than rollers and work best in smaller areas. They are particularly good for applying water-soluble finishes.

Combinations. Successful finish coats sometimes require one tool to apply the finish and another to manipulate it after application. An example of this is applying a finish with a roller and following up with a brush or applicator to even out the coat and to remove any sagging or curtaining.

Vertical surfaces (such as walls) and horizontal surfaces (such as tabletops) each have finishing problems that can be solved by using the proper technique.

When you finish a wall, sags or curtaining may develop, especially if you have applied too heavy a coat. You can reduce curtaining not only by applying the proper amount of finish, but also by applying the finish in an up-and-down motion. If sags do develop, they can be brushed out if the finish is still wet.

A tabletop presents a different problem. If the table is not level when the finish is applied, it will "pool" at the lower area. To avoid this, check that the table is level prior to applying the finish by using a level—a tool for just this purpose. If the level shows a low area, shim up the table legs to make the tabletop level. Where this leveling is impossible (for example, on an installed window bench), be sure to continually brush out the areas where the pooling is occurring while the finish is still wet.

SELECTING THE POLISHING TREATMENT

How a finish looks to the eye and how it feels to the hand are very important to the success of a project. When light will be striking a painted finish (a console or a mirror frame, for example) or when a finish is going to be touched (e.g., a dining-room tabletop or a banister), it serves both the client and the decorative painter well to have finer finish treatments—the client for the pleasure and pride the finish provides, the decorative painter for the enhancement of his or her work and reputation. These treatments are done after many layers of gloss finishes have been applied; lower-gloss finishes are not suitable for the rubbing-down treatment required for these finer finishes.

There are three standard treatments for finishes after they have been applied and have dried. These treatments vary in the amount of time that must be spent to achieve the desired results. For the professional, this time differential can result in a wide variance in the fee charged for each finish. Finish coats can be

- left "as is" after application;

- rubbed with wax and steel wool; or

- rubbed down with several abrasives to a fine furniture finish.

UNTREATED FINISH COATS

This method involves simply coating the painted surface with one or two applications of flat, eggshell, satin, or semigloss finish directly from the can and letting the

finish dry. This method is not recommended for glossy finishes as the look and "hand" (feel) of a gloss finish is quite harsh unless it is rubbed down.

If you need the strength of a gloss finish but do not have the time to rub one down, use a gloss finish for the first finish coat and the desired stepped-down finish for the second. You may or may not need to sand between coats; if the label on the can's instructions directs sanding between coats, sand lightly with a 120- or 220-grit sandpaper between the first gloss finish coat and the second, lower-gloss coat.

STEEL-WOOL-AND-WAX TREATMENT

On certain projects you may want a better hand to the finished surface than can be achieved with an untreated finish, but may not wish to invest the time required for a rubbed-down furniture finish. The steel-wool-and-wax method fits this bill. This method requires the application of two coats of gloss finish, the second being applied after the first has dried. When the second coat is thoroughly dry, rub the surface lightly with 0000 steel wool that has been lightly coated with a clear wax with a high percentage of carnauba wax (available at most paint or hardware stores). The rubbing should be done with a few quick passes; you are removing just the sheen, not attempting to level the surface.

When using a new pad of steel wool, unroll it so the strands are parallel with your fingers. This will permit the steel wool to abrade the surface quickly with minimal scratching. Keep changing the steel wool as it becomes worn out.

After you have dulled the surface, buff it with a no-nap fabric, such as wool serge or cotton sheeting. While the buffing will help the finish look and feel better, it will still show waves and imperfections if examined under a direct light.

RUBBED-DOWN FURNITURE FINISH

If your goal is to obtain a smooth, level surface with minimum imperfections and a good hand, you should use a rubbed-down furniture finish. While this finish is labor-intensive, the results will greatly enhance the decorative painting that is being protected. The rubbed-down surface is primarily done on the horizontal surfaces of tabletops or on small valuable objects. This is because it is so time-consuming. The technique is usually too costly—and often unnecessary—for walls or other large surfaces.

Basically, the technique involves building up a thickly layered finish coat, letting it dry, and then leveling it using abrasives of decreasing strengths. In fact, these abrasives scratch the surface while making it smooth. To minimize the depth of the scratches, the abrading is done using a lubricant of water, oil, or wax. The process is as follows:

1. Assemble the following tools:

• a small container of water or household oil

• a good supply of paper napkins, paper towels, or cheesecloth

• several sheets of 400- and 600-grit wet/dry (silicon carbide) polishing paper (available at most paint or hardware stores), cut into 1- to 2½-inch (2½ to 6¼ cm) squares

• a box of rottenstone (pulverized limestone), available at most paint and hardware stores (rottenstone is preferable to pumice, which is pulverized lava and coarser than rottenstone)

• a palette on which to mix the rottenstone with water or household oil (water produces a higher sheen)

• (optional) a tube of white toothpaste, a can of clear wax containing a high percentage of carnauba wax, or a commercial cleaning compound specially formulated with waxes

• a hard, no-nap buffing cloth, such as wool serge or cotton sheeting

2. Apply five to ten coats of a gloss finish. This finish can be either quick-drying or longer-drying; water-soluble or paint-thinner-soluble. Be sure that each coat is dry before applying the next. While we often apply five or six finish coats without sanding in between, sanding may be done every three layers (see Step 3). Let the final coat dry thoroughly before proceeding.

3. Moisten a square of 400-grit wet/dry paper with water or household oil and then use the square to sand a small area (approximately 4 inches [10 cm] square) of the surface. Sand with a light touch in straight small strokes; circular strokes cause depressions. Make sure that the surface is kept free of any particles that could cause deep scratches that might be difficult to remove.

4. When this small area is sanded, wipe it off with a damp paper towel or napkin. The area will appear gray from the scratches; however, this grayness will disappear when the scratches are removed with milder abrasives and the final buffing.

5. Continue sanding and wiping adjacent 4-inch-square (10-cm-square) areas, one at a time, until the surface has been completely sanded. Be careful not to create

repetitive low areas. Low areas on the surface will be visible as a bits of untouched shiny finish coat, in contrast to the sanded, grayed areas surrounding them. If some of these shiny pockets are on the surface, apply one or two additional finish coats to the surface. When these added coats are dry, sand the surface again with 400-grit polishing paper.

There are two reasons to add finish coat layers rather than to continue to sand the shiny "pools" that remain after the initial sanding: (1) if you continue to sand these low areas, you may cut through the layers of finish coats and damage your decorative painting (repairing this damage is very difficult); and (2) if you sand the pools without adding additional finish, you are likely to cause depressions in these areas, which will mar the beauty of the final surface.

6. When the surface is equally smooth and dull, it is ready for polishing with the next milder abrasive. Sand the surface in the same orderly manner using 600-grit wet/dry paper. Note: The above sanding procedures can be most easily done with a "palm sander" (a small sanding machine that fits in the hand), using water (or oil) poured or wiped on the surface as a lubricant.

7. Place a few spoonfuls of rottenstone on a palette and mix in just enough water or household oil to make a paste. (Oil gives a rich, warm finish, while water results in a higher polish; in most cases water is recommended. Experiment with both these liquids to provide options for a particular project). The liquid is merely the vehicle to carry the rottenstone to the surface.

The traditional way to use rottenstone is to pick the paste up from the palette with your fingertips, place it on the surface, and rub it against the surface with the flat of your hand. The body warmth is believed to help the polishing process. However, while rottenstone is nontoxic, the mixture is difficult to clean from your hands, especially from under your fingernails. Fortunately, there are commercial products (such as Protect) available from paint and hardware stores. These products can be placed under your nails to reduce the accumulation of substance. Scraping your fingernails on a bar of soap prior to picking up the rottenstone can accomplish the same results. An alternative to using one's hands that many of our students use is to do this rub-down with a gloved hand or a pad of cheesecloth. It is axiomatic that the milder the abrasive, the more rubbing it requires to achieve the desired smoothness and hand. A good finish takes time and "elbow grease."

8. When you have completed the rottenstone treatment, buff the surface with a hard cloth. The resulting finish should be beautiful.

9. (Optional) If you want an even brighter shine, try rubbing the surface very vigorously with white toothpaste on a soft, mildly damp cloth. Or try other products, such as auto-body wax or cleaning compounds, following label directions.

10. If, in the final stages of perfecting the finish coat, you discover low dust-pimples, you can carefully remove them by dipping a very small piece (¼-inch [½ cm] square) of 600-grit wet/dry paper in the rottenstone-and-water paste and lightly rubbing it against the high area. After the dust-pimple is gone, vigorously buff the area it was in with a damp no-nap cloth until the area blends in with the surrounding areas.

Although wax may be applied to the surface to provide added protection and a higher sheen, we find it easier to maintain the surface without wax (which must be removed and renewed periodically).

PROBLEMS WITH FINISH COATS

Most problems with finish coats can be traced to one of the following causes:

- A finish coat has been applied over another that has not completely dried.

- Two products have been applied and a chemical reaction has occurred (information to prevent this from happening often can be found on the label on the product cans).

- Label instructions on use were not followed.

The defects that affect finish coats are referred to as cracking, checking, crocodiling, shriveling, wrinkling, and crazing. Although these look slightly different, they all result in cracks in the surface and/or ridges on the surface.

To treat these conditions, first be sure that the damaged surface has cured (i.e., is fully dry and stable). (Sometimes applying an isolating layer of a different solvency will help stabilize the surface.) Then build up finish coats to make the surface completely level (wet-sanding with 400- and/or 600-grit wet/dry paper can be done between every two finish coats if desired).

This remedy is time-consuming and does not completely rule out the possibility of the problem reoccurring at a later date. Therefore, the best thing to do is prevent the problems in the first place by

- reading labels thoroughly;

- testing all procedures on parallel samples; and

- allowing finish coats to dry thoroughly.

COLOR

Whether you are a decorative painter or a person who hires and supervises decorative painters, you will be faced constantly with the challenges of working with color, from the initial evaluation and final selection of the colors needed for each project to the processes of media selection and pigment mixing. Color is the single most important element in successful design. By increasing your understanding of color, you will be able to select and mix colors with confidence and efficiency, and anticipate and solve problems of color communication.

SEEING COLOR

If you leave a red book alone in a dark room, is the book red? No. The three factors necessary for a color to exist are a light source, a surface, and a viewer. Without a light source, there is no color: in the dark, objects appear as black or gray. With no surface to reflect light, there is no color: a beam of light reveals no color until an object crosses its path. And without a viewer there is no color: only when light reflecting from a surface reaches a person's eyes and is interpreted by his or her brain does that light become color.

COLOR AND LIGHT

Color is light. Just as there are vibration frequencies in the acoustic spectrum of the musical scale, there are light frequencies. Light waves of various frequencies are seen as different colors. Isaac Newton discovered this fact in 1666 when he watched sunlight pass through a prism. A rainbow-colored band of light appeared, which he named the "color spectrum." Although each color blended into the next with no specific dividing line, Newton gave seven separate areas names: red, orange, yellow, green, blue, indigo, and violet. Today these colors are called the visible spectrum, as they are the light waves that can be seen with the naked eye. They are but a small part of the electromagnetic radiation spectrum, the range of which goes from very long, low-frequency radio waves to tiny, high-frequency cosmic rays. Only a certain range of wavelengths of electromagnetic radiation is visible to the human eye. The shortest visible light wave is violet; the longest, red. The light wave before violet on the spectrum is ultraviolet; the light wave after red, infrared.

Light is crucial to our perception of color. As a light source changes, so does the appearance of a color. Daylight gives cooler colors in the morning; strong, intense colors at noon; and warmer colors in the

afternoon. Colors appear different as well in winter and summer sunlight.

Colors also look different depending on whether the surface they are on is horizontal or vertical. This is because the angle of light reaching a horizontal surface usually differs from that of light reaching a vertical surface.

The change in a color exhibited under different lighting conditions is called metamerism. It is probably the one aspect of color that causes the most trouble to designers. The delicious warm rose your client loved in her dining room may turn grayer under the kitchen fluorescent lighting (which depresses red and emphasizes green). The problem may be solved by rebalancing the quality and quantity of lighting— for example, replacing the kitchen lighting with incandescent bulbs—or by selecting a color that is not as adversely affected by the lighting.

Because of the effect of light on color, it is important that you select and mix your paints and prepare your samples under the same lighting conditions and at the same angle plane in which they will be viewed.

SURFACE CONDITIONS

When light strikes an object, the light must be either reflected or absorbed. If the light is bent when it is reflected (as in the case of light bouncing off a glaze) it is considered to be refracted. The pigment molecules in every object, on every surface, interact with a light source, absorbing certain light wave frequencies and reflecting back others. Those light waves that reflect back are viewed as specific colors.

The nature of the surface reflecting the light affects the colors we see. Surfaces that are naturally glossy, or that have been coated with gloss varnish, refract light in one main direction in a specular or mirrorlike manner. If viewed in glaring bright light, these surfaces sometimes lose their color, even appearing to be white. This is the basis for the white highlight that is painted on flat surfaces to give a trompe l'oeil effect. Viewed in the correct light, color on a glossy surface will look dark and rich. Colors appear lighter and less rich on surfaces that are irregular, rough, or matte, where they are subject to diffuse refraction—light waves reflecting in all directions.

The collage of smooth, rough, and patterned red swatches in the photograph on page 49 demonstrates the possible hazards of attempting to produce an exact match to the color of a fabric, tile, or large expanse of

This collage of smooth, rough, and patterned red swatches demonstrates how different types of surfaces reflect color and light.

pile carpet. The varied ways that surfaces reflect light as color—smooth surfaces bouncing light back and surfaces with a nap or pile absorbing light and creating shadows—can complicate the requirements of a project. Before you begin mixing colors, be sure that all parties concerned are in total agreement as to the overall color concept of a space as well as the preferred target colors. Experimenting with the refraction, absorption, and reflection of light from both smooth and rough surfaces will expand your ability to create color effects using one or more layers of pigmented media and finish coats.

Approach with caution any request that involves matching iridescent substances such as opals, mother-of-pearl (nacre), peacock feathers, and butterfly-wing chatoyance. These colorations are the result of a phenomenon of light called thin-film interference. Caused neither by pigments nor by refraction of light, these colors are created when two beams of color having the same wavelengths, and traveling in the same direction in rather parallel paths, interact with each other to produce constructive interference or reinforcement. These colors change with the viewer's orientation and very often appear to be metallic. You can match the

purity of the colors, but capturing the iridescence requires a great deal of experimentation. A new class of pigments—called interference colors—may solve the problem.

COLOR PERCEPTION

There are two aspects to color perception in the eye and in the brain. One is tangible: the sun's spectrum received by the lenses of your eyes. The other is intangible: your brain's discrimination of what is transmitted to it.

How the Eye Receives Color
The retina of the eye is the light-sensitive lining of the eyeball. In it exist two types of light sensitive cells: rods and cones. The rods contain the pigment that operates in dim light (dark interiors and outdoor night light) to help you see achromatic colors. The cones contain pigments that are sensitive to color in daylight. As the eye sees color, impulses related to the color's wavelengths are sent from the optic nerves to the brain, where they are decoded to give a sensation of a specific color. Some colors, such as strong reds, excite the optic

nerves more than others. This may be because red is closer on the spectrum to infrared waves, which produce heat, or because the lens of the eye must adjust to focus on red wavelengths.

Do not be surprised if you have more difficulty mixing certain colors than others. This may be because of psychological associations or because of your own optical chemistry. For instance, it has been documented that blue-eyed males have difficulty differentiating among various blues. Also, you may have retinal fatigue, which is often caused by working under bad lighting conditions. This can sway your color judgment more than you may realize.

How the Brain Interprets Color

The intangible aspect of color perception—how your brain interprets the color messages your eye sends it—is extraordinarily complex. This results from the fact that the brain is rarely concerned with only one color at a time; it must deal concurrently with the interrelationships among the many colors that are viewed together. What may look just right on your palette often looks just wrong on the wall. This is because no facet of color is independent of its surroundings.

The messages received by the brain can range from visually simple through visually complex. These include colors that are flat or patterned, adjacent or layered, and opaque or translucent. The brain must cope with diverse color phenomena in making decisions about the optical information it receives—phenomena that can be sometimes quite deceiving.

The brain's role in interpreting various color mixes often creates optical illusions of space, time, and mood. Various manipulations of the hue, brightness, intensity, patterns, and amounts of various colors can cause spaces to appear to expand, shrink, raise, or lower. This enables bad features to be camouflaged and good ones emphasized. Mood can be altered, providing excitement, comfort, and/or serenity. For example, the color green has been documented scientifically to be a psychological primary because of the sensation of serenity it engenders in so many people.

These optical illusions may be caused by one of the following reasons:

- changes in the sensitivity of the eyes' receptors to different colors as their intensity changes

- possible fatigue in certain receptors in the eye

- the need for the eye to seek equilibrium

- the fact that the human eye retains an image for one-tenth of a second after it has been viewed

- resolution in the eye: at various distances, the eye and brain respond to certain visual effects in specific ways. For example, small amounts of paint that are adjacent to each other cannot be differentiated; the eye sees them as one fused color. (This is the principle behind impressionism and pointillism.)

Contrasts, such as the ones on page 51, play all kinds of optical illusions in the eye and brain: between light and dark, small areas of color and large ones, warm colors and cool ones, full-strength complementaries, translucent layers and opaque ones.

The following examples illustrate how these optical illusions can affect your design:

- The Wedgwood blue that you painted your client's bedroom is perfect until you look into the beige-colored hallway and find that the subtle beige now has a horrid yellow cast. This happened because your eye's receptors had adapted to a specific hue—in this case, blue. The fatigue of the hue's receptors in the retina caused the hue's complement to appear. This effect, initially termed "successive contrast," is now known as "afterimage" or "chromatic adaption." This is the reason operating-room personnel wear a certain shade of green (the complement to blood red). Looking up from the operating table, their eyes supply a green afterimage that might throw a different, unpleasant quality onto a color other than that green.

- The separate color samples you worked up for a suite of offices coordinated extremely well with each other; the finely striped wall that you subsequently painted using two of these colors looked terrible. This disturbing effect resulted because the brain merged the two colors into one, and the complement of the dominant color washed over, or shifted, the color of the lesser one. This is known as retinal adaption; one set of nerve cells receives information from the eyes about one color, inhibiting reception of information about the adjacent color. As an example, a red that has a hint of blue when placed next to a shade of salmon looks yellow when it is set next to a purple. This is called "simultaneity" or "simultaneous contrast." Identical colors viewed against different backgrounds appear different to the eye.

Two other color effects deal with optical relationships. The first, which is called spreading, occurs when colors of the same value (brightness) are set next to each other and lose their common edge. The values fuse, blending the two colors along the joint. This subtle relationship can be an advantage or not. If you want to change this effect, change the value of one of the colors.

Examples of simultaneity: Identical colors placed on different backgrounds result in optical illusions of color changes.

The second effect is also seen on adjoining colors. In this effect, colors appear lighter or darker than they really are, according to the value of the colors that adjoin them. This is particularly noticeable when adjacent colors are painted in a series from light to dark—each color will appear lighter where it abuts the next darker one, and will appear darker where it abuts the next lighter one. The changes in value often lend a dimensional, or undulating, quality to the series.

Further distortion occurs with the phenomenon of advancing and receding colors. The warmer colors, especially red, seem to advance toward us; the cooler colors seem to recede. This may be because of the cones' reaction to certain wavelengths.

THE DIMENSIONS OF COLOR

Although the colors of light and pigment appear the same, they interact and mix in entirely different ways. Mixing together equal amounts of red, green, and blue lights creates white light. This is the basis of additive mixing, which is used in theatrical lighting, television, and computers. Paint mixing is subtractive; as different-colored pigments are mixed in a medium or vehicle, more and more light is absorbed (subtracted).

Pigments consist of finely ground, absorptive particles of coloring matter that are derived from animal, vegetable, and mineral sources. These particles are mixed into a liquid called a medium or vehicle to make

a paint or glaze. Pigments do not dissolve in liquids—as do dyes—but remain suspended as individual particles. These particles are transparent and colored, making them act as color filters that change the light waves as they are reflected back to the eye. Media appear white when the pigment particles are totally colorless and reflect back the white light (the entire visible spectrum) shining on them.

Many people discuss color by using names that refer to nature (such as seafoam green or peacock blue); however, this is an imprecise way of describing color and can lead to misunderstandings among all parties involved with decorative painting projects. While there are numerous systems of color classification, the most useful, usable system not only for rapid determination of color but also for precise color specification and communication is the Munsell System, used internationally. This system catalogs over 1,500 colors by number; as new pigments are developed by modern technology they can be placed within the total system. The Munsell System is based on the measuring of the three dimensions of color: hue, value, and chroma. Hue is the specific wavelength of a color; value, the amount of lightness or darkness in a color; and chroma, the amount of pure unadulterated colorant in a color—a color's intensity. These dimensions of pigment coloration describe specific colors in much the same way that length, width, and depth describe the dimensions of an object.

HUE

The first dimension commonly identified when distinguishing one color from another is hue—the name of a color. Hues are usually represented as a continuous circle of specifically ordered sections of color, called a color wheel. Color wheels illustrate several theoretical divisions that are very useful: primary hues, complementary hues, and warm and cool hues.

The Munsell System encompasses five major hues—red, yellow, green, blue, and purple—and five intermediary hues—yellow-red, green-yellow, blue-green, purple-blue, and red-purple. The three primary hues—red, yellow, and blue—form an isosceles triangle on the Munsell color wheel, with red and yellow close together and blue at the apex of the two longer sides. This arrangement accurately reflects the visible spectrum wavelengths (as shown below), where yellow-red (the Munsell System's term for orange) occupies a very small space on the spectrum in relation to blue. This is in contrast to the standard color wheel, where the secondary color orange is given space equal to the three primaries. The position of hues around the color wheel becomes very important when making color-mixing decisions—particularly where complementary hues are concerned.

Complementary Hues

Opposite pairs of hues assembled around the color wheel are called complementary hues. The hue produced when equal amounts of any set of complementaries are mixed is a neutral, achromatic gray. Scientific studies have shown that this gray is the simplest color for the human eye to process, the one that restores equilibrium and balance to the physical equipment of the eye.

Every set of complementaries contains the same proportion of primary red, yellow, and blue pigments—about 25 percent red, 25 percent yellow, and 50 percent blue. When trying to determine what color to add to a hue to make it the complement of another, think of which primaries are missing and in what proportions. The primary hues that provide the most accurate results when adjusting paint mixes in any media are alizarin crimson (a red that leans toward blue, not orange), phthalocyanine blue (a blue that leans toward green, not red), and cadmium yellow (a yellow that has no red).

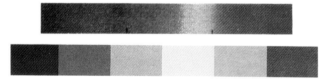

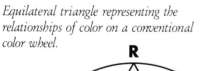

The electromagnetic spectrum (above) contrasted with the traditional color-wheel spectrum (below). Note the differences in the amounts of color.

Equilateral triangle representing the relationships of color on a conventional color wheel.

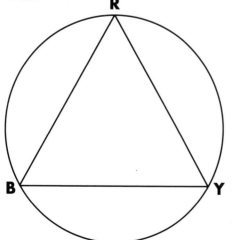

Isosceles triangle representing the relationships of color on the Munsell color wheel.

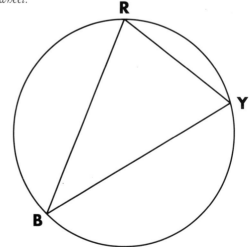

The Temperature of Color: Warm and Cool Hues

Thinking of hue in terms of temperature—warm and cool—provides another perspective on making color choices. The warm side of the spectrum contains red-purple, red, yellow-red, and yellow; the cool side, yellow-green, green, blue, and blue-purple.

Every hue can be made warmer and cooler by the addition of pigments that are warmer or cooler than itself. In addition, the warmth or coolness of a hue is a comparative condition in any given situation because of the hue's relation to the color next to it; for example, a red-purple appears warm until a red is placed adjacent to it—then it turns cooler.

Very often there is an unpleasant, inharmonious effect (clashing) when a warm and cool version of the same hue are placed adjacent to one another (for example, a bluer red next to a yellower red). To remedy this situation, you can separate the colors with a neutral color that will act as a transition between them, or supply textural interest that may alter the color relationship. Understanding the concept of the two-sidedness (warmer or cooler) of any hue allows you to pinpoint many problems and choose wisely when mixing colors.

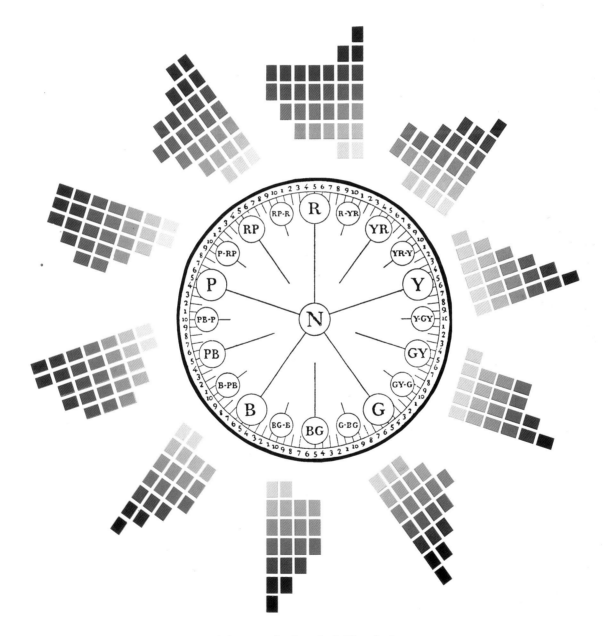

Munsell student charts placed correctly around the Munsell color wheel. The wheel indicates the placement of the color hues; the charts, value and chroma within each hue.

VALUE

The second dimension identified when describing a color is value—the amount of white and black in a color. Specifically, value measures the amount of lightness or darkness of a color as compared to a neutral gray scale that extends from absolute white to middle gray to absolute black. The blocks of value in this scale are assigned specific numbers that are keyed to an international scale of light reflectance values (LRVs), which are measured in percentages; for example, yellow measures between 60 and 70 percent LRV in normal light. (Sources for the neutral gray scale of light reflectance value are listed in the appendix.)

Understanding the LRV of a color is the key to solving many color problems; it will not only allow you to lighten or darken colors, but also to maintain the value of a color while changing its two other dimensions. To do this, the LRV of any color you add to a mixture should be the same as that of the original color, although a few percentage points difference is within reasonable tolerance.

If LRV scales are not available for the media you select, you can make your own value comparison by doing one of the following tests:

1. Squint to shut out as much light as possible (this eliminates your eye's ability to register hue and chroma while making value easier to compare). Different hues of the same value, regardless of chroma, will exhibit the same amount of grayness. Lighter or darker values will be apparent immediately.

2. Place cards of two different colors so that their corners overlap as shown below. Stare at the top color for at least fifteen seconds; then quickly remove it and

look at "C" (the place where the colors overlapped). If "C" appears lighter than the bottom card, the upper color is darker in value. If "C" appears darker than the bottom card, the upper card is lighter in value.

Shades, Tints, and Tones

Three terms—shade, tint, and tone—are used often to describe the value of a color. A shade is obtained when black only is added to any hue, giving the illusion that light has been reduced and the color is in shadow. A tint is obtained when white only is added to the hue, making it appear to be in sunlight. According to some experts, warmer hues make better shades, while cooler hues make better tints. A tone is a hue that has had both black and white (gray) added to it.

CHROMA

The third, and often least understood, dimension of color is chroma, which indicates the amount of pure pigment saturation in a color. Chroma measures the intensity of a color by how far it extends from neutral gray out to the strongest intensity obtainable in its hue and its specific line of value. For example, yellow has its strongest chroma at a high, light value, while violet has its highest chroma at a low, dark value. Chromas at the strongest intensity are the colors at their purest—any addition to them will reduce their chroma. Strong-chroma colors are termed saturated, vibrant, electric, shocking, rich, bold, strong, loud, and gaudy. A client wanting you to increase the chroma of a color might ask you to "bring it up," or give it more "oomph," "pizzazz," or "liveliness."

A color whose chroma is near the neutral gray scale may be termed neutralized, weak, soft, of reduced

Place cards of two different colors so that their corners overlap as shown. Stare at the top color for at least fifteen seconds.

Quickly remove the top card and look at "C." If "C" appears lighter than the bottom card, the upper color is darker in value. If "C" appears darker than the bottom card, the upper card is lighter in value.

saturation, muddy, muted, faint, quiet, subtle, or grayed down. A client asking for a color's chroma to be decreased might ask you to "tone it down," "kick it back," or "subdue it."

These subjective descriptions for both strong and weak chroma indicate desirable or undesirable preferences according to how they are used in any given situation and by whom. For instance, strong flamingo pink for the office of a bank president would be called gaudy (and be considered most inappropriate), while the same color might be termed vibrant in an ice cream parlor. A rich, dark, subtle red would be a more suitable choice for a bank president's office, particularly because maroon is one of the preferred colors of the 3 percent of the American population that is the most affluent (dark green is the other). Yet the same red might be called muddy and dull, rather than rich and subtle, if used in an ice cream parlor (especially since fluorescent lighting would emphasize the green in the maroon and depress the red).

Strengthening Chroma

Select colors with the strongest chroma possible when mixing paints; it is much easier to weaken chroma than to strengthen it. If you need to increase saturation, add more of the hue in the form of pure, saturated pigments found in japan paints and in artists' oil tube colors. Most paint dealers also stock pure colorants to mix in with base paints; however, when using more than a certain amount of these in a formula you may also need to add driers (substances that help paint dry; see page 13). Commercial tints are usually too weak to strengthen chroma; if used in larger proportions than suggested on the label, they too will require the addition of driers.

Reducing Chroma (Neutralizing)

Any addition to a totally pure color will lower its chroma. This is called neutralizing. For most situations, the best results can be achieved by adding the correct complement of a color. The next best results are achieved with the addition of an earth color, and the least preferable results are achieved with the addition of black and white. Here are some basic guidelines:

Neutralizing with complementary colors. Although the correct hue is the most important color dimension to consider when neutralizing a color with a complement, the value dimension is almost as important, particularly when you wish to keep a hue's value while neutralizing it. For example, try mixing the complementary colors yellow and purple-blue as they are found in their strongest chromas—yellow is very light, purple-blue is

very dark. If you mix the two, the resulting color will be very dark. To keep the value the same, you should choose a purple-blue along the same value line (and with the same LRV) as the yellow you wish to neutralize. The Munsell charts around the color wheel on page 53 not only indicate which hue to choose, but also show how various hues appear at any given value and chroma. They are invaluable for reference while color mixing.

Neutralizing with earth colors. You also can lower a color's chroma by using earth colors. Earth colors are inorganic pigments derived from minerals—of which there are only ten with enough strength to provide usable color. Minerals including the iron-oxide-colored red and yellow ochers (in use since the days of cave painting), hematite, and manganese provide almost the entire range of hues found on the color wheel, particularly low-chroma versions of mixtures that contain the three primaries. The words *raw* and *burnt*—as in raw umber and burnt umber—differentiate between the raw, light state and the burned (calcined), darker state of the same mineral.

Each earth color is produced in its highest grade in one particular locality and has a unique set of properties. Becoming familiar with the possibilities offered by each one will permit faster, more uniform, and more sophisticated color-mixing. The characteristics of earth colors range from light to dark in value and from warm to cool in temperature.

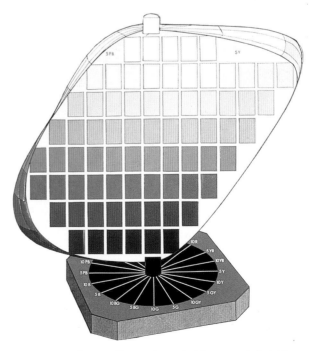

Munsell color charts yellow and purple-blue set side by side, indicating the position of similar levels of value.

Each earth color lowers the chroma of a color differently from the color's complement. For example, you may want to neutralize a yellow just a bit. Using the earth color yellow ochre, you will have more control than you would by adding a similar value of the yellow's complement (blue-purple). (In addition to their use in neutralizing colors, the earth colors by themselves are excellent additions to your palette, supplying consistent, interesting hues that otherwise would have to be mixed anew each time. Merely by adding black or white to earth colors, a large range of neutralized, complex, subtle colors may be created quickly and accurately.)

Comparison between neutralizing chroma with (1) a color's complement (here, a blue-green of the same value); (2) burnt sienna; (3) raw umber; and (4) black. Note the differences among the results.

White added to each of the neutralized reds. Note the change in hues as white increases; the pinks acquire a bluish cast.

EARTH COLORS

Earth colors are inorganic pigments, derived from mineral sources. Minerals such as limonite, hematite, ocher, and manganese, among others, supply low-chroma versions of all the hues of the spectrum. In their raw form, earth colors are of lighter value; they turn darker when they are heated (burnt). Whether raw or burnt, earth colors retain the same warm and cool characteristics.

Name	Description	Uses
Yellow Ocher	light-value dull yellow with some red-purple; semi-opaque	• adds yellow • dulls chroma • turns colors warmer • makes blacks green • combines well with white, raw sienna, raw umber • neutralizes red-purple
Raw Sienna	medium-value dull yellow-orange with a pink caste; contains red-purple; transparent	• adds pinkish orange • dulls chroma • combines well with yellow ocher • neutralizes blue
Burnt Sienna	darker-value orange red-brown; contains red-purple and yellow; transparent	• turns colors warmer, more orange red, darker • turns green toward gray-red • neutralizes blue
Raw Umber	darker-value gray-brown with the weakest chroma and the least iron content of all the earth colors (making it cooler); transparent	• adds gray or gray-green • turns colors grayer and/or darker • combines well with white, and raw or burnt sienna • mixes to good grays with black and white • neutralizes red-purple
Burnt Umber	even darker-value brown than raw umber; warmer than raw umber; cooler than burnt sienna; transparent	• turns colors very warm and dark • mixes to warm grays with black and white • neutralizes blue
Lampblack	darkest value of all earth colors; has cool (blue) component; transparent	• turns colors cooler (bluer) and darker • neutralizes orange

Neutralizing with black and white (gray). Except for Mars Black (a warm black made from iron oxide), the other blacks in use—ivory, bone, charcoal, drop, carbon, and lamp black—lend a cool (blue) quality to mixtures. Whites also turn mixtures cooler. As a result, neutralizing with these colors has more limited uses than neutralizing either complements or earth colors.

THE INFLUENCE OF COLOR ON DESIGN

The role of color on surfaces affects both size and mood. Warm colors (those with red) and light colors advance toward you; cool colors (those with blue) and dark colors recede into the distance. Strong color stimulates while subtle color calms. Delicacy is associated with light pastels; virility with deeper colors.

As a rule, spaces that are used only intermittently can take a vibrant warm color, while the same color in a space that is used more often might prove intrusive.

Color choices depend on several factors:

Function. Frequently used rooms call for colors that "wear well"; guest-oriented rooms, with their short-term use, allow a wider color latitude.

Client's taste. This can be either very definite or flexible.

Lighting conditions. How colors appear under varied natural and artificial lighting conditions can be emphasized or altered.

Size. Colors can be used to enlarge or diminish the feeling of a space.

EFFECTS OF COLOR ON DESIGN

Color information outlined below for the whole color spectrum (including woods and metals) will help you determine the colors you need more quickly.

Color	Effect on space	Effect on Mood	Best Uses
Light colors, pale neutrals, bleached woods	Enlarges space; makes space airy	Quiet or insipid; tranquil or boring	Ceilings, walls, floors, furnishings
Medium-value nonintense colors, neutrals, fruitwoods	Diminishes space slightly	Conservative or stuffy	Walls, floors, furnishings
Deep colors, dark stained woods, black	Diminishes space; erases boundaries, lowers ceilings	Dramatic or depressing; traditional or old-fashioned	Library walls, floors, entryways
Autumn colors, mahogany, rosewood	Diminishes space substantially	Cozy, rich, or too warm	Walls, floors, furniture
Pale blue or green	Enlarges space	Serene; suggests sky, space, spring	Walls, ceilings
Dark blue or green	Diminishes space	Mysterious; suggests the sea, night	Walls
Yellow	Enlarges space	Suggests sunshine if lighting is good; drab in weak lighting	Walls in brightly lit rooms

In combining colors, there are four main color schemes that are the most basic and useful in interior design:

Monochromatic. This scheme uses variations of one color; many values and chromas of blue, for example.

Analogous. This scheme uses colors that are closely related or adjacent to each other on the color wheel, such as blue and green.

Complementary. This scheme uses colors that appear opposite each other on a traditional color wheel; red and blue-green, for example.

Triadic. This scheme uses three colors that are equidistant from one another on a traditional color wheel, such as red, yellow, and blue.

The proportioning of color is as important as choosing the color scheme. Results turn out best if the colors chosen for any color scheme are used in unequal proportions and strengths.

SELECTING AND MIXING COLOR

Since color is such a crucial element in the ultimate success of a project, the decorative painter has two main challenges:

1. To determine the target colors (i.e., make color choices) that will work best for any given project (the success of these choices depends on how finely tuned are the perception of color and the sense of style of the decorative painter, the designer, and the client).

2. To mix these target colors in an effective, efficient way that produces predictable results.

DETERMINING THE TARGET COLORS

Before experimenting with color mixes, you should explore with your client (the person who has the authority to approve all color mixes) the following factors that will determine color choices:

- the use of the room or object

- the light in which the work will be viewed

- the mood desired

- the degree of gloss that is appropriate

- the plane on which the work will be seen

- the size or area of the work

- the colors and textures that must interrelate with the work (e.g., existing or to-be-installed draperies and wall or floor coverings; the nap factor—the change in color on a pile surface when seen from various angles)

- the viewing distance of various elements

- optical illusions of color and space

- the design project as a whole

Decorative painting projects encompass diverse painted finishes. The three major painted finish disciplines—glazing, marbling, and graining—are treated in this book. Specific target colors are identified for each of the marbles and woods demonstrated in its appropriate section; additional guidelines are provided for finding colors for marbles and woods that are not demonstrated.

Identifying target colors for glazing, however, presents unique problems. There is nothing specific from which to copy—as there is for a marble or a wood—and, in addition, the perception of a base-coat/glaze optical mix cannot occur until a wet glaze has been manipulated over a dry base coat. In other words, you must create the glaze mix before it can be evaluated.

Matching fabric and glazing samples

Glazelike interactions of color as found on magazine pages

How do you decide what colors to choose?

Fortunately, there are several ways to answer this question. First, assemble all the elements that you and your client have decided will be viewed at the same time. This should include real marbles and/or woods as well as the usual fabric and carpet swatches. Very often target colors may be chosen from the swatches.

If desirable target colors appear clearly by themselves, or in a pattern that includes other colors, isolate the target colors with masking tape. In addition, you may want to pull out relevant threads from woven fabrics to find suitable glazing colors. A word of warning: Target colors chosen from complicated printed fabrics (in contrast to woven ones) often exhibit an unpleasant cast when isolated from the colors adjacent to them. This happened to us when, after successfully matching a glazing mix of colors taken from a printed fabric, we found that a large rendition of the colors looked terrible next to the original fabric.

If the target colors are not present in any material given to you, try to unearth them on your own. Use colors and color relationships from past projects for reference; clip suitable examples from magazine color pages. Printing inks often mimic glazelike interactions of color and show definite combinations that can be chosen for base-coat and glaze target colors.

Another way to hone in on glazing target colors is to select chip strips of possible base-coat colors from your paint dealer's racks and apply glazes over them. This often creates the right combination of colors without requiring you to prepare numerous sample base coats (see page 26).

One word of caution: When selecting colors from a small sample or chip strip, be aware that these colors will appear darker and more intense when covering a larger area and/or when coated with varnish. If a color looks perfect on a chip strip, you may want to consider using a value one or two shades lighter. If in doubt, you can try your choice on a 2- to 3-foot-wide (60- to 90-cm-wide), floor-to-ceiling sample called a lay-up (see page 255).

Before mixing paint, use the following steps to get as precise matches as possible to your target colors:

1. Collect or purchase all the chip strips of the paint company whose paint you will be using. You will find it useful to have these chip strips on hand, as well as the Munsell color charts on page 53.

2. Adjust your lighting (if necessary) to simulate that in which the color(s) eventually will be viewed. If you wear glasses, put them on. Light is so important when mixing and matching colors that as small a difference as

not wearing prescription glasses will cause colors to appear more gray. When we mix colors, we often use head magnifying glasses.

3. Make sure that your target color and the chips you are considering can be placed so they abut one another completely with no intervening space between them. Direct, adjacent comparison is the key to matching colors.

4. Analyze your target color (or the nearest color to it). First determine its hue. For example, is your target color a red-purple or a blue-purple? Next, study your color to find its value—is it light, medium, or dark?

5. Find the commercial paint chip that is closest in hue and value to your target color.

6. Finally, focus on the color's chroma. Is it strong and pure, or weak and grayed-down? Look for a chip of similar chroma. If you cannot find one, choose a paint chip whose chroma is stronger than that of your target color, making sure that the hue and value are very close to the target color. You will find it is easier to neutralize a color (gray it down) than to make it more intense.

7. If the target color is precisely matched, proceed to *Mixing Target Colors*, below. If your paint chip is not right yet, analyze it for hue, value, and/or chroma adjustments it may require. Using the Munsell color charts will help you pinpoint your color a little more closely.

MIXING TARGET COLORS

You have discussed the project with your client and selected a target color (or colors). You must now determine how to mix the colors you need to develop sample finishes.

Paint mixing can be one of the most frustrating and time-consuming activities connected with decorative paintings. The end result is usually the same: cans and cans of the wrong colors and none of the right ones mixed. This is generally caused by

- using overly large quantities in the initial mixing and testing phases;

- counteracting too much dark pigment with even larger amounts of a lighter one; or

- faulty record-keeping when a small amount was mixed correctly.

The procedures outlined in this section have proven to us to be the least time- and paint-wasting method possible. They have been tested on hundreds of job

sites and by innumerable students at The Finishing School.

First, choose a worktable of a comfortable height and cover it with several layers of newspapers, each of which may be discarded as you are working to expose a clean dry surface. Do *not* let newspaper or any other table protector extend beyond the edges of your worktable. We have seen many a spill because the table stopped but the can of paint did not.

Assemble all materials and supplies necessary to produce the target color. These usually include the following:

- your chosen paint chip or isolated target color

- paints

- solvents

- finishes

- inexpensive ¼-inch (6 mm) brushes

- coated paper plates

- 5-ounce and 8-ounce (150 ml and 240 ml) coated paper cups

- short stir sticks (we use the flat-ended stems from the insides of foam brushes)

- one or more sets of measuring spoons

- plastic spoons

- paper napkins

- paper towels

- newspaper

- trash containers (doubled paper bags are fine)

- straining cloths

- rubber bands or masking tape to secure the straining cloths

- empty quart and/or gallon paint cans with lids (do not use glass jars; they are notorious for breaking at the least opportune times)

You have two possible options in selecting paint: working from formula-mixed paints from one or more paint companies or mixing your own color(s) using japan, oil tube, or acrylic paints. We believe the most effective method, even after you have become very experienced with paint mixing, is to utilize the thousands of paints available from the various paint companies. You may have to adjust them, but they provide an excellent range of colors and consistencies from which to start.

The paints and solvents you select can be either paint-thinner soluble or water soluble (see *Media*, pages 10–14). If you are using paint-thinner-soluble paints you should assemble alkyd interior house paints, japan colors, and/or oil-tube colors, plus paint thinner. If you are using water-soluble paints, you will need latex interior house paints, casein paints, gouache, and/or acrylic tube colors, and water.

Purchase the very best paints for your decorative painting. Used by themselves and for mixing into other paints and glazes, top-of-the-line paints have more color saturation and less filler than lesser brands—which means you will require smaller amounts of paint to get the results you want.

You can now begin mixing as follows:

1. Determine the most dominant color within your target color (for example, if you have a blue-green that is more blue than green, your dominant color is blue). This is your starting color; you will add other colors to it. With a plastic spoon, drop a little bit of this paint onto a coated paper plate.

2. Decide which other paint color or colors you think you should add to this paint to change its color to that of the target color. Using a clean plastic spoon or spoons, drop very small amounts of these colors onto the same coated paper plate. Keep each color separate.

Please note that only a few colors should be mixed together. The fewer colors you use (i.e., the more carefully you select your colors), the better chance you have of reaching your target color and of reproducing the results. If your target color cannot be reached with two colors, it is usually best to change one color rather than to add a third. The likelihood of mixing a muddy color increases geometrically with each color addition. For example, if you unsuccessfully add raw umber to a paint company's red to warm it and you then try to correct the color by adding a yellow, the color is likely to become dull and lifeless. It would be better to start over and add burnt sienna to the original red and watch it come alive.

Also, limit the amounts of paint you use. By using very small amounts of paint you have less temptation to put additional paint into the mixture to try to save it. This is how small tests turn into cans and cans of unwanted paint.

3. Using a ¼-inch (6 mm) brush, mix the altering paint(s) into your dominant color a little at a time, constantly comparing the resulting mixture to your target color.

4. If at any stage in your mixing you find the color veering too far from your target color, throw the color-mixing plate away and start over with a new mixing plate and possibly a different altering color.

5. Continue these small-scale mixing attempts until you think you have reached, or have come close to, your target color. Remember that an opaque target color is easier to evaluate than a glaze, as the glaze must be evaluated on the proper-colored base coat.

6. If your client has requested a sheened surface, you should let the paint dry and coat the sample with a suitable finish. This will show you how the color will change—and give you the opportunity to compensate for these changes during subsequent mixing.

7. Once you have reached your target color, save (and mark) the sample and start your mixing over, this time using the measuring spoons and 5-ounce or 8-ounce (150 ml or 240 ml) coated cups, measuring every amount of paint before you mix it into the host mixture. Record exactly what you use. This will enable you to mix larger quantities of paint later on without having wasted your time and paint too early in the mixing process. For example, ½ teaspoon of blue to 1 tablespoon of red can translate into 1 quart of blue to 6 quarts of red or 1 gallon of blue to 6 gallons of red.

8. Test again with finish coats if necessary.

The above color mixing procedure should be followed for each target color required. To mix and test glaze colors, you may have to coat several sample boards with opaque base-coat color and wait for them to dry. This takes patience but is absolutely necessary to forestall possible color problems later.

The more you work with color, the more you realize that it is a life-long study, made all the more fascinating by the discoveries you make yourself. As in any science or art, you can learn only so much from other people and books. The real learning comes from experimenting and working on your own. The key to working with color—and that which will hone the color perception of both your eye and your brain—is comparison. Train yourself to see the differences between any of the three dimensions of one color as related to those of another. For design solutions, run through your available options: neutralizing too-strong chroma; being more selective in the color and number of paints you use; and staying alert to color relationships that can distort perception.

COLOR RULES
(To be broken with good reason)

Use of contrast (light and dark) in rooms.	A sharp contrast in color between walls and furnishings emphasizes the lines of your furniture as well as bad proportions.
The "weight" of color in a room.	The darkest (heaviest) colors usually appear on the lower portions of a room, such as floors or baseboards.
The dominance of color in a room.	Every room should have one dominant color.
The amount of color in a room.	Colors appear darker and more intense in large areas than in small ones, particularly in spaces where light is reflected back and forth, strengthening the color vibrations.
Color aging.	Color on an aged surface usually displays a yellow component due to the yellowing of the finish.
Color on home furnishings other than painted finishes.	Wood and metal colors should be factored into color schemes for spaces.

DESIGNING WITH PAINTED FINISHES

Both traditional and avant-garde painted finishes are used to solve problems with architectural space, lighting, inappropriately scaled and/or proportioned fireplaces and trim, functional but unsightly elements, and poorly done projects. Painted finishes offer the most versatile, cost-effective, and often, only, solution to a host of design problems.

Interior design problems involving the proportions of one or more architectural units in a room often can be solved by using painted finishes to rebalance the color and pattern on elements such as the baseboard or skirting board that links the floors and walls; the dado that runs around the room at approximately one-third of the way up the wall from the floor (not present in less-traditional spaces); the wall space between the dado and cornice; the cornice molding that acts as a transition between the walls and ceiling; the window and door casings; and the doors themselves. The most harmonious relationships among these elements are seen when color and pattern emphasize good proportion and deemphasize bad proportion. The chart below illustrates how this concept applies.

PAINTED FINISHES USED AS SOLUTIONS TO INTERIOR DESIGN PROBLEMS

Problem: Baseboard, cornice, and trim moldings too narrow.

Solution: Expand the size of each molding by extending its painted finish onto the adjacent wall areas as necessary. Edge this extended area with a thin molding painted with the same finish—or add trompe l'oeil highlights.

Problem: Baseboard, cornice, and trim moldings too wide.

Solution: Diminish their size by extending the painted finish from the adjacent walls onto the moldings as necessary, stopping at a place where the profile changes planes.

Problem: Wall or rotundas too low.

Solutions: (1) Render the same, or a related, painted finish on both wall and cornice molding. Include the baseboard molding, if necessary. (2) Enlarge cornice upwards by applying thin molding strips on the ceiling 3 or 4 inches (8 to 10 cm) in from the edge. Apply painted finishes to the cornice and to the adjacent horizontal band on the ceiling. (3) Add elements with height. For example, attach pilasters to the wall from floor to ceiling. Apply marbled finish for style and "weight." (4) Use color to raise the ceiling. You might glaze the walls, grading from dark at the bottom to light at the top, or paint the ceiling a lighter version of the wall color. (5) Render units that keep the eyes from traveling upwards too fast. For example, apply a painted finish of Caen stone blocks.

Problem: Wall or rotundas too high.

Solutions: (1) Render strongly contrasting painted finishes on the wall and cornice moldings. Include the baseboard molding, if possible. Strié glazing or straight-graining on moldings emphasizes the horizontal, making the room appear lower. (2) Diminish the cornice height by extending the painted finish on the walls onto the moldings as necessary, stopping at a place where the profile changes planes. (3) Apply a chair rail at dado height, painting the chair rail and everything below it with straight-graining that simulates wainscot panels. (4) Apply molding as the frames of vertical panels. Paint the frames with a finish that differs from the surrounding walls. (5) Lower the ceiling by painting it very dark or black. (6) Break up the space into several tall, rectangular blocks with a painted finish of Caen stones that are higher than they are wide. (7) Shorten the wall height by applying a border of a decorative finish, preferably with horizontal bands edging it.

Problem: Badly placed windows and doors.

Solution: Rebalance the architecture by applying moldings from floor to ceiling in locations that would make the windows and doors appear to be symmetrically placed. Render painted finishes within the areas framed by the moldings.

Problem: Functional but unsightly elements (e.g., radiator covers).

Solutions: (1) Make an asset out of them, if possible, by unifying the existing unit and the surrounding areas with a common decorative theme using painted finishes. (2) Fade the objectionable item into the surrounding areas with a painted finish that hides the outline of the functional item.

Problem: Walls with no windows.

Solution: Open up the solid wall with trompe l'oeil windows, French doors, or open loggias with the sky in a composition.

CASE STUDIES

The accompanying case studies provide an insight into the variety of design challenges that can be met with painted finishes.

INTEGRATING EXISTING ELEMENTS

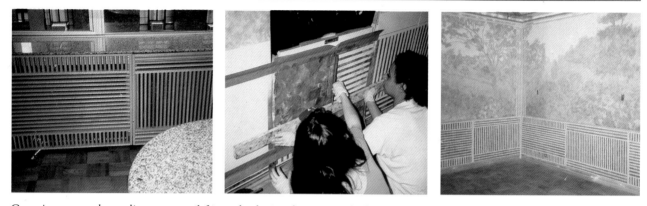

Conspicuous wooden radiator covers (left) made glazing this room a challenge. Rather than hide them, the decorative painter integrated them into her design by painting a matching trellis entirely around the lower portion of the walls. To mimic the shadows behind the radiator openings, she

applied mottled glazes of the same value and colors and then pulled through the glazes with a cut squeegee (center). On the upper portion of the wall, she used glaze media to paint a trompe l'oeil view seen partially through sheer curtains. The radiator covers are unnoticeable in the final room (right).

CORRECTING SCALE

A bulky curved wall emphasized the narrowness of this poorly lit corridor. The decorative painters decided to dissolve the wall and bring light to the space by treating the corridor as an interior space overlooking a bright, sunlit vista. They used strong shadows and colors to take the viewer's attention away from the bulkiness of the wall, and they painted deep trompe l'oeil windowsills to give the impression of more width.

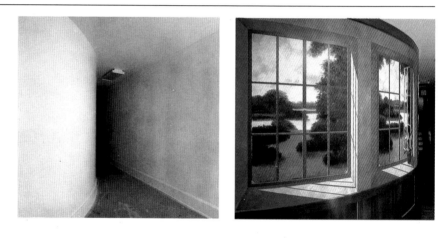

ADDING VISUAL TEXTURE

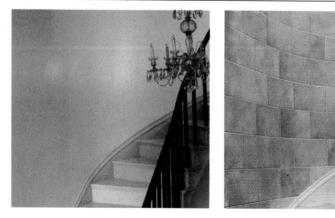

The uninteresting wall by this circular staircase did little to complement the staircase's graceful curves. By rendering the wall as stone blocks, the decorative painters drew attention to the staircase area.

During the late 1880s, this mansion in Washington, D.C.—one of the largest and most costly in the city at that time—was home to Alexander Graham Bell and his family. The landmark building was acquired by the National Paint and Coatings Association in 1940 and converted into their offices. Refurbishing, completed for their 1987 centennial, showcased the building as the headquarters of the major manufacturers of paints and coatings in the United States. We and forty-six students were brought in to render numerous painted finishes that were appropriate to the period of the building and that celebrated the beauty and versatility of paint as a decorative tool.

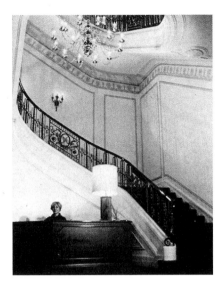

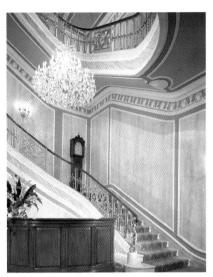

The rotunda of the headquarters of the National Paint and Coatings Association had been spectacular when the building was constructed in the 1880s. By the 1980s, the original finishes had been covered with coats of paint (left). We and our students glazed the rotunda in sixty-six panels of vertical pink travertine, going up four stories, surrounded by several types of veined marble (right).

The National Paint and Coatings Association wanted to convert a drab business office at their headquarters (left) into a corporate boardroom. We and our students used a combination of glazing, gilding, and marbling to restore the room to its original elegance (right).

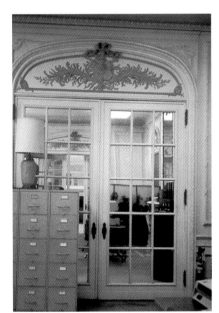

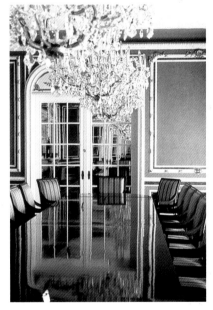

Because the Portoro marble fireplace opposite this room's main seating area was out of scale with the room's 22-foot (7 meter) ceilings, the room lacked a focal point (left). We decided to expand the fireplace to a more appropriate size. Because the moldings outlining the fireplace, mirror, and upper arch were well placed, we used them as the outer framework for our rendering. In addition, we enclosed the raised brick hearth with ¾-inch (2 cm) plywood, which we marbled as Portoro. The marbling around the fireplace was painted as an extension of the 3 inches (7½ cm) of real Portoro that bordered the fireplace opening. The finished fireplace is now the focal point of the room (right).

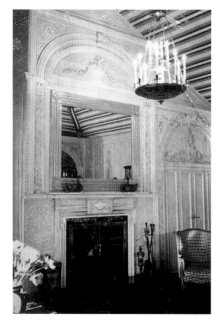

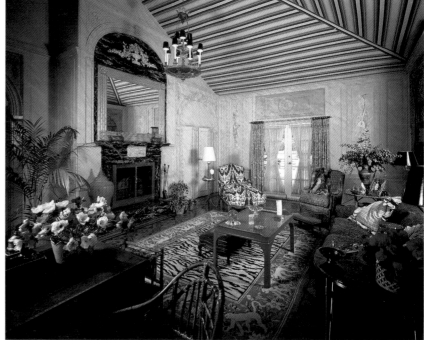

PART TWO
TECHNIQUES

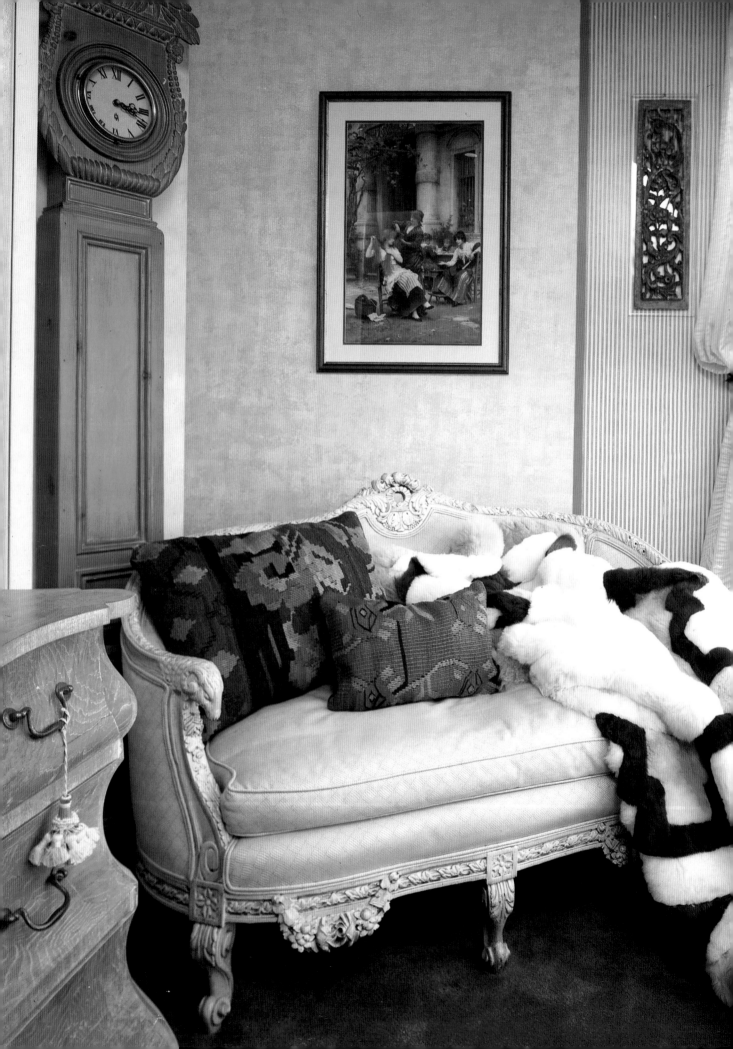

GLAZING

For thousands of years, people of all cultures who paint pictures, furnishings, and interiors have used glazes to achieve results unobtainable with any other media. Simply defined, glazes are translucent films of colored media that are manipulated, while wet, over dried undercoats. This rather spare definition gives no hint of the often magical colors and patterns that can be developed. By using diverse tools in novel ways, you can create patterns that vary from abstract, all-over designs through ordered, elegant graphics to simulations of nature, such as marbling and graining. Overlaying colored undercoats with glazes blends the colored layers into optical mixes—sometimes subtle and mysterious, other times dramatic and electric, all with varying degrees of depth. ❧ The infinite combinations of pattern and color made possible by the use of glazes open a world of design choices. In addition, glazes may be a tool to solve even the most difficult spatial, decorative, and color-related problems—graded glazes can expand confined spaces, and unique color blends and innovative patterns can unify unrelated fabrics and furnishings or add new life to otherwise ordinary environments.

This wall treatment in an interior designer's showroom combines hard-edged strié and a texture done by applying glaze with a synthetic sponge.

SURFACE PREPARATION AND ABSORPTION

Glazing can be done on any surface that can be sealed (i.e., made nonporous) and painted. Since glazing is a removal technique and can be done only while glazes are wet, the most essential requirement is to keep the media workable for as long a period as needed. Two key factors affect working time:

1. *The absorbency of the surface to be glazed.* The less porous a surface is, the less it will absorb the glaze, thereby permitting the glaze to remain wet for a longer time.

2. *The composition of the glaze.* The glaze must remain wet long enough to allow the "wet edge" (the place where glaze applications join) to remain wet. It also must have the qualities needed for the particular technique you plan to use.

After damaged surface areas have been repaired and, if necessary, textured to match adjacent surfaces (see *Preparation of Surfaces*, pages 27–31), the first step in obtaining proper surface absorbency is to apply a primer-sealer-undercoater. As its name implies, this is a first layer that seals the surface, thus reducing porosity and preventing the absorption of subsequent paint and glaze layers. Whenever possible, use alkyd primers; these work better than latex primers to seal the surface. In addition to keeping the glaze wet longer, primers prevent glazes from being absorbed into hairline cracks and other repaired areas, which would result in dark lines and patches.

After priming, you should apply your base coat. Sheened alkyd or latex paints are the usual choices for base coats because they provide additional barriers to glaze absorption. However, flat base coats may be appropriate for those techniques that require glazes to be absorbed into the surface (e.g., scrubbed-in washes). The differences that flat and sheened base coats have on glazed surfaces is shown in the chart below.

On an already-existing painted surface, test for proper absorption by applying patches of paint thinner in inconspicuous areas. If the thinner does not stay wet for at least two to three minutes, the surface is probably too absorbent for glazing. Also, check for any cracks or repairs. Even if the surface seems sealed enough to keep the glaze workable, any previous repairs to the surface that were not properly sealed may result in uneven glaze absorption.

Before starting a job, you should experiment to determine if you will have sufficient working time, based on your working speed and the final effect desired. If you are unable to adequately extend the drying time of your glaze by altering its formula, try the following:

1. If you need only a moderate extension of working time, brush or roll a film of paint thinner on the surface and allow it to just dry (the sheen will turn dull) before applying the glaze. The paint thinner will form a mild barrier coat.

2. If you need more time, apply a film of one of the following materials just prior to applying the glaze:

- kerosene (this is preferred by many of our students because it gives more working time than paint thinner)

- boiled linseed oil (this is very slow-drying, but may cause considerable yellowing and/or cracking)

Be sure to apply the films evenly over the entire surface so that uneven patches will not appear after the glaze dries. Also, before starting work, test your glaze media and techniques on sample surfaces that have been coated with the film you have chosen. These films remain moist for a long time and can sometimes result in completely different visual effects from those achieved on dry surfaces. Equally important, allow a longer drying time than usual before applying the final finish coats, or cracking may result.

FLAT BASE COATS	SHEENED BASE COATS
• are porous and absorb glazes, marrying base coat and glaze	• are nonporous, allowing glazes to remain on top of the surface
• cause glazes to dry faster, making it difficult to work on large unbroken areas	• allow glazes to stay wet longer, making it possible to work on large areas
• cause patterns to appear softer and more diffused with no pure base coat showing	• cause patterns to appear sharper and more contrasted, and allow the possibility of pure base coat showing
• make removing even wet glazes difficult and time-consuming; often a ghost of color is left on the surface	• permit the easy cleaning of glazes from the surface

GLAZE COMPOSITION

Ingredients for formulating a glaze may be chosen from a wide range of media. Any pigment may be made into a glaze if it can be combined with materials of the same solubility to provide translucence and adequate working time. If the formula also includes ingredients that allow the glaze to hold an imprinted pattern (called being in a state of megilp), even more innovative and exciting effects may be developed.

Glaze formulas were developed over many years by artisans working with media. Myth has it that these formulas were passed on only to family members or to those who had worked their way up through the apprentice system. Turpentine-solvent pigments, varnishes, and linseed oils—both boiled and raw—were found in most of the early glazes and in some form are used today. The main disadvantages of these materials are (1) the higher rate of toxicity of turpentine over today's solvents, (2) the yellowing of the linseed oils, and (3) the inability of varnishes to provide enough body to hold an imprint.

Becoming familiar with, and making use of, the contemporary materials unavailable to prior artisans will expand your creative and economic options in countless ways. In addition to the most basic glaze requirements of translucence, adequate working time, and ability to hold an imprint, modern glazes

- are made from relatively available materials that provide consistent results;

- mix easily, allowing pigment to disperse quickly and smoothly into the vehicle;

- cling to vertical surfaces without sagging; and

- dry evenly and thoroughly overnight so that overglazing and finish-coating may be done the next day.

All of these requirements are met by two basic glaze formulas: one paint-thinner-soluble (alkyd), the other water-soluble (latex).

Green and blue linseed oil/ varnish glazes coated on yellow and green base coats, demonstrating the build-up of color as subsequent coats are applied.

Varnish glazes can be effective on carved moldings as well.

ALKYD GLAZES

Today's alkyd glazing media often have the term glaze (or glazing) on their labels (e.g., glaze coat, glazing liquid, glazing fluid). These proprietary ready-mixed glazes provide uniform quality and predictable results in the visual effects that can be created. The problem with deriving a formula for using these glazes is that their viscosity ranges from thin and translucent to quite thick and opaque. The Basic Alkyd Glaze formula given below is based on a glazing medium of a moderate consistency and utilizes an even balance of glaze medium to solvent (paint thinner), a 1:1 ratio. Thinner, looser products will require the addition of less solvent; thicker, more viscous products will require more.

For most techniques, glazes should have the consistency of skim milk. To text viscosity, dip a palette knife in the fluid, remove the knife and hold it at an angle, and watch the fluid flow off. The speed of the flow indicates the viscosity of the glaze. As you become more familiar with how glazes work, this simple test will allow you to make adjustments when mixing and as work progresses.

We recommend the use of alkyd interior house paints to make glazes in most situations because

- they can be mixed in thousands of colors and have consistently reproducible formulas;

- they use specific numbers within a paint company's system, simplifying discussion about color; and

- they are relatively inexpensive and widely available.

When you need to adjust alkyd paints to match colors more closely, to add more intensity, or to darken their values (this is particularly important when mixing deep-colored glazes), you can use any of the following paint-thinner-soluble materials by themselves or in combination with the other materials:

- artists' tube oil colors

- japan paints

- sign painters' paints

- nonpenetrating wood stains

- asphaltum

- powdered pigments

- tinting colors

All of these materials have different consistencies. Therefore, you must adjust and thoroughly test the Basic Alkyd Glaze formula to ensure glaze workability and adequate drying time.

For the vast majority of the glazing that we (and our thousands of students) have done, the Basic Alkyd Glaze formula has given consistently good results. While work is in progress, though, you may need to make minor adjustments in the amounts of one or more of the three ingredients (glaze medium, alkyd interior house paint, and paint thinner). Specific reasons for these adjustments include any of the following:

Differences in products. For example, pigment-to-vehicle ratios in interior paints differ between paint companies; more or less paint thinner may be needed.

Formula substitution. Using materials other than alkyd interior house paints will affect the glaze-formula ratio. For example, a glaze made with artists' oils, which have a high concentration of pigment, would probably need less paint than a traditional glaze.

Techniques used. For example, to prevent sagging of a glaze for a horizontal strié done with a squeegee, you are apt to use less thinner than you would in a glaze for a vertical strié.

Job conditions. Variables such as the size of the surface to be glazed or the humidity of the working area can require more or less thinner.

Product availability. Note: Products that are not usually stocked can often be specially ordered.

Personal preference. Some painters prefer a looser medium.

BASIC ALKYD GLAZE FORMULA

1 part glazing medium (moderate viscosity)

1 part alkyd interior house paint (flat or sheened)

1 part paint thinner (used alone or mixed with compatible solvent)

You might need to adjust the Basic Alkyd Glaze formula to slow down its drying time if you are working alone, working too slowly, or glazing high walls or stairwells—or maybe you would just like to take your time. In any case, you can slow down the drying time of the glaze by reducing the amount of paint thinner in the formula and substituting an equal amount of

- kerosene (up to 50 percent), which is preferred by many of our students; or

- boiled linseed oil (from 5 to 10 percent), which must

be tested to make sure that there will not be an unacceptable yellowing and that finish coats will not be unduly delayed.

Additives available for helping alkyd paints flow and level out also help keep glazes workable longer. In fact, we know some decorative painters who use these additives as their glazing medium.

If you need custom-mixed formulas for individual projects, or if you have trouble obtaining any proprietary glaze medium, develop your own formula. Select the components of your glaze from the following:

Media: boiled or raw linseed oil, finishes

Pigments

Solvents: paint thinner or kerosene

The combinations are innumerable and should be carefully tested. Consider the qualities that the different medium choices provide.

Linseed oils. These give translucence and workability. Raw linseed oil is darker, heavier, takes longer to dry, and yellows more than boiled linseed oil. When using glazes that include a high linseed oil content, be aware that they tend to slide down vertical surfaces, mandating a return to previously done areas to correct sags. They also require constant stirring to prevent streaky color. Most important, they take a long time to completely dry—sometimes several weeks. Many types of finish coats crack when applied to still-drying linseed oil glazes; for this reason, you should always test finish coats first on sample surfaces that were done at the same time as the work itself. (Note: Liquid dryers are available to speed up the drying time of linseed-oil glazes.)

Finishes. These give some body to glazes. Matte, semigloss, or gloss finishes may be used; each has a different effect, but all make formulas tackier. Finishes can be thinned with solvents for easier application. Paints that have strong, pure, saturated pigment, such as japan paints and artists' oils, are better than alkyd interior house paints for tinting finish glazes. Mix the pigment first with a little finish, then add more finish until the desired depth of color is reached. Strain if necessary. The mixture will last a short period of time if stored in a tightly closed container.

Driers. These add drying capabilities. Too much fosters cracking.

Whiting. This gives formulas body to hold imprints.

Since glaze formulas are thin, there is more leeway in the selection of materials than there would be in formulating an opaque mixture. There is no exactly correct proportion of one material to another; just keep in mind the function of each.

WATER-BASED GLAZES

Traditional water-based glazes (see distemper media formulas on page 182) tend to be fairly thin and therefore unsuitable for glazing large areas with the types of imprint manipulations shown in this chapter. Today, however, there is a whole range of polyvinyl emulsions available that can make acceptable water-based glazes. These include latex paint, water-soluble finishes, water-soluble wallpaper paste, water-soluble concrete bonders, acrylic mediums, and additives for latex paint. Unless a pale, thin wash is desired, merely adding water to latex paints does not make as satisfactory a glaze as does including ingredients that lengthen working time and provide more body.

Latex glazes dry quickly, offering little working time. They tend to bubble on the surface and often look a little flat, lacking the depth of color or subtlety of alkyd glazes.

Any glaze technique that can be done with latex glazes may also be done with alkyd glazes. We use latex glazes as first layers under alkyd overglazes. This allows us to glaze two layers in one day, which is particularly useful when we are doing multilayer glazing, such as marbling or graining, on large surfaces.

Other water-soluble paints that can be used instead of, or in conjunction with, latex paints are acrylic, casein, tempera, gouache, and watercolor. In addition, you can use powdered pigments (not alcohol-based aniline powders) and tinting colors, which are soluble in water as well as in other solvents. These paints vary widely in the amount of thinning they require and the depth of color they provide. To lengthen their workability time, use glycerin, latex concrete bonders, or the additives available for leveling out latex paints.

LATEX GLAZE FORMULA

1 part latex interior house paint (flat or sheened)

1 part water-soluble finish (full-bodied type)

—or—

1 part vinyl wallpaper paste (the premixed variety is easier to use than the powder, which has to be mixed with water)

Up to 1 part water

ESTIMATING AND MIXING GLAZES

To estimate the amount of glaze you will need, measure the area to be glazed to arrive at a square-foot (square-meter) measurement. If glazing walls, deduct window and door measurements. The label on each can of paint indicates the approximate coverage it will provide. Multiply that figure by three, since the paint is only one-third of the formula. Compare this figure with the square-foot (square-meter) measurement to determine how much paint is needed. Include an extra quart or two of glaze in case disaster strikes: the glaze tips over, someone (not you, of course) thins it with the wrong solvent, parts of the job must be done over, and so forth. Here is an example of how this works:

A foyer is 12 feet by 16 feet with 8-foot ceilings. This converts to 448 square feet. The label on a quart of paint indicates that coverage is roughly 150 square feet. Multiplying 150 by three equals 450 square feet. You probably could squeeze through with one quart of paint but should get two quarts to be safe. Although more glaze can always be mixed, there is a possibility that there might be a slight, but noticeable, color difference.

Being neat and organized makes mixing and straining glazes almost pleasant. Have on hand the following supplies:

- empty quart and gallon cans and lids
- mixing buckets
- stir sticks
- measuring cups, paper cups, and aluminum cans
- straining cloths (fine mesh curtains, scarves, or hosiery)
- rubber bands or tape for securing straining cloths
- napkins, paper towels, and/or cheesecloth

The following hints will be helpful when mixing glazes:

- Different cans of the same paint color should be "boxed" or mixed together before use to ensure color uniformity. To box paints, empty all of the same color paint into a large mixing bucket, stir thoroughly, and pour the paint back into the original cans.

- Alkyd glazes and open cans of paint that have been sitting for a while should be strained, even if there is no "skin" formation. After straining them, you will probably find many little bits of solidified media on the straining cloth.

- At school, we use a nail to punch holes into the rim around the tops of paint cans so that media that collects there will drip through and allow us to seal the cans tightly. This helps keep out air, lessening the skin formation on the glaze.

- Keep cans as full as possible. Full cans will "skin" less than partially filled cans.

- We save time when mixing alkyd glazes by premixing one part glazing fluid with one part paint thinner. We label this mixture "1-1" and always keep it available, like the French soup pot kept on the back of the stove. Remember to add two parts of the 1-1 mixture to one part of paint when mixing the basic glaze. Strain the 1-1 mixture before adding it to any formula, unless it has just been mixed.

- Mix glazes using the entire can of paint (for example, mix one quart of paint with one quart of glaze medium and one quart of paint thinner), or use measuring cups, paper cups, or aluminum cans to calibrate smaller amounts. An alternate method is to mark a wooden stir stick into three equal segments. Place one end on the bottom of the can and pour each liquid up to the appropriate mark.

- We find it helpful to leave our stir sticks (the plastic stems found inside foam brushes) in the can. They tuck right under the lip of the can, saving us the trouble of coping with the usual long wooden stir sticks, which often drip media where it is not wanted.

TECHNICAL PROPERTIES OF GLAZES

Most glazing techniques are simple, although some require more practice than others. However, to reach the highest standards you must understand how the technical properties of glazes affect both the glazing process and its final appearance. These properties (which involve consistent reactions of glazes under specific conditions) are both liberating and restricting. They permit you to develop exciting new finishes by knowing what will happen with glazes and then deliberately daring to push the media in unorthodox ways. However, if the properties are not given the respect they deserve, problems most certainly will occur.

HOW DRYING TIME AFFECTS GLAZING

It is important to understand how glazes dry and what can be done to them at each stage of drying. The chart below shows the properties of glazes at each stage. This information is essential as it affects every aspect of the glaze from the time it is applied to the time it is given a finish coat.

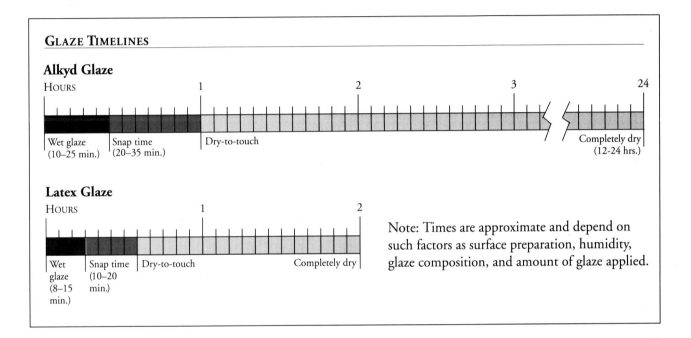

GLAZE TIMELINES

Alkyd Glaze

HOURS 1 2 3 24

Wet glaze (10–25 min.) Snap time (20–35 min.) Dry-to-touch Completely dry (12-24 hrs.)

Latex Glaze

HOURS 1 2

Wet glaze (8–15 min.) Snap time (10–20 min.) Dry-to-touch Completely dry

Note: Times are approximate and depend on such factors as surface preparation, humidity, glaze composition, and amount of glaze applied.

DRYING STAGES OF GLAZES

Wet Glazes	Glazes at "snap time" (tacky)	Glazes dry to touch	Glazes completely dry
• can be manipulated • can have additional glaze added • can be evened out • can be repaired	• can no longer be manipulated, evened out, or repaired • will be damaged by the addition of more glaze • can be removed with a solvent • would be likely to be damaged by being touched or brushed against	• would probably be damaged if touched with a solvent • can still be removed with a solvent • possibly would be damaged by being touched or brushed against	• are almost impossible to remove with a solvent without damaging the base coat • can be finished or overglazed

HOW TOOLS AFFECT GLAZING

The removal tool (or tools) you use affects the technique based on the amount of glaze coverage; the number of times the tool passes over the same area; and the pressure exerted on the tool. The chart below illustrates the effects of these three factors.

Tan glaze applied to a white base coat in four different ways: (1) dabbed with cheesecloth; (2) rolled with plastic; (3) dragged with a cut squeegee; and (4) dragged with a dragger/flogger.

GLAZING PROBLEMS AND SOLUTIONS

Glazing problems can usually be traced to one of the following areas:

- the way surface absorbency is affecting the glaze

- the consistency of the glaze (which will change due to evaporation)

- the condition of the tools used to manipulate the glaze (cheesecloth that is too saturated to absorb much glaze, for example)

- the uniformity of the technique

- the ability to manipulate glaze before it dries

- the preventing and/or correcting of damages and sags

- the relationship between work in progress and work already done

- how drying is affecting glaze color and depth

- the awareness of how changing light patterns can affect perception

- communication between client, designer, and decorative painter

HOW TOOLS AFFECT GLAZING

Technique	Dark-colored glaze over light base coat	Light-colored glaze over dark base coat
More glaze coverage creates a "closed" texture with not much base coat showing.	Appears darker	Appears lighter
Less glaze coverage leaves an "open" texture with more base coat showing.	Appears lighter	Appears darker
One pass of a tool creates a broad texture with moderate pattern imprints and large intervals between imprints.	Appears darker	Appears lighter
Many passes of a tool creates a fine texture with many pattern imprints and small intervals between imprints.	Appears lighter	Appears darker
Light pressure on the tool leaves a thick, opaque glaze that masks the base coat.	Appears darker	Appears lighter
Heavy pressure on the tool leaves a thin translucent glaze that interacts with the base coat to create a new color.	Appears lighter	Appears darker

GLAZING PROBLEMS AND SOLUTIONS

Examples assume a dark glaze on lighter base coat.

Problems	Causes	Solutions
Glaze is sagging, curtaining, or moving slowly downward along a vertical surface, along with the pattern that has been imprinted into it.	More glaze was applied than the surface could "grab" because not enough glaze had been scraped off the roller. Also, the base coat might have too much of a sheen, not providing enough "tooth" to hold the glaze.	If noticed immediately, quickly dab the sagging glaze with cheesecloth to remove excess glaze, and then do the technique again. An alternative is to quickly apply more glaze, in spots or over the entire area, and then repeat the technique. If the base coat has too much of a sheen, try thickening the glaze a touch.
Glaze is pooling on a horizontal surface.	Too much glaze on the surface. Alternatively, the surface of the structure may be have uneven areas.	Same as above.
Glaze is too dry to work with, or looks washed out, showing little pattern after manipulation.	Too little glaze was applied, or too much removed, before manipulating.	Clean glaze from the surface if necessary. Apply more glaze and do the technique again.
Holes or other light areas appear on the glazed surface.	Uneven heavy finger or hand pressure.	If wet, glaze can be rebalanced by walking the glaze or softening the edges. When glaze is completely dry, feather in more glaze.
Corners or edges appear blotchy, having spots that are both too dark and too light.	Uneven heavy finger or hand pressure.	If wet, glaze can be evened out. Once the glaze is dry, try adding glaze to the light spots and around the dark areas and then feathering out the edges. If the blotchiness is severe, consider overglazing.
There is a defined change in value along corners and edges, as if a light border had been applied.	Too much pressure was applied along the border.	Rebalance the glazes, when dry, and feather in more glaze.
Isolated areas that are too dark appear on the surface.	(1) Uneven pressure that is too light in spots; (2) too much glaze on the surface, or not enough removed before manipulation; and/or (3) manipulating implement is too saturated.	The dark areas cannot be lightened because the glaze has absorbed into the wall itself. The options are (1) to darken the surrounding areas to try to lose the repairs; (2) to overglaze, if possible; or (3) to prime, base-coat, and texture the dark areas to match surrounding areas. (This only works on some textures. Sometimes it is more efficient to rebalance the glazes and then feather in more glaze.)

GLAZING PROBLEMS AND SOLUTIONS
Continued

Problems	Causes	Solutions
Hairline cracks and blotches appear darker on the walls after glazing.	Repaired areas were not adequately primed. Areas that have been spackled need priming to equalize the absorbency of the rest of the wall.	Unfortunately, once it has started to set up, dark glazing cannot be removed without leaving rings or damaging the substrate. You can try either of the following: (1) When the surface is dry, add dark glaze around the problem area and feather out the glaze; or (2) overglaze.
Glaze is too dry; wet edge is drying too fast.	(1) The surface was not prepared properly; it is too absorbent; (2) the glaze was improperly mixed; (3) you are trying to glaze too large an area at a time; and/or (4) air is blowing from the heating or cooling ducts.	Your options are (1) to have someone else apply glaze; (2) to apply glaze to smaller, workable areas; (3) to coat the surface first with solvent or other substances that will extend the working time; (4) to add a retarder to the glaze to slow drying; or (5) to try extending the wet edge by adding a narrow swath of glaze, and then to continue the technique through the original wet edge, leaving a new, fresh wet edge.
The wet edge is remaining wet, but appears darker after completion.	Glaze was applied over the wet edge rather than adjacent to it, giving a double thickness of glaze.	It might be possible to add glaze unevenly around the dark lines to try to lose the pattern, especially if the problem is not too extensive. Otherwise, try overglazing or starting over.
As the day progresses, the glazing becomes darker and more opaque.	(1) The solvent evaporated from open cans of glaze; (2) the lighting changed and you did not make adequate compensation; (3) the depth of color of the wet glaze was matched to the finished glaze, which had dried darker; and/or (4) you got tired and started pressing more lightly, leaving a heavier glaze film.	Your options are (1) to remove the glaze from one or more of the walls (if you notice the problem before the glaze has completely dried); (2) to darken the lighter sections with a wash coat; or (3) to reapply base coat to one or more of the walls and then reglaze.
After you had completed the glazing, the protective coat you applied changed the glaze color.	The sample (if any) was not completed through the final finish coats.	Before redoing the job, try overglazing with white or a light-color glaze, or try using a tinted finish to rebalance the color.
Prior to glazing, everyone liked the base coat/glaze color combination. After completion, no one liked it.	The sample was probably not large enough and/or it was not placed against carpets, fabrics, or	Try overglazing or using a tinted finish to rebalance the color.

GLAZING SMALL AREAS: CAEN STONE

To those who have not glazed before, the thought of tackling an entire wall might seem intimidating. Why not begin by breaking up the wall into some type of blocks? You can explore the basic principles of glazing and the properties of the glazes themselves most easily while treating small, easily managed areas without having to worry about the problem of the wet edge (see pages 82–84). You also have two additional benefits: (1) glazing individual blocks allows work to be stopped and started, even on different days, and (2) more than one person can work on the same surface, since the slight variations in tone foster the effect of separate blocks.

Even if you do not wish to glaze in block formation, you should become familiar with the information in this section, especially that on the manipulation of cheesecloth, walking the glaze, and how the properties of glazes affect working. This information is essential for executing any glazing technique, and it will be referred to throughout this book.

Many kinds of architectural stonework, or rustication, have been used continually since earliest times. In the United States, painted versions were particularly popular in the nineteenth century and may be seen replicated in many restorations. In addition, contemporary architects and designers are using real and painted stonework in intriguing ways. This simple glazing project will simulate a limestone quarried in Caen, France. Caen stone is a rather pale, slightly peach-colored stone. It has been used extensively in interior and exterior cladding for over 100 years.

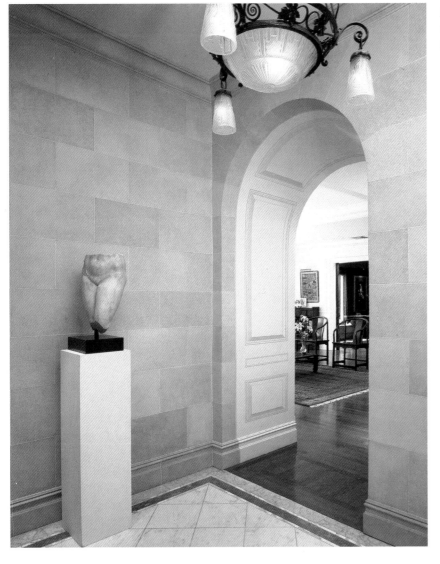

Painted Caen stone with a trompe l'oeil molding turns this archway into an impressive entryway.

TECHNIQUE

1. Tape the wall (see instructions on pages 38–39).

2. Prepare cheesecloth (see page 18) before applying the glaze. Take a large piece (3 to 4 square feet [91 to 122 square cm]) and form it into a pouf, making sure that corners and edges remain tucked in so that they will not make a harsh impression in the wet glaze. Aim for a light, airy ball rather than a densely packed pad. Other removal tools—muttoncloth, for example—neither absorb as well as cheesecloth nor leave as smooth an all-over homogeneous glaze film after dabbing. Cheesecloth dabbing is most similar to stippling.

3. Mix the glaze according to the Basic Alkyd Glaze formula (see page 73).

4. Apply the glaze with a 2-inch (50 mm) foam or bristle brush right up to the edge of the tape. Start at the top to off-load excess glaze so that any drips will remain within the confines of the block. To prevent damage, do not allow any glaze to touch adjacent blocks that have not fully dried.

5. Starting at one end of the block, remove the glaze with a dabbing motion of the cheesecloth, lifting straight back. Do not twist or drag the cheesecloth. Determine the pressure you need to create the visual texture you wish and to best suit your physical abilities (in terms of both strength and endurance).

6. Continue dabbing in an orderly sequence, without jumping around, until you reach the other end of the block. Most people find it easiest to completely finish a 2- to 3-inch-wide (5- to 8-cm-wide) vertical stripe and

to travel in one direction until the block is complete. When a surface of the cheesecloth becomes saturated with glaze, shake the pouf out to expose a fresh area and quickly form the cloth into a new pouf. Change cheesecloth when it has no more absorbent surfaces. Stand back constantly to monitor the visual appearance of the wall, checking particularly for too-light and too-dark areas.

7. If problems appear after the glaze has begun to set, adding even a little glaze over these problem areas will usually cause rings to appear, which get larger with repeated attempts to remove them. To prevent rings from forming, or to remove one that develops, use dry cheesecloth to grade the edge of the hole or ring into the surrounding area and then leave it until it is completely dry (overnight for alkyd glazes, four hours for latex glazes). Then lightly apply more glaze to the area with cheesecloth and blend it in by walking the glaze (see page 81).

8. If you are displeased with the painting technique in any block, remove the glaze from that block with paint thinner. The glaze is easily removable soon after its application. It remains soluble for up to about ten hours and can be removed during this time using paint thinner and increasing amounts of elbow grease. A matte base coat is far more difficult to clean because it holds the glaze; two or three "washes" with solvent are often needed to remove the glaze completely.

You may find smudges of glaze caused by glaze-saturated cheesecloth overlapping onto surrounding blocks. There is no problem if these overlaps are on blocks that have not been glazed or are completely dry. However, attempts to clean glaze that is overlapping onto a block that is not thoroughly dry will expose the base coat and necessitate reglazing the entire block.

9. If you are not doing any shadowing, you may remove the tape when the glaze is completely dry; the lines left by the tape will simulate grout lines. Clean any seepage, and the stones are finished and ready to be varnished (if desired).

10. If miters have been cut out, the tape is reserving the base coat, which will become the highlighted portion of the stone. However, the shadows, which are darker than the glaze, must be added. There are many ways to do this, including using paint, glaze, or pastels—freehand or with tape. We have found the easiest method is to use artist-grade markers. They are easy to use and give a translucent effect very similar to the glaze. Since markers have a more limited color selection than glazes, choose them first in a darker, duller color than you will

eventually select for the glaze. To draw the shadow lines, take a straight-edge and place it parallel to the tape a tape's width away. Run the marker along the straight-edge, being sure to go into the cut-out miters. Make sure the glaze is completely dry before marking.

11. After the lining is completed, remove the tapes, clean any seepage, touch up, and—voilà—the stones are completed.

WALKING THE GLAZE

To smooth out holes showing base coat or noticeable flat and pie-crust-edged borders and rings, we use a technique we call "walking the glaze." This technique is so essential in glazing that perfecting it will be well worth the time spent practicing it. It is not only useful for repairing problems caused by uneven pressure, but it also is the secret for creating seamless blending of glazes—whether even or graded (where variation of

pressure creates color gradations—from light to dark or the reverse—sometimes known as ombré).

The basic idea of walking the glaze is to take glaze from areas where it is too heavy and apply it to areas where the glaze is too light. The keys to obtaining even results are consistent pressure and slightly overlapping dabs. As in the basic dabbing technique, you dab the surface with cheesecloth, lifting it straight back, without twisting or dragging. Then, using consistent pressure, repeat the process, "walking" over the surface in small overlapping increments. Develop an even, repetitive, rhythmic pace that advances and retreats over the areas involved. As if a magic wand had been waved, the glaze will be transferred by the cheesecloth from areas where there is too much glaze into areas where more glaze is needed.

Walking the glaze differs from the basic dabbing technique in that smaller areas are done at one time, the dabs overlap, the size of the imprint is reduced, and a more even visual texture is produced.

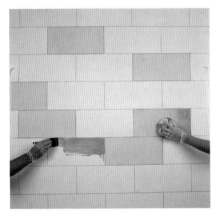

Glaze (BM 1167) is applied with a foam brush (left) and then dabbed off with cheesecloth (right).

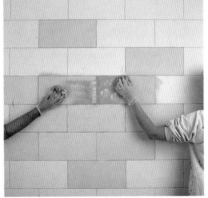

Imperfections in the glaze caused by uneven finger pressure can be blended by "walking the glaze."

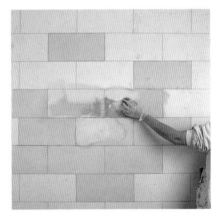

Unwanted blocks can be eliminated by removing the glaze with paint thinner.

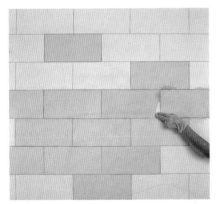

Cleaning overlapping glaze from blocks that are not fully dry will cause damage. Blocks that have cured can be cleaned safely.

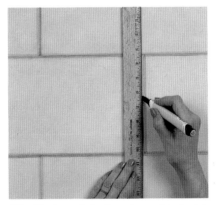

The illusion of shadows is rendered with a straight edge and a felt-tip marker the same width as the tape.

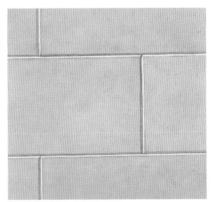

The completed stones, shown with highlights and shadows.

GLAZING LARGE AREAS

After successfully mastering the glazing of small areas, you can apply the same principles and techniques to larger, unbroken surfaces. However, for consistent, mistake-free glazing on unbroken surfaces, it is essential to keep the glaze workable for as long as is necessary for manipulation and removal. This requires a working knowledge of the composition of glazes and their absorption into surfaces (see pages 70–73).

Glazing large areas is accomplished by blending whole sections of separately applied and manipulated glazes into a unified whole. This is done by making use of a wet edge—a 3- to 4-inch (7½ to 10 cm) strip of unmanipulated glaze at the edge of each section—that allows sections of glaze to be applied adjacent to one another with an imperceptible join.

Rollers are used more often than foam or bristle brushes to apply glaze to large areas. Foam rollers are particularly suited to glazing as they hold the right amount of glaze without dripping, do not shed fibers, and are inexpensive. These rollers are usually available in 9-inch (23 cm) widths, but they can be cut easily with a razor blade to fit smaller cages.

Before applying glaze with a roller, reduce the amount of glaze on the roller with a plastic, metal, or wooden scraper made for cleaning rollers. First load the roller, then hold it over the well of the paint tray and scrape the tool along the roller. Although a few hours of experimentation in the studio will give you the best indication of the right amount of glaze for a particular technique, two general guidelines can be followed:

1. If your pattern is imperceptible and the glaze dries too fast, there is two little glaze on the surface (assuming proper surface preparation and glaze consistency).

2. If the pattern drips, curtains, or fuses together, there is too much glaze on the surface. Although excess glaze can be removed with cheesecloth before executing the technique, keep in mind that the less extra glaze you apply, the less time you will spend removing the excess.

ORDER OF GLAZING

You will find it easier to glaze large areas working with another person. The "applier" applies the glaze and feeds supplies to the "finisher," who manipulates the glaze and assumes responsibility for the final visual effect (since each person has a unique, recognizable glazing style, these roles should not be switched when executing the same finish). A knowledgeable applier can

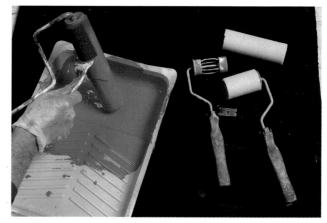

Excess glaze is removed with a roller scraper. Note the foam roller cut to fit a 3-inch (7½ cm) roller cage.

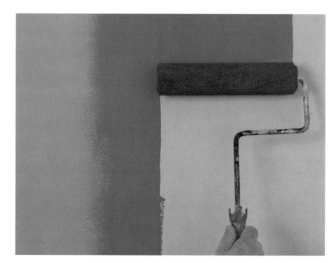

A section of red glaze (BM 1321) has been applied with a roller to a pink (BM 1186) base coat and patted with cheesecloth, leaving an approximately 4-inch-wide (10-cm-wide) wet edge of unmanipulated glaze at one end. Fresh glaze is rolled on adjacent to the wet edge.

Cheesecloth is patted through the wet edge into the freshly applied glaze. The entire wet edge should be eliminated before starting work on the newly applied glaze.

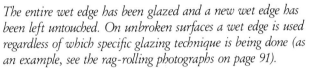

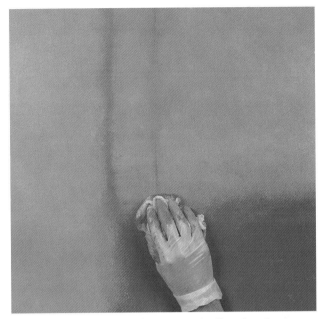

The entire wet edge has been glazed and a new wet edge has been left untouched. On unbroken surfaces a wet edge is used regardless of which specific glazing technique is being done (as an example, see the rag-rolling photographs on page 91).

Blotchy lines result when the wet edge is allowed to dry too long before being manipulated. Once the glaze is too dry to be worked, obtaining an even finish is impossible.

A basic dabbing technique was used to glaze this pair of full-size ceramic-tile doors.

be a great help with technical and aesthetic evaluation. This person can be either a semitrained assistant or an equal partner who might be the finisher on the next job.

Working as a team not only makes it easier to finish manipulating the glaze before it dries, but it is time-efficient as well. A good team can glaze a room in less than half the time it takes one person.

The applier and finisher can stay out of each other's way by working in a checkerboard fashion, as shown in the sketches to the right. First, the applier applies glaze to the upper corner of a wall. Then, while the finisher is patting off the glaze and leaving a wet edge (shown by the heavy black line), the applier applies glaze to box #2. This process is repeated in boxes #3 and #4. Note how the wet edge shifts as the work progresses.

If the wet edge is drying faster than it can be manipulated, there are a number of approaches you can take. Before trying any of them, however, first test the absorbency of the surface with paint thinner (see page 70).

• Add a retarding agent to the glaze (see pages 72–73).

• Coat the surface with solvent (see page 70).

• Apply the glaze in smaller, more easily handled sections.

• Instead of applying glaze to a complete box, just extend any wet edges that are in danger of drying. This is done by applying one roller width's worth of glaze next to the wet edge and patting through it, leaving a new wet edge 9 inches (23 cm) away from the original.

• Apply the glaze in narrow floor-to-ceiling stripes.

The size of the room to be glazed determines how it is approached.

In a mid- to large-size room, opposite walls are usually taped off and glazed. The remaining walls are glazed after the first two walls are dry and taped off. Be sure that the taping is precise, allowing contact between the two walls without reserving a thin line of base coat.

In a small room that can be glazed in one day, place painters' tape in the least important corner. Start glazing on one wall. When you reach a corner, do not have the

wet edge end where the two walls meet. Instead, apply the glaze so that the wet edge is on the new wall at least a few inches past the corner. By the time all four walls are completed, the glaze that was done first will probably be dry enough to be protected with painters' tape. An alternative is to try an old-time painters' trick of protecting a not-quite-dry surface by holding 80-grit sandpaper against it. The coarse grit of the sandpaper prevents accidental smudging of the glaze.

If for some reason you have to stop glazing before you reach a corner, try to end in the most inconspicuous spot possible (perhaps behind where there will be draperies or an oversized armoire, or above a door). Instead of leaving a wet edge, feather out the end of the glaze so that the next application of glaze can be feathered into it; this will keep the join from being visually disturbing when the glazing is completed.

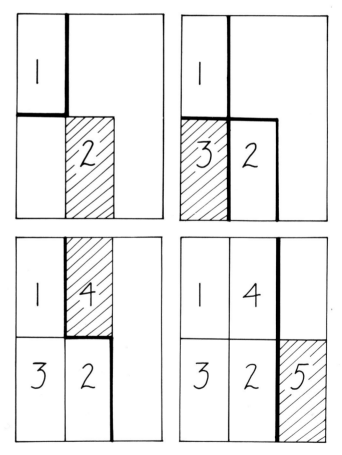

The sequence for glazing with an applier and a finisher

MULTILAYER GLAZING

Multilayer glazing, also called overglazing, is simply one layer (or layers) of glaze applied over another, already-dry layer(s). An alkyd overglaze can be used over an alkyd first layer without interlaying (protecting the first layer with shellac), provided the first layer is completely dry (usually in twelve to twenty-four hours). A latex glaze can be overglazed with an alkyd or latex glaze in about two hours.

Overglazing can be used to adjust a hue or value, or to soften blotchy areas of the first layer. Another use of multilayer glazing is to develop more complex design and color relationships.

Tremendously effective finishes can be obtained using even the simplest glazing techniques (e.g., dabbing) by combining layers of glazes and taping to create simple or complex patterns. Taped designs with multilayer glazing may be symmetrical or abstract, and may be used over an entire surface or only as a border. There are two basic concepts to using overglazing to create graphics:

1. Tape applied to any layer will reserve a strip of that layer while it is being overglazed.

2. The basic principles that affect the appearance of a single layer of glaze over a base coat (i.e., color relationship, pressure, scale) apply to multilayer glazing.

Creating a floor design: A white base coat has been reserved with ⅛-inch (3 mm) and ½-inch (12 mm) tapes, and a light terra-cotta (BM 1182) glaze has been rolled on the surface and dabbed with cheesecloth.

Creating a design: (1) ⅛-inch (3 mm) tape has been applied over a white base coat to reserve solid white stripes. (2) After the first glaze (BM 1182) has been applied, patted, and allowed to dry, ⅛-inch (3 mm) and ½-inch (12 mm) tapes have been applied to reserve this first glaze color. (3) Breaking up the space with tape gives you the opportunity to use different pressures in defined areas, when overglazing, to create varied tonal values. Since the white overglaze in this example is lighter than the first layer, areas where less pressure was applied (between the ⅛-inch [3 mm] and inside the ½-inch [12 mm] tapes, for example), appear lighter and bluer. (4) It is always exciting to remove the tapes and see a crisp, well-defined design (assuming the tapes have been burnished well).

Close-up of finished work. Note how the green (BM 704) overglazed tiles relate to those that have the first layer of glaze only.

NOVELTY EFFECTS/SPECIAL TECHNIQUES

The following exercises were designed to show how manipulations of two glazes within the same layer can give a wide range of depth, tonality, and texture to glazed surfaces. These techniques indicate the type of thinking that will allow you to develop your own unique finishes to complement standard techniques.

GRADED GLAZES

Two different glazes can be graded together so that there is a completely even flow from one color to the next, similar to the seamless blend of airbrushing. The blended areas exhibit a third color, which is a mixture of the two glazes. Grading can be used floor to ceiling, in graphics, or to create softly diffused color blends such as those seen in sunsets or misty landscapes.

TECHNIQUE

1. Begin by applying bands of two different-colored glazes on either side of the surface to be glazed. Leave an open area between the bands.

2. Use cheesecloth or a foam or bristle brush to intermingle the two glazes randomly between the bands of pure color. Some people prefer extending 1- to 2-inch (25 to 50 mm) stripes of both color glazes into a common area.

3. Using cheesecloth or a stipple brush, begin blending the area where the glazes meet, as the ends have more glaze and therefore will stay workable the longest.

4. Continue blending into the untouched glaze, being sure to even out any areas that break the flow. A stipple brush is being used in the photograph below, but dabbing with a cheesecloth would work equally well. This dabbing can be done by walking the glazes both horizontally and vertically until they meld into each other (see *Walking the Glaze*, page 81).

The final effect should be of two colors blending into each other without a perceptible break.

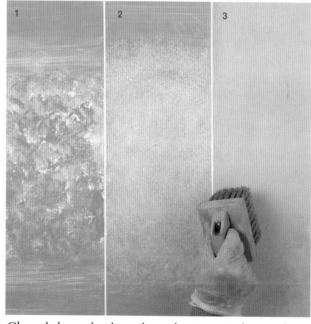

Cheesecloth or a brush can be used to intermingle two colors of glaze (1). The blending is further refined, using either cheesecloth or, as shown here, a stipple brush (2, 3).

The final result is a blend so smooth that it is imperceptible where one color ends and the other begins. The colors used here were BM 1167 (orange-pink) and BM 704 (green).

BLENDED STRIPES

Applying glazes over a film of paint thinner allows easy blending and the choice of subtle or strong depth of color.

TECHNIQUE

1. Apply a film of paint thinner to the base coat with a wad of cheesecloth.

2. With a foam or bristle brush, apply random streaks of two different-colored glazes both next to and on top of each other.

3. Drag a cheesecloth pouf gently along the length of the streaks to give a subtle striped texture. The finish may be left at this stage for a darker color range.

4. For softer, paler stripes, pat out the streaks with cheesecloth. The texture can be softened and lightened a great deal since the layer of paint thinner keeps the glazes from absorbing into the surface. Aim for uneven spacing, varied color saturations, and some interlacing.

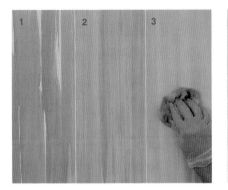

At far left, random streaks of orange-pink (BM 1167) and green (BM 704) have been placed adjacent to each other with a brush (1), then dragged through gently with a cheesecloth pouf (2), and finally dabbed with cheesecloth to soften the effect (3). The end result is shown near left.

LIQUID COLOR

Glazes are intermingled and fused in this technique, creating blends that would be difficult to obtain any other way. Some of our students have painted bathrooms using this technique, giving the whimsical effect of paint turned molten by steam from the shower.

TECHNIQUE

1. Apply the first-color glaze along the bottom of your surface with a wad of cheesecloth.

2. Saturate a piece of rolled cheesecloth with paint thinner so it is fully loaded but not dripping. Place the cheesecloth on the surface above the entire boundary of the glaze, and squeeze it.

3. Next, apply the second-color glaze with a wad of cheesecloth in and above the area where the first cheesecloth was squeezed (a green glaze was used in the study below), and squeeze a second paint-thinner-saturated cheesecloth above the second color's boundary.

4. Continue alternating glazes and squeezing paint thinner until you are pleased with the effect.

Coverage can be solid and all over, as in the study shown here, or it can have a more open texture, exhibiting more base coat and translucence.

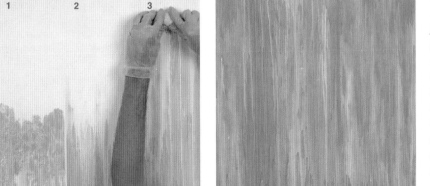

At far left, an orange-pink glaze (BM 1167) has been applied with cheesecloth, paint thinner has been drizzled over the glaze to open it up, and a green glaze (BM 704) has been applied in and above the area where the paint thinner was added (1); paint thinner has been drizzled over the green glaze (2); and more orange-pink glaze has been applied and paint thinner is being drizzled over it (3). The end result is shown near left.

REMOVAL WITH LAID-ON PLASTIC

These techniques use sheets of plastic for imprinting textures and are some of the simplest you will ever do. In addition, the techniques allow more than one person to work on the glazing layer as the little differences among individual "hands" can easily be blended together. In general, the color contrast between the base coat and the glaze should not be too great, as these textures tend to be a little broad (although they may be refined as shown below). Done in dark browns, plastic manipulation looks convincingly like leather. Different thicknesses of plastics will give different effects. We use 1-mil (1 mm) plastic drop cloths because they are readily available in several sizes, manipulate easily, and create good textures.

TECHNIQUE

1. Begin by applying glaze to the entire surface.

2. Dab off any excess glaze with cheesecloth.

3. Immediately cover the glaze with a large sheet (or sheets) of plastic, which will stick to the glaze and keep it workable for a longer time than usual.

4. Using your fingers, push the plastic in varying directions to create random patterns. The flat and raised sections of the plastic give a good indication of what the final textures will look like; the raised "lines" in the plastic are where the base coat will show through.

5. Remove the plastic and, if desired, make the units of the texture smaller and less angular by pressing crumpled plastic into the still-wet surface.

This detail shows a textured glaze rendered with the laid-on-plastic technique in the grand salon of the National Paint and Coatings Association headquarters. Full sheets of plastic were used to cover the large surfaces so that many workers could manipulate the plastic at one time.

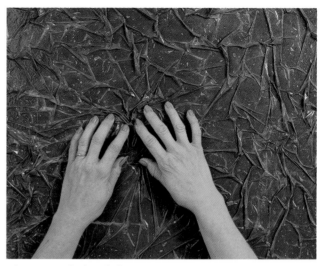

Plastic is pushed with fingers over the glazed surface.

Crumpled plastic is pressed into the still-wet glaze to further break up the texture.

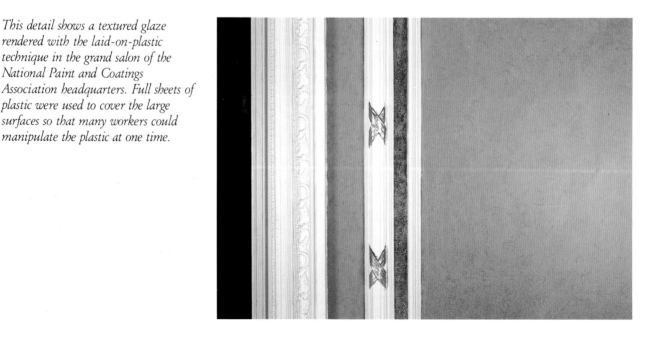

COMPARATIVE GLAZE CHART

This chart begins to show the variations in visual texture and tonality that can be obtained by creating an optical mix between the glaze and the base coat. In actual installations there are specific reasons for choosing one optical mix instead of another, including the size of the room, the degree of drama desired, the fabrics and floor-coverings used, and the client's preferences.

The many variables that effect the final appearance of a glaze technique include

• the color relationship between the base coat and the glaze;

• the glaze consistency (when imprinting a strong pattern on a vertical surface it is sometimes helpful to have the glaze a little thicker to avoid sagging);

• the type of material used to remove the glaze (make sure there is enough to do the entire room);

• how the material is held (e.g., how loosely or tightly crumpled, or how many surface depressions are left);

• the amount of pressure applied (light pressure leaves glaze as is, with little base coat showing; heavy pressure leaves a light coat of glaze over the base coat).

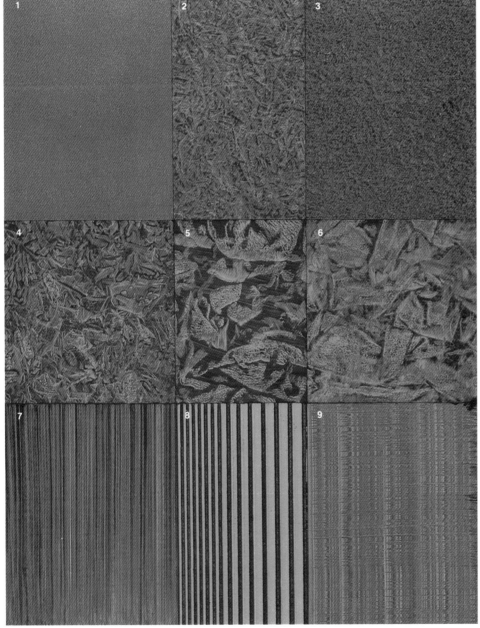

Each of these optical mixes was done by applying a deep red-purple glaze (BM 1267 and black) over a bright yellow base coat (BM 301) and creating all-over textures by using medium pressure to remove the glaze with the following materials and methods:

1. a pouf of cheesecloth, dabbed

2. a wad of crumpled plastic, dabbed

3. a dampened marine sponge, dabbed

4. a wad of crumpled 1-mil plastic, rolled

5. a wad of crumpled, well-washed sheeting, rolled

6. a piece of crumpled chamois, rolled

7. a flogging brush, dragged

8. a graduated rubber comb, dragged

9. a synthetic sponge, dragged vertically; then, when the glaze was just short of dry, a dry dragging brush was dragged horizontally (simulating slubbed silk).

RAG-ROLLING

Rag-rolling is one of the most widely used methods to obtain an optical mix. Its name withstanding, this relatively simple technique does not have to be done with rags.

TECHNIQUE

1. Apply the glaze to the surface and remove any excess by dabbing lightly with cheesecloth.

2. Bunch up the rolling material (various materials may be used as shown below) in both hands so that there are many depressions. These hollows allow glaze to remain on the surface.

3. Roll the material across the surface either in random directions or in rows. The final effect should be nonrepetitive and flow evenly. If the material leaves a repetitive strié pattern, rebunch the material to get a more random pattern.

4. After you have finished going over the surface, you may need to make slight adjustments to make it visually cohesive. Break up heavy areas by lightly touching them with the manipulating material. Light areas can be filled in with glaze and rerolled.

A variation of rag-rolling is to remove the glaze by using a dabbing motion with the material rather than rolling it. When using this technique, be sure to keep turning and readjusting the material to avoid a repetitive pattern.

A variety of textures, scales, and depths of color may be obtained using different fabrics, papers, and plastics to remove the glaze. Try these:

Fabric. Cotton and linen cloths are the most traditional fabrics used for rag-rolling. However, any fabric may be used, including burlap, lace, and velvet.

Paper. Many types of paper may be used for glazing, including newspaper, tissue paper, and specialty wipes. Each differs in thickness, crispness, and absorbency, giving a wide range of textures. For example, rolling a crumpled *Manchester Guardian*, a crisp British newspaper, gives a more defined texture than is achieved with the more absorbent *New York Newsday*. Some newspapers, like the *New York Times*, bleed newsprint when used with paint-thinner-soluble glazes (this can be a nice touch if a little gray is desired). Unprinted newspaper, called whitewash, is often available from printers in whole or partial rolls.

Plastic. Since plastic is not absorbent, prior to rolling with it you must remove more glaze than usual from the surface. While working, turn and change the plastic frequently so that you do not redeposit glaze on the surface. The visual texture of a plastic-rolled glazed surface differs in scale, color, and pattern from that of a laid-on-plastic glazed surface (see page 88).

Chamois. When rolling chamois, first wet it with water and wring it out to make it absorbent. It will then produce a soft, diffused texture.

This detail of a glazed wall shows texture achieved with rag-rolling.

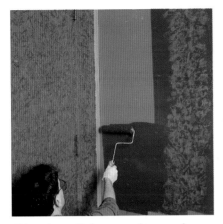

Glaze is applied next to the wet edge on the right side of the applier. Note the tape covering the dried glaze on the adjacent wall.

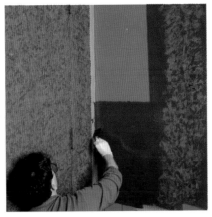

In the corner, next to the painters' tape, glaze is applied with a 1-inch (25 mm) foam brush.

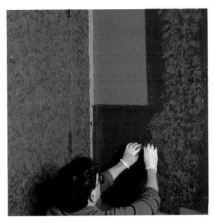

A crumpled piece of industrial "wipe" is rolled through the wet edge.

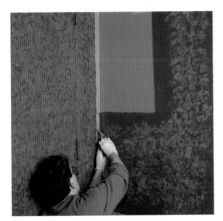

The wipe is carefully rolled down the surface in the corner.

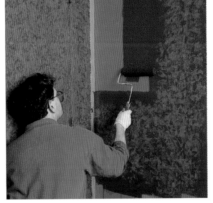

Glaze is applied adjacent to the wet edges on the right side, above the area already rolled.

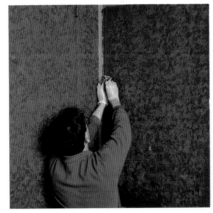

The wipe is rolled into the glaze at the corner with the same pressure as used in adjacent areas.

A rag-rolled floor. The herringbone blocks were painted on the floor prior to glazing.

STRIÉ

Strié, a French adjective meaning striated or scratched, is the general term now in use for glazing techniques that involve pulling a tool vertically through a wet glaze to create linear or graphic patterns. Traditionally, a dry brush has been used to produce soft vertical stripes, with the pressure of the bristles leaving an overall coating of thin stripes of light to dark value. In addition to these soft stripes, decorative painters now offer a whole range of sharp-edged patterns done with tools that scrape the glaze completely off the base coat, leaving straight or curved stripes, bands, and plaids. Traditional graining tools, such as steel and rubber combs, also make good strié tools. Strié textures have wide applications and may be done

- on an entire wall or floor;

- on part of a wall or floor as a border or inlay; and

- on architectural elements such as real or implied moldings, doors, panels, or columns.

When developing color relationships, keep in mind that soft strié textures mask the base coat, creating many variations of the base-coat and glaze-coat colors, while more hard-edged striés allow pure base coat to show through in the intervals between the stripes. By experimenting with both soft and hard-edged striés and using varying degrees of contrast between the base coat and glaze layer(s), you will discover a whole range of effects, from subtle to dramatic. For example, try a hard-edged strié with low-chroma colors of the same value to see how subtle a strong pattern may appear.

Some strié textures are done freehand, while others are most effective done with a guide stick. The choice depends on the type of tool used and the context. Soft textures are usually done freehand to foster a casual, natural look. On the other hand, guide sticks are almost always used when executing sharp-edged or graphic striés, except when curved, wavy, or deliberately misaligned stripes are part of the visual effect. There are enough slight, almost subliminal variations in pattern and depth of color in even a "perfect" strié to prevent an overly mechanical look.

TECHNIQUE

1. Apply a wide band of glaze to the full length of the surface (i.e., floor to ceiling). The width of the glaze will depend on its workability factor (see *Glazing Large Areas*, pages 82–84). (If you are glazing a horizontal strié, apply glaze in a wide horizontal band starting at the ceiling.)

2. Use cheesecloth to pat the glaze out slightly, leaving a wet edge (see page 82).

3. Starting at the top of the surface, pull the tool you have selected through the glaze to the bottom. (If you cannot make one continuous sweep, feather out the stroke as far below eye level as possible. Then start a stroke at the bottom and pull upwards, feathering out the stroke where the two strokes meet so that they interlace. Stagger the areas where the downward and upward strokes meet to prevent a horizontal line from forming.) If you need a ladder, set it up slightly to the left of the strip to be done (if you are right-handed), and walk slowly down the ladder as you drag the tool.

4. When you get close to the wet edge, apply a new vertical band of glaze, pat off any excess, and continue the strié.

Often, excess glaze collects where the wall meets a ceiling, floor, or horizontal molding. Clean, even edges can be achieved in two ways:

1. Pat off a little more glaze than usual along these edges before pulling the tool through the glaze.

2. Lightly drag a brush or other tool (such as a putty knife wrapped in cheesecloth) a few inches (about 7 cm) downward from the top edge and upward from the bottom edge before starting your full-length stroke.

With either method, be sure that the visual texture along the edges does not appear too different from the rest of the wall.

DRAGGING

Pulling a brush along a glaze, one of the softer glazing techniques, is called dragging. Dragged striés are commonly used on moldings and doors, both dimensional and trompe l'oeil, or as part of an entire dragged room.

The most popular brush for this technique is a long-bristled brush called a flogger or dragger. It is most effective when drawn down through the glaze in a position parallel to the glazed surface. Dragging can be done either with one hand alone or with your other hand pressing the brush bristles into the glaze; choose whichever method feels most comfortable and gives the desired results. Other tools that can be used for

dragging include house-painting brushes and wallpaper-smoothing brushes, used either as they are or with clumps of bristles cut out and the brush then covered with cheesecloth.

There are many possible variations of the basic dragging technique. The following were selected to give you ideas to explore:

Repetitive strié bands. Single or multiple bands of strié can be alternated with dabbed or textured bands to create a formal, rhythmic pattern. Another option is to alternate soft and graphic striés. Plan the pattern and intervals based on good design principles.

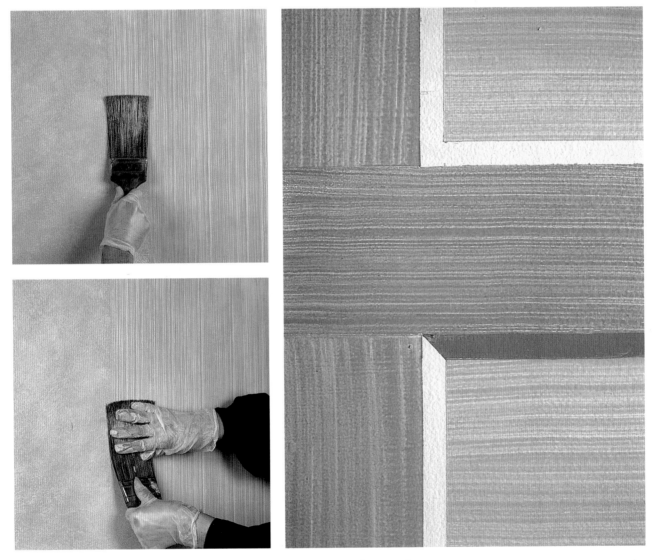

Soft striés can be done with one hand alone (as shown above, upper left), or with your other hand pressing the bristles into the glaze (above, lower left). The detail on the right shows trompe l'oeil panels rendered with dragged striés.

Slubbed silk. A stiff-bristled brush can be pulled very delicately across a soft strié texture that has not dried completely (has just lost its sheen) to simulate slubbed silk. This technique also can be used on more graphic striés when the glaze is wet to give "fuzzy" edges.

Basket weave. Creating small squares or rectangles with alternating direction gives a woven effect.

Interwoven color. Two or more glazes (e.g., light blue-purple and dark red-purple as in the photograph below) can be applied with cheesecloth and pulled through vertically several times with a dragging brush to create intermingled stripes. You can also pull through them horizontally. The same two glazes give a totally different effect when done on a different base coat (for example, red instead of white, as shown below). When a third glaze is added, the optical mix becomes even more complicated.

At right, two glazes (BM 829 and BM 1267 with black) have been applied with cheesecloth (1); dragged through vertically several times with a flogger (2); and dragged across with a flogger (3). At far right, the same two glazes on a different base coat (red [BM 1321] instead of white) give a totally different effect.

The addition of a third color (BM 1182) makes the optical mix even more complex.

HARD-EDGED STRIÉS

Hard-edged striés can be either random patterns, spaced stripes, or symmetrical or repetitive designs. The more sophisticated the pattern, the more planning is required (graph paper is useful for plotting patterns).

TOOLS

There are many tools that will produce a hard-edged strié pattern by completely removing glaze from the base coat. These tools can be made of rubber, heavy cardboard, plastic, or metal. The tool that removes glazes the most cleanly, can be cut into custom patterns, and has the longest durability is a squeegee (used for cleaning windows). It is usually used with a guide stick. (Tools such as bronze or steel wool, nylon stucco rollers, and synthetic sponges also scrape the glaze completely off the base coat; however, they produce such thin lines that the final appearance of the strié is fairly soft, similar to those obtained by dragging.)

Try to find squeegees that are put together with screws rather than rivets so that you can detach the blade. The rubber blade is easier to mark and cut when it is removed from the handle. In addition, you can attach a larger blade to a smaller handle without too much difficulty. Avoid squeegees that will bleed when exposed to glaze or solvent; our experience is that the red (pink) rubber squeegees are less likely to bleed than the black ones.

To cut the squeegee, first disassemble it and mark the rubber blade with your strié pattern. Next, place the blade on corrugated cardboard or another suitable cutting surface and cut the blade with a single-edged razor blade or mat knife. Most patterns can be cut with V-shaped notches. Remember that glaze remains on the surface where spaces are cut from the squeegee, while the "teeth" completely remove the glaze.

If the spaces to be cut out are very thin, or if you need more precise cutting, first cut straight back through the blade about ⅛ to 3/16 inches (3 to 5 mm) and then flex the blade to scoop out U-shaped notches.

After cutting the blade, flip it over before reassembling the squeegee. This places the cleaner edge against the surface, keeping to the back any "burrs" that would spoil the strié.

Guide sticks can be made from any smooth wood that will not warp and is free from imperfections that would cause the strié tool to jump. We use 1- to 2-inch (25 to 50 mm) #2 grade or select pine boards, cut the full length of the surface to allow a completely unbroken stroke. If you are glazing striés of different lengths, do

Profile of cut cardboard for strié-striped wall pattern.

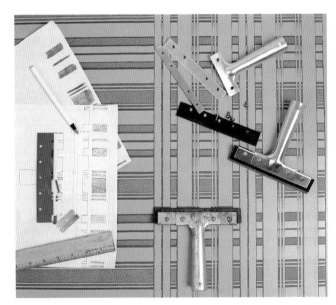

First, the pattern is sketched on graph paper, as shown to the left. The squeegee is then disassembled and the rubber blade marked and cut in the strié pattern.

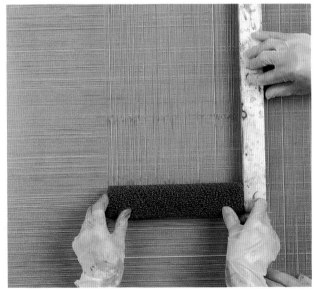

A nylon stucco roller being used to scrape off glaze. Note the knot in the guide stick, chosen to demonstrate how it throws off the pattern if it is on an edge.

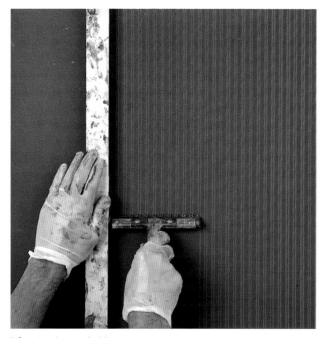

The squeegee is held against a guide stick and pulled vertically through the glaze. The base coat used here was BM 1321; the glaze, BM 623.

A custom-cut stencil and a cut squeegee can be used to render stripes above a diagonal skirting (staircase molding).

the longest first and then cut down the guide stick to fit the smaller surfaces. When there are no baseboards, cornices, or other moldings present, glue or tack ½-inch (13 mm) battens to both ends of the guide stick to keep it raised from the surface. You may also want to attach handles to the guide stick for easier handling.

Either of the following methods may be used to complete an entire wall. How the squeegee is cut will depend on which method is used.

Guide-stick placement based on the squeegee pattern. In this method the squeegee itself is used to align the guide stick. This is done by cutting the squeegee so that a tooth is on the edge facing the area you are heading toward and a space is on the edge against the completed work. The stripe from the tooth on the leading edge becomes a reference line for your next stroke. (A symmetrical pattern can be "shifted" on the squeegee to get a tooth on one edge and a space on the other.) An alternate method is to have a tooth on either end of your squeegee and overlap the resultant stripes.

Careful use of the squeegee for alignment can give fast, consistent striping without requiring you to measure the entire room. Since walls are usually not exactly vertical, hold a level against the guide stick for the first stroke, and as you work check occasionally with the level to make sure there has been no shift.

Guide-stick placement determined by measurement. Place tape on the baseboard and cornice moldings (or on the floor and ceiling if there are no moldings) and mark it for squeegee-width intervals. Use a level (or plumb line) to make sure that the top and bottom starting points line up exactly. This method does not require any special manner of cutting the squeegee.

TECHNIQUE

1. Roll on the glaze and pat off enough so that the opaque border lines that are formed by the squeegee displacing the glaze will remain thin. You will find that more glaze has to be removed for hard-edged striés than for a softer ones. Glaze removal is especially important with horizontal stripes to keep the pattern from sagging.

2. Align the guide stick with the vertical and pull the squeegee through the glaze from top to bottom, holding it at an angle of at least 45 degrees from the surface. If the guide stick is kept in exactly the same position, smudged areas can be pulled through again.

3. Continue across the surface, remembering always to wipe the squeegee before doing another stroke.

4. If any areas are unacceptable, reapply glaze to those areas and pull the squeegee through again.

If you are a right-handed person working alone on a short surface, you can hold the guide stick in your left hand and more across the surface from right to left. If someone else is holding the guide stick, you would probably want to work from left to right to keep out of each other's way. (Reverse directions if you are left-handed.) Horizontal stripes should be done from top to bottom; in wide rooms this often requires two people to hold the guide stick.

You will usually have a bit of wall narrower than the squeegee in corners or against obstacles such as windows, doors, or thermostats. Heavy cardboard can be cut in the same pattern as the squeegee to fit in these small areas. Alternatively, if your pattern has stripes of uniform width, you can reapply glaze to a little of the completed strié, creating a squeegee-width strip of glaze that goes right into the corner. If the pattern is made of tape-width stripes, use tape to reserve the base

coat in the corner. (Another use of tape is to reserve stripes at regular intervals that are different widths from the squeegee pattern. This has the added advantage of creating midwall stopping points.)

As with any removal method, touch-ups will be needed. Once glaze stripes are dry, you can correct flaws by applying glaze with a brush. For stripes that have not been scraped cleanly, try the following:

- If you notice this before moving the guide stick, try pulling the squeegee through a second time.

- If you notice a few imperfections while the glaze is still wet, you can carefully clean up lines with small absorbent tools such as cotton swabs, pastel stumps, or artists' brush handles wrapped in cheesecloth.

- If extensive touch-ups are needed, reapply glaze and pull the squeegee through again.

- After the glaze is dry, you can paint over it with the base-coat paint where necessary.

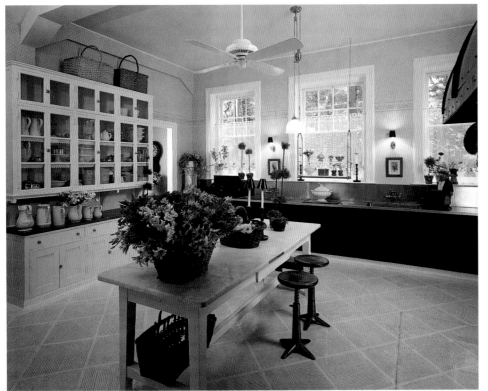

The subtle graphics of this floor pattern were achieved by rendering squares of hard-edged striés in alternating directions.

DIMENSIONAL SURFACES

It is difficult to do a strié into a nonperpendicular molding or ceiling, or on a diagonal, without "fudging" the edges (which is time-consuming and usually noticeable). The easiest solution is to incorporate a border into the design either by painting a strip of base coat along the edge of the surface after completing the strié or by masking off a border with tape prior to glazing.

PLAIDS

Plaids are simply two-directional stripes. A variety of patterns and color combinations are possible using either of two techniques:

1. You can pull the second direction through the glaze while the first direction is still wet. This increases the amount of exposed base coat, emphasizing the openings of the plaid.

2. You can overglaze (reapply glaze) after the first layer is dry and then pull your tool through in the second direction. This reduces the amount of visible base coat, emphasizing the lines of the plaid.

Either technique may be used; however, it is difficult to glaze large areas of plaids that are pulled through while wet without breaking up the surface into more manageable sections. Remember always to pat off more glaze than usual when doing any horizontal strié to minimize sagging.

If a plaid is done on a flat rather than the more usual sheened base coat, a "ghost" will often appear in the intersections of the removed stripes. This hint of glaze color adds interest and makes the plaid seem more complex than it actually is. The increased surface absorption that causes this phenomenon also dictates that only relatively small, taped-off areas be done at a time.

A symmetrical pattern can be "shifted" on the squeegee to get a tooth on one edge and a space on the other, as can be seen here. The plaid on the left was pulled through in two directions in a single application of glaze and appears lighter than the plaid on the right, which was done with two separate applications of glaze. The base coats used were BM 648; the glazes, BM 623.

When a flat base coat is used, ghosts of glaze color will often appear in the intersections of strié that are being pulled through in two directions, as seen here.

FREE-FORM PATTERNS

After working with stripes and plaids in our strié class, we give students 2-inch (5 cm) squares of cardboard and let them loose. This composite of spontaneously rendered studies photographed during class shows the ingenuity of our students. In every example glazes have been rolled on and the excess has been dabbed off.

(This is especially important when using a tool like cut oak tag that scrapes the glaze back to the base coat.) The opaque line of glaze that is pushed aside by the tool becomes an integral part of the design, often fostering dimension; however, this line can sag if it is too heavy.

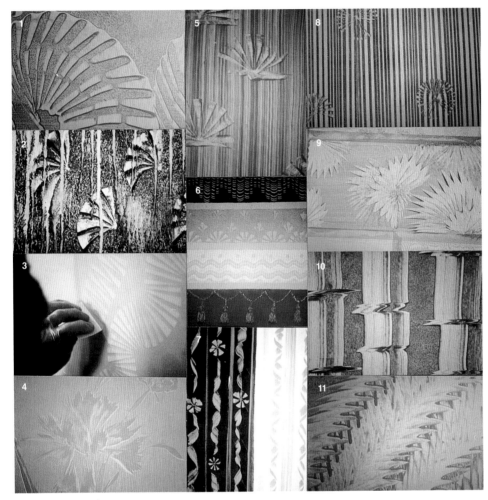

A cardboard tool was used to render a gently turned ribbon. The hand and wrist were held in the same position and moved, from the shoulder, so that the cardboard shifted gently sidewards and back to the center at the same time it traveled down the board. This action caused the white glaze to follow a consistent path of highlighting the edges and curves of the "ribbon."

1. A flexible oak tag was held in a curved position, pressed down, moved clockwise from a pivot point, and lifted.

2. Paint thinner was drizzled over a simpler version of example 1, opening up the glaze in rivulets.

3. The press-move-lift motion in process, using multiple pivot points to form curves.

4. Separate, slightly sawtooth-shaped markings form the petals of a flower similar to an iris.

5. The edge of a synthetic sponge was dragged vertically down the surface. Then, while the glaze was still workable, an oak tag was used to imprint a repetitive motif.

6. Border designs. From top to bottom: a squeegee was held vertically and pressed into the glaze; horizontal variations of examples 1, 2, and 5; cardboard was dragged through the glaze in a wavy pattern and a fingerprint was placed above each depression; the corner of an oak tag was used to create a rhythmic rendition of a chain of tassels.

7. Vertical renditions of the ribbon stroke (described above) and the press-move-lift motion of examples 1, 2, 5, and 6.

8. A similar pattern to example 5 with a squeegee dragged vertically first.

9. In this rendition, a darker glaze was used over a white base coat; the repetitive sawtooth motion has left consistent dark undersides on each "petal."

10. A notched oak tag card was dragged vertically; at intervals it was shifted sharply to the left and back again.

11. A continuous sawtooth motion alternating directions along a 45-degree axis.

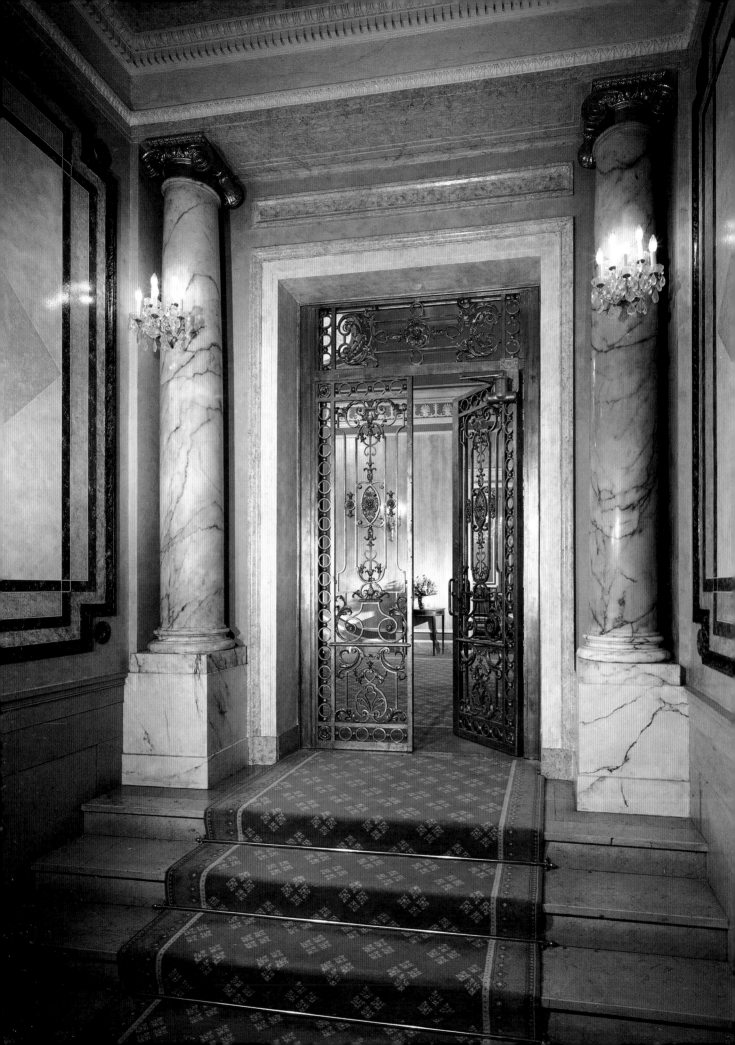

MARBLING

The qualities of translucence and easy manipulation that are inherent in glazing media and techniques create exciting effects when glaze is used to simulate marbles and stones. In some cases, all that is necessary to render a marble or stone is to manipulate the glaze in a specific direction. For example, the strié technique described on pages 95–97 can be used to produce the fine lines so characteristic of banded malachite, and strié and rag-rolling techniques can be combined to render travertines. Even the tools used in glazing—cheesecloth, crumpled paper and plastic, and synthetic sponges—are used to help create the surface patterns of marbles and stones. The main difference between glazing and marbling is that to simulate a real marble or stone in paint you must consider visual textures and realistic placement of the various masses, drifts, and lines (veins) of color. ❧ Rendering the unique patterns of specific marbles and stones requires first analyzing the real substance, then determining how to capture its unique characteristics by manipulating the media. This may require only one layer, or many. After analyzing and learning to replicate certain patterns—a specific type of vein or the way one color blends imperceptibly into another, for example—you will be able to use these patterns to produce other marbles and stones by changing color and scale.

The vestibule of the National Paint and Coatings Association headquarters, displaying eleven different painted marbles and gilding. The columns are real marble.

THE FORMATION AND REPLICATION OF STONE

Most rocks are either metamorphic (formed from recrystallized limestone), sedimentary (formed by the depositing in layers of water-borne decomposed material), or igneous (formed by the cooling of molten lava). Aside from semiprecious stones like malachite and porphyry, there are four major categories of ornamental rocks, classified according to their scientific origins, chemical compositions, and hardness:

Travertine. The travertines, whose name comes from the Travertine area of Italy, are sedimentary layers of limestone through which water has percolated, leaving bands of cavities throughout.

Stone. Ornamental rocks that cannot be polished are called stones. These include both hard rocks, such as shale and basalt, and soft rocks such as limestone.

Granite. Granites, made up of quartz, feldspar, and mica, are very hard, compacted igneous rock with visible crystals.

Marble. Marbles, the term commonly (and usually incorrectly) employed for most rocks, are smooth, close-grained, compact, crystalline calcium carbonate, made mainly of limestone of moderate hardness. They are capable of taking a high polish. While unpolished marble can be somewhat drab, polishing brings out dramatic colors and decorative patterns.

Limestone, in which most of the more common marbles are found, was formed millions of years ago from the calcium carbonate found in the bones and shells of tiny water animals such as oysters, clams, snails, and corals. When the animals died, waves broke up their bones and shells to make shellsand limestone. When this ordinary limestone changed to a mass of closely packed crystals, it became marble.

The most important distinguishing visual characteristics of these four categories of rock are color and surface pattern.

COLOR

Every hue in the visible spectrum is imparted to stones through a combination of the natural colors of minerals and the action of impurities and acids on them at any period in a particular stone's formation. Colors range from green from chromium, to red from iron oxide, to black from carbon. When a stone is structured of crystals of different minerals, infinitely intriguing color nuances appear. Mineral exhibitions at museums and trade shows can give you an idea of the enormous range of colorations the earth provides.

SURFACE PATTERN

Types of stone are distinguished by their surface patterns. For example, in granites separate units of color are seen as an all-over texture. Travertines show form and color as individual bands. Marbles appear in a wide range of patterns—from very smooth and even, to layered in strata, to composed of angular fragments (brecciated). This wide range of textures is caused by magma—hot gases and liquids locked in the hollow center of the earth that have exerted pressure against the mineral layers for millions of years, causing layers to shift, fracture, and fragment. Whatever formations of color existed in any location prior to movement of the earth—whether in bandings, stripes, or specks, for example—later turn into a specific stone different from any other. In certain cases the pressure of the magma was accompanied by such intense heat that the minerals were liquefied and ran together. Any defined boundaries that might have existed between the minerals were eliminated, and a fused blending of color was produced, subtle or dramatic according to the mineral colors involved. Minerals also run and seep into cracks and faults in stones to create patterns.

The individual coloration and structural composition of a stone occur throughout the entire stone, whether in small or enormous quantities. When the stone is cut, certain recognizable surface patterns appear. The angle of the cut—either along the direction of the flow of the minerals (called sawn with the bed) or perpendicular to the flow (called sawn across the bed)—determines the individual surface pattern even more.

The patterns created by the natural forces occurring in any given area over long periods of time are specific to that particular place. After the entire amount of any marble is quarried out, there is no more. Anyone wishing to use that marble must recycle previously used marbles—or replicate the marble in paint.

The variegated marbles (those with patches of diverse colors), the streaked marbles, and the breccias found in various locations around the world get their unique characteristics from the individual concentrations of minerals and the chemical phenomena that acted on them at a particular time and place.

Breccia marbles (termed *brèche* in French) are named for the Breccia region in Italy. These marbles are formed when streams of molten minerals that encompass and

carry along fragments broken off from other rocks harden within particular strata. Each type of breccia marble has its own character; for example, some breccia chunks are fairly rounded off at the corners (see *Rosso Verona*, pages 140–43), while others, like Verde Issorie (see pages 124–26), contain sharp-edged chunks. This is because the hardness of the chunks varies; softer, more brittle rocks tumbling against others would break easily, becoming more rounded than harder rocks.

The marbles with the greatest depth and translucence (mostly Italian marbles) derive this quality from the way that light penetrates through their uppermost translucent crystals and then reflects back the color from the deeper-lying crystals.

FINISHES

The appearance of both the color and the surface pattern of a marble may be manipulated by the choice of the final finishing process. Processes such as fine and rough scabbling, honing, sand-blasting, scorching, and hammering all provide a relatively grayed-down coloration. High polishing, on the other hand, brings out the most intense coloring possible for any given marble. To find out how strong the colors of a real unpolished marble will be when it is polished, apply water to it—the dull colors and often indistinguishable surface pattern will be revived by the change in light refracted from the wet surface.

The decorative painter can provide sheens in much the same range as that of the stone finisher: highly sheened (using many coats of finish, rubbed down), mildly sheened (using a coat of satin or flat finish), or matte (using no finish at all). Appropriate colors relative to each painted marble accompany each degree of sheen—a higher sheened marble has higher chroma (more intense colors) than the same marble would unpolished.

REALISTIC RENDERING

The following guidelines will help you keep renderings realistic when you are replicating marbles:

- If any shape, form, or line you have painted suggests something that can be given a name (e.g., a square, a triangle, antlers, a fish), it must be eliminated. Chopin's étude *Fantastic Impromptu* was spoiled for many as soon as the words "I'm forever blowing bubbles" were set to this piece of music.

- Avoid going into, coming out of, or cutting across corners. Because corners are so obvious, they are the refuge of the decorative painter who is short on style and long on clichés.

- Continually observe your rendering from a distance. Overly bright spots, heavily weighted areas, badly formed lines, and spotty masses of color leap out more from further away than they do at close range.

- One trick that fosters the illusion of a real surface is to give a sense of more beyond the actual edge of the rendition. This is accomplished by making sure that every line, mass, or color that is near any edge goes off the edge in its entire width. In other words, an ⅛-inch-wide (3-mm-wide) vein in a marble must be a full ⅛ inch (3 mm) as it exits off the end of the rendering. It also means that any line, mass, or color may enter into the rendering from an outer edge and trail off in the interior.

- Enhancing the illusion is achieved also when a line, mass, or color goes through, past, and around carvings and moldings rather than ending at an arras (sharp edge). As these lines, masses, or colors travel across depressions, take special care to insert them into the crevices.

Unpolished travertine

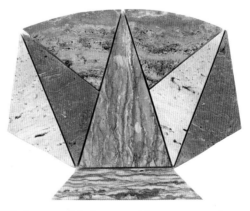

Wetting unpolished stones with water approximates the change in color from pale to rich that occurs after polishing.

MALACHITE

Malachite, a semiprecious stone of distinctive color and pattern, has been found in artifacts from earliest civilizations; pulverized it was even used as a pigment. Carbonate of copper is the basis for malachite's rich, saturated, blue-green color (the Italian name for malachite, *verdeazzuro*, actually means green-blue). A light value of this same blue-green makes up verdigris, the film seen on surfaces of objects containing copper that are exposed to carbon dioxide and water (bronze statues that are exposed to the elements, for example). Malachite is available as a solid or as slices of veneer. Solid pieces appear as carved objects, specimen chunks, and stones to be set in jewelry.

The pattern of malachite when it is cut appears as fine stripes of many widths, called banding, and as groups of full and partial circles and ovals, called nodules. Each sharply edged stripe is a separate horizontal layer laid down during the formation of malachite. In addition to bands and nodules, small dots of medium-value blue-green often appear on the surface of malachite, looking as if they had been sprinkled all the way along several of the lighter-colored bands.

We have found that malachite's botryoidal structure—the geological term for a formation that resembles a cluster of grapes—may be understood more easily if the structure is thought of as being clusters of eggs, not grapes. Then imagine these eggs cut across horizontally so that all of them reveal their yolks and surrounding white rims. Each would look somewhat different from the one next to it—much like the diversity you see when you cut actual hard-boiled eggs with an egg slicer.

A quite unique relationship exists between the nodules and the banding elements: the banding rarely

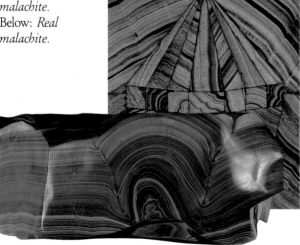

Right: *Painted malachite.*
Below: *Real malachite.*

touches the edges of the nodules. Each set of striped banding swings around the curves of the nodules as if being repelled by a magnet. This causes the banding to appear as partial arcs of a circle or oval. Arcs are directly related to nodules: arcs closest to the nodules exhibit tight curves; as the arcs get further away from the nodules they straighten out.

Where one arc meets another arc or straight banding, a change in direction occurs. The change in direction at that junction causes the most trouble for decorative painters. In the photograph below you can see exactly where the arcs and the banding meet. There is a slight V formation at this juncture. All the V's line up as if an imaginary straight line runs through the V formation. Where a V formation occurs on both sides of any one nodule, a wedge- or fan-shaped section of banding results.

Since the elements of nodules and arcs of striped bandings combine in an enormous variety of ways, the secret of rendering believable malachite is how clever you can be in designing a surface that displays the most interesting arcs and V formations.

After years of rendering malachite and teaching others to do so, we have determined that the removal method is far superior to the applied method in capturing the very precise repetition and exact spacing of malachite banding. No matter how skilled you might be in handling a brush in the applied manner, there is no way you can mimic the precision, crispness, and subtle value changes achievable when a removal method is used with skill and restraint. The removal method is particularly suited to rendering the V formations; it permits near perfect alignment of the V's. Unfortunately, too often the removal method is used with tools that produce not only a scale that is too broad but also a gross contrast between the base coat and the paint layer. Also, the manipulations are often too repetitive, unimaginative, and boring.

The one limit to using a removal method is that it does not enable you to make a full circle or oval. There is a noticeable line where the medium gathers when strokes come full circle. As a result, you must plan your design carefully so that arcs of banding in the major portions of your rendering leave a mere hint of the nodules from which the banding emanated.

The strength of color displayed in malachite may be obtained in three ways: (1) by using a base coat with a very strong chroma (the technique shown here); (2) by applying an appropriate tinted finish over the whole surface; or (3) by combining both of these options.

Blue-green sheened alkyd interior house paint

MEDIA

1. dark blue-green glaze: 10 parts C.P. green medium japan paint, 1 part lampblack japan paint, 1 part Prussian blue japan paint or artists' oil tube color, ½ part glaze medium, ½ part paint thinner (add more glaze medium and paint thinner as needed to allow the formula to respond to the technique)

2. shellac: 1 part three-pound cut shellac, 1 part denatured alcohol

3. gloss finish (paint-thinner- or water-soluble)

TOOLS

painters' tape

torn cardboard or other heavy paper (or a dry synthetic sponge)

¼- or ½-inch (6 or 12 mm) soft-bristled brush

wide flat palette

toothbrush

#0 artists' script liner brush

stump or wipe-out tool

base coat: BM 592 1. dark blue-green (formula above)

TECHNIQUE

Prior to Painting

1. Design your surface. Determine the direction and "cut" of the veneers or solid piece of malachite. Quick sketches will help you develop your design. Include sections that have

- directions that are slightly off-angle and not parallel to any edge;

- relatively few perfect arcs;

- uneven spacing of the arcs that succeed each other;

- arcs that curve off the edges so that partial curves of the nodules may be placed below the last arcs; and

- crossbanding (these areas are cut straight, and may be used in single sections or lined up to form a band of straight pieces. They are very effective and extremely easy to render).

2. Tape off alternate sections with painters' tape.

3. Prepare your removal tools. You will want them to be wide enough to cover the entire width of any area you will be traversing. If you are considering rendering a section of malachite that includes a juncture with a V joint, you will need a wider tool. Our favorite "tools" for rendering malachite are torn from cardboards of all kinds; for example, oak tags, the boxes of household products, and shirt cardboards. The fibers of paper products drag the paint off in much more subtle stripes than those achieved through the use of other hard-edged strié tools. Oak tags, in particular, are excellent for producing the very fine, varied spacing exactly in the scale of real malachite (try tearing in from the outer edges of the board). The next most acceptable tool is the sharp edge of a synthetic household sponge, although it does not produce the subtle variety seen when using the torn cardboard.

To decide whether a torn piece of cardboard will be appropriate, examine the rough, torn edge. If the edge looks relatively straight, it will yield interesting lines of varied widths. Avoid convex bulges and concave depressions. Where the torn edge exhibits deep depressions, the rendition will show totally solid stripes of dark green paint. Bulges of cardboard on the torn edge will scrape the paint off back to the base coat.

After a few tries, you will be able to relate the shape of the cardboard's edge to the striped pattern it produces. Sometimes, an adjustment as minor as tearing off a bit of the torn edge here and there is enough to produce just the results you are looking for—other times you will have to discard your "tool." Fortunately, it costs only pennies—if anything at all.

Applying the Figure Layer

1. Tape off the first piece to be done.

2. With the ¼- or ½-inch (6 or 12 mm) soft-bristled brush, paint on an even, but not excessive, amount of glaze. Bring the glaze over the edge of the tape to ensure that the malachite piece will completely fill the area and will appear as if it were cut from a larger piece.

3. Holding your cardboard tool at an angle so that the most absorbent edge is on the glaze, pull the tool toward you across the surface with even, moderate pressure. Overly firm pressure destroys any chance you

have to produce subtle distinctions in the quality of the lines.

4. Remove the tape as soon as you have finished with each section.

5. Tape off other sections and repeat steps 2 and 3 (tape may be placed on already done sections when the glaze is dry to the touch).

As you work, evaluate your rendering to be certain you have included a variety of characteristic curves. Try also to include a slight wavering here and there; this produces faint "fracture" lines, suggesting the crystalline structure of malachite.

After you complete each section, judge it for choice of direction, line quality, and craftsmanship. Look for crisp alignment of the junction where the lines from two directions meet. The painting and dragging processes are so easy and take so little time to do that you would be wise to wipe off any rendition that is not up to your standards and repeat the processes.

6. If you are pleased with all aspects of your rendering except for a possible skip in a line or too much glaze accumulation, "fudge" a solution by adding a line with the script liner brush or wiping out excess paint with a stump or wipe-out tool.

7. When the rendition is completed, let all the paint dry. Isolate the layer with shellac and let the shellac dry.

Applying Specks

1. Pour a small amount of the dark blue-green paint into the wide, flat palette.

2. Dip the toothbrush into the paint.

3. Holding the toothbrush about 6 inches (15 cm) above the surface, flick the bristles with your fingertip to produce the dark specks characteristic of malachite. (It often makes sense to spatter a newspaper first to assure that you have the correct density.)

4. With the stump or wipe-out tool, wipe spattered paint off of the dark bands (which do not have specks in real malachite) and off of any areas where you do not feel they look right.

5. With the script liner brush, add nodules underneath the lowest arc of several sections.

6. Let the paint dry and isolate the layer with shellac. Let the shellac dry.

7. Apply gloss finish and rub down to a fine furniture finish (see pages 46–47).

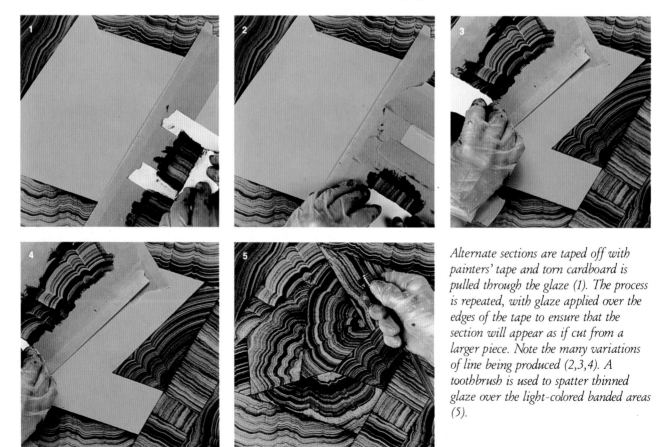

Alternate sections are taped off with painters' tape and torn cardboard is pulled through the glaze (1). The process is repeated, with glaze applied over the edges of the tape to ensure that the section will appear as if cut from a larger piece. Note the many variations of line being produced (2,3,4). A toothbrush is used to spatter thinned glaze over the light-colored banded areas (5).

TRAVERTINE

Travertine is a type of limestone found in caves and around springs. It is deposited over long periods of time in rather horizontal bands of water-soluble minerals that are carried up to the surface by hot springs that originate deep within the earth. The main deposits are often of a cream-colored calcium carbonate, with mineral banding running the gamut from almost equally pale to strong and vibrant. Travertines exhibit small openings or "pits" that are left from the evaporation of mineral-laden water.

Since the patterns in travertines are relatively straight in direction, the stone is useful from a design standpoint. Herringbone, chevron, and checkerboard patterns are common; any pattern is possible that makes use of straight pieces put together with joinery.

Whether the painted installation employs small units (e.g., 12-inch [30 cm] floor tiles) or large units (e.g., the 10-foot-high [3-meter-high] and 4- to 8-foot-wide [1¼- to 2½-meter-wide] panels we painted in the National Paint Coatings Association building in Washington, D.C.), the theory and methods of painting are the same (the scale, of course, will differ as will the tools and time-frame of the work). The unexpected benefit in rendering travertine on any surface is that it may be done area by area. Since travertine exhibits fairly separate horizontal strata, each may be painted and manipulated separately with no need to integrate paint at the same time as in a blended rendition.

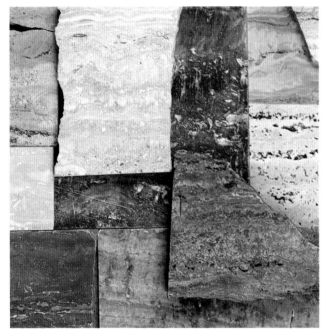

Real travertine

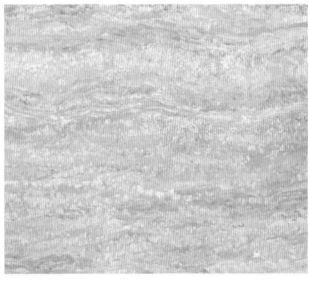

Painted travertine

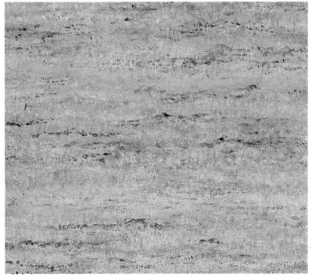

Painted travertine with pits

BASE COAT

Off-white sheened alkyd interior house paint

MEDIA

Note: Media should be slightly thicker when being applied to vertical surfaces.

1. medium tan alkyd glaze: 3 parts medium tan flat or sheened alkyd interior house paint, 1 part glaze medium, 1 part paint thinner

2. pale gray alkyd glaze: 3 parts pale gray flat or sheened alkyd interior house paint, 1 part glaze medium, 1 part paint thinner

3. beige-gray alkyd glaze: 3 parts beige-gray flat or sheened alkyd interior house paint, 1 part glaze medium, 1 part paint thinner

4. medium taupe-gray alkyd glaze: 3 parts medium taupe-gray flat or sheened alkyd interior house paint, 1 part glaze medium, 1 part paint thinner

5. sepia gouache (or other watercolor paint)

6. shellac: 1 part three-pound cut shellac, 1 part denatured alcohol

7. water

8. paint-thinner-soluble finish

TOOLS

¼-inch (6 mm) bristle brush

several #0 artists' script liner brushes

cut pieces of synthetic sponges, wet with water and wrung out

torn piece of natural sponge, wet with water and wrung out

newspaper

12-inch (30 cm) square of 1-mil plastic, crumpled

cotton swabs

cheesecloth (optional)

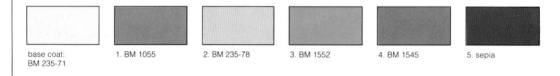

base coat: BM 235-71 | 1. BM 1055 | 2. BM 235-78 | 3. BM 1552 | 4. BM 1545 | 5. sepia

TECHNIQUE

Prior to Painting

Tear the newspaper into long strips and pleat them.

Figure Layer

1. With the ¼-inch (6 mm) bristle brush, apply the medium tan glaze in a rather wavering (although not repetitively patterned) horizontal line. According to the size of your surface, this line can be from 4 to 12 inches (10 to 30 cm) long.

2. Apply a second line of the same color glaze, in the same manner, slightly above or below the first line. Let this line overlap the first line in places. Avoid "basting-stitched" lines (lines that alternate with spaces).

3. While the glaze is still wet, use the script liner brush to apply the pale gray glaze above and/or below the first one in the same manner.

4. Apply the beige-gray and medium taupe-gray glazes in the same manner.

5. Drag the edge of a piece of synthetic sponge horizontally along the band of colors. To create the characteristic perpendicular markings, release your pressure here and there, twist your wrist occasionally, and hesitate in your stroke intermittently.

6. Continue to apply the four different glazes in irregular bands of color, trying to introduce as many different combinations as possible. The eye should not be able to notice any repetition in the sequence of stripes.

7. With a piece of natural sponge, push the painted colors upwards or downwards very slightly to simulate seepage. Do not push diagonally. The vertical movement of the sponge will pick up whatever colors are adjacent to each other in the horizontal bands and fuse them, creating fine horizontal lines of intermediate colors.

8. Dab crumpled plastic into the wet glazes to fragment the rows.

9. Press short strips of pleated newspaper into the glaze to create the appearance of sediment seepage. The strips may also be rolled along the adjacent horizontal band.

10. While the glaze is still wet, pull cotton swabs horizontally through some of the bands to open channels, and press the swabs into the paint along several bands to imprint circular and oval openings that allow the base coat to appear.

11. Study the rendition for repetitive stripes of color, an uninteresting overall aspect, or lack of relatively "calm" areas. If any of these appear, add more glaze and manipulate again. It might be necessary to first open up the texture by wiping out a few horizontal bands.

12. When you are pleased with your rendition, let the media dry and isolate it with shellac. Let the shellac dry.

Creating the Pits

1. With a brush, sponge, or cheesecloth, lay a swath of water along a short section of a horizontal band.

2. While the surface is still wet, add small amounts of sepia gouache into the water with a script liner brush. The paint will clump together, creating irregular markings that simulate the pits found in travertine.

3. If any paint mars your rendering (for example, lines that are too straight or long or run vertically), remove it with a cotton swab. Let the paint dry.

4. Apply paint-thinner-soluble finish coat(s) as desired. (Note: If you are using a water-soluble finish, you must isolate this layer with shellac before applying the finish coats or the water-soluble pits will disappear.)

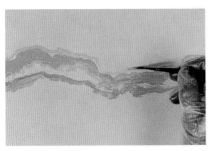

The first lines of the rendering are applied with a brush.

The sharp edge of a piece of synthetic sponge is dragged along the band of colors.

A piece of natural sponge is pushed upwards or downwards very slightly to simulate seepage.

Crumpled plastic is dabbed into the glazes.

Short pieces of pleated newspaper are pressed horizontally into the glaze.

A synthetic sponge is pulled through the glaze again.

Cotton swabs are pressed into the glaze to create oval depressions and dragged along the bands to open channels.

Sepia gouache is added into a swath of water.

The gouache is reduced with cotton swabs to form well-shaped pits.

UNPOLISHED STONE

Unpolished stone has been one of the longest and most universally used building materials. While marble deposits may be remote, and quarrying and transportation expensive, unpolished stone is usually inexpensive and readily accessible in most areas. Architecturally, stone has been used both in its natural shapes and cut into blocks that are fit together precisely. Painted stone also has been popular for many years as demonstrated by the wide use of painted Caen stone and many others for over a century.

The rendering of many types of unpolished stones, each having visual texture, is much more effective than its easy and fast removal techniques would seem to indicate. Visual effects differ according to whether a sheened or flat base coat is used, with less contrast seen on the flat base coat. Finish coats enrich a stone's colors, but may detract from any desired worn effects that matte finishes will provide.

BASE COAT

White flat or sheened alkyd interior house paint

MEDIA

1. beige-gray glaze: 1 part beige-gray flat or sheened alkyd interior house paint, 1 part glaze medium, 1 part paint thinner (add more paint if a more opaque medium is desired)

2. matte finish (optional)

TOOLS

tape (optional)

foam brush or roller

newspaper (or other absorbent paper or nonabsorbent plastic; different materials give different stonelike textures)

#2 artists' script liner brush

pink rubber eraser (optional)

base coat: white 1. BM 1552

Nine different stonelike textures, all using the same base coat and glaze color combination in a single layer. The base coat is an off-white sheened alkyd (BM 235-71); the glaze a light terra-cotta alkyd glaze (BM 1182). Additional layers would make the effects more complex; light-colored overglazes would lessen the contrast and create more subtlety, for example.

The various effects were produced by laying the following materials on the surface after the glaze was applied:

1. two sheets of photocopy paper, each laid on once

2. one sheet of photocopy paper, laid on once

3. a piece of oak tag, laid on once

4. a piece of a paper bag, laid on once, followed by a piece of chamois, laid on once

5. a piece of a paper bag, laid on once with light pressure over a heavy application of glaze

6. a piece of a paper bag, laid on once with heavy pressure over a light application of glaze

7. a sheet of tissue paper, laid on once, followed by a piece of paper bag, laid on once

8. a sheet of tissue paper, laid on twice

9. a sheet of tissue paper, laid on once, followed by a sheet of 1-mil plastic, laid on once

TECHNIQUE

Achieving Overall Texture

1. (Optional) Tape off surface into blocks (see pages 38–39).

2. Apply the beige-gray glaze with a foam brush or roller.

3. Lay a sheet of newspaper large enough to cover the size of one or more units *lightly* on the surface with the fold on top. Let your fingers and palm(s) play over the surface, using pressure varying from light to heavier. Some newspapers leave gray smudges more than others; this can sometimes be an advantage—providing another mineral color without demanding any effort.

4. Peel off the paper.

5. After several units have been rendered, look at the surface to see how much solid glaze remains. You want a visual effect that displays both solid and textured

areas. If necessary, reapply the newspaper, manipulate it again, and remove it.

6. Repeat steps 2 through 4 on the remaining blocks.

Refining the Texture

1. With the script liner brush and the beige-gray glaze, fill in sections that do not reach the edge of the unit, have uncharacteristic markings (such as lines that are too straight or shapes that are out of scale or evoke images), or could not be taken for stone.

2. Let the glaze set up (its sheen becomes matte).

3. (Optional) Create additional visual texture in any areas you desire by pulling the corner of a pink rubber eraser downward slowly through the glaze with hard pressure to produce more interesting areas in the stone.

4. Let the glaze dry.

5. Leave the surface as is or apply matte finish coat(s).

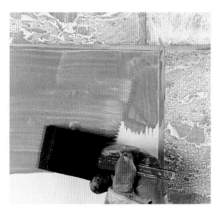

Glaze is applied with a foam brush.

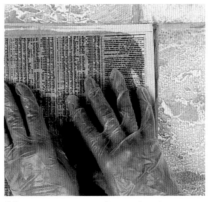

Newspaper is pressed into the glaze to create texture.

The effect seen after the paper has been peeled off the surface.

Detail of an architrave rendered as unpolished stone.

ALTERNATE TECHNIQUE

A different removal technique can be used to produce another stonelike texture. This effect can be either realistically rendered, with varied colors and interesting textures, or more stylized. The shape of the stones can be either round and pebblelike or more angular.

BASE COAT

Off-white sheened alkyd interior house paint

MEDIA

1. beige-gray glaze: 1 part beige-gray flat or sheened alkyd interior house paint, 1 part glaze medium, 1 part paint thinner

2. matte finish (optional)

TOOLS

foam brush or roller

12-inch (30 cm) square of 1-mil plastic, crumpled

chamois (wet with water and wrung out)

base coat:
BM 235-71

1. BM 1552

TECHNIQUE

1. Apply glaze over the entire surface with a foam brush or roller.

2. Roll and/or dab the plastic on the surface to break up the glaze.

3. Form the damp chamois into shone-shaped wads, then press and twist the wads into the textured glaze to remove individual stone shapes. Aim for varied sizes and random patterns.

4. Let the media dry.

5. Leave as is or apply matte finish coat(s).

Chamois wads are pressed into textured glaze to achieve a stonelike rendering.

Stonelike renderings gracing a kitchen.

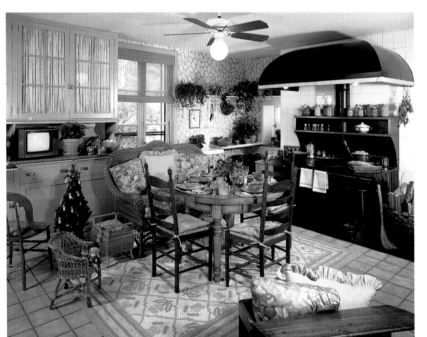

GRANITE

Granite is an igneous stone; that is, a stone formed from the hardening of molten lava. Formed from 280 to 360 million years ago, granite is harder than marble.

The variety in colors, scale, and auxiliary brecciated chunks, mica, and other mineral elements seen in granite is rather surprising. The sizes of the infusions of mineral in various granites range from that of a grain of rice through breccia-type chunks about 1 to 2 inches (2½ to 5 cm) in diameter. In some granites, like Cold

Spring granite from Michigan, the breccia chunks are accompanied by swaths of mineral matter that color areas adjacent to the chunks. The entire color spectrum, with the possible exception of a true purple, is represented in granite. The optical mixes exhibited range from quite bland, pale, and small-scale all the way to very dramatic, dark, and large-scale.

Granite is best rendered with applied methods, using suitable pieces of marine sponges.

Real granite

Painted granite

Base Coat

White sheened alkyd interior house paint

Media

1. black glaze: 3 parts black flat or sheened latex interior house paint, 2 parts latex glaze medium, ⅛ part water

2. dark gray glaze: 3 parts dark gray flat or sheened latex interior house paint, 2 parts latex glaze medium, ⅛ part water

3. light gray glaze: 3 parts light gray flat or sheened latex interior house paint, 2 parts latex glaze medium, ⅛ part water

4. terra-cotta glaze: 3 parts terra-cotta flat or sheened latex interior house paint, 2 parts latex glaze medium, ⅛ part water

5. paint-thinner- or water-soluble finish (optional)

Tools

tape (optional)

pieces torn from marine sponges (Test the pattern of the sponge on paper prior to use. Look for patterns closest to those on the variety of granite you are replicating.)

three wide rimmed palettes

many sheets of newspaper

cotton swabs (optional)

1-inch (25 mm) foam or bristle brush

several #0 artists' script liner brushes

cheesecloth

¼-inch (6 mm) soft-bristled brush

base coat: white 1. black 2. BM 1615

3. BM 1558 4. BM 1301

TECHNIQUE

Creating Texture

1. (Optional) Tape off the granite piece that you will be rendering. (Granite is especially effective used as borders or inlay.)

2. Pour a small amount of each glaze into separate flat palettes.

3. Press the rounded edge (the one with the "prickly" ends) of a separate whole or cut marine sponge into each color. Pick up very little paint and off-load the excess onto the sheets of newspaper so that the sponge will print clean clusters of color.

4. Apply paint to the surface with the sponges in the order, and with as much or as little coverage, as desired. Aim for uneven, nonrepetitive color distribution. The most predominant color desired should be applied last, with the exception of black, which should be applied early to add a sparkle to the rendering. The secret of good work is to be sure that the edges and corners of your surface are totally covered, with no gaps.

5. With the script liner brush, touch in paint in spots adjacent to any edge where the base coat shows. This is especially important where tapes are used to reserve an inlay within the granite rendition. Although it can be very tedious to find every bit of uncovered base coat along every edge, your rendition will suffer if you allow some to get away.

6. Let the media dry and isolate the layer with shellac. Let the shellac dry.

Applying and Wiping out the Black Overglaze

1. With the foam or bristle brush apply the black glaze to the surface.

2. Dab lightly with cheesecloth to remove any excess glaze.

3. With a cotton swab or a finger wrapped in cheesecloth, wipe small random chunks out of the black glaze, revealing the first layer. Light areas should predominate slightly.

4. Let the media dry and isolate the layer with shellac. Let the shellac dry. (This step could be your last, if preferred.)

(Optional) Applying the Terra-cotta Formations

1. With the tip and side of a ¼-inch (6 mm) soft-bristled brush, apply the terra-cotta glaze in random patches, mainly over the lighter areas. Allow many darker areas to show between the patches.

2. Dab the surface with cheesecloth to soften any harsh edges of color and to reduce the opacity of the glaze, creating varied intermediate values and chromas of the different hues.

3. If too much terra-cotta glaze has been removed for good contrast, apply additional amounts of terra-cotta glaze with the ¼-inch (6 mm) soft-bristled brush.

4. Let the media dry and apply finish coat(s) as desired.

Note: The many variations of granite may call for combining different techniques in the same renderings, such as texturing done prior to sponging, complete or partial overglazing, and mixing blended and crisp areas.

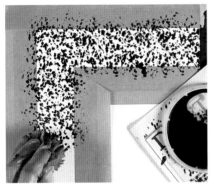

Black latex glaze is applied with a sponge.

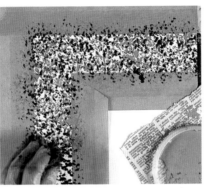

Dark gray latex glaze is applied with a sponge over the black glaze.

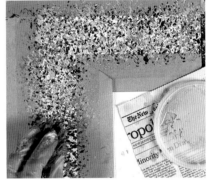

Light gray latex glaze is applied next.

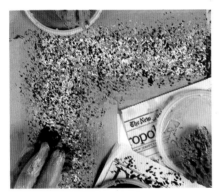

Another layer of black latex glaze is then applied.

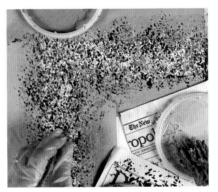

Spots of glaze are added to exposed areas at the edge of the tape.

A black overglaze is applied and then rubbed off in areas with cheesecloth.

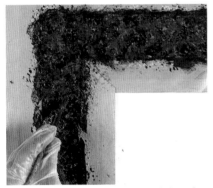

Terra-cotta formations are added with a script liner brush.

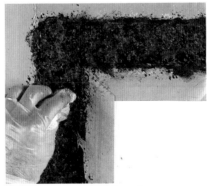

Cheesecloth is dabbed on the terra-cotta formations to soften them.

RASOTICA

Rasotica marble is a crinoidal marble from Yugoslavia containing varied sizes of mostly oval shell fossils suspended in black and brown-gray minerals. The black, which is carbon, adds the sparkle that appears in almost all marbles. Recognizable shell fossils exhibiting strong contrast with the surrounding texture are densely massed in some areas and less so in others. The marble also includes varied areas of broken shell pieces, providing closer color and value contrast and more restful areas visually. The dimensional quality of many of the shells may be seen by analyzing where the lightest sections of the fossils are found. For example, where the fossil shells are closest to the top surface, the lightest colors appear; as the shell pieces curve downward, the colors become darker, reaching the darkest values where there are deep recessions.

In rendering this marble, it is important to pay attention to the shape and scale of the fossils. Rendering perfect whole shell shapes lends an unrealistic appearance, as does including shapes that are too round or too large. Emphasize parts of shells and clusters of broken fragments. This combination of recognizable oyster-type sea creatures and broken bits of their white shells interspersed among black and brown-gray minerals gives this marble an appearance that can be simulated quite comfortably using removal methods.

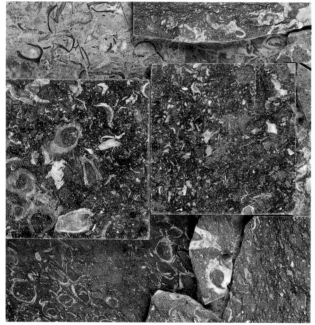

Real Rasotica

Painted Rasotica

BASE COAT

Off-white sheened alkyd interior house paint

MEDIA

1. black glaze: 2 parts black flat or sheened alkyd interior house paint or japan paint, 1 part glaze medium, 1 part paint thinner

2. medium dark brown glaze: 3 parts medium dark brown flat or sheened alkyd interior house paint or japan paint, 2 parts glaze medium, 1 part paint thinner

3. special walnut penetrating stain with black paint: 3 parts special walnut penetrating strain, 1 part black alkyd or japan paint

4. paint thinner (optional)

5. 1-1 mixture: 1 part glaze medium, 1 part paint thinner

6. shellac: 1 part three-pound cut shellac, 1 part denatured alcohol

7. paint-thinner-soluble finish

TOOLS

potatoes (the smaller and thinner the better)

corn plasters (optional)

sharp knife

scissors (optional)

1-inch (25 mm) foam or bristle brush

newspaper

rimmed flat palette

eraser or wipe-out tool

cotton swabs

toothbrush

#0 artists' script liner brush

paper napkins

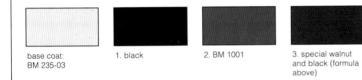

base coat: BM 235-03 | 1. black | 2. BM 1001 | 3. special walnut and black (formula above)

TECHNIQUE

Prior to Painting

1. Slice the potatoes into ½-inch (12 mm) slices. If the diameter of any slice is wider than 1¼ inches (30 mm), cut across it diagonally to make two smaller-sized slices. Your longest "fossil shell" should not exceed this size unless your rendition will be viewed from a distance, in which case your scale may be enlarged very slightly.

2. Trim the outer edges of the potato slices into roughly oval shapes, varying their shapes and sizes. Cut these outer edges into ruffles similar to those on oyster shells. Cut off, and cut into, these fossil shapes in random places to give them realistic-looking breaks and fractures. Amass enough different potato slices so that you have variety from which to choose for any area. Make sure that the face of the potato tool is flat or it will not lift off the glaze evenly.

3. Carefully use the knife to scoop out off-center depressions in the flat side of the potatoes.

Note: Corn plasters may also be used as removal tools. They should be trimmed into fossil shapes with a knife or scissors.

Shell-shaped tools are cut from potatoes.

Creating Overall Texture

1. With the foam or bristle brush, coat the surface with a layer of the black glaze.

2. While the glaze is still wet, lay sheets of newspaper on the surface and press it with your fingers to fragment the glaze (see *Unpolished Stone*, page 111). Err on the side of lifting off too much glaze rather than too little. You are looking for many shades of gray and a little bit of the off-white base coat, with enough black to lend depth. More black paint can be added later where needed to clarify shapes and provide contrast.

3. Press and twist the flat side of the potato tools firmly onto the surface, lifting more of the first-layer black glaze and revealing more shades of gray and a little of the off-white base coat. Continue this process, remembering to turn the tools and vary their placement so that a random nonrepetitive conglomeration of whole and broken seashell fossils is created in many values of off-white through gray. Clustering your placement here and there will allow you to give the illusion that many broken shells are lying in one area.

4. If the glaze becomes too dry to lift with the potato tool, pour a very small amount of paint thinner into a flat palette and dip a potato tool into it; then press the tool onto the surface. This not only will remove paint in a fossil shape but will also provide more areas of base coat that you will be able to turn into interesting masses of broken shells.

5. Dip an eraser, wipe-out tool, or cotton swab into the 1-1 mixture and press the tool into the textured areas to lift off more glaze, giving the illusion that broken fragments have accumulated there.

6. Wherever you want more dark contrast, add small amounts of black glaze with the script liner brush. Before leaving this stage, look at the rendition carefully to check

- that there are more gray areas than white and black ones;

- that fragments are visible among the more complete fossil shapes;

- that shell shapes are placed diagonally and horizontally, not vertically;

- that individual shells exhibit random portions of off-white base coat;

- that there are areas of relative "calm" (particularly on larger renderings, these portions should have few fossils and less color and textured contrast than the more dramatic areas).

7. Let the media dry and isolate the layer with shellac. Let the shellac dry.

Adding Dimension to the Shells

1. Some of the shells on the real marble exhibit definite depressions, as if you could poke your finger through them. These shells obviously had a cuplike opening in them. To convey this illusion of dimension, use the script liner brush to paint the medium dark brown glaze on the shell, leaving a thin border of lighter color along one edge. Let the media dry.

2. Isolate the layer with shellac. Let the shellac dry.

Toning Layer

1. With a foam brush, apply the special walnut penetrating stain with black paint over the entire surface, scrubbing it in so that there is very little excess.

2. Press paper napkins or other absorbent paper into the stain to remove some of it both over the fossils and elsewhere. You want the rendition to have asymmetric color placement with all-over color distribution; color contrast lending a sparkle to the rendition; and relatively "calm" areas of color and texture. When you are satisfied with your rendition, let the media dry.

3. Isolate the layer with shellac. Let the shellac dry.

4. Apply paint-thinner-soluble finish coat(s) as desired.

The surface is coated with a layer of black glaze.

Newspaper is pressed onto the surface to lift and texture the still-wet glaze.

The newspaper is removed to reveal a stonelike texture.

The flat side of the potato tools are pressed and twisted on the surface, removing more of the glaze.

If the glaze is too dry to remove, the potato tool is wet with paint thinner and then pressed on the surface.

A cotton swab is dipped in 1-1 mixture and then pressed into areas to lift off more glaze.

Black glaze is touched in with a brush to add contrast.

Medium dark brown pockets of color are applied to create the appearance of depressions.

After the surface has been shellacked, toning stain is rubbed over it with cheesecloth.

SERPENTINE MARBLES

The mineral serpentine supplies the name for a whole class of hard green marbles, which, with few exceptions, includes most of the marbles with the term *verde* or *vert* (Italian and French for green) as part of their names. There is a wide diversity of appearance in the serpentine marbles. They display varying amounts of many values of a nonyellow green, along with black and white, according to the specific type of marble. For example, Verde Aver is predominantly lighter green with white veins and very little black, while Verde Issorie has small to large black chunks interspersed in a medium to dark green. Still other serpentine marbles, such as Tinos Green, exhibit as their most prominent feature a webbing or lacelike network through which dark areas of many different sizes appear.

We have included Red Levanto in the serpentine category because, although it is not a true serpentine, it contains the serpentine mineral. In addition, the visual appearance and technique are similar to Tinos Green.

Many of the serpentine marbles can be rendered with the same base coat and media. We prefer to use flat black alkyd or japan paint for base coats (except for Verde Antico) because these paints are deep and rich. Latex black paints often appear as a cold, charcoal gray. While latex paint, alkyd paint, or japan paint could be used to render serpentine marbles, we recommend the media that we use in our school: casein, tempera, and gouache. We use these paints because they are easy to thin to a watery translucent quality; they dry quickly, which helps keep textures from becoming too homogeneous and also allows us to shellac them quickly to see how the texture is developing; and they enable textures to be "opened up" easily if they become too dense, even after they have dried. In addition, sponges used with this media can be cleaned in water easily and frequently.

There are two disadvantages to this media: (1) it may be difficult to obtain in some areas, and (2) in contrast to house paints, the colors have to be mixed. For these reasons, many of our students have used latex or alkyd paints instead—with excellent results.

The key to success with serpentine marbles is to use media thinned to a consistency not much thicker than water. To test for proper consistency, wet a flat synthetic sponge with water and wring it out well (we call this a water-wet-wrung-out sponge), then dip it into the paint. The consistency is correct if the paint soaks into the sponge and the holes then quickly reappear; this will enable you to produce clear impressions. Medium that is too thick (which is the usual consistency problem) lies on the surface of the sponge without being absorbed and produces blurred, messy patterns. Media that is too thin will be too translucent to show adequate contrast with the base coat.

Painted Red Levanto attracts the eye to this fireplace. Although not a true serpentine marble, Red Levanto contains the mineral serpentine and is rendered similarly to Tinos Green.

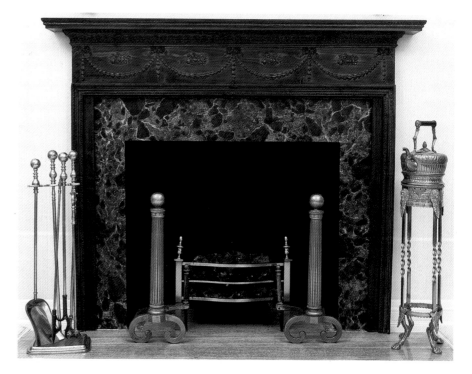

VERDE AVER

Verde Aver is a close-grained serpentine marble that shows very little carbon black and that has diagonal drifts of white flowing across it. It comes from a different area of the same quarry as Verde Issorie. Verde Aver is the lightest in color of all the serpentine marbles. The visual texture of the greens appears to be rather subtle, yet the surface sparkles because of the lighter values mixed in with them.

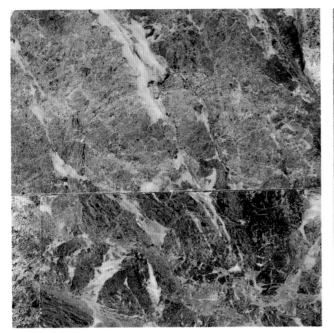

Real Verde Aver

Painted Verde Aver

BASE COAT

Black japan paint or flat alkyd interior house paint

MEDIA

1. dark green paint: 5 parts Prussian green designers' color tempera, 1 part raw sienna gouache, ¼ part black gouache (or 7 parts Prussian blue gouache, 4 parts raw sienna gouache, ¼ part black gouache)

2. medium green paint: 15 parts white casein, 1 part dark green paint (5 parts Prussian green designers' color tempera, 1 part raw sienna gouache, ¼ part black gouache, or 7 parts Prussian blue gouache, 4 parts raw sienna gouache, ¼ part black gouache)

3. white casein, thinned with water to a watery consistency

4. shellac: 1 part three-pound cut shellac, 1 part denatured alcohol

5. paint-thinner- or water-soluble finish

TOOLS

four wide rimmed palettes

several flat synthetic sponges, wet with water and wrung out (select sponges with the widest variety of sizes of oval openings)

several #0 artists' script liner brushes

cotton swab

base coat: black

1. dark green
(formula above)

2. medium green
(formula above)

3. white

TECHNIQUE

Applying Overall Texture

1. Pour the dark green, medium green, and white paints into three separate rimmed palettes (old china plates, paper plates, or wide plastic-container lids will do).

2. Dip separate water-wet-wrung-out flat synthetic sponges into the dark green, medium green, and white paints.

3. Print with the sponges over the entire surface, allowing all three colors to blend into each other. You are aiming for a random, textured effect. As you print with the sponges, be alert to what is happening on the surface. Avoid the following effects:

Even-sized (almost ⅛-inch [3 mm]) dots of each of the colors. This speckled effect makes the rendering look more like granite than marble. (To correct this problem, tilt the sponge so that only one corner of the flat side of the sponge touches the surface. Adjust the paint by dabbing with a very delicate touch to break up the harsh outlines. Stay in one area only long enough to soften and blend the paints, but not so long that the colors lose all distinction.)

An almost totally flat, even, middle green color. This happens when more dabbing is done than necessary, mixing the two greens and the white into one homogeneous color. (To correct this problem, add more dark green paint to the surface. While the paint is still wet, dip a sponge into the white paint and apply it directly on top of the green paint. The two colors will blend together. Very slightly adjust the "mix" with delicate touches and move on to another area. After the initial application of the medium green paint, avoid using medium green again; use only the dark green and white paints.)

An overall lacy effect. This happens when the dark green paint is allowed to become too dry before the white paint is applied on top of it. Instead of fusing and blending with the green paints in an interesting way, the white paint forms an overly dominant mesh layer. (To correct this problem, add more dark green. Then while it is wet, add white and remanipulate.)

4. When satisfied with your final effect (be careful not to overdo your sponging), let the surface dry and isolate it with shellac. Let the shellac dry.

Painting Mineral Deposits

1. Look for places where spurts of white paint appear on the surface. To assure that the mineral deposits you will be rendering appear realistic, you will want to add them so they appear to flow naturally from these stronger, more opaque white areas.

2. Dip a script liner brush in water and run it across the surface, leading from the white areas. (If you are using paint-thinner-soluble paint, use paint thinner instead of water.)

3. Immediately add white paint to the water by dipping a script liner brush into the white paint and then placing the brush in the water with the bristles along their long side. Do *not* apply the paint from the tip of the brush. As you apply the paint, twirl the handle of the brush slightly—this helps prevent "straight-arrow" lines that make the rendering look unnatural. You are aiming for driftlike areas that are up to 4 inches (10 cm) long and 1 inch (2½ cm) wide, with varying opacity.

4. With a cotton swab, pick up the sharp edge of paint along one side, allowing the colors to feather into the surface. This makes the newly applied painted drifts part of your rendition.

5. Add nonrepetitive versions of these drifts where desired.

6. Let the paint dry.

7. Add paint-thinner-soluble finish coat(s) as desired.

(Note: If you are using a water-soluble finish, you must first isolate the final layer with shellac.)

Avoid these effects: Equal-sized dots of each of the colors (1); an almost totally flat, even middle-green color (2); an all-over lacy effect (3).

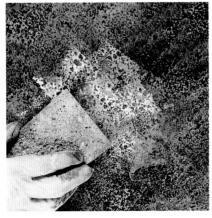

The paints are printed on the surface with synthetic sponges.

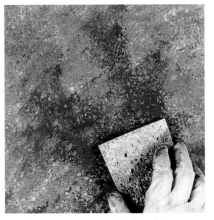

Dark green paint is added to bring more contrast to the rendering.

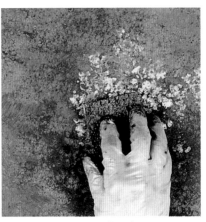

White paint is applied with a sponge directly over the wet green paint.

If the dots are too even, the paints can be delicately adjusted with a sponge.

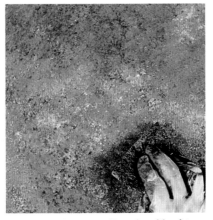

All three colors are allowed to blend into each other.

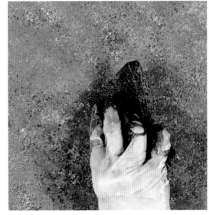

Harsh outlines are broken up by very lightly dabbing the paint with a sponge.

The paints are softened and blended.

White paint is applied into a swath of water from a small artists' brush held with its bristles parallel to the surface.

A cotton swab is used to reduce the white paint and feather the colors into the surface.

VERDE ISSORIE

Verde Issorie, a serpentine marble from Issorie, Italy, has been a popular marble for centuries, used on columns, fireplaces, tabletops, and floors. One type of Verde Issorie, which is no longer quarried, exhibits small to very large chunks that range in color from off-white through green to black and near-black; no veins appear (the Farnese table, a sixteenth-century table now at the Metropolitan Museum of Art in New York City is

bordered around its 12½-foot [3⅘-meter] length with this marble). In contrast, more modern Verde Issorie displays only small to medium-sized chunks of near-black and black, accompanied by mostly short white veins, scattered randomly over the surface, but all running in the same direction. The chunks in both marbles are surrounded by medium green, throughout which small black fragments are dispersed.

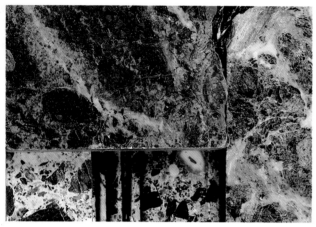

Real Verde Issorie

Painted Verde Issorie

BASE COAT

Black japan paint or flat alkyd interior house paint

MEDIA

1. dark green paint: 5 parts Prussian green designers' color tempera, 1 part raw sienna gouache, ¼ part black gouache (or 7 parts Prussian blue gouache, 4 parts raw sienna gouache, ¼ part black gouache)

2. medium green paint: 15 parts white casein, 1 part dark green paint (5 parts Prussian green designers' color tempera, 1 part raw sienna gouache, ¼ part black gouache, or 7 parts Prussian blue gouache, 4 parts raw sienna gouache, ¼ part black gouache)

3. white casein, thinned with water to a watery consistency

4. shellac: 1 part three-pound cut shellac, 1 part denatured alcohol

5. paint-thinner-soluble finish

TOOLS

low container for water

paper from sterile cotton roll (or other absorbent paper)

dental tool (optional)

paper napkins (or other absorbent paper)

four wide rimmed palettes

several flat synthetic sponges, wet with water and wrung out

several #0 artists' script liner brushes

base coat: black	1. dark green (formula above)	2. medium green (formula above)	3. white

TECHNIQUE

Prior to Painting

1. Fill the low container with water.

2. Tear the cotton-roll paper into breccia-shaped pieces. These pieces should be angular, with no convex or concave curves, and should vary in size from ½ inch to 2 inches (12 to 50 mm). The shapes should be irregular and nonrepetitive; they should not be recognizable geometric forms. Think of irregular pentagons rather than equilateral or elongated isosceles triangles.

3. If the surface you are painting is horizontal, place the papers on the surface to plan your design. (The design for vertical surfaces may be worked out on a horizontal sample board.) Arrange the papers in randomly scattered clusters, leaving wedge-shaped negative spaces between any two or more shapes. If you see a repetitive pattern, move the offending papers to more random positions. Since there are relatively few chunks in this marble, monitor the placement of the paper reserves carefully to project a well-balanced design. For example, do not place papers exactly in a line or in any corners, and do not allow extra-large pieces to cut the design in two.

4. Once you have finalized the design, wet the papers thoroughly by immersing them in the water one at a time and then return them to their places on the surface. Wipe off any excess water that remains visible on the black surface with a paper napkin or other absorbent paper.

Applying Overall Texture

1. Pour the dark green, medium green, and white paints into three separate rimmed palettes.

2. As in the instructions for rendering Verde Aver (see pages 121–23), dip a water-wet-wrung-out sponge into each of the three paints.

3. Pat the sponges lightly over the surface, allowing the dark green, medium green, and white paints to fuse into each other, while still maintaining the sparkle of black that is so characteristic of Verde Issorie. Pay particular attention to the spaces between and around the papers; crisp, sharp-edged chunks are produced when the paper reserve is outlined carefully. The white paint should drift subtly around some of the papers; however, you should avoid repetitive clumps of white. If the white drifts are randomly placed and look well designed, they can be used as a foundation for the stronger, more

opaque white veins that will be added later. Do not press too hard along the edge of the sponge or straight lines will appear that destroy realism.

4. When the paint has just dried but the papers are still wet, remove the papers by hand or with a dental tool. Some of the surrounding paint will seep into the now-exposed areas. This seepage enhances the illusion that these are chunks that have become embedded within a network of smaller stone fragments. Let all of the paint dry.

5. Isolate this layer with shellac. Let the shellac dry.

6. If you are not adding texture to the chunks and/or adding veins, apply finish coat(s) as desired.

(Optional) Adding Texture to the Chunks

1. Mix small amounts of the dark and medium green paints in a palette with a script liner brush to get various shades of green.

2. Use a script liner brush to paint over several random chunks with varying shades of medium green paint. The paint should cover some chunks completely and others only partially. In either case, paints should cover the entire chunk and not stop just short of an edge.

3. Blot and/or drag the surface with absorbent paper to add a hint of mineral toning and/or a broken texture. Varied pressure will create lighter and darker colorations. Let the paints dry.

4. If you are not adding veins, apply paint-thinner-soluble finish coat(s) as desired. (If you are using a water-soluable finish, you must first isolate this layer with shellac.)

(Optional) Adding Veins (Modern Issorie)

1. With a script liner brush, paint the short white veins of varying length that appear in the more recently quarried Verde Issorie. These "veins" should wend their way around the "chunks," leading from or into the white drifts that are there already. The rendition is much more believable and pleasing if these veins blend into the texture and do not overpower or unbalance the design. Let the paint dry.

2. Apply paint-thinner-soluble finish coat(s) as desired. (If you are using a water-soluble finish, you must first isolate this layer with shellac.)

Note: Both textured chunks and white veins can be included in the same rendition.

The paper shapes that reserve the black chunks are arranged according to the principles of good composition.

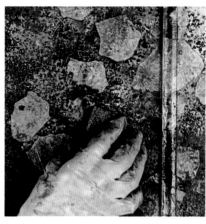

Paint is applied with a synthetic sponge around the paper shapes, outlining them so that they will produce crisp, sharp-edged chunks.

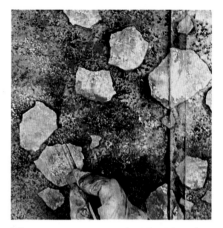

The papers are removed with a dental tool.

Seepage is visible on the black areas.

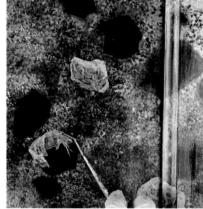

Random black areas are painted with medium green paint.

Texture is added to the chunks by blotting the paint with a facial tissue.

TINOS GREEN

Tinos Green is but one of many serpentine marbles that has a networklike infusion of translucent-through-opaque white within it. In some places this lacy web is pale, delicate, or fine-lined; in others, it is swirly with strongly contrasted colors and large, sharp, opaque whites. This configuration often resembles the foam of the ocean as it spreads out on the sand.

The initial stages of the network or webbing can be rendered with a brush, with paper reserves, or with a combination of the two methods. The brush technique is described here; the paper-reserve method is descibed under Red Levanto (see pages 130–32).

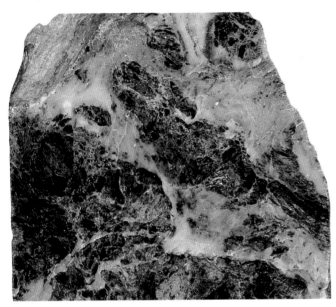

Real Tinos Green

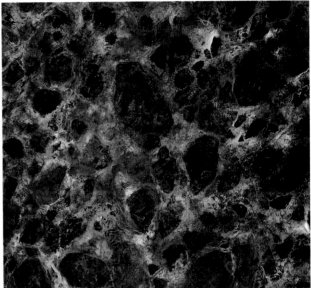

Painted Tinos Green

<u>BASE COAT</u>

Black japan paint or flat alkyd interior house paint

<u>MEDIA</u>

1. dark green paint: 5 parts Prussian green designers' color tempera, 1 part raw sienna gouache, ¼ part black gouache (or 7 parts Prussian blue gouache, 4 parts raw sienna gouache, ¼ part black gouache)

2. medium green paint: 15 parts white casein, 1 part dark green paint (5 parts Prussian green designers' color tempera, 1 part raw sienna gouache, ¼ part black gouache, or 7 parts Prussian blue gouache, 4 parts raw sienna gouache, ¼ part black gouache)

3. white casein, thinned with water to a watery consistency

4. shellac: 1 part three-pound cut shellac, 1 part denatured alcohol

5. paint-thinner-soluble finish

<u>TOOLS</u>

four wide rimmed palettes

several flat synthetic sponges, wet with water and wrung out

several #0 artists' script liner brushes

cotton swabs

paper napkins (or other absorbent paper)

base coat: black

1. dark green
(formula above)

2. medium green
(formula above)

3. white

TECHNIQUE

Applying Background Texture

1. Pour the three paints into wide rimmed palettes.

2. Load a water-wet-wrung-out sponge with all three colors and print a texture similar to the first layer of Verde Issorie (see pages 124–26). Leave a few random areas of black base coat in rather breccia-shaped chunks. The specific appearance of this layer is not crucial, as most of it will be covered up by later layers. Let the paints dry.

3. Isolate the layer with shellac and let the shellac dry.

Creating a Network

1. Determine the direction of the flow.

2. Apply dark green paint with a #0 script liner brush in shapes that are similar to the lozenges described on pages 152–53.

3. With the #0 script liner brush, apply white paint over the still-wet green paint in spontaneous, lozengelike shapes. Areas of dark paint should mix in with the white paint, creating many nuances of color, from white to dark green.

Refining the Network

The network usually needs to be refined and adjusted. Use the following suggestions in conjunction with the material in the drift, lozenge, and veining sections (pages 148–162) to create an interesting and realistic appearance:

- In areas that are too dense, cut through the paint with a cotton swab in clusters of varied sizes of geometric shapes to reveal the first layer. Overly dense areas also can be broken up by sprinkling them with water and then hitting the surface sharply with a crumpled napkin.

- Highlight select portions of the network with more white paint from a script liner brush. Do not outline whole shapes; instead, choose a corner of a shape, or a partial side, on which to apply opaque white paint. Allow this sharp white paint to fuse into the darker greens near it.

- Evaluate your rendering to eliminate repetitive lines, measurable distances between units, and predictable polka-dots of opaque white.

- Add very small areas of texture by applying white and medium green paint to the surface with a flat synthetic sponge. Soften these areas in places by blotting them with a paper napkin, or open them up with a cotton swab.

Reducing Contrast

1. When you are satisfied with your rendering, reduce any undesirable contrast between the large, dark areas and the network by darkening any white areas of the network that are too stark with dark green paint on a brush or sponge and by lightening any overly dark areas with small amounts of white and medium green paint applied with a sponge, crumpled paper napkin, or brush. The idea is to obtain a unified appearance that does not look as if the dark areas were cut out with a cookie cutter.

2. With a #0 script liner brush and medium or dark green paint, paint fine lines to simulate fissure cracks and to relieve any unevenness of color. These lines should run across the surface of the chunks only. They may cross one another at an angle. The lines should be quite thin; skive these lines with cotton swabs if they are too thick. Let the paint dry.

3. Isolate the layer with shellac and let the shellac dry.

4. Apply finish coat(s) as desired.

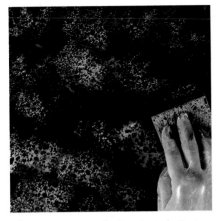

The paints are applied with a synthetic sponge.

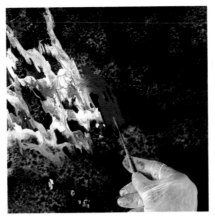

Green and white paints are applied alternately in lozengelike shapes.

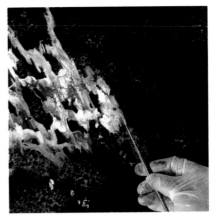

The white paint is applied directly over the green paint.

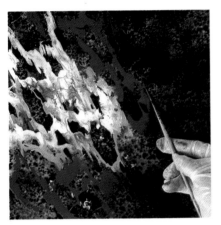

The pattern of applying paint is repeated as the rendering continues, with green applied first.

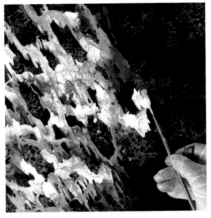

White paint is again applied directly over the green paint.

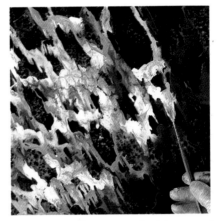

Be sure to apply paint in the direction of the flow.

The surface is dabbed with cheesecloth to blend the paints.

The paints should fuse into many variations of color.

Small brecchia shapes are removed with a cotton swab.

RED LEVANTO

Red Levanto is a marble that contains a great deal of carbon and serpentine and looks like many of the serpentine marbles. Our rendering of Red Levanto combines the overall texture of Verde Issorie with a variation of the type of networking found in Tinos Green. The element that sets Red Levanto apart from the serpentines is the addition of a maroonish red (red-purple with the addition of black) along with a bit of red-orange (red with a bit of yellow). Both colors are present in the background texture; the maroon also is used alone in the network layer, where it mixes with the greens and whites to produce a lavender gray, although green and black fragments are still visible.

Because this is a relatively complicated marble both in terms of analysis and technique, isolating each layer takes on added importance. Note: There is a less common marble from another region called Rosso Antico D'Italia that looks almost identical to Red Levanto.

Like Tinos Green, the networking in Red Levanto may be done in three ways: with a brush, using paper reserves, or by combining the two methods. The paper reserve method is shown here; the brush method is described in Tinos Green (see pages 127–29).

Real Red Levanto

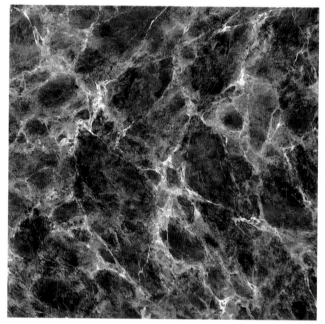

Painted Red Levanto

Black japan paint or flat alkyd interior house paint

MEDIA

1. dark green paint: 5 parts Prussian green designers' color tempera, 1 part raw sienna gouache, ¼ part black gouache (or 7 parts Prussian blue gouache, 4 parts raw sienna gouache, ¼ part black gouache)

2. medium green paint: 15 parts white casein, 1 part dark green paint (5 parts Prussian green designers' color tempera, 1 part raw sienna gouache, ¼ part black gouache, or 7 parts Prussian blue gouache, 4 parts raw sienna gouache, ¼ part black gouache)

3. white casein, thinned with water to a watery consistency

4. deep red-purple gouache, tempera, or casein, thinned with water to a watery consistency (add a bit of black gouache if necessary)

5. red-orange gouache, thinned with water to a watery consistency (add a bit of yellow gouache if necessary)

6. black gouache

7. shellac: 1 part three-pound cut shellac, 1 part denatured alcohol

8. paint-thinner-soluble finish

TOOLS

paper from sterile cotton roll (or other absorbent paper)

six wide rimmed palettes

several flat synthetic sponges, wet with water and wrung out

several #0 artists' script liner brushes

low container for water

paper napkins (or other absorbent paper)

dental tool (optional)

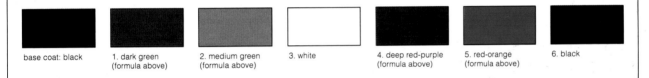

base coat: black | 1. dark green (formula above) | 2. medium green (formula above) | 3. white | 4. deep red-purple (formula above) | 5. red-orange (formula above) | 6. black

TECHNIQUE

Prior to Painting

Tear cotton-roll paper into small to large breccia-shaped chunks (see *Verde Issorie*, pages 124–26).

Applying Background Texture

1. Pour the paints into the flat rimmed palettes.

2. Load a water-wet-wrung-out sponge with the dark and medium green paints and print a rather open texture similar to that of the first layer of Tinos Green (see pages 127–29). Leave a few random areas of black base coat in breccia-shaped chunks. The specific appearance of this layer is not crucial, as most of it will be covered up by later layers. Let the paints dry.

3. Dip a water-wet-wrung-out sponge into the deep red-purple paint; then apply red-orange paint to a small area of the sponge with a script liner brush.

4. With the sponge, apply a sparse layer of deep red-purple with a little bit of red-orange to the surface.

Allow both green and black to show through the reds. Let the paint dry.

5. Isolate the layer with shellac and let the shellac dry.

Painting the Network

1. Determine the directional flow.

2. Fill the low container with water.

3. Dip the lozenge-shaped papers in the water and then place them on the surface, disregarding any discernible pattern in the first layer. The papers should have a fairly directional flow—either oblique vertical or oblique horizontal, not angled at 45 degrees. Place the papers close together where you want to create thin vein lines; place them further apart to create areas that will become networked or webbed later on.

4. Pat the surface with paper napkins or other absorbent paper to absorb any excess moisture.

5. Randomly sponge uneven amounts of medium and dark green paint on all the exposed surfaces.

6. Tear geometric holes out of the bottom of a water-wet-wrung-out sponge and use it to apply the deep red-purple paint to the surface.

7. While the deep red-purple paint is still wet, apply white paint with a sponge so that the colors intermix but do not blend. Because the paints were applied irregularly, the network that is produced will display many different tints of green—almost to white.

8. Dab the surface with a crumpled paper napkin both to blend the paints and reduce opacity. Let the paints dry.

9. When the paint is dry, remove the papers by hand or with a dental tool.

Refining and Coloring the Network

1. Refine the network as described in Tinos Green (pages 127–29).

2. Sponge additional medium and dark green and deep red-purple paints, plus a touch of black paint, on the surface to turn the white network toward mauve, green, and off-white.

3. Emphasize the networking by applying white paint with a script liner brush to corners and other random areas. Let the paints dry.

4. Isolate the layer with shellac and let the shellac dry.

5. Apply finish coat(s) as desired.

A layer of deep red-purple paint is applied over the green paints.

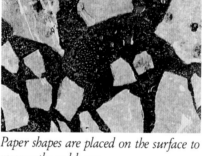

Paper shapes are placed on the surface to reserve the red layer.

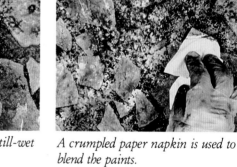

Medium and dark green paints are applied to the surface.

More red-purple paint is applied directly over the green paints.

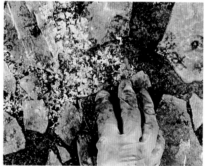

White paint is applied over the still-wet red paint.

A crumpled paper napkin is used to blend the paints.

The papers are removed.

Overly dense areas are opened up with a cotton swab.

White paint is applied to emphasize the outer edges of the network.

VERDE ANTICO

Verde Antico (sometimes called Vert Antique) is a serpentine marble that exhibits a strong linear directional flow and a great deal of visual texture. To render this marble, we use a removal technique because it quickly produces veining texture of great movement. Verde Antico texture exhibits shifting light and dark areas, sparks of light and medium green, and realistic intermingled veins. This texture would be next to impossible to get using applied methods.

We render Verde Antico using a different base coat and media from those used for the other serpentine marbles. We find that glazes work better than paints for simulating this marble. In addition, the use of glazes gives you the option to incorporate decorative inlays into your design in the most efficient way possible. (Floors are often rendered in this marble.)

Real Verde Antico

Painted Verde Antico, inlaid quarter-match.

BASE COAT

White sheened alkyd interior house paint

MEDIA

1. medium green glaze: 1 part medium green latex or alkyd interior house paint, 1 part glaze medium, 1 part paint thinner (Note: As in any multilayer glazing, a first layer of latex will allow overglazing the same day with either latex or alkyd glaze.)

2. dark green-black glaze: 2 parts C. P. Green M. japan paint, 1 part black paint, 3 parts glaze medium, 3 parts paint thinner

3. kerosene

4. water

5. water-soluble finish

TOOLS

sheet of paper

pencil

⅛-inch (3 mm) masking tape

painters' tape

burnishing tool

single-edged razor blade

several foam brushes or rollers

cheesecloth

1-mil plastic painters' drop cloth, cut into 12-inch (30 cm) squares

several sheets of tissue paper, about 9 x 12 inches (23 x 30 cm)

#0 artists' script liner brush

base coat: white

1. BM HC134

2. dark green-black
(formula above)

TECHNIQUE

Prior to Painting

1. Plan your inlay design on a sheet of paper. First, determine whether the marble will flow in one direction or be book- or quarter-matched. Then, with a pencil, lightly mark on the paper the direction(s) in which the marbling will flow.

2. Tape your design on the surface according to the instructions outlined in *Designing and Organizing the Surface*, pages 32–40.

Applying First Glaze Layer

1. Set painters' tape along the outer edges of two diagonally opposed sections. Miter the tapes where they overlap with a single-edged razor blade. Burnish these tapes with a burnishing tool.

2. With a foam brush or roller, apply the medium green glaze to one taped-off square. If the glaze sags or drips, press an elongated piece of cheesecloth into it along your predetermined direction.

3. Holding a 12-inch (30 cm) square of 1-mil plastic with your left and right hands at each end, pleat the plastic by pulling it up with the fingers of both hands. Lay this pleated plastic along your diagonal flow, pressing the knife-pleated edges, as well as the flat part, here and there, into the wet glaze. Watch out for fingertip pressure that is too heavy; this will cause holes in the texture. Run your fingertips lightly on top of the plastic along the direction of the pleats.

4. Lift and reposition the plastic to create a broken, rather linear texture. Do not press the plastic into the glaze one stroke directly after another; this will produce rhythmic lines that are good for accordion pleating but not for the random effect desired here. Pay particular attention to the marbling of the band between the ⅛-inch (3 mm) tapes where the medium green you are applying will not be covered by the subsequent dark green overglaze.

5. Follow this same procedure on the opposite taped-off area.

6. Remove the painters' tape and let the glaze dry.

7. Set painters' tape along the edges of the already glazed areas, burnish them, and proceed to texture the other two exposed areas. If you are using latex glaze for the first layer, allow the layer to dry for a minimum of one hour before applying the second layer of glaze. If you are using alkyd glaze, let the first layer dry at least twenty-four hours before taping over it.

Applying Overglaze Layer

1. When all the first-layer glazes have dried, apply masking tape. Place a ¾-inch (19 mm) tape over the medium green you plan to reserve, between the previously applied ⅛-inch (3 mm) tapes, this time overlapping both edges of the parallel ⅛-inch (3 mm) tapes.

2. Burnish the edges of the masking tape.

3. With painters' tape, block off opposite quadrants.

4. Prior to painting, use a wad of cheesecloth to apply a thin film of kerosene over the latex or alkyd glaze; this will enable you to manipulate the glaze for a longer period of time.

5. With a foam brush or roller, apply the dark green-black glaze.

6. Remove any excess glaze with cheesecloth.

7. As you did with the plastic sheets in the first layer, with both hands hold tissue paper tautly at the top right and left ends and make accordion pleats in the paper. Crease the tissue paper over your knee or a table edge to set the pleats.

8. Place the pleated tissue paper along the same diagonals of the medium green first-layer glaze. Relax your grip on the hand holding the upper end so that the paper fans out very slightly. Press the tissue paper into the glaze quickly and sharply.

9. With the fingertips of one hand, lightly smooth out the tissue paper in the direction of the pleats.

10. Repeat the procedure, sometimes slightly criss-crossing the strokes in short sections to vary the visual texture. Change the tissue paper when it is depositing more glaze than it is picking up.

11. If any areas lack contrast, apply more dark green-black glaze with a foam brush and repeat steps 6 through 9.

12. When all the glazes have dried, place painters' tape over the glazed areas that are complete and burnish the tapes so that the remaining areas can be glazed.

13. Remove the painters' tape. Let the glaze dry.

14. Remove the ⅛-inch (3 mm) and wider tapes carefully. Scrape off any glaze seepage with the sharp edge of a single-edged razor blade or touch it up with the base-coat paint, using a #0 artists' script liner brush. Let the surface dry.

15. Apply water-soluble finish coat(s) as desired.

The white base coat is reserved with a ⅛-inch (3 mm) tape applied in an inlay design.

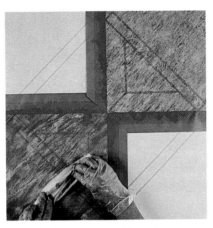

Pleated plastic is pressed into the wet latex glaze in the direction of the predetermined directional flow.

Texture is added by lightly running fingertips on top of the plastic in the direction of the pleats.

Painters' tapes are set along the edges of the dry glazed areas, and glaze is applied to the other two exposed areas.

Masking tape is placed within the borders of the band to reserve the dried latex marbling.

Opposite quadrants are taped off with painters' tape.

Dark green-black glaze is applied, and the excess is removed with cheesecloth.

Pleated plastic, held so that the plastic fans out slightly, is pressed into the glaze.

Dark green-black glaze is applied to specific areas to add contrast.

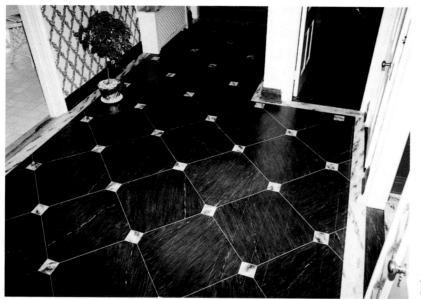

A painted Verde Antico floor with small marble squares.

Students' class exercises with Verde Antico demonstrate the infinite variety of inlay designs possible.

FRENCH GRAND ANTIQUE

Although French Grand Antique is no longer being quarried, it has such style and drama and is so simple to render that we have included it in this book. The marble is characterized by strong, sharp-edged contrasts of black and white. Although there are some middle-value grays present in both the black and white areas, and pencil thin veins run throughout the marble, there is no other marble that gives such a starkly contrasted appearance. The juxtaposition of the varied sizes of the angular chunks (many of which would not be graceful enough to be used alone in most marbles) creates a strong pattern that has the effect of an abstract painting.

This marble is best approached as a white network including both solid and fragmented areas, surrounding black, angular chunks.

Real French Grand Antique

Painted French Grand Antique

BASE COAT	
Black sheened alkyd interior house paint	

MEDIA

1. white alkyd glaze: 2 parts white flat or sheened alkyd interior house paint, 1 part glaze medium, 1 part paint thinner

2. shellac: 1 part three-pound cut shellac, 1 part denatured alcohol

3. paint thinner

TOOLS

low container for water

paper from sterile cotton rolls (or other thin, absorbent paper)

flat rimmed palette

12-inch (30 cm) squares of 1-mil plastic

newspaper

1-inch (25 mm) foam or bristle brush

#0 artists' script liner brush (optional)

dental tool (optional)

cotton swabs

tissue paper or paper napkins (optional)

base coat: black 1. white

TECHNIQUE

Prior to Painting

1. Fill the low container with water.

2. Tear the cotton-roll paper into breccia-shaped chunks (these will be used to reserve the black base coat). The chunks should be angular, exhibiting very few, if any, curves. Sizes should vary; include chunks ranging in length from ½ inch to 1 inch (12 to 25 mm) to about 4 to 8 (or more) inches (10 to 20 cm), depending on the size of the installation. The outer contours of the chunks should include many different angles. Include some that look like pointed isosceles triangles and others with more blunt angles and right-angle corners.

3. As in Verde Issorie (see pages 124–26), place the papers on the surface (if it is horizontal) to plan your design. (For vertical surfaces, use a horizontal sample board to plan your design.) Although there can be quite a bit of space between some chunks (from 1 to 3 inches [2½ to 7½ cm]), others abut each other quite closely. The entire surface should be covered, as opposed to the sparser coverage in Verde Issorie. The chunks should seem to come from all directions, creating random, angular spaces with no discernible flow.

In the actual marble, you can see by studying the matching contours of two adjacent edges that larger pieces have often cracked and separated. When simulating this effect, place any chunks that would have been originally connected slightly off angle to each other, so that there is a thin wedge between them rather than a straight line.

Some of the chunks in French Grand Antique are so large that they can overpower small installations. The way to prevent this, while still keeping the strength of the marble, is to imply that the large chunk extends beyond the edge of the area that is being marbled. A realistic effect will be achieved if you shape a large piece of paper and then place only a portion of it in the area to be painted, allowing the rest to remain off the surface.

4. Once you have finalized your design, dip the papers in the water one at a time and then place them back on the surface.

Applying the Texture Layer

1. Pour the white glaze onto a palette.

2. Dip a loosely crumpled or pleated 1-mil plastic square into the glaze.

3. Offload the glaze from the plastic by lightly dabbing it on newspaper.

4. Touch the plastic lightly to the surface. Pleated plastic produces a sharper texture with more direction than crumpled plastic. Try to keep most of the texture sharply contrasted, with a few areas that have less distinct edges. The texture, like the papers reserving the chunks, should not have discernible flow from any direction.

5. While the glaze is still wet, fill in solid white areas with a 1-inch (25 mm) foam brush or a #0 artists' script liner brush (or use a combination of both). These white areas can cover either completely or partially the spaces between the chunks. Aim for a mixture of completely or partially solid white areas, leaving no solid black areas between chunks. Extend the brush strokes onto the papers to make sure that the glaze goes right up to the edge of the chunk.

Adjusting the Texture

1. When the papers start to dry, remove them by hand or with a dental tool.

2. Evaluate the rendering. Look for too much "washy" texture, curved or fuzzy edges on the chunks, or too much conformity in texture, chunk shape, spacing, and/or direction. Fine-tune the marble by removing glaze with a cotton swab (either dry or wet with paint thinner) to open up the texture, and/or applying white glaze to fill in areas with a foam and/or #0 script liner brush.

Adding Texture to the Black Chunks

1. Just as when applying the initial texture, dip pleated plastic into a paint-loaded palette.

2. Offload much more paint onto the newspaper this time, so that very little paint will be deposited on the surface.

3. Touch the plastic lightly to the surface, creating a very open texture. This texture may or may not have direction.

4. Make any necessary adjustments by wiping out and/or softening the texture with tissue paper, paper napkins, or cotton swabs.

Crumpled plastic is pressed into the white glaze to create texture.

Pleated plastic is then pressed into the glaze to produce a sharper texture with more direction.

White glaze is filled in with a 1-inch (25 mm) foam brush.

The papers are removed with a dental tool.

More white glaze is added with a 1-inch (25 mm) foam brush to create greater liveliness and contrast.

Pleated plastic is pressed into the black areas to apply small amounts of glaze for texture.

ROSSO VERONA

Rosso Verona marble has been in use for at least 2,000 years (we have seen weathered Verona Imperial Roman columns). It is a brecciated marble, held together by the initial forces of heat and pressure that acted on it 200 million years ago. The shapes of both modern and older Verona chunks, unlike Verde Issorie, are rarely angular or geometric. Owing to the soft and brittle nature of the rock itself, the chunks have a tendency to split apart into several pieces and break at the edges, giving them a chipped-off, roundish appearance. Sometimes the fractures within larger chunks are so fine that, after dark-colored minerals have seeped into them, they show up as thin vein lines. Small broken-off bits of rock are scattered among the larger chunks. The jagged edges of these small pieces have been smoothed out in a process similar to that which occurs when stones are put in a tumbling machine. Modern Rosso Verona, in general, seems to exhibit more of these smooth-edged chunks than the older versions of the marble. Typical, also, are off-center markings that look like holes formed in the chunks. In all probability, these are areas where water evaporated.

The mineral most dominant in Rosso Verona—iron oxide—supplies a whole range of light-to-dark orange-brown colors to the marble. The lightest values appear in the chunks; the spaces around them are darker, showing several closely allied hues. Often these darker minerals also are spattered over the lighter chunks.

The most eye-catching color of this marble is the vibrant red ocher that runs over the chunks. These red ocher lines of minerals have no relation to the chunks below; undoubtedly they were formed at a later time. They run rather parallel to each other, often diagonally, undulating and splitting into finer threads, at times almost disappearing.

The marble also exhibits thin white veins, which do correlate to the chunks in a specific way. These white veins meander across the chunks, but end after reaching the edge, only to reappear in between the chunks at a slightly higher or lower level.

Rosso Verona is most realistic when rendered using applied methods in several layers.

Real Rosso Verona

Painted Rosso Verona

BASE COAT

Medium orange-brown sheened alkyd interior house paint

MEDIA

1. dark purple-brown glaze: 2 parts dark purple-brown flat or sheened alkyd interior house paint, 1 part glaze medium, 1 part paint thinner

2. burnt sienna glaze: 2 parts burnt sienna flat or sheened alkyd interior house paint, 1 part glaze medium, 1 part paint thinner

3. medium dark orange-brown glaze: 2 parts medium dark orange-brown flat or sheened alkyd interior house paint, 1 part glaze medium, 1 part paint thinner

4. light orange-brown glaze: 2 parts light orange-brown flat or sheened alkyd interior house paint, 1 part glaze medium, 1 part paint thinner

5. red ocher glaze: 2 parts red ocher flat or sheened alkyd interior house paint, 1 part glaze medium, 1 part paint thinner

6. white glaze: 2 parts white flat or sheened alkyd interior house paint, 1 part glaze medium, 1 part paint thinner

7. 1-1 mixture: 1 part glaze medium, 1 part paint thinner

8. shellac: 1 part three-pound cut shellac, 1 part denatured alcohol

9. paint thinner

10. clear, high-gloss, paint-thinner-soluble finish

TOOLS

low container for water

paper from sterile cotton rolls (or other thin, absorbent paper)

paper towels (or other absorbent paper)

several #0 artists' script liner brushes

cotton wads

dental tool (optional)

cotton swabs

wide rimmed palette

toothbrush

newspaper

1-inch (25 mm) foam or bristle brush

base coat: BM 1222 | 1. BM ET19 | 2. BM ST93 | 3. BM 1210 | 4. BM 1221 | 5. BM 035 | 6. white

TECHNIQUE

Prior to Painting

1. Fill the low container with water.

2. Tear cotton-roll paper into breccia shapes that will be used to reserve chunks of the base coat. These chunks should be broken-edged, nongeometric, and both small and medium-sized (ranging from 1 to 3 inches [2½ to 7½ cm]). After shaping them, fold over and crease a few of the papers toward one end and tear out a small opening to create an off-center hole.

3. As in Verde Issorie (see pages 124–26), plan the design with dry papers, either on the actual surface, or, if the surface is vertical, on a horizontal sample board. Coverage should be relatively complete over the entire surface, with a few open areas. Place several papers close together to create thin lines between their edges; push others further apart. Turn adjacent chunks so that wedge-shaped spaces, instead of straight corridors, appear between them. Lay some papers over the edges of your surface to enhance the illusion that there is more marble beyond your rendition.

4. When you are satisfied with your pattern, dip each paper into the water and then press it firmly onto the surface with your finger.

5. Press paper towels (or other absorbent paper) on the surface to blot excess water from both the papers and the base coat.

Applying the Background Color

1. Apply glazes #1, #2, and #3 with a script liner brush to random areas of exposed base coat, allowing bits of the base coat to show in spots.

2. Dip a cotton wad into the 1-1 mixture and dab it over the still-wet glazed sections. This dabbing motion will break up the sharp outlines of the individual paint strokes and allow the three colors to fuse until they are rather mottled. Avoid concentric circles or rivers of color running around the chunks.

3. Let the papers dry and then remove them, using a dental tool if necessary.

4. With a dry cotton swab, remove any seepage that may have occurred (unlike Verde Issorie, where the seepage enhances the rendition, in Rosso Verona each chunk should have clean, crisp edges).

5. Touch up the rendition by adding glazes #1 and/or #2 with a script liner brush to complete any missing boundaries of the chunks (this usually occurs when two papers are pressed too closely together).

6. With a dry cotton swab, rub out glaze in certain areas to create small single and clustered fragments of stone. Avoid a necklace effect by taking extra care not to create a repetitive single-file pattern.

Adding Fissure Cracks

1. Using a script liner brush loaded with glaze #1, add nervous lines of glaze to the chunks to simulate the fine lines formed when minerals seep into hairline cracks. These cracks usually appear toward the ends of the chunks, where breakage is most likely to occur. Let the glaze dry.

2. Push a dry cotton swab perpendicularly against the lines of glaze from both sides to thin them and give them a characteristic nervous quality.

3. Isolate this layer with shellac and let the shellac dry.

Adding Texture to the Chunks

1. With script liner brushes loaded with glazes #3 and #4, coat the exposed base coat of the chunks and fragments in a random manner.

2. Again, dip a wad of cotton into the 1-1 mixture and dab the cotton over each chunk to mingle the two colors. Avoid leaving dark glaze in the middle of the chunk, which will give the illusion of a depression, or leaving a darker rim of glaze around the outer edge of the chunk, which will make the chunk appear to bulge forward.

3. With a cotton swab, clean off any glaze that has been deposited on the darker texture surrounding the chunks. Be sure to remove all the glaze on the darker areas or they will appear veiled. Let the layer dry.

Adding Spatters

1. Pour a small quantity of glaze #2 onto a palette.

2. Dip a toothbrush into the glaze and then flick the bristles with your finger above a newspaper to test the consistency of the media. If it is too thick and will not spatter, thin the glaze with paint thinner until a fine spatter can be achieved. When the consistency is right, lightly spatter the media over the surface.

3. In areas where too much glaze has been spattered, press a paper towel or other absorbent material onto the surface to pick up the excess. Let the media dry.

Adding White Veins

1. With the script liner brush and the white glaze, paint veins that stop at the end of various chunks. Move up or down and continue the veins over the intervening spaces between the chunks. Avoid rendering veins that are parallel, evenly spaced, or of equal lengths. Do not paint too many veins, as they are more of an accent than a fundamental element of Rosso Verona.

2. Press the veins with paper towels or other absorbent material to lift off excess glaze.

3. Let the media dry and isolate it with shellac. Let the shellac dry.

Adding Red Veins

1. With a foam or bristle brush, apply a covering coat of clear, high-gloss, paint-thinner-soluble finish to the surface.

2. While this finish is still wet, use a script liner brush loaded with glaze #5 to paint meandering horizontal red ocher lines across the surface.

3. Pull cotton swabs (held vertically) through the red ocher lines to break them up into thin, parallel lines. Repeat this as often as desired to produce thinner lines. These lines should break up and diffuse into the finish. Continue to the next step or let the media dry.

4. (Optional) If desired, roll over the lines with a cotton swab to blend them into the surface even more. Let the media dry.

5. Apply finish coat(s) as desired.

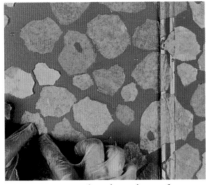

Wet papers are placed on the surface.

Colors 1, 2, and 3 are applied to random areas of exposed base coat.

A cotton wad is dipped into 1-1 mixture and dabbed over the surface.

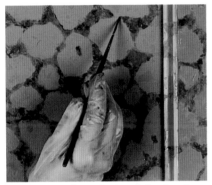

Any missing boundaries of the chunks are painted in.

A dry cotton swab is used to create stone clusters.

A cotton swab is pushed against a painted line to thin and shape it.

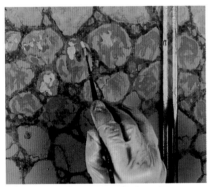

Glazes 3 and 4 are applied to the exposed chunks and fragments.

Cotton is dipped into 1-1 mixture and dabbed over each chunk.

Glaze 2 is spattered over the surface from a toothbrush.

Fragmented white lines are added with a script liner brush.

Red ocher lines are painted into the wet finish with a script liner brush.

A cotton swab is held vertically and pulled through the red ocher lines.

FRENCH ROSE

French Rose is the current name for Languedoc marble, a marble from France that has been quarried for several hundred years. Few deposits remain. This strongly contrasted marble shows red coloring (derived primarily from the mineral hematite) alongside off-white and dark gray mineral formations.

French Rose's characteristic terra-cotta color is covered randomly with fine line markings of deep gray punctuated by configurations of off-white and dark gray that run intermittently along the length of the marble. These configurations vary from 1 to 4 inches (2½ to 10 cm) in length and from ½ to 1½ inches (1¼ to 4 cm) in some areas and up to triple that size when several configurations appear to be joined together. These configurations exhibit both wispy edges and sharply contoured outlines.

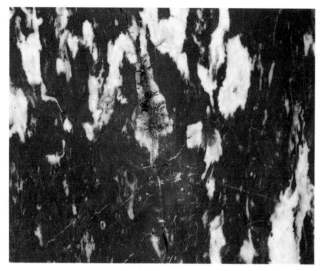

Real French Rose

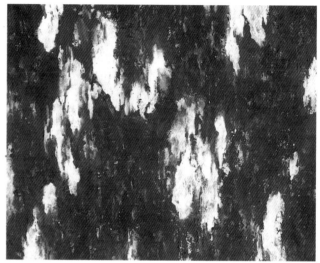

Painted French Rose

BASE COAT

Black sheened alkyd interior house paint

MEDIA

1. terra-cotta glaze: 2 parts terra-cotta flat or sheened alkyd interior house paint, 1 part glaze medium, 1 part paint thinner

2. off-white glaze: 2 parts off-white flat or sheened alkyd interior house paint, ½ part glaze medium, ½ part paint thinner

3. dark gray glaze: 2 parts dark gray flat or sheened alkyd interior house paint, 1 part glaze medium, 1 part paint thinner

4. shellac: 1 part three-pound cut shellac, 1 part denatured alcohol

5. 1-1 mixture: 1 part glaze medium, 1 part paint thinner

TOOLS

two 2- or 3-inch (50 or 75 mm) foam brushes or rollers

12-inch (30 cm) squares of 1-mil plastic, pleated

two flat rimmed palettes

¼-inch (6 mm) soft-bristled brush

sterile cotton

cotton swabs (optional)

| base coat: black | 1. BM HC50 | 2. BM 235-71 | 3. BM 1615 |

TECHNIQUE

Applying Background Texture

1. Apply the terra-cotta glaze with the foam brush or roller to one area at a time.

2. While the glaze is still wet, press into it with the plastic held with the pleat lengthwise. The edges of the pleats in the plastic will pick up fine lines of the wet glaze, allowing the black base coat to read as dark gray lines.

3. Repeat this process down the length of the surface as well as across it, adding terra-cotta glaze with a foam brush as necessary to fill the designated areas that you are rendering. Change the plastic squares often so that the glaze can be picked up.

4. Brush the tips of a foam brush lightly down any markings that are out of line or too wide. Let the media dry.

5. Isolate the layer with shellac. Let the shellac dry.

Creating the Configurations

1. Pour off-white and dark gray glazes onto two flat palettes.

2. Apply the off-white glaze with the ¼-inch (6 mm) brush. Stroke on from 3- to 4-inch (7½ to 10 cm) lengths of glaze so that they abut each other side by side. Their lengths may vary, creating an almost ragged effect.

3. While the off-white glaze is still wet, add the dark gray glaze with the ¼-inch (6 mm) brush and/or wads of cotton that have been pulled into elongated shapes and wet slightly with the 1-1 mixture. The gray should mix in with the off-white in nonrepetitive formations. The edges of this white and gray intermingling can look sharp or wispy.

4. With the ¼-inch (6 mm) brush and the white and dark gray glazes, add smaller variations of these configurations. Be aware that you do not create the same measurable intervals between any two configurations. More massive formations may be produced by connecting several stroked units together. Space these larger units more sparsely in your rendering.

5. Analyze your work to see that the large and small configurations are spaced unevenly in relation to each other and that the dark gray lines and cloudlike wisps appear quite randomly throughout. Let the media dry thoroughly.

6. Apply finish coat(s) as desired.

Pleated plastic is pressed into the glaze to expose some of the base coat.

The tip of a foam brush is brushed down the surface to soften harsh lines.

More terra-cotta glaze is applied.

Pleated plastic is pressed into the glaze again, in a vertical direction.

The glaze is brushed again, exposing a pattern of thin streaks.

White and dark gray glazes are applied and allowed to intermingle.

BOTTICINO

Botticino is an example of a marble that exhibits mineral deposits—often off-white—dispersed within the rock in a seemingly random manner. These mineral deposits combine pale, smoky wisps with more sharply outlined forms. The process of dispersal of the minerals is likened by geologists to subjecting a balloon filled with white paint to enormous heat and pressure so that it bursts, spewing forth its contents. Accompanying these mineral deposits are nervous jagged raw-sienna-colored veins that travel across the stone horizontally and vertically.

The first-layer instructions that follow are useful for simulating these random bursts of minerals. This technique creates a unique texture that can be used with strong and intense colors as well as the pale colors found in Botticino marbles.

Real Botticino

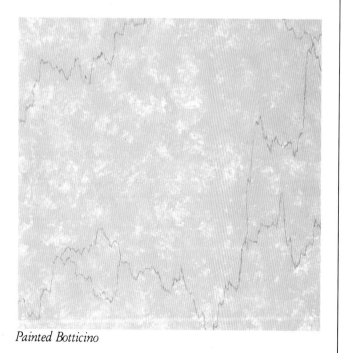

Painted Botticino

BASE COAT

Light beige-gray sheened alkyd interior house paint

MEDIA

1. white alkyd paint: 2 parts white flat or sheened alkyd interior house paint, 1 part glaze medium, 1 part paint thinner

2. medium tan glaze: 2 parts medium tan flat or sheened alkyd interior house paint, 1 part glaze medium, 1 part paint thinner

3. 1-1 mixture: 1 part glaze medium, 1 part paint thinner

4. shellac (1 part three-pound cut shellac, 1 part denatured alcohol) or low-luster or satin water-soluble finish

5. water-soluble finish

TOOLS

cotton torn into approximately 3-inch (7½ cm) wads

flat rimmed palette

#0 artists' script liner brush

cotton swabs

base coat: BM HC80 1. white 2. BM 1055

TECHNIQUE

Applying Overall Texture

1. Dip a cotton wad into the 1-1 mixture. Squeeze out the excess and wipe the wad across the surface to deposit a fine film over the base coat.

2. Pour a small amount of the white glaze onto a palette.

3. Fluff out the cotton wad used in step 1 so that it has protrusions, and dampen it with more 1-1 mixture.

4. Roll the 1-1-saturated cotton lightly in the glaze.

5. Place the glaze-saturated cotton on the surface and roll it with a delicate motion, stopping after one turn. Lift the cotton and repeat the process on all the uncovered base coat. The deposits formed from the freshly loaded cotton will be more sharply outlined and more opaque than the deposits formed after the glaze has been off-loaded from the cotton. To produce additional opaque markings, you may need to reload the cotton with media.

6. Roll the media-soaked cotton very lightly on the surface between large units to produce very small deposits of paint that lead the eye from one form to another. Aim for varied sizes and values, and nonevocative forms (no Teddy bears, worms, or balls) with an all-over coverage balancing opacity and translucence. Let the media dry.

7. Isolate the layer with shellac (if a slight yellowing is not a problem) or coat it with a low-luster or satin nonyellowing water-soluble finish.

Painting Veins

1. Load the script liner brush with the medium tan glaze, and hold the brush against the surface so that the bristles are aligned in the direction you will be going, i.e., vertically.

2. Starting at one end of your rendition and traveling toward the opposite side (right-handed artists should start at the left and work to the right), move your script liner brush up and down in short, nervous, connected strokes, at the same time as you move sideways in shallow-to-deep jagged configurations. Attempt to emulate the graphlike lines that appear in the real Botticino marble. These seem to be rather profuse in some areas and absent from others. They travel across the surface in a mainly horizontal direction but with lines leading off from each other in an angular direction.

Be careful not to paint a series of diagonal lines, or form equal-sized or repetitively shaped sections and zig-zags. Aim for a line that has a slight graphlike quality and that travels in a nonrepetitive jagged fashion. These lines may show shallow and subtle movement as well as dramatic depths and heights, depending on the size of your rendition. Resist the temptation to paint a series of isosceles triangles that start and end at the same base line and contain the same angled line at each side of a sharp central point. A large rendition may have areas with many lines accompanied by areas that have no lines at all; in either case, do not divide the space equally.

3. After the glaze has dried slightly, thin the vein lines down with a cotton swab. Do not run the swab along the line; rather, push it perpendicularly up from underneath and down from above. This action of the cotton swab fosters the nervousness of the lines, while, at the same time, thinning it down. Let the media dry.

4. Apply water-soluble finish coat(s) as desired. (Paint-thinner-soluble finish coats yellow this marble too greatly.)

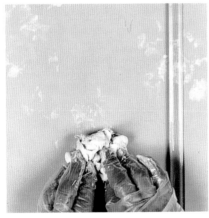
Glaze-saturated cotton is rolled on the surface.

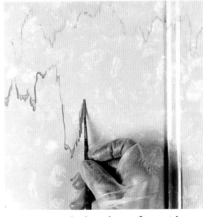
Veins are applied to the surface with short, nervous, connected strokes.

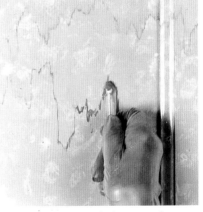
A cotton swab is pushed against the veins from above and below to thin them.

DRIFT AND MOTTLED MARBLES

Drifts of minerals in marbles exhibit one or more masses of color, according to the marble. These drifts usually have wide tops and tapered bottoms. The instructions detailed here are for methods that include both applied and removal techniques. While the manipulations themselves are simple, you must remember to maintain a directional flow and to let small amounts of many values of your marbling colors appear and disappear, as if running below the surface. This creates a great deal of depth and richness.

This marbling technique is quite useful; it can be used either in one layer by itself or as part of other techniques. It even can be toned with sparse or dense paint coverage to achieve unusual visual blends.

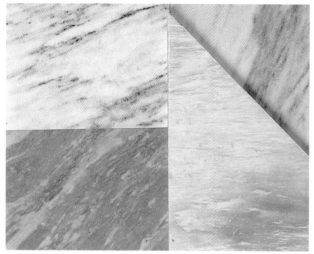

Real drift and mottled marble

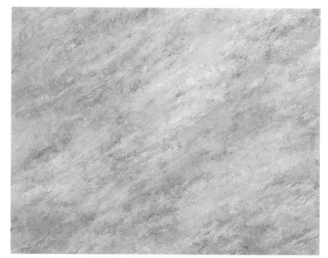

Painted drift and mottled marble

BASE COAT

White sheened alkyd interior house paint

MEDIA

1. white glaze: 1 part white flat or sheened alkyd interior house paint, 1 part glaze medium, 1 part paint thinner

2. dark gray glaze: 1 part dark gray flat or sheened alkyd interior house paint, 1 part glaze medium, 1 part paint thinner

3. light terra-cotta glaze: 1 part light terra-cotta flat or sheened alkyd interior house paint, 1 part glaze medium, 1 part paint thinner (optional)

4. 1-1 mixture: 1 part glaze medium, 1 part paint thinner

5. finish (paint-thinner- or water-soluble)

TOOLS

foam brush

two or three flat rimmed palettes

turkey feathers

paper napkins

wads of sterile cotton

paper napkins

| base coat: white | 1 white | 2. BM 1615 | 3. BM 1182 |

TECHNIQUE

Applying the Drift

1. Determine the directional flow.

2. Use a foam brush to coat the surface with a film of 1-1 mixture.

3. Load the flat palettes with the two (or three) glazes.

4. Charge a feather with white glaze. (Try not to use a feather whose tip has a V-formation.)

5. Lay the charged feather on the surface in the direction of your flow, leaving many touched areas of base coat.

6. Charge a second feather with gray glaze.

7. While the white glaze is still wet, lay the broad side of the feather (concave side up) on the surface several times, disregarding the pattern of the white glaze. Several applications of gray glaze should abut each other at staggered heights, forming a small grouping. Add further groupings and single imprints further away. Do not stroke on the paint. Keep in mind the "wide-top, tapered bottom" formation of authentic mineral drifts. Do not cover too much of the base coat.

8. If the gray glaze is too heavy and solid, looking dull and lacking "spark," lift the excess off with a napkin. Fold the napkin lengthwise and pick up glaze only from the center spine of the wet gray glaze.

9. (Optional) If this technique is done with an additional color, you can use another turkey feather to apply the additional color adjacent to, and nestled amid, the gray. This additional color can vary in dominance from one area to the next. Aim for variety in the placement and lengths of these color drifts, especially if marbling repetitive elements such as tiles or blocks. Also, make sure that the glaze is placed right up to (and slightly over) the edge of the border.

Manipulating the Paint

1. Dip an elongated cotton wad in the 1-1 mixture and squeeze out a slight amount of excess. Be sure to retain the elongated shape of the cotton.

2. Place the cotton lengthwise along one long edge of gray glaze, then roll your hand away from the glaze, lifting the cotton so that the glazed edge becomes fragmented, slightly diffused, and lighter.

3. Gently place this glaze-saturated cotton on an unglazed area of base coat near the initially deposited white glaze to leave a soft bit of color.

4. Repeat this process over the entire surface.

5. Dip a wad of cotton into the 1-1 mixture and dab it on the surface, if needed, to eliminate any glaze applications that retard the flow of the drifts. The aim is to fragment and lighten the glaze where it has been applied; to create other, paler tonalities where only the base coat shows; and to enlarge and fill out the drifts. Change the cotton when it has turned a solid middle-value color.

6. Let the surface dry and isolate it with shellac. Let the shellac dry.

7. If you are not applying overglaze, apply finish coat(s) as desired.

(Optional) Applying Overglaze

1. Apply the light terra-cotta glaze with cheesecloth to random areas of the surface.

2. With a clean wad of cheesecloth, dab the surface to blend and soften the glaze. Wipe out several areas almost back to the base coat. Let the media dry.

3. Isolate the layer with shellac and let the shellac dry.

4. Apply finish coat(s) as desired.

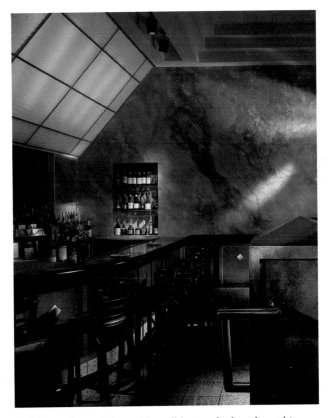

A drift-and-mottled-marble wall brings high style to this Rhode Island restaurant.

A glaze of the base-coat color is applied with a feather.

The gray glaze is added into the white glaze.

Excess glaze is picked up with a folded paper napkin.

A cotton wad is dipped in 1-1 mixture and then rolled and dabbed on the surface.

The completed rendition without mottle.

Light terra-cotta glaze was applied with cheesecloth to add mottle.

Additional glazes can be added. Here, a yellow glaze (BM 308) is applied.

Areas of the glaze are wiped away with cheesecloth.

The completed rendition.

VEINING IN MARBLES

There are many different types of markings seen on marbles. They vary from blurred, amorphous opaque or translucent striped bandings of color to sharply detailed, very linear vein lines. Instructions have already been given for bandings (in malachite and travertine), fused intermixed color (in Verde Aver), slight drifts of white (in Verde Issorie), pale red translucent markings and short thin white veins (in Rosso Verona), and thin nervous graphlike veins (in Botticino). These diverse markings are always intermixed with visual elements of one sort or another and are only one element of the marbles mentioned. Attention should not be drawn to these markings—they should be seen as part of a whole unit.

On the other hand, drifts of color with a directional flow, as discussed in the mottled marbles, assume more visual importance because they make up the entire pattern of these marbles. However, since there is a flickering mass of color or colors, the eye sees drifts as a whole unit, and not as separate lines of color.

The most difficult part of marbling is rendering sharp, linear veins of color. This is especially true when rendering the Italian veined marbles where the lines of veining are all that appear on the surface. The two main stumbling blocks seem to be where to place these veins and what they should look like. The first problem, where to put the veins, is solved too often by most decorative painters by angling them at 45 degrees, in parallel rows, with repetitive measurements between them. Other attempts to solve the problem of veining result in

- single veins that branch out into two open-ended lines like the two sides of an isosceles triangle (we call them "snake's tongues");

- sideways zig-zags and wiggles;

- lines that end in midair; and

- criss-crossed lines that make X's all over the surface (probably the most common error of all).

Real veined marbles. When sharp vein lines have a shadow of color, usually grayish, along one edge (as seen in the marble fragment here), it indicates that the mineral infusion is lying diagonally along the top surface of the marble.

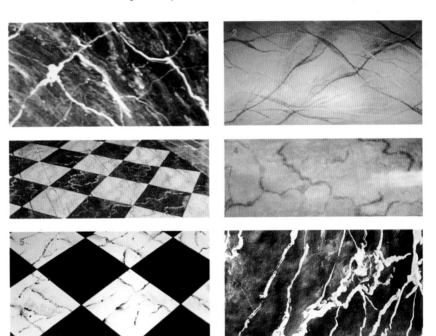

Examples of incorrect painted veining:

1. Vein lines at right angles to each other

2. Snake's tongues and X's

3 and 4. Two examples of wriggling vein lines

5. Vein lines leading nowhere alongside X's

6. Short vein lines and straight diagonals

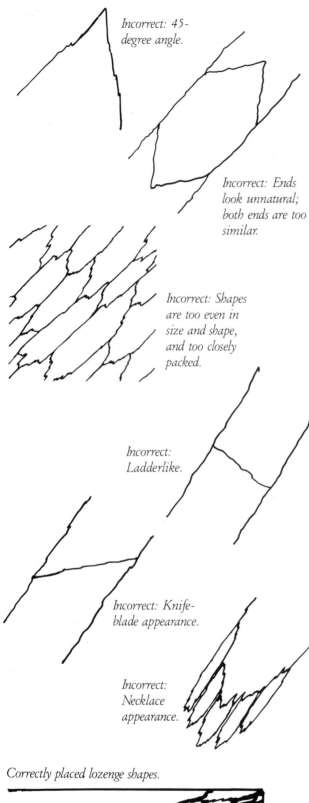

Incorrect: 45-degree angle.

Incorrect: Ends look unnatural; both ends are too similar.

Incorrect: Shapes are too even in size and shape, and too closely packed.

Incorrect: Ladderlike.

Incorrect: Knife-blade appearance.

Incorrect: Necklace appearance.

Correctly placed lozenge shapes.

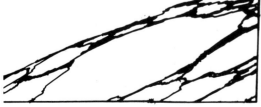

PLACEMENT OF VEIN LINES

After wrestling with the problem of how decorative painters could relate vein lines to a surface, we came up with a unique solution; testing it these past years not only has verified our original concept but also has been the salvation of the decorative painters who have studied with us.

We maintain that veining can be done with more speed and style if you stop thinking of veins as lines. Think of them instead as boundaries that enclose forms with specific shapes. We call these shapes lozenges because they are longer than they are wide. These lozenges exhibit some semblance of a triangle at each narrow upper and lower end; there are no straight diagonal sides and pointed ends that, together, result in "mountains." The boundary lines are irregular and a little jagged in places; the ends are slightly blunted.

By treating these lozenges as individual units you will be free to simulate veins by placing the lozenges anywhere and in any size. The concepts that follow will provide a guide. It is surprising how many veined marbles—subtle through dramatic—can be analyzed and rendered using these concepts and methods.

- The direction of the flow should be at a very oblique horizontal or vertical angle. This serves two purposes: (1) it prevents the 45 degree/parallel line syndrome, and (2) it presents a longer space in which to render interesting veins.

- Before applying or removing any media, determine your scale and flow. Decide on a size range for the lozenges, both in terms of length and width. Within your chosen scale you should aim for a great variety in size and shape. This eliminates the possibility that your rendition will look like sardines packed in a tin or baked potatoes in a pan.

- Think about how you will stagger the placement of the lozenges. No two lozenges should share the same long sides. If they do, you may find yourself looking at a row of rungs in a ladder-type configuration (this is especially true if the short ends are straight—although straight, short lines occur in real marbles when the long shapes fracture across their narrow width, this formation is not particularly pleasing to emphasize). When the triangular ends of the lozenges are pushed all the way over to one side or the other, a craft knife-blade shape results; when these shapes share long sides, they can resemble a row of knife blades.

- Give the lozenges room to breathe. Slip in clusters of small, narrow lozenges in unexpected places, and

apply paint along the short ends to simulate more mineral seepage in one place than another.

- In other areas, place several different sizes of lozenges very close together so that fine vein lines are created.

- Render each lozenge as a separate unit. If you attach one lozenge to another, without including all sides, your rendition takes on the appearance of a bunch of long pendants hanging on a necklace.

- Do not allow one vein line to intersect another at a perpendicular angle.

- Be conscious of what happens at the edges of your work. All lozenges must lead out to the edge. For more style at the edges, slip in the tops, bottoms, and sides of lozenges here and there. This prevents parallel lines from marching one after another along the border edge.

- For the veining with the greatest style of all—and the one that is the hardest to do (because so few lines are rendered)—enlarge your scale so that only parts of the lozenges fit into your space. The partial lines read as especially dramatic veins. This means that a 3-foot-long (91-cm-long) line can be thought of as a portion of the side of a 5-foot-long (1½-meter-long) lozenge.

- Whenever you are rendering real substances like marbles and woods you are asking the viewer to participate in your trompe l'oeil (fool the eye) rendition. On a dimensional surface—the edges of a marbled table or fireplace, for example—the way that you treat any plane that is angled can make or break your illusion, especially one in which the vein lines are the most prominent features.

When a cut is made perpendicular to the length of a marble's pattern, every line that touches that edge must be brought across the short depth of the marble slab. When a cut is made along the length of a marble's pattern but perpendicular to it, long veins will show. By examining the vein lines in real marble you can determine how to place your painted veins.

QUALITY OF THE VEIN LINE

The second challenge of rendering veining is to paint vein lines with a realistic appearance. Often veins are painted as rather straight, heavy lines that lie on the surface looking like electric cords. Veins should be integrated into the rendition. Realistic veins vary in line width. To achieve this line-width variation, you must adjust the line as your render it. As you are drawing your brush, feather, charcoal, or pencil across a surface to produce a vein, apply pressure in random places; this will swell the line out with more medium. In other places, pull back on your implement so that only the tips of the tool touch the surface; this will leave a very fine line. In areas where a fine line is needed but the medium is too wet to produce it, you should paint the line so that it is as thin as possible; then, before it dries thoroughly, thin (skive) it with cotton swabs or a wipe-out tool (examples of skiving may be seen in the photographs for Rosso Verona on page 143, Botticino on page 147, and Portoro (Black and Gold) on page 173).

Another way to give veins an interesting quality is to accent portions of them as they travel on a surface by varying their darkness and lightness. To achieve this variation in value, touch the veins in certain areas with your finger, a cotton swab, or facial tissue—or soften them with a brush or a moist wad of cotton. We call those processes "pushing the veins back into the marble." It is amazing how these simple actions transform an obvious line into a more subtle one.

When sharp vein lines have a shadow of color, usually grayish, along one edge (as seen in the fragment of marble pictured on page 151), it indicates that the mineral infusion is lying diagonally just below the surface of the marble. The Italian marbles are so translucent that the underlying minerals read as shaded areas. Making use of this visual aspect of translucence lends great depth and style to marbling. (Shading techniques for veins appear in subsequent instructions.)

Rendering veins, particularly ones on which the eye focuses, should be done when you are mentally and physically rested. To help you determine whether what you have rendered is really what you want, take a tip from a student of ours—he snaps Polaroid photographs of his work as he is doing it. The instant developing of the prints allows him to evaluate objectively his work-in-progress.

Diverse instructions and demonstrations are given in the following pages to illustrate our concepts of vein placement and line quality. Both removal and applied painting methods are provided so that you will have several alternate techniques from which to choose. Except where otherwise indicated, all the demonstrations have been rendered in the same directional flow and with the same media and color combinations to further emphasize our teaching concepts and methods.

CHARCOAL VEINING

To test the lozenge concepts, try them out first in charcoal or pastels. Working in these media is less intimidating than working with paint.

TECHNIQUE

Applying the Veins

1. Determine the directional flow.

2. With soft charcoal, draw the outlines of lozenge shapes of varied sizes.

3. Rub these outlines lightly with your finger to soften and fuse the lines.

4. Use a soft eraser to vary the width of the vein lines.

5. Add accents here and there with the charcoal to spark up your rendition and give it more depth.

6. (Optional) If you would like to see how color might look, tone the rendition by rubbing in some pastels.

7. Spray the surface with a flat fixative to lock in the charcoal and pastels.

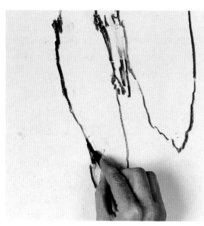

The vein lines are sketched in with charcoal.

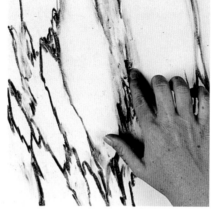

The charcoal is rubbed to diffuse it.

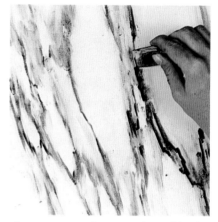

An eraser is used to vary the width of the vein lines.

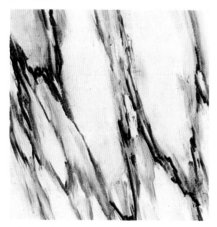

Charcoal accents have been added to give the rendition more depth.

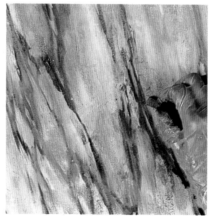

Blue pastel can be rubbed in to change the tonality.

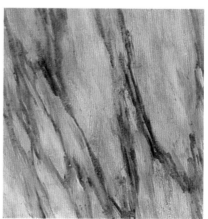

The completed rendition.

VEINING WITH CHAMOIS

Creating veining with chamois is a removal method with several advantages. First, it provides you with instant gratification as to where to place the veins. It is also a very useful method for rendering veined marbles on moldings and other narrow members. Rendering veins with chamois is most effective on narrow surfaces with widths of up to 4 inches (10 cm). Overglazing turns this technique into extremely subtle marbling.

BASE COAT

White sheened alkyd interior house paint

MEDIA

1. gray-green glaze: 1 part gray-green flat or sheened alkyd interior house paint, 1 part glaze medium, 1 part paint thinner

2. white glaze: 1 part white flat or sheened alkyd interior house paint, 1 part glaze medium, 1 part paint thinner

3. shellac: 1 part three-pound cut shellac, 1 part denatured alcohol

4. water-soluble finish

TOOLS

1-inch (25 mm) foam brush

several wads of cheesecloth

piece of chamois or sheepskin, wet with water and wrung out

soft-bristled brush (optional)

foam brush or roller

base coat: white 1. BM 1578 2. white

TECHNIQUE

Applying the Vein Lines

1. Determine the directional flow.

2. With the foam brush, apply a covering coat of gray-green glaze in the predetermined direction. If the glaze is too wet or runny, dab it with cheesecloth, preserving the angle.

3. Fold the water-wet-wrung-out chamois into long, sharp-edged shapes.

4. With your fingers, press the chamois edges into the glaze to form an oblique flow of varied-sized whole and partial long, narrow lozenges. Place the chamois edges close together to form thin veins; between other lozenges leave some wider areas of glaze and then press the chamois into these areas to form small(er) lozenges.

Refining the Veining

1. To improve the marble design, you may want to add more lozenges. To do this, hold the sharp edge of a 1-inch (25 mm) foam brush loaded with gray-green glaze perpendicular to the surface along the *exact* angle of the flow to form the outlines of small, long, narrow lozenges. Do not turn the handle of the foam brush or you will form parts of an equilateral triangle. Instead, holding the brush along the direction of the flow, add lines with a slight fragmentation or hitch in them to close up the ends of your lozenge shapes. You may also want to glaze over any shapes that do not work.

2. When the glaze is almost dry, wipe along the direction of the flow with dry cheesecloth or a soft-bristled brush to soften the lines and create varied values. This gives the illusion of shadows of mineral seepage at and below the surface. Let the surface dry overnight. (If you must work more quickly, you can isolate this layer with shellac once it is dry to the touch and let the shellac dry.)

Overglazing

1. To push the veins back into the marble, making them less apparent, use the foam brush or roller to apply a covering glaze of white.

2. Rub the white glaze off with cheesecloth, with adequate pressure to leave a thin film but no brush marks on the surface. Let the media dry.

3. Apply water-soluble finish coat(s) as desired.

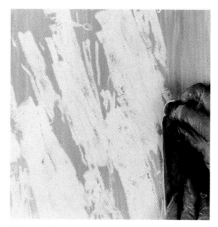

Edges of wet chamois are pressed into the glaze to form lozenges.

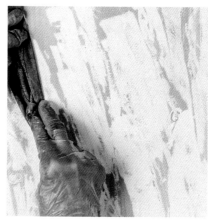

The chamois is moved to different areas to form various-sized lozenges.

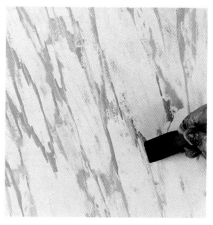

A foam brush is used to refine the lozenge pattern.

Dry cheesecloth is rubbed along the lines of almost-dry glaze to soften them.

An overglaze of white is applied and then rubbed off with cheesecloth.

The completed rendition.

VEINING WITH A SWORD STRIPER

The following applied method of veining is quite linear and graphic, yet creates an illusion of depth.

BASE COAT

White sheened alkyd interior house paint

MEDIA

1. gray-green glaze: 2 parts gray-green flat or sheened alkyd interior house paint, 1 part glaze medium, 1 part paint thinner

2. dark gray-green glaze: 2 parts dark gray-green flat or sheened alkyd interior house paint, 1 part glaze medium, 1 part paint thinner

3. 1-1 mixture: 1 part glaze medium, 1 part paint thinner

4. water-soluble finish

TOOLS

sword striper (or #0 artists' script liner brush)

wads of sterile cotton or cheesecloth

cotton swabs

base coat: white 1. BM 1578 2. BM 1582

TECHNIQUE

Applying the Veins

1. Determine the directional flow.

2. Load a sword striper (or script liner brush) with the gray-green glaze.

3. With the sword striper (or script liner brush), paint in lozenge outlines one at a time, following the suggestions on pages 152–53.

4. When you are pleased with one or more of your lozenges, use the sword striper (or script liner brush) to add the dark gray-green glaze to the lower and/or upper ends of the lozenges; this will create more depth.

Manipulating the Veining

1. Dip a wad of cotton or crumpled cheesecloth into the 1-1 mixture and squeeze out any excess. The wad should be saturated but not dripping.

2. Use the wad to whisk the short, triangular ends of the lozenges with a small, lengthwise forward or backward motion. Do not whisk in any direction other than with the flow, and be careful not to overwork the surface—one or two whisks are usually enough to be helpful; too many whisks may destroy the rendering. Aim to create a new set of endings that emphasize the drift and flow of the marble. The new endings often suggest the beginning of new, interestingly placed lozenges or, at the very least, provide shadings and fine lines in unexpected areas.

3. Evaluate each set of lozenge outline strokes before going on to the next. Aim for a wide variety of visual effects and tones.

4. Add more lozenges, both in small and large clusters. When you are pleased with the rendition, let the media dry.

Refining the Vein Lines

1. With a dry cotton swab, thin down the veins and clean out any paint left in interior spaces. Let the media dry.

2. Apply water-soluble finish coat(s) as desired.

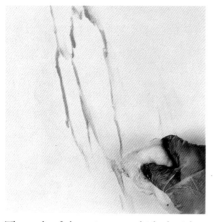

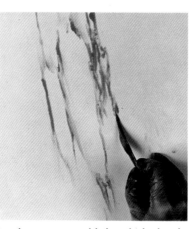

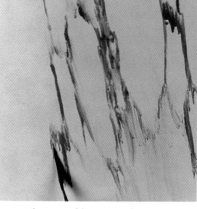

The ends of the veins are whisked with cotton dampened with 1-1 mixture.

More lozenges are added with the brush. Here, small clusters are added.

Large clusters of lozenges also are added.

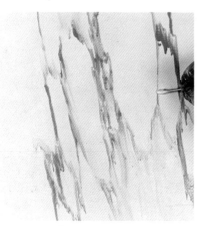

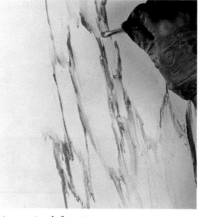

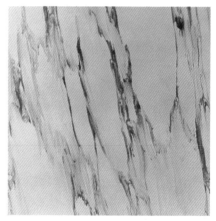

A cotton swab is used to thin down the veins.

Any paint left in interior spaces is cleaned out with a cotton swab.

The completed rendition.

FEATHER VEINING

Feathers have been used for veining for centuries. In fact, some people find feathers easier to use than a brush. Veining with a feather may be done in exactly the same way that veining is done with a sword striper or script liner brush (see pages 157–58), or it may be done with this technique.

BASE COAT

White sheened alkyd interior house paint

MEDIA

1. gray-green glaze: 2 parts gray-green flat or sheened alkyd interior house paint, 1 part glaze medium, 1 part paint thinner

2. water soluble finish

TOOLS

flat rimmed palette

turkey feather(s)

cheesecloth

base coat: white	1. BM 1578

TECHNIQUE

Applying the Veins

1. Determine the directional flow.

2. Pour the gray-green glaze onto the flat palette.

3. Charge a turkey feather with glaze from the palette and place the broad side of the feather on the surface with the concave side up. Flick the feather sideways to the left and to the right, depositing glaze from both edges.

4. Paint fine lozenges with the narrow edge of the feather to create vein lines.

Refining the Veins

1. Press a finger wrapped in cheesecloth lightly over any areas where the "veins" are too parallel or too straight, or where the veins cross over one another, to soften and fuse the media.

2. Add accents of the gray-green paint to various spots on the surface with the tip of the feather to create more opacity and depth.

3. Dip a wad of cotton or crumpled cheesecloth into the 1-1 mixture and squeeze out any excess. The wad should be saturated but not dripping.

4. Use the wad to whisk the ends of the lozenges as done in _Veining with a Sword Striper_, pages 157–58. Let the media dry.

5. Add water-soluble finish coat(s) as desired.

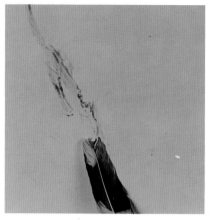

A feather is flipped back and forth to deposit paint.

The process is repeated, with the feather held concave side down.

The fine edge of the feather is used to paint thin vein lines.

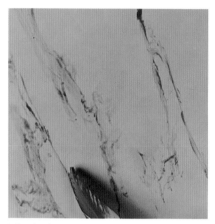

The feather is moved across the surface as veins are applied.

The lines are softened with a finger wrapped in cheesecloth.

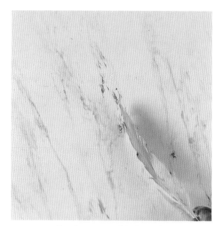

Accents of color are added with the feather edge.

The same instructions as above were used for rendering this marble, which has a white glaze over a black base coat; however, less paint was used to avoid the veiled look that occurs if too much light paint is left on a surface with a dark base coat.

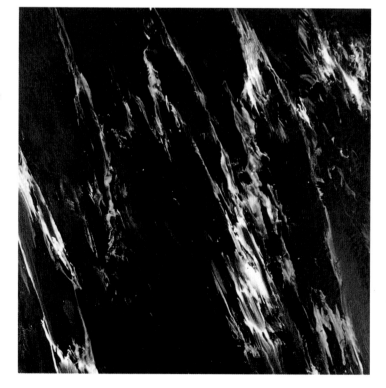

PALE SUBTLE MARBLING

This method of veining creates very pale marbling, exhibiting no visible strokes. Instead, when the rendering is completed, most of the base coat is covered with a subtle bloom of color. Nonrepetitive areas of uncovered, or barely covered, base coat are visible throughout.

TECHNIQUE

Applying the Veins

1. Determine the directional flow.

2. With cheesecloth, wipe a thin film of 1-1 mixture or paint thinner on the surface just prior to marbling.

3. Dip the wedge tip of the 1-inch (25 mm) foam brush into the gray-green glaze and use it to sketch rough outlines of long, oblique, thin lozenges with pointed ends. Allow more base-coat color (in this case, white) to be exposed than you will want in the final rendition.

Refining the Veins

1. With a dry, crumpled cheesecloth wad remove most of the glaze by stroking lightly down along the oblique vein outlines. This stroking will spread out and diffuse most of the glaze.

2. With the same cheesecloth wad, stroke sideways—perpendicular to the oblique veins—to further diffuse and soften any remaining sharp edges.

3. Finally, lightly stroke the cheesecloth wad again down along the original oblique veins to fuse the glaze even more into the base coat. If more glaze remains than is desired, repeat the process. Let the media dry.

4. Apply water-soluble finish coat(s) as desired.

Bear in mind that finishes (even flat ones) will make the colors more lively and will accentuate the contrast between the base-coat and marbling colors.

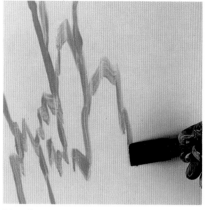

Vein lines are applied with a 1-inch (25 mm) foam brush.

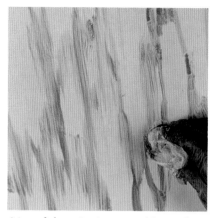

Most of the paint is removed by stroking along the veins with a dry cheesecloth.

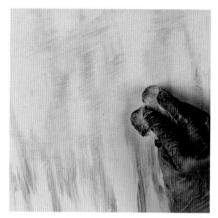

The same cheesecloth is stroked sideways to further diffuse and soften any remaining sharp edges.

The cheesecloth is stroked again along the original oblique veins to fuse the paint even more into the base coat.

If too much glaze still remains, cheesecloth can be stroked across the vein lines again.

The rendition being completed.

NORWEGIAN ROSE

On first glance Norwegian Rose marble does not seem to have any similarity with veined marbles; however, if you study the structure of Norwegian Rose you will find that it has the same varied lozenge shapes as do the veined marbles. The main difference is the infusion of mineral hues of pink and green from iron oxide and chromium. Even though the areas of pink and green minerals may be more vibrant in marble from one part of the quarry than another, the way in which the mineral colors meld stays basically the same. Traces of each hue infiltrate into the other, intermixing in between, and on, the lozenge shapes. In some lozenge outlines it is almost impossible to tell where one hue begins and the other ends. In addition, flecks of mica in random areas lend an unusual speckled quality to the marble.

We have found that a combination of applied and removal methods creates the most natural-looking rendition. Because the rendering is all done in one layer, we refer to Norwegian Rose as a "one-pass" marble.

Real Norwegian Rose

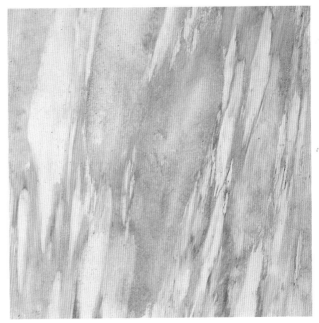

Painted Norwegian Rose

BASE COAT

White sheened alkyd interior house paint

MEDIA

1. gray-green glaze: 2 parts gray-green flat or sheened alkyd interior house paint, 1 part glaze medium, 1 part paint thinner

2. dark gray-green glaze: 2 parts dark gray-green flat or sheened alkyd interior house paint, 1 part glaze medium, 1 part paint thinner

3. light bluish pink glaze: 2 parts light bluish pink flat or sheened alkyd interior house paint, 1 part glaze medium, 1 part paint thinner

4. medium bluish pink glaze: 2 parts medium bluish pink flat or sheened alkyd interior house paint, 1 part glaze medium, 1 part paint thinner

5. water-soluble finish

TOOLS

#0 artists' script liner brush

¼-inch (6 mm) or wider soft-bristled brush

cheesecloth

wipe-out tool

cotton swabs

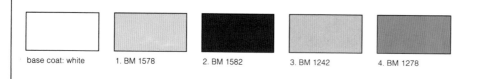

base coat: white 1. BM 1578 2. BM 1582 3. BM 1242 4. BM 1278

TECHNIQUE

Applying the Veins and Mineral Colors

1. Determine the directional flow.

2. With the script liner brush and the gray-green glaze, paint in a few lozenges of varied sizes (see pages 152–53).

3. Use the script liner brush to add the dark gray-green glaze randomly next to the gray-green glaze.

4. While the glaze is still wet, paint in the two pink glazes with the ¼-inch (6 mm) or wider brush in varied lengths and widths over the surface. Be sure to leave some varied-sized areas of white base coat visible—about 15 to 25 percent of the surface. When you have covered an area that you feel you can comfortably complete before the media dries, you should begin manipulating the glazes.

Manipulating the Glazes

1. Using a wad of dry cheesecloth, wipe the wet glazes very delicately in the direction of the flow, fusing and blending them together.

2. Dab the surface with the wet crumpled cheesecloth to eliminate any streaks and to simulate the speckling seen in real Norwegian Rose.

3. With the ¼-inch (6 mm) brush, add more gray-green glazes where the rendition seems too pink or unvaried.

4. While the glazes are still wet, use a finger wrapped in cheesecloth, a wipe-out tool, and cotton swabs to wipe out wide and narrow lozenges that expose the white base coat. This is particularly effective when clusters of several small, thin lozenges are wiped out at a distance from larger ones. This wiping-out technique can be used also to wipe away a narrow band of glaze around several small pink areas, making them into large lozenges (do not space them too evenly).

Because Norwegian Rose has long, sometimes narrow lozenge shapes, take care to avoid any similarity to the long narrow slices cut from corned beef or pastrami. Most of these wiped-out areas should be rather clean; remove any unnatural-appearing residue. As you work, stop occasionally to step back and study your rendering. Look at the balance between the colors and the white areas—the rendering should have style, with colors distributed asymmetrically over the surface.

Continuing the Process

1. When you are pleased with one area, move onto the next area and repeat the process: Apply the initial lozenge outlines with the two gray-green glazes; paint in the two pinks leaving white areas; wipe back to the white base coat with a finger, cotton swab, and a wipe-out tool.

2. When you are finished, let the media dry.

3. Apply water-soluble finish coat(s) as desired.

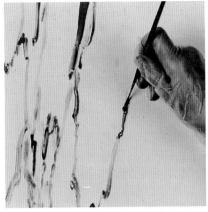

Medium and dark gray-green glazes are applied in lozenge shapes with a script liner brush.

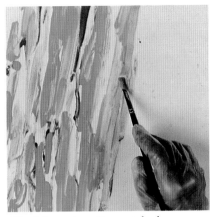

The light and medium pink glazes are applied inside of the wet gray-green glazes with a brush.

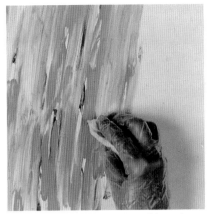

A wad of dry cheesecloth is delicately wiped along the wet glazes in the direction of the flow, fusing and blending them.

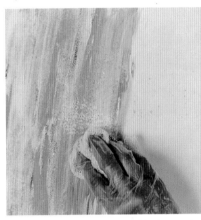

The same cheesecloth is dabbed into the glazes to eliminate streaks and to simulate mica speckling.

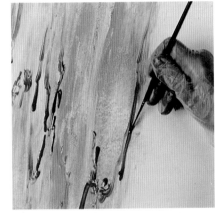

More dark gray-green glaze can be added where the rendition seems too pink or unvaried.

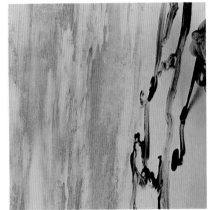

The gray-green glazes are applied in lozenge oulines.

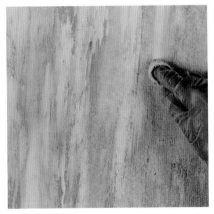

A finger wrapped in cheesecloth is used to wipe out thin lozenge shapes.

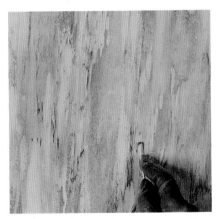

Additional lozenge shapes are created with a cotton swab.

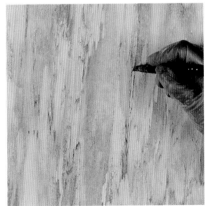

Even thinner lozenge shapes are created with a wipe-out tool.

YELLOW SIENNA

Yellow Sienna marble was a great favorite of architects in the late nineteenth and early twentieth centuries. Public buildings such as court houses display large amounts of it. One of the largest and most accessible installations is in Marble House in Newport, Rhode Island (painted versions appear here, also). Yellow Sienna is another example of a marble quarried today that differs from the same marble quarried years ago. The older Yellow Sienna marbles exhibit strong carbon and iron oxide infusions. These appear as black, gray, and burnt sienna veins within the lighter yellow-ocher-and-raw-sienna coloring of the rest of the marble.

Typical, also, of these older marbles are the areas of relative calm adjacent to vibrant veining; this may be seen on the middle of the lintel of the fireplace shown below. The huge interior spaces of Marble House are clad in this more restful type of Yellow Sienna marble, accompanied by small amounts of marble showing more dramatic veining. The Yellow Sienna being quarried today is of this more tranquil variety.

Two methods for rendering the modern Yellow Sienna follow. The first, an applied method using thick applications of very diluted media, is suitable for horizontal surfaces only. It is a useful technique to learn, since glazes will fuse and blend more completely when they are applied wet into wet. The second method, a removal method, may be used for vertical as well as horizontal surfaces. To replicate the older Yellow Sienna, follow the instructions for the vein structure at the end of the basic instructions.

Yellow Sienna painted without veins

Yellow Sienna painted with veins

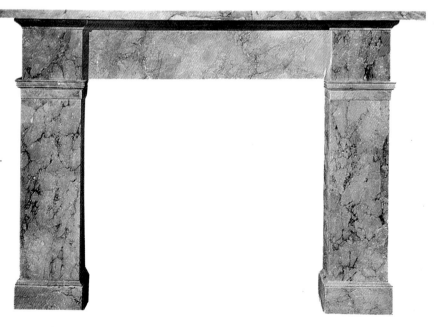

Real Yellow Sienna on a seventeenth-century fireplace.

BASE COAT

Beige-yellow sheened alkyd interior house paint

MEDIA

1. Beige-yellow glaze: 2 parts beige-yellow flat or sheened alkyd interior house paint, 1 part glaze medium, 1 part paint thinner

2. dark gray glaze: 2 parts dark gray flat or sheened alkyd interior house paint, 1 part glaze medium, 1 part paint thinner

3. white glaze: 2 parts white flat or sheened alkyd interior house paint, 1 part glaze medium, 1 part paint thinner

4. yellow ocher glaze: 2 parts yellow ocher flat or sheened alkyd interior house paint, 1 part glaze medium, 1 part paint thinner

5. raw sienna glaze: 2 parts raw sienna japan paint or flat or sheened alkyd interior house paint, 1 part glaze medium, 1 part paint thinner

6. burnt umber glaze: 2 parts burnt umber japan paint or flat or sheened alkyd interior house paint, 1 part glaze medium, 1 part paint thinner (optional)

7. black glaze: 2 parts black japan paint or flat or sheened alkyd interior house paint, 1 part glaze medium, 1 part paint thinner (optional)

8. 1-1 mixture: 1 part glaze medium, 1 part paint thinner

9. paint thinner

10. shellac: 1 part three-pound cut shellac, 1 part denatured alcohol (optional)

11. paint thinner-soluble finish

TOOLS

1-inch (25 mm) foam or bristle brush

turkey feathers (the tips should be rounded and not exhibit a V-shape)

seven wide flat palettes

large cotton wads (approximately 3 inches [7½ cm] long)

cheesecloth (optional)—second technique

blending brush—second technique

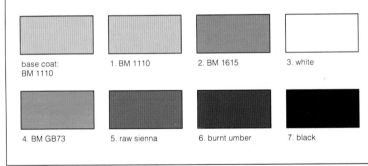

base coat: BM 1110 1. BM 1110 2. BM 1615 3. white

4. BM GB73 5. raw sienna 6. burnt umber 7. black

TECHNIQUE FOR HORIZONTAL SURFACES

Applying the Paint

1. Determine the directional flow. It must *not* be 45 degrees.

2. Pour the glazes into wide flat palettes.

3. With the 1-inch (25 mm) foam or bristle brush, apply a film of beige-yellow glaze to the surface.

4. While this glaze is still wet add the dark gray glaze to the surface with the flat side of a feather, held concave side up. Place the glaze on the surface so that it is distributed asymmetrically over the entire area being worked at one time. Do not stroke the glaze on or place it in even stripes, repetitive diagonals, lines that go from one end to another, or sideways angles.

5. Apply the white glaze, the yellow ocher glaze, and the raw sienna glaze in the same fashion, wet into wet. Apply one color after the other, creating interesting intermediary hues by placing the glazes in varied combinations next to, on top of, and distant from each other. (Note: Even one color by itself applied to the wet film of beige-yellow may be manipulated to create a believable marble. Also, when using two or more colors, varying the order of glaze applications will affect the final result.)

Manipulating the Paint

1. Wet a cotton wad with 1-1 mixture and squeeze out the excess so that the cotton is well moistened but does not drip.

2. Lay this heavily moistened wad on the surface where two colors meet and then lift it off. The glazes will begin to lose their sharp edge and blend.

3. With the moist cotton wad, soften harsh spots of color, blend colors together, and remove any offending off-angled or badly placed areas. Study the surface as you work so that the softening, blending, and removing processes are done only where necessary to create a marbled look. Overmanipulation results in a solid mud color. Remember, also, to move quickly; 1-1 mixture used on drying paints acts as a solvent and removes them. (Note: This technique should be used alternately with the technique in step 2.)

4. When you are pleased with your rendition, let the surface dry.

5. (Optional) If you plan to apply subsequent veining, isolate the surface with shellac and let the shellac dry. Proceed to the veining instructions.

6. Apply finish coat(s) as desired.

TECHNIQUE FOR VERTICAL AND HORIZONTAL SURFACES

1. With a wad of sterile cotton, wipe a thin film of the 1-1 mixture on the surface.

2. Dip separate wads of sterile cotton or crumpled cheesecloth into the white, medium gray, and raw sienna glazes.

3. Use the cotton or cheesecloth to apply the glazes to the surface, blending the colors in places and leaving the colors separate in others. In some places, roll the cotton or cheesecloth a short way to get a slightly broken texture. Aim for uneven drifts of random color combinations—some dramatic, some calm.

4. Dip a fresh wad of cotton or cheesecloth into the 1-1 mixture and dab it delicately over the boundaries where the colors meet.

5. With a blending brush, fuse the glazes into a more subtle film, allowing the base color to appear intermittently.

6. When you are pleased with your rendition, let the surface dry.

7. (Optional) If you plan to apply subsequent veining, isolate the surface with shellac and let the shellac dry. Proceed to the *Veining* instructions.

8. Apply water-soluble finish coat(s) as desired.

(OPTIONAL) VEINING (OLDER YELLOW SIENNA)

1. With feathers, apply lozenges (see pages 152–53) of dark gray and burnt umber glazes to the surface. In some areas integrate the veining with the colors in the first layer by surrounding defined color areas. In other areas let the veining cover many colors, with no outlines around specific colors.

2. Add small amounts of black glaze to certain areas of the veining with a script liner brush to emphasize those areas and add depth.

3. Dip a wad of cotton or cheesecloth into the 1-1 mixture and dab it delicately on the edges of the black glaze.

4. When you are pleased with the veining, let the media dry.

5. Apply finish coat(s) as desired.

A glaze of the base-coat color is applied with a 1-inch (25 mm) foam brush.

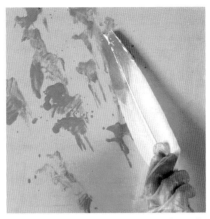

Dark gray glaze is applied over the still-wet glaze with a feather.

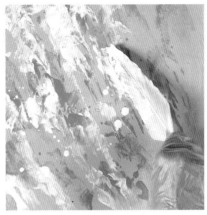

White glaze is added in the same manner.

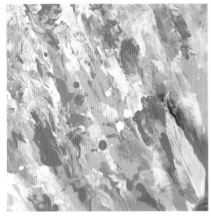

Yellow ocher and raw sienna glazes are applied next, into the other wet glazes.

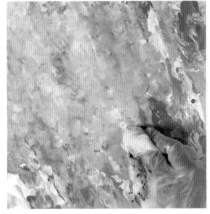

A cotton wad moistened with 1-1 mixture is used to blend the glazes.

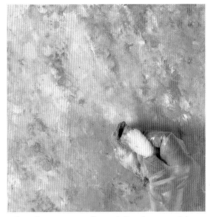

The glazes are softened further, with care being taken not to overblend them.

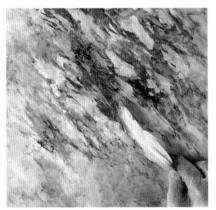

Veins are applied with a feather.

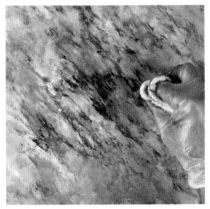

The painted veins are thinned and softened with cheesecloth.

PORTORO (BLACK AND GOLD)

Portoro is the Italian name for a marble that is commonly referred to as Black and Gold (gold refers to the color rather than actual gold deposits). Several years ago the Portoro marble quarries were closed; the present availability of this marble is limited to existing Portoro until the quarry is reopened (if it ever is).

Portoro marble has been used architecturally and for ornamentation for many centuries. The various levels uncovered by quarrying through the years have exposed marbles that differ from each other in color and pattern, but are still recognizable as Portoro. All Portoro—whether Portoro Macchia Larga (the scale seen in the top photograph below) or Portoro Macchia Fine (the more finely proportioned, threadlike version) share similar characteristics.

Portoro is a black marble with strongly contrasting off-white-through-raw-sienna-colored veining in rather stylized horizontal and vertical patterns. The veining is comprised of several separate light-colored linear configurations that flow into each other and connect to form 1- to 3-inch (2½ to 7½ cm) bandings that often resemble cut sections of stylized lace or embroidery. Each separate vein contrasts sharply with the black surrounding it and displays a nervousness. The veins swell into areas with curved contours and often rather abstract shapes, containing ample amounts of minerals. The older, quarried-out Portoro also displays opaque sections of deep raw sienna veining. More modern Portoro veining appears in a mixture of off-white, a taupelike beigy-gray, and gray, with a hint of translucence under which a darker tonality is visible.

The veining in all varieties of Portoro encases small to large round and oval openings. These tend to be filled with dark gray mineral matter that oftentimes is rather strongly outlined and at other times seems to evaporate towards the outer edges. In all cases there is a black area between the vein outline and the inner mineral matter.

These bands of veining alternate with even wider areas of black; we call these black areas corridors because they occupy a rather evenly spaced wide section between any two bands of veining. Also typical of Portoro are curved sections of the bands of veining extending into the upper and lower edges of the corridor. These interruptions of the even nature of the black corridors are an important factor not only in replicating real Portoro, but also as a design element to inject style into what otherwise might be a too-even band of veining.

The last unique component of Portoro marbles is strong white veining that runs almost perpendicular to the horizontal banding. These white veins cross the "banding" and "corridors" at angles ranging from 75 to 90 degrees. If the flow of the banding has been diagonal, bear in mind that the perpendicular veining will run at right angles also, creating an opposing diagonal. Any veins veering toward 45 degrees look unrealistic, since they would cross over other veins they might encounter. Veins relate to the bandings in several special ways: They may cross over or under the entire band, or they may thread through the various openings of the bandings, shifting slightly as they appear.

Although you can render an impressionistic Portoro marble with removal techniques, we believe that applied techniques produce more realistic results. Applied techniques offer the greater control of line placement, quality, and clarity that this marble requires. Portoro does not require the illusion of depth and texture that removal methods provide and that are part of so many other marbles.

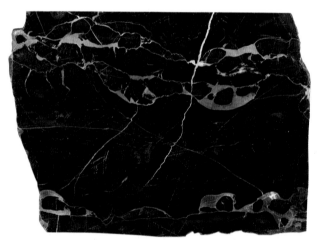

Real Portoro

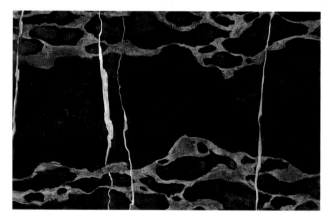

Painted Portoro

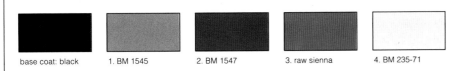
TECHNIQUE

Prior to Painting

1. Determine your directional flow. You may render this marble horizontally, vertically, or on a diagonal. The instructions that follow are written for rendering a horizontal flow.

2. Determine which color(s) will predominate and how much variation there will be. Medium taupe-gray may be used by itself, with off-white, or intermingled in many places with raw sienna.

Painting the Vein Network

1. Charge the #0 script liner brush with medium taupe-gray glaze and test to see that the media flows smoothly from the bristles. (If it does not, add a bit more paint thinner.)

2. Hold the brush very loosely in your hand with your palm facing upwards, the bristle end of the brush resting on the surface to be painted, and the pad (the underside) of the first joint of your thumb resting lightly over the handle of the brush. The brush should lie horizontally over your upturned fingertips, not point up in the air.

3. Begin painting the veined bandings with a line that meanders horizontally across the surface. Aim for a nonrepetitive slight wavering; avoid patterned zig-zags.

While you are painting the line horizontally, roll your thumb up at times and down at others. This will cause the brush handle to roll away from you. Since the bristles are parallel to the surface, glaze will be deposited in small, horizontal lines. These will provide interesting starting points for the embroideries that will be placed at irregular intervals along each band.

4. After you have taken this first band to the end of the surface, return to the just-formed small horizontal lines and extend them into the upper and lower edges of varied-sized elongated irregular oval outlines.

The following suggestions will be helpful in rendering the characteristic horizontal yellow veins in a realistic, flowing, and aesthetic manner:

• Paint some of these outlines in the direction of the flow, others in slightly upward or downward arcs.

• With a script liner brush, add the raw sienna intermittently over the medium taupe-gray glaze.

• Paint with authority. Your lines must make a clear, sharp, definite statement, not appear indecisive, sketchy, or tentative.

5. As the lines flow they should swell in a dynamic exciting way and then slim down to a very thin thread. This is achieved by pressing down on the bristles for release of more paint or by pulling the hand back so that only the tips of the bristles touch the surface.

6. In real Portoro, veining lines appear to be almost translucent in some areas. To create this translucence, lay a fine-weave paper towel, paper napkin, or other absorbent material over the still-wet glaze and press the paper firmly to pick up excess glaze, leaving a thin film of glaze on the surface through which the black base coat will show. This action will cause the glaze to spread in places.

7. Skive down any overly thick lines by pressing a dry cotton swab along almost-dry upper or lower sections of the lines.

8. The majority of the lines interconnect with a wishbone flow rather than hitting into each other perpendicularly, as in a T-square. Alternate embroideries—always at irregular intervals—with narrow, linear stretches of thin lines in between.

9. The banding that has been created by these interconnected lines should not be level on either the upper or lower edges. To prevent this from happening, consciously vary the height and depth of these lines by swelling your outline up or down, forming extra bulges of embroidery along the banding.

10. To create the large areas of flat color that appear within and throughout the banding, use a script liner brush to enlarge and fill in random areas of the outline with taupe-gray and raw sienna glazes so that they turn into rather abstract forms combining curves and angles.

11. With a dry cotton swab, rub out small ovals within these thickened lines when the glaze is almost or just dry. Under no circumstances should your linear and rubbed-out shapes look like a doughnut. Nonrepetitive, interesting negative spaces should coexist with the lines and spaces formed by your applied paint.

12. Thin the lines with cotton swabs as described in step 6.

Applying Smoky Areas

The typical gray smoky shapes of Portoro are placed within the enclosed veins and in the corridors after all the paint has dried. A protective layer is not required, since no part of the linear outer veining is touched.

1. For small and medium-sized openings, dip a cotton swab into the dark gray-brown glaze, picking up a very small amount. Place this wet swab in the center of a shape and spread the glaze around lightly with your fingertip so that glaze fills the entire area except for a very defined black outline of at least ⅛ inch (3 mm) inside the outer edge. Do not let the gray-brown glaze dry and then wipe a border off around it—this will result in a harsh, unnatural appearance. Keep the outer edge soft and fairly diffused.

2. For larger openings, fill several with one grayed shape; others with two.

3. For the corridors, apply gray-brown smoky shapes to random areas away from the banding, leaving a predominately black appearance.

4. When you are satisfied with your rendition, let the media dry.

5. (Optional) Isolate this layer with shellac and let the shellac dry. (Note: Although protecting the completed layer is optional, we strongly advise it; this will allow you to wipe away anything that might displease you in the next layer without affecting the lower layers.)

Painting the White Veins

1. With the #0 script liner brush, paint the perpendicular veins with the off-white glaze. These veins should vary in width from quite thin to up to ¼ inch (6 mm) or more in places. Avoid curves, zig-zags, and wiggles; instead, fragment and hitch the veins as you would any vein. Also undesirable is a straight, even-width vein.

2. When you are pleased with your veins, let the media dry.

3. Apply paint-thinner-soluble finish coat(s) as desired.

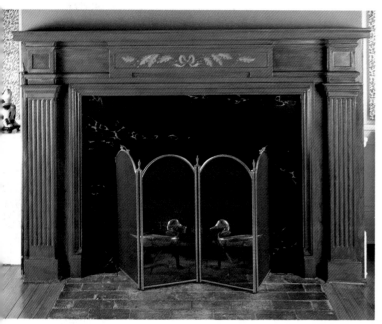

Grained fireplace with painted Portoro marble.

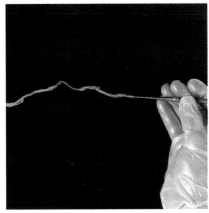

The first vein line is applied with a rolling motion of the brush.

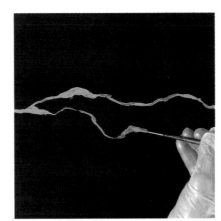

The second vein line is attached to the first in a typical Portoro configuration.

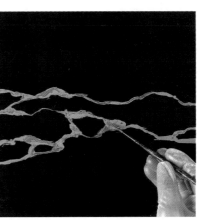

Random areas of the pattern are accented with glazes 1 and 3.

An absorbent facial tissue is pressed into the glazes to create translucencies.

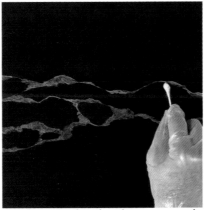

Vein lines are skived with a cotton swab.

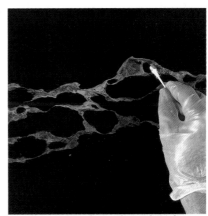

Small round ovals are formed in the wet glaze with a dry cotton swab.

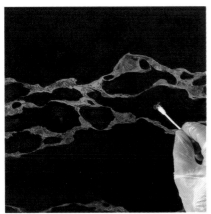

Dark gray-brown glaze for the smokelike formations is applied.

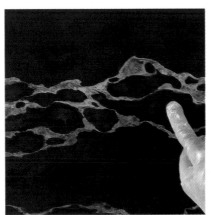

The glaze is spread out with a fingertip to form a sheer, smoky film.

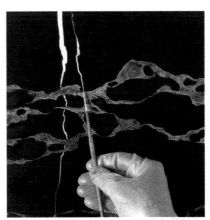

Off-white vein lines are applied with a script liner brush.

GRAINING

Graining, painted wood, and *faux bois* are all names for the simulation of natural woods in any artistic medium. That simple statement describes what the ancient Chinese, Egyptians, and Romans did thousands of years ago; it describes what has been done throughout all the centuries from then until now. The challenge for grainers has always been to understand the structure of trees and the ways they are cut so that their renderings look like authentic wood to any viewer. ❧ Trees grow upward and outward, forming the familiar rings that mark yearly growth. These annual growth rings are comprised of a wide light ring (spring/earlywood growth) and a narrower, dark ring (summer/latewood growth). Whenever a tree is cut, the grain pattern that results is an indication of the direction in which the cut was made in relation to the growth rings (and other portions of the tree). In other words, any grain pattern in wood is a combination of two factors: the configuration of the specific part of the tree from which the piece of wood was cut and the angle of the cut that exposed that part of the tree. ❧ Fortunately for grainers, there are only a limited number of cutting options for all trees. This fact makes the task of rendering woods logical and accessible; specific cuts always reveal specific wood-grain patterns. An analysis of tree structure and sawing methods is presented here to provide a broad overview of the patterns available to grainers (more details are found under particular woods). The woods chosen for the graining instructions in this book were selected to provide experience in a wide range of wood-grain patterns, colors, and techniques. Using this information you should be able to render many other wood grains.

Painted mahogany inlay and cornice, rendered over real Circassian walnut, in the library of the National Paint and Coatings Association headquarters.

ANALYSIS OF WOOD GRAIN PATTERNS

To be able to render wood realistically, you need an understanding of the various patterns that typically appear: pores, straight grain, medullary rays, crossfire, heartgrain, ring cuts, knots, burl, and the crotch figure.

PORES

A lengthwise cut in hard wood will reveal pores that are related to the structure of the tree. Pores represent cut-open sections of the longitudinal cell structure of hardwood trees only. Soft woods do not have pores. Diffuse-porous woods, like maple, birch, and beech, exhibit evenly distributed small markings. Ring-porous woods, like oak, ash, and hickory, exhibit alternating rings of larger and smaller pores.

STRAIGHT GRAIN

Straight-grain patterns appear when a tree is divided lengthwise into quarters, each quarter cut into wedges, and then each wedge cut into boards. The end grain (grain at the end of the board) appears as straight, parallel lines. Also known as quarter-sawn, this grain pattern shows a pattern of straight grain that exhibits the same variations in the widths and colors of the dark and light lines that are seen in the tree's annual growth rings.

MEDULLARY RAYS

Also known as silver grain, silver streaks, ray flecks, and ray flakes, medullary rays are food-storage tissues extending from the center of the tree out to the bark like the rays of the sun. Seen in quarter-sawn wood, medullary rays range from narrow and subtle through broader and more strongly marked. They interrupt the lengthwise pattern of the straight grain.

CROSSFIRE

Also known as mottle, crossfire is the reflection of light from wavy or interlocked grain. Interlocked grain results from twisting of the annual growth rings in alternate directions along the length of the tree. This occurs in many species, particularly tropical woods such as mahogany, which exhibits numerous crossfire figures.

HEARTGRAIN

Also known as cathedral grain, V-grain, plain sawn, and flat sawn, heartgrain is an annual growth-ring pattern of consecutive V-like shapes that is revealed when parallel vertical cuts are made all the way across the width of a tree. Although trees seem columnar, they grow off-angle enough to provide many different heartgrain patterns.

RING CUTS

When a tree is cut across the trunk, perpendicular to the length of the tree, the resulting pattern is called ring cut. Also known as cross-cut and end grain, this pattern shows the annual growth-ring structure of a tree. The pattern is made up of dark rings (the thinner, more dense latewood [summer] growth) and alternating light rings (the wider, less dense earlywood [spring] growth). As the sapwood (the new rings that supply the tree's nutrients) is added annually at the tree's outer circumference, the heartwood (the older rings surrounding the center or pith of the tree) turns darker. Any cracks that form on the ring cut always lead in toward the heart of the tree.

KNOTS

The patterns of knots vary with the way the tree is cut. Knots represent end-grain sections of a branch that the tree's annual growth rings eventually encapsulated. If the branch was growing at a diagonal to the tree trunk, the knot will be oval; if the branch was growing straight out of the tree, the knot will be round. Since a knot is a miniature ring cut, it exhibits all the characteristics of a ring cut.

BURL

Also known as burr figure, burl is wood from irregular growths on the outside of trees, cut to produce highly ornamental figures. Burls contain thousands of bud formations—would-be knots—and, in some species, a convoluted grain structure. Other species exhibit a pigmented mottling instead of grain lines. For decorative purposes, burl is cut as a veneer only because of its lack of lengthwise grain structure. The outer shell of the whole burl may be fashioned into a thick (up to 1 inch [2½ cm]) bowl.

CROTCH FIGURE

Wood that is cut from the section of certain trees where the central stem (trunk) has begun to form two limbs exhibits strong patterns. This figure, known as crotch figure, changes as the wood is cut further toward the outer circumference of the tree.

Also known as plume, swirl, and feather figures, crotch figure is a strongly contrasted pattern that looks like an upside-down rib cage. When crotch figure is used decoratively, it is usually installed in the reverse manner of the way it forms.

Diffuse-porous

Ring-porous

Pores

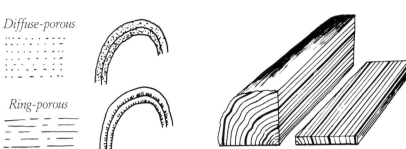

Straight Grain

Straight Grain with Medullary Rays

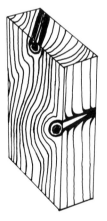

Straight Grain with Crossfire

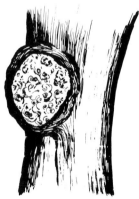

Heartgrain

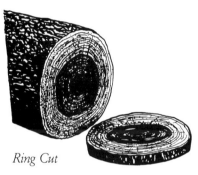

Ring Cut

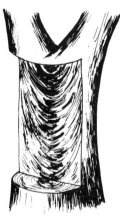

Knots

Burl

Crotch Figure

COLOR

After the pattern of the wood, color is the next most important element in graining. Any type of brown seems to convey "woodiness." Even today our initial reactions to brown surfaces are similar to those who saw brown for centuries on architectural and furnishing surfaces and thought they were looking at real wood.

Since color obviously plays such an important part in the illusion of graining, the first step in realistic graining is to discover the colors of actual wood. Wood veneers are available (see appendix for sources) and are invaluable for studying colors and grain patterns. In addition to real veneers, other sources for studying wood colors are chips on commercial stain charts (as shown below), laminates that simulate woods, and books about woods (see appendix).

The colors of each family of real woods are similar wherever they are found. For example, a wood labeled oak is a light-to-medium-value brown in its natural state wherever it is grown. Mahogany is in the darker, warmer brown family, while cherry is lighter and has more red and less brown. These examples indicate that

wood colors, although basically brown, shift toward other hues; they may be called yellowish, pinkish, reddish, greenish, bluish, and so forth. This is particularly easy to see when comparing one wood color to another, since even a slight shift in color usually helps emphasize the differences between the woods rather than the similarities.

To be used in a functional context (e.g., as a cabinet door rather than as a piece of sculpture), raw wood must be protected from dirt, dust, and stains. The finish coats used for protection change the color of the wood. This change can range from a slight to a dramatic darkening (as shown on the left five pairs of veneers below). The older and dryer the wood, the darker it will turn. Whenever real wood installations must be matched, make sure that you are matching to a piece that already has its finishing coats. A quick method to approximate the change in tonality finish coats will create is to wet an area of the raw wood and study the change in the wood color. The color change with the actual finish coats will be somewhat darker and more amber.

These veneers have been partially shellacked to illustrate how protective coats can result in varying degrees of color changes.

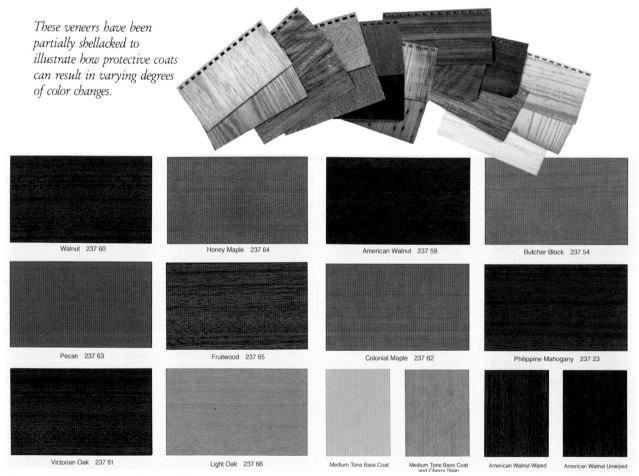

Walnut 237 60	Honey Maple 237 64	American Walnut 237 59	Butcher Block 237 54
Pecan 237 63	Fruitwood 237 65	Colonial Maple 237 62	Philippine Mahogany 237 23
Victorian Oak 237 61	Light Oak 237 66	Medium Tone Base Coat / Medium Tone Base Coat and Cherry Stain	American Walnut Wiped / American Walnut Unwiped

A commercial stain chart, showing the natural colors of woods.

GRAINING IN LAYERS

The approach that we use in developing graining techniques is to analyze real woods so that what is seen as a total optical mix can be divided into separate layers. Isolating separate layers has several advantages, including the following:

• When you are developing a sample, it is easier to select accurate colors and techniques when you are considering only one layer.

• Greater depth is achieved with layering, especially when the translucent properties of toning glazes are exploited.

• There is more control of texture and figure when they are rendered one at a time.

• Options increase when everything is not done in one layer. Techniques from different woods can be combined and the working time of the glaze becomes less of a factor.

• Analyzing and executing woods in layers almost assures that the results will more realistically simulate real wood.

The basic layers are as follows:

1. Base coat

2. Grain pattern, including pore structure

3. Toning, including crossfire

4. Finish coat(s)

The technique demonstrations in this chapter have been set up so that each layer is visible. Note that the number of processes varies for different woods depending on the complexity of the pattern and color relationships.

SELECTING A BASE COAT

When developing techniques, first determine the base coat color. To do this, focus on the lightest color you can see in the real wood. In general, the base coat should be the same hue as this color, but slightly lighter in value and with a slightly higher chroma. This allows for the darkening and muting that the toning glazes will provide in subsequent layers. If dark toning glaze(s) will be used, the base coat could be even lighter and brighter. Taking the time to choose the correct base coat is well worthwhile since it affects all subsequent layers. If you are not sure of the exact base coat to use, choose a light one, as it is relatively easy to darken with toning glazes, and often impossible to lighten. The plates in this book give examples of suitable base coats.

Base coat colors are found in a relatively small part of the spectrum, ranging from bright golden yellow to deep reddish brown (Munsell numbers 10R through 2.5Y). There is a broad range of values and chromas. Although it is hard to generalize, for darker woods you should choose base coats of medium value (4–6 Munsell) and medium-to-high chroma (6–12 Munsell, with higher chroma base coats especially suited to tropical woods). For lighter woods, you should choose base coats of high value (7–9 Munsell) and low chroma (2–4 Munsell).

SELECTING GRAIN-PATTERN COLOR

The color of the grain-pattern layer is usually the easiest to determine, as it often appears as the darkest, most strongly contrasted opaque color seen against the base coat. Pores appear either as short fine lines of the same (or a closely related) color as the grain pattern, or as an overall texture, in which case the color of the pores is usually lighter than the grain pattern. The colors used for grain patterns and pore structure are even more limited than those used for base coats. They are all medium-to-dark-value reddish or yellowish brown (Munsell 2.5YR to 2.5Y). Usually, they are of low value

Making your own comparative stain charts over several base coats can be invaluable when selecting figure and toning colors.

(2–4 Munsell) and low chroma (2–8 Munsell). Colors for the grain pattern and pore structure should be a little lighter than the final result desired to allow for the slight darkening that will occur when the toning glaze(s) is applied.

SELECTING COLOR FOR TONING GLAZES

The colors used for toning are similar to those used for grain patterns and pores, following the same Munsell ranges of hue, value, and chroma. Toning glazes are used for many reasons, including the following:

Unifying. They may lower the contrast between the grain-pattern layer and the base coat, uniting both of them into a more harmonious whole. In addition, they enable more intense colors to be used for base coats (toning down a bright base coat adds interest to a rendering).

Adding depth. They may be used to provide random shading, enriching renditions that would otherwise appear flat and lifeless.

Providing figure. They may be used to simulate crossfire, which is a rather overall mottled effect that ranges from translucent through semiopaque. Crossfire is an integral part of many woods, such as harewood and orientalwood.

Adjusting. They may be used to turn a base-coat color and grain pattern color towards another hue, value, or chroma. This is especially important in cases where the original color choices were misguided.

Choosing toning glazes is easiest when there are semiopaque areas, such as in crossfire. When these are present, focus on the darkest value of the hue that you can see in the real wood and analyze what additional quality is needed. Think along the lines of, "I know it needs to be darker, but does it need more reddish brown, like cherry, or something cooler and bluer, like fruitwood?" Making your own comparative stain charts over several base coats (see page 179) creates an invaluable reference guide for selecting base coat, figure, and toning combinations.

The pigment you select for the toning glaze should be a few shades darker than the final color desired to allow for the lightening that occurs when the pigment is made into a glaze. Both paint-thinner-soluble glazes and tinted finishes can be used as toning layers. Each will create a slightly different translucent effect, with the alkyd glaze masking the underneath layers a bit more than the tinted finish. Another method to add subtle toning is to rub a thicker, more opaque paint coat (rather than a glaze) over the protected surface and then wipe it off, leaving a thin film of "ghost" color. Choices will become easier as your eye becomes attuned to the nuances of these toning options.

Up until now we have been discussing "natural" wood tonalities. Traditionally, innumerable stains, dyes, and pigments have been used to enrich and alter raw-wood tonalities. These range from pickled wood (off-white or pastel paint rubbed into bleached wood) to dark, richly stained mahogany. The imitation of woods that have been stained or dyed can be approached the same way as natural wood; i.e., by analyzing the color and figure of each layer.

MEDIA

Graining effects are achieved by superimposing relatively simple layers. The requirements of graining media are less complicated than for marbling media because there is less manipulation required for each of the layers (burl is the notable exception, because its random-pattern technique is more like marbling than graining). For this reason, there are many viable media options for graining including glazes made from alkyd paints, stains, finishes, beer or apple cider, and aniline powders and shellac.

PAINT-THINNER-SOLUBLE GLAZES

Paint-thinner-soluble glazes for graining can be mixed from alkyd paints, nonpenetrating stains, penetrating stains, and finishes. In addition, undiluted penetrating stains can be used as a glaze.

ALKYD GLAZES

Any of the paint-thinner-soluble paints used for glazing and marbling, such as alkyd interior house paints and japan colors, can be used for graining. There are a wide range of "woody" colors available that can be adjusted with earth colors and black. Consistencies used range from a mixture of two parts paint to one part glaze medium and one part paint thinner, for applied grain lines, to the Basic Alkyd Glaze formula (see page 72), for removal straight-grain lines and toning.

STAIN/GLAZES

Nonpenetrating interior stains (often called opaque, pigmented, wiping, or masking stains) have a high pigment content and are uniquely suited for making graining media we call stain/glazes. The main advantage of nonpenetrating stains is that they come premixed in a wide range of wood colors. Take advantage of all the trouble paint manufacturers have gone to in developing realistic wood tones; if necessary, you can adjust these colors with japan or alkyd paints.

The portion of the nonpenetrating stain that is used in making stain/glazes is the solid pigment that settles to the bottom of a can that has been sitting on a shelf for several weeks (be sure that the paint store does not shake the can or else you will have to wait for the pigment to resettle). Pigment amounts vary among stains from different companies, so try to buy stains that have the most pigment and the least liquid. To use the pigment, first pour off any liquid that is on top of it. The thick, saturated pigment that remains can substitute for alkyd paints in the formulas given above. Because

different products have different consistencies, the formulas may have to be adjusted.

PENETRATING STAINS

Penetrating stains are another type of stain that is used in graining, mostly for toning. These contain little (if any) solids; usually are formulated with transparent aniline dyes instead of the heavier, more opaque pigments found in nonpenetrating stains; and do not have enough body to hold a grain-line pattern.

Use penetrating stains right from the can, without diluting them. You may apply them to the surface with a foam or bristle brush, then wipe them off to your desired depth of color with cheesecloth, facial tissue, or a soft cloth. Note: Because penetrating stains are designed to soak into wood, they do not contain the same driers that are in paints and stains designed to remain on the surface. As a result they remain tacky for a very long time, sometimes seeming as if they will never dry. Before further graining layers or paint-thinner- or water-soluble finishes can be applied over penetrating stains, a shellac barrier coat must be applied. This shellac coat can be applied over stain that is tacky but has no actual wet areas.

GLAZES MADE FROM FINISHES

While usually limited to toning, glazes made from finishes can be used for rendering figure as well. They have a special translucent quality almost like stained glass. Years ago, we developed the following glaze, which we call Marglaze, for a persistent client who would not believe that we could not simulate a mid-nineteenth-century regional variation of painted crotch-figure mahogany.

Marglaze will keep well in a tightly closed container; however, it should be stirred thoroughly before and during use. It is *essential* that before any paint-thinner-soluble medium (e.g., more Marglaze or finish) is applied over the Marglaze, a layer of shellac is applied. Any bit of Marglaze that is not covered with the shellac barrier coat will be dissolved when the next paint-thinner-soluble layer is applied over it.

MARGLAZE

8 parts red mahogany penetrating stain

7 parts high-gloss paint-thinner-soluble finish

5 parts canned black asphaltum

WATER-SOLUBLE MEDIA

Decorative painters traditionally have used water-soluble media for graining. While any water-based paint (such as latex, acrylic, or casein) can be used, the best water-based media for graining is distemper made with beer or, more recently, apple cider. While both beer and apple-cider media are suitable for sophisticated, subtle graining as well as more broadly done and country removal methods, we find the apple-cider mixture clearer, which allows for more brilliant colors.

Three formulas for distemper media are given here. Additional formulas appear in *Country Graining*, page 233.

Water-soluble media are applied over flat base coats. Considering that water-based media usually dries quickly, apple-cider-vinegar distemper has a surprisingly extended manipulation time. There are many advantages for those who take the trouble to explore this medium, including the following:

- the washy, watercolor-like textures and shadings that can be obtained

- the ready availability of powdered pigments and tube watercolors

- the ability of the media to receive an overcoat in an hour or less due to its quick-drying consistency

- the efficiency of not having to use a barrier coat before applying paint-thinner- or alcohol-soluble media

BEER DISTEMPER

3 parts stale (flat) beer

3 parts water

2 parts powdered pigment (not aniline powders)

APPLE-CIDER-VINEGAR DISTEMPER

1 part artists' tube watercolor

2–4 parts apple-cider vinegar (Note: regular vinegar is not glutinous [sticky] enough to act as a binder)

—or—

1 part powdered pigment (not aniline powders)

1–2 parts apple-cider vinegar

- the long shelf life of the media

- the low cost of the media

ALCOHOL-SOLUBLE MEDIA

While not manipulated barrier coats per se, clear shellac barrier coats can be enriched by the addition of aniline powders. Adjust and intermix the colors as needed. Orange shellac also can be used as an isolating layer to impart a rich color.

RENDERING GRAIN PATTERNS

Grain patterns may be done with applied or removal techniques or a combination of both. Choose applied graining techniques where you need controlled placement of individual lines and toning. You may stop and start applied graining whenever you desire.

Removal techniques are used to produce an entire range of graining effects. These effects can be surprisingly realistic and have a natural quality that is difficult to obtain using applied methods. Just as when glazing, you must grain the entire taped-off board or panel while the glaze is wet.

The tools used in graining range from the strié tools used in glazing to traditional graining tools such as steel and rubber combs, rubber heels, pipe grainers, mottlers, and blending brushes. Specific tools are discussed with the techniques where they are used.

PORE STRUCTURE

The unique quality of different pore structures, which in real woods range in size from fine to coarse, in shape from specklike to linear, in coverage from sparse to dense, and in color contrast from subtle to dramatic—is simulated in several ways. The following three techniques for creating pores are the most common:

• flogging

• spattering and whisking

• steel-wool dragging

The effects of these techniques can be compared in the photograph to the right, in which all three techniques were done with the same glaze over the same base coat. Check-rolling, another technique for rendering pores, is used almost exclusively for producing the pore structure of oak graining. It is demonstrated in the instructions for American oak (pages 210–11).

Comparison of pores created by three methods: flogging (1); dragging steel wool (2); and spattering and whisking (3). Each technique was done with a BM 1237 glaze over a BM 1063 base coat.

FLOGGING

Flogging is a removal technique that produces an even layer of closely packed, separate, short (¼- to ½-inch [6 to 12 mm]) strokes that cover the base coat completely. The tool used is a thin, wide brush with long natural bristles called a flogger or dragger. If a flogger is unavailable, try a natural-bristle house-painting brush instead. Whichever brush is used, the final effect should look realistic, with all strokes crisp and vertically aligned.

Flogging provides a "woody" background for any grain-pattern layer that is applied over it. However, flogging is especially effective when done on a glaze that already has been broken up into randomly spaced light and dark streaks. This can be seen in the bottom left photograph, where the medium was applied with a roller and then dragged with cheesecloth before flogging. Strié variations for producing light and dark streaks (such as whether dry or glaze-saturated cheesecloth is used and what degree of pressure is applied) alter the visual texture of the flogging.

Many woods that do not have a defined grain pattern can be imitated simply by manipulating the toning layer(s) over a flogged surface, as can be seen in the instructions for orientalwood on pages 196–97.

Although distemper media (mostly beer) have been used for hundreds of years for flogging, we have found that other media may be used as well; glaze formulas made with paint or stains are particularly suitable.

Technique

1. Apply the media with a brush or roller (on larger surfaces you might need to keep a wet edge ahead of the flogging).

2. Begin flogging in a lower corner. Slap the flogger down and lift it up, keeping the bristles as parallel to the surface as possible.

3. Repeat this process while moving rhythmically up the surface in ½-inch to 1-inch (1¼ to 2½ cm) increments.

4. After completing one brush-width row, move to the bottom edge of the next row and repeat the process.

5. If you want additional light streaks in certain areas, drag cheesecloth through the media once more with heavier pressure and flog these areas again.

6. Repeat the process of applying glaze, flogging vertical rows bottom to top, adding light streaks, and continuing on to adjacent rows until the entire surface is completed.

If your strokes look imprecise, sloppy, and splayed out in all directions, you probably did not remove enough media during the wiping stage. It is surprising how little glaze is needed to properly execute this texture. Minor imperfections, such as out-of-line brush strokes, may be repaired by lightly touching the surface with the edge of the flogger, and moving it up the surface in ½-inch to 1-inch (1¼ to 2½ cm) increments.

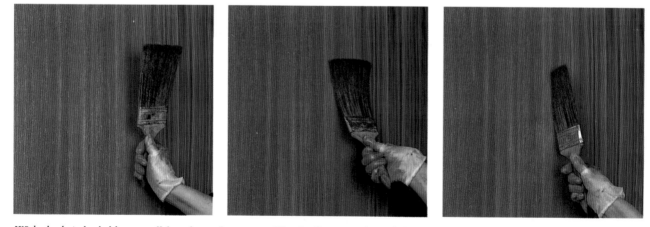

With the bristles held as parallel to the surface as possible, the flogger is slapped down and lifted up (above, left and center). Note the position of the wrist—and the dragged texture of the yet-to-be flogged section. The thin edge of the flogger can be used to realign the pores and fix other imperfections (above, right).

SPATTERING AND WHISKING

Spattering and whisking is an applied technique that simulates pores by creating ¼-inch to ⅜-inch (6 to 9 mm) irregularly spaced fine streaks. This technique allows control of both coverage (ranging from light to dense) and quality of the pores.

To spatter, lightly load a spattering brush with a small amount of spattering media (see formula to the right). The brush used to spatter can be any brush that is springy enough to flick off bits of media—toothbrushes or cut-off brushes, for example. Aim the loaded brush at a specific area and, with your index finger, flick the bristles slowly in succession. To avoid blotchy patches of spatter, keep moving your hand across the surface while flicking the bristles.

In addition to the consistency of the medium, other factors that affect spatter quality and density are how heavily the brush is loaded, the distance the brush is held from the surface, and how fast the hand is moved. Test media consistency and your technique on scrap paper before spattering an actual surface.

The whisking process is done while the spatters are still wet. Flexible, stiff-bristled brushes (e.g., hog-bristle shellac brushes) are used to elongate and align the spatters. Hold the whisking brush so that the handle is parallel to the spatters and drag the brush along the direction of the grain. Select the size of the area to be spattered by determining how quickly the media is drying and the whisking can be done.

Although flicking a brush is the spattering technique that gives you the most control, you can also spatter media by moving a loaded brush along the teeth of a hair comb that is held parallel to the surface or by hitting a loaded brush against a piece of wood that is held a few inches from the surface. There is also a tool specially made for spattering, called a fuso machine, that is useful for those who spatter a great deal.

<div style="border:1px solid">

SPATTERING MEDIA

2 parts nonpenetrating stain pigment

1 part glaze medium

1 part paint thinner

Adding more solvent (or less pigment) will form larger, translucent pores; using thicker media will create pores that are finer and more opaque.

</div>

STEEL-WOOL DRAGGING

Simply dragging steel-wool pads through wet glaze gives an effective wood texture that has almost as much coverage as achieved with flogging as well as the broken quality obtained by spattering and whisking. Since steel wool is not absorbent, the markings appear darker than those from flogging or spattering and whisking. In addition, steel wool "bleeds" gray when used with paint-thinner-soluble media (if this is not desirable, use bronze wool instead). The quality of the texture is affected by the following factors:

The grade of steel wool used. The coarser the steel wool, the broader the texture. Steel wool is graded, from coarsest to finest, as 3, 2, 1, 0, 00, 000, and 0000.

Whether the steel wool is continually refolded to expose fresh areas. Fresh steel wool will remove more glaze than steel wool that is saturated with glaze.

The number of passes over the surface. Each pass breaks up the glaze into finer, more broken lines.

Factors that affect all glazing techniques. These would include the consistency of the glaze and the color contrast between the base coat and glaze.

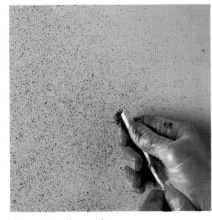

Spattering the media.

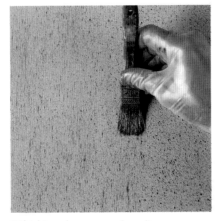

Whisking the spattered media to produce pores.

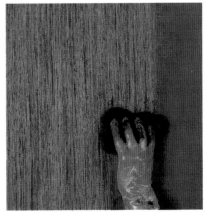

Dragging a steel-wool pad down a glaze to create pores.

STRAIGHT-GRAIN WOODS

Grain lines that are relatively straight and parallel—called straight grain—are a basic element found in many woods. Exploring different tools and techniques to render this simple grain pattern (to be used alone, with heartgrains, and/or under toning glazes) will yield limitless possibilities, particularly considering the color interaction among the base coat, figure coat, and toning layers. With the exception of bird's-eye maple, burl, and crotch-figure mahogany, all of the woods in this book use some form of straight graining.

Although straight-graining techniques are simple, keeping in mind certain basics about straight-grain patterns will make the rendering realistic and logical. All grain lines are yearly growth rings, forming as if they are columns encircling the whole tree. Each column must remain separate from the other. This means that

• grain lines may not cross over, converge on, or cut off

another grain line; and

• all grain lines must reach every edge of the rendering.

When two separate boards are butted together, the grain lines at the edges often appear to converge. A joint line separating the two boards will clarify the pattern.

STRAIGHT-GRAIN CHART

This chart illustrates the wide variety of straight grains that can be achieved using various removal tools—from a nylon pot scrubber (example 7) to traditional graining combs (examples 6, 9, and 11). The selection of tools on the chart by no means should be considered definitive. In-studio experimentation (or focused playtime) will no doubt uncover countless others that could be used. All of these examples were done with the same glaze and base coat with no additional toning.

The tools used to drag through the wet glaze are listed below. All examples were done with a BM 1237 glaze over a BM 1110 base coat.

1. Horizontally pleated plastic, dragged once, with hesitation.

2. Dragger/flogger dragged once vertically. When the glaze was almost dry, the dragger/flogger was pulled across horizontally. Good for mahogany and satinwood.

3. Synthetic-bristled brush, dragged once.

4. Overgrainer brush, dragged once, with hesitation. Good for walnut.

5. Ribbed carpet, dragged once.

6. Steel comb with ⅛-inch (3 mm) teeth, wrapped with the smooth (right) side of stockinette and dragged once, with hesitation.

7. The sharp, 90-degree edge of a plastic-looped pot scrubber.

8. Flogger, dragged once vertically.

9. Triangular rubber comb, dragged once vertically. While the glaze was still wet, the comb was dragged again, slightly off-angle, over the same surface. Good for both American and quarter-sawn English oak.

10. The textured (wrong) side of stockinette, crumpled, with many depressions. Heavy finger pressure was used to create the lighter stripes.

11. Steel comb with ⅛-inch (3 mm) teeth, wrapped with well-washed sheeting to absorb the medium. Good for harewood and sycamore.

12. Triangular rubber comb, combed once.

13. The smooth (right) side of stockinette, crumpled, with many depressions.

14. Widely notched cardboard, dragged through several times, then whisked lengthwise. Good for zebrawood.

15. Cheesecloth, crumpled with many depressions, then flogged.

16. The sharp, 90-degree edge of a synthetic sponge.

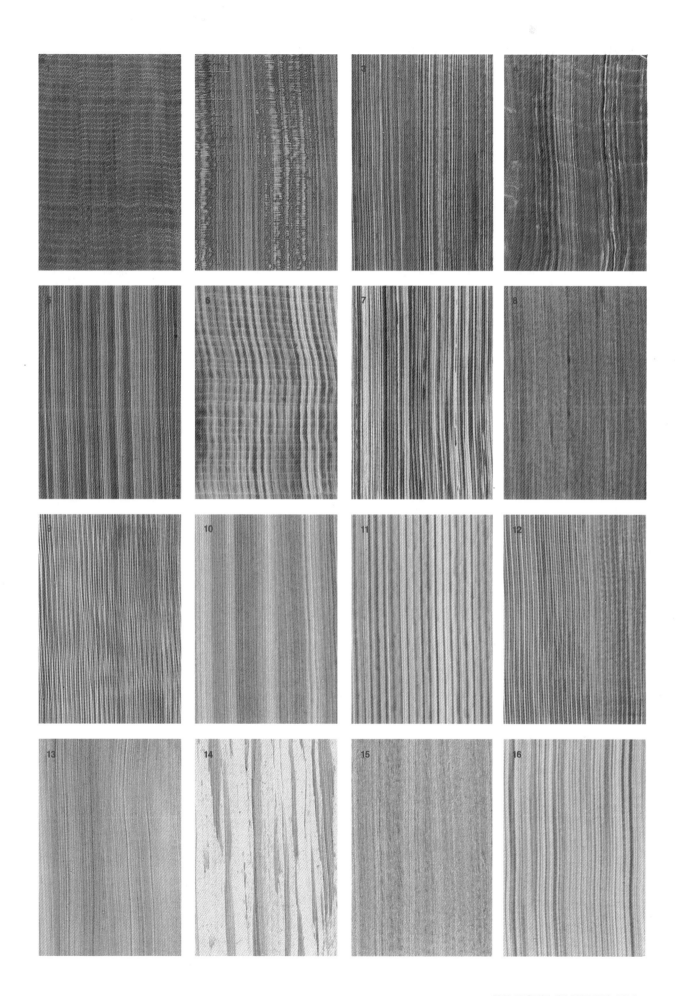

MACASSAR EBONY

Macassar ebony is a valuable East Indian wood that is most often used as a straight-grain veneer. It was particularly popular during the Art Deco period on furniture. Today, it is used both architecturally and on furnishings.

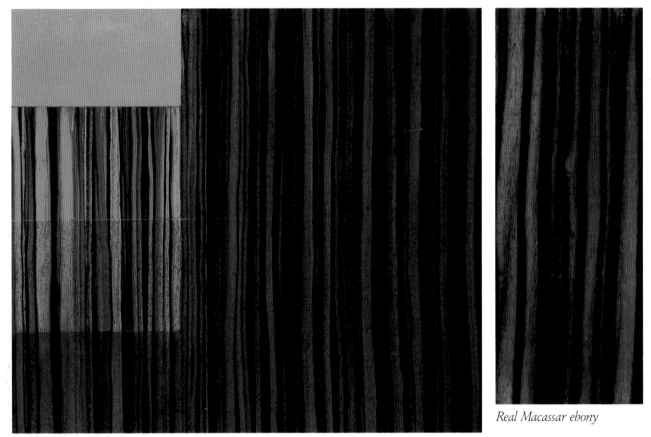

Real Macassar ebony

Stages of painting Macassar ebony; inset shows base-coat layer (BM 1210), figure layer, and pore-structure layer.

BASE COAT	TOOLS
Medium dark orange-brown sheened alkyd interior house paint	one or more pieces of cut cardboard (or a cut squeegee)
MEDIA	brush or roller
1. black alkyd glaze: 2 parts black flat or sheened alkyd interior house paint, 1 part glaze medium, 1 part paint thinner	cotton swabs
	toothbrush
	whisking brush
2. dark oak penetrating stain, undiluted (or other dark toning glaze)	foam brush (optional)
3. shellac: 1 part three-pound cut shellac, 1 part denatured alcohol	cheesecloth
	facial tissue (optional)
4. finish (either paint-thinner- or water-soluble)	

TECHNIQUE

Prior to Painting

Cut the cardboard in a pattern that will leave uneven, random stripes of glaze up to ½-inch (1¼ cm) wide and base coat stripes no wider than ¼ inch (6 mm). The cardboard should have more "spaces" than "teeth," so that there will be enough glaze to manipulate after the first removal.

Figure Layer

1. Apply the black glaze to the surface with a brush or roller. Coverage should be opaque, but not so heavy that the glaze drips, sags, or spreads.

2. Pull the cardboard through the glaze to form sharp stripes. Although the stripes should be generally parallel, some very slightly off-angle and/or minutely curved sections will foster realism.

3. Pull cotton swabs through the glaze before it dries, following the angle of the stripes. Two swabs, as well as one, may be held together and pulled through. Drag the swabs both along the edges of and off-center within the black stripes; this colors the base coat with a translucent layer of black glaze and at the same time opens up channels of different widths. Exert varied pressure to create many subtle half-tones.

4. Let the glaze dry and isolate this layer with shellac. Let the shellac dry.

Pore-structure Layer

1. Spatter and whisk the black glaze (see page 185) in the direction of the grain. Coverage should be just enough to mute the solid, opaque base coat, but not so much that it makes the base coat appear gray.

2. Let the glaze dry and isolate this layer with shellac. Let the shellac dry.

Toning Layer

1. Apply the dark oak penetrating stain to the entire surface with a foam brush or cheesecloth.

2. Using varied pressure, wipe cheesecloth or facial tissue on the surface to create light and dark areas that enhance the illusion of yearly growth patterns. Wipe in the direction of the grain in unevenly spaced streaks.

3. Let the stain dry and isolate it with shellac. Let the shellac dry.

4. Apply finish coat(s) as desired.

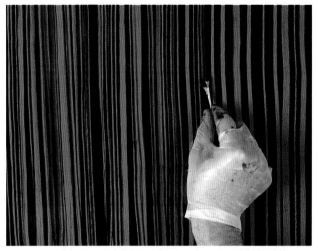

Dragging two cotton swabs down the stripes divides them into random widths, at the same time creating additional tones.

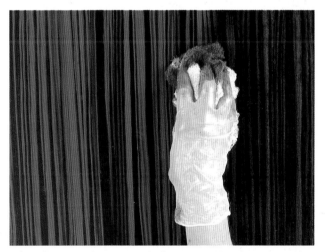

After the toning layer is applied, it is wiped with cheesecloth in unevenly spaced streaks to create light and dark areas.

ZEBRAWOOD

Zebrawood, also known as zebrano and zingara, is a West African wood used almost exclusively as a straight-grain veneer, both architecturally and in furnishings. Like Macassar ebony, zebrawood exhibits parallel stripes and is valuable. The dissimilar visual appearance of the two woods regarding color (dark vs. light), stripe-streak size (wide vs. narrow), and toning (all-over dark vs. subtle light) demonstrates how exploring various grain intervals and color possibilities can produce a whole range of straight-grained woods.

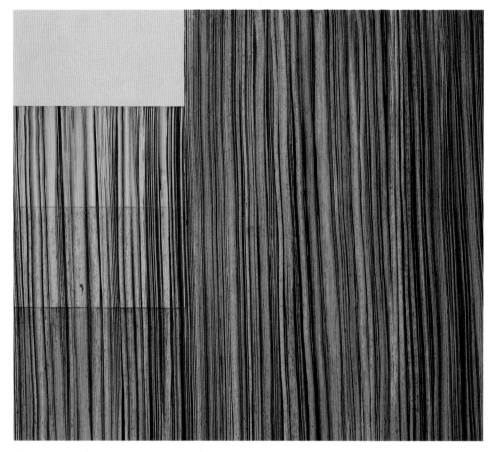

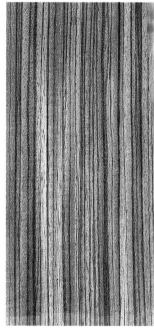

Above: *Real zebrawood.*

Left: *Stages of painting zebrawood; inset shows base-coat layer (BM 164), figure layer, and pore-structure layer.*

<u>BASE COAT</u>

Pale beige sheened alkyd interior house paint

<u>MEDIA</u>

1. dark walnut stain/glaze: 2 parts dark walnut nonpenetrating stain pigment, 1 part glaze medium, 1 part paint thinner

2. light walnut stain/glaze: 2 parts light walnut nonpenetrating stain pigment, 1 part glaze medium, 1 part paint thinner

3. fruitwood stain/glaze: 2 parts fruitwood nonpenetrating stain pigment, 1 part glaze medium, 1 part paint thinner

4. finish (either paint-thinner- or water-soluble)

<u>TOOLS</u>

one or more pieces of cut cardboard (or cut squeegee)

brush or roller

nylon-looped kitchen pot scrubber (or any other removal tool that will give fine, sharp lines)

cotton swabs

toothbrush

whisking brush

cheesecloth

TECHNIQUE

Prior to Painting

Cut the cardboard to the same scale as was used in Macassar ebony; that is, leaving randomly spaced glaze stripes up to ½ inch (1¼ cm) in width and base-coat stripes no more than ¼ inch (6 mm) wide, with more "spaces" than "teeth." (In fact, the same cardboard was used for both the Macassar ebony and zebrawood demonstrations.)

Figure Layer

1. Apply the dark walnut stain/glaze with a brush or roller.

2. As in Macassar ebony, pull the cardboard through the glaze to produce sharp stripes.

3. Drag the nylon pot scrubber one or more times along the direction of the grain to break up the dark stripes into thin, defined lines.

4. Open up the texture and add interest here and there by dragging cotton swabs along the stripes. Then, if you like, drag the pot scrubber through the glaze again one or more times. In zebrawood there are often groupings of narrowly spaced thin lines among wider-spaced bands, an effect that can be obtained with the cotton swab if needed.

5. Let the glaze dry and isolate the layer with shellac. Let the shellac dry.

Pore-structure Layer

1. Using the light walnut stain/glaze, spatter and whisk (as shown on page 185) with the direction of the grain. Coverage can vary from rather dense to almost nothing, but should be consistent within each stripe. A cotton swab can be used to lessen coverage on some stripes.

2. Let the glaze dry and isolate the layer with shellac. Let the shellac dry.

Toning Layer

1. Use cheesecloth (or a brush) to apply streaks of the light and dark walnut and fruitwood stain/glazes.

2. While the glazes are wet, wipe all excess media off the surface with cheesecloth, leaving a slight film of translucent color. As always, aim for random, uneven distribution of color and pattern.

3. Let the glazes dry and isolate the layer with shellac. Let the shellac dry.

4. Apply finish coat(s) as desired.

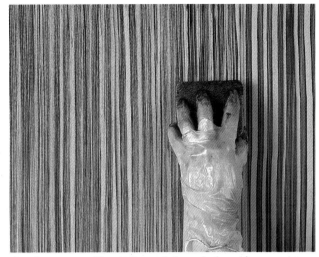

A nylon pot scrubber is dragged through the wider, more opaque stripes to create finer lines and lighter color.

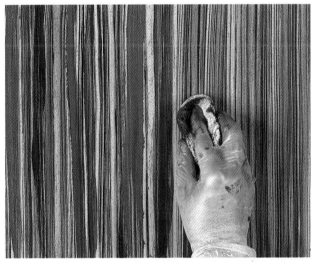

While the glazes are wet, cheesecloth is used to wipe excess media off the surface, leaving a slight film of translucent color.

STRAIGHT GRAIN WITH MEDULLARY RAYS

Oak is one of several woods that exhibit a unique pattern of rays or streaks—but only when the wood is quarter-sawn. The rays, known as medullary rays, interrupt the tan-to-dark-brown straight grain. These rays, radiating outwards from the center of the tree, can vary from thin and slight all the way to large, showy, and lustrous. They also vary in direction. The following guidelines will keep them looking realistic and natural:

• The most important (and trickiest) concept is that medullary rays follow a consistent direction and shape along any specific vertical strip. In other words, although the rays curve, if you look at any isolated 1- to 3-inch (2½ to 7½ cm) vertical strip, the rays appear to curve in the same direction. (Note: this is true even in the traditional stylized renderings.)

• The rays viewed as a whole generally exhibit a strong diagonal flow. They often have relatively straight sides and arcs at the top and bottom. The pattern of different pieces will vary according to where and how the wood is cut; straight markings are usually seen as oblique to the straight grain, and the curves seen at the top and bottom of the arc seem to approach the perpendicular.

• The rays vary in size and are shingled; that is, the lower end of one overlaps the top end of an adjacent one.

• The rays generally start thin, widen out a bit, and then thin again. The streaks that are horizontal are sometimes wider and thicker than the diagonal streaks.

• Although the rays can curve down or up, they do not curve both ways in the same short marking. In other words, do not make an "S" curve.

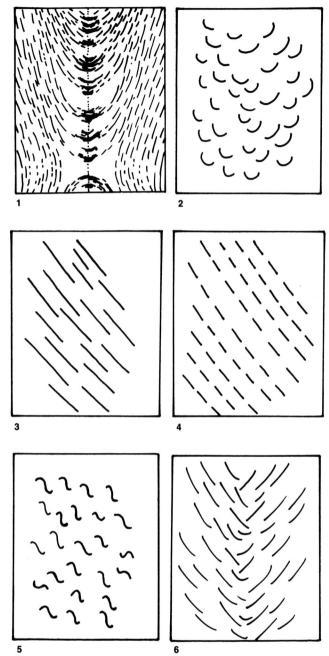

Correct configuration of medullary rays (1). Incorrect configurations of medullary rays: scoops (2); too straight (3); no shingling (4); double curves (5); and out of line (6).

ENGLISH BROWN OAK, QUARTERED

Often known as English quartered oak, English brown oak is, in reality, white oak that gets its color from the infestation of bacteria that occurs after limbs are cut (pollard is the term for this process). The more rare green oak gets its color from mineral infiltrates.

The great dimensional stability and medullary ray patterns of English quartered oak have made it a favorite for more than five centuries for use in architectural elements and furnishings. It has been rendered, traditionally, with removal techniques.

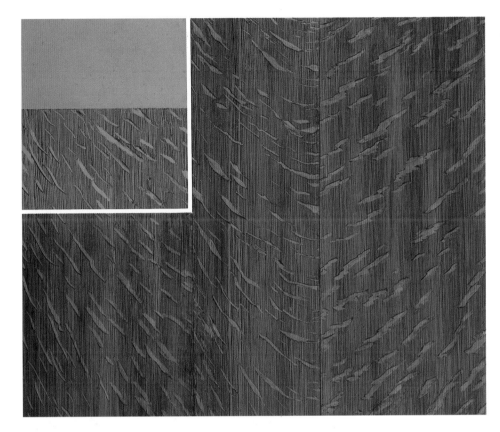

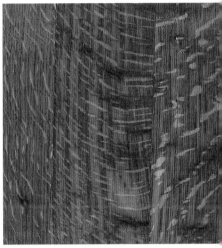

Above: *Real English brown oak, quartered.*

Left: *Stages of painting English brown oak, quartered; inset shows base-coat layer (BM 1063) and figure layer.*

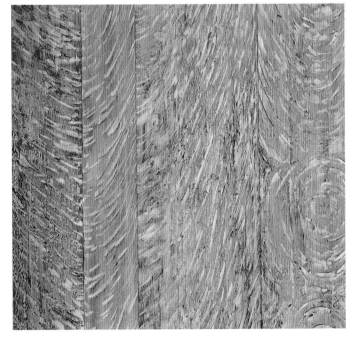

Stylized rendition of butted veneers of green English oak, quartered.

BASE COAT

Beige sheened alkyd interior house paint

MEDIA

1. fruitwood stain/glaze: 2 parts fruitwood nonpenetrating stain pigment, 1 part glaze medium, 1 part paint thinner

2. oak stain/glaze: 2 parts oak nonpenetrating stain pigment, 1 part glaze medium, 1 part paint thinner

3. walnut stain/glaze: 2 parts walnut nonpenetrating stain pigment, 1 part glaze medium, 1 part paint thinner

4. shellac: 1 part three-pound cut shellac, 1 part denatured alcohol

5. alcohol (optional)

6. paint thinner (optional)

7. finish (paint-thinner-soluble or water-soluble)

TOOLS

three foam brushes

steel comb with ⅛-inch (3 mm) teeth

several squares of well-washed sheeting

triangular rubber comb

the rubber top of a mucilage container, a rubber eraser with a beveled edge, or a piece of cut potato

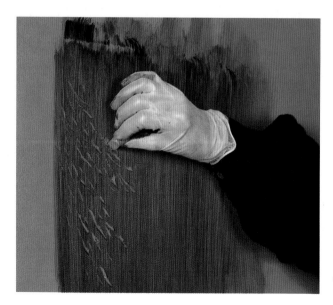

TECHNIQUE

Note: All of the following stages must be done before the media dry.

Straight-grain Patterns

1. With foam brushes, apply the three stain/glazes to the surface in vertical streaks. The walnut stain/glaze should be the least visible.

2. Wrap the steel comb in the square of well-washed sheeting and pull it fairly vertically through the stain/glazes several times. For better absorbency, adjust the cloth to a clean surface before each combing.

3. Comb through the stain/glazes with the triangular comb at an angle very slightly off the vertical, to break up the previously combed lines.

Medullary-ray Patterns

1. Plan the pattern (it may be helpful to sketch it first).

2. Press the sharp edge of the rubber mucilage top, eraser, or potato piece into the glaze in the predetermined direction (a piece of horn wrapped in cloth was used by traditional grainers). As you make your stroke, twist the tool downward so that the beveled section touches the glaze; this will wipe out a wider area. Continue the stroke, lifting the tool up into the position in which it began.

3. Let the layer dry, then isolate it with shellac. Let the shellac dry.

4. Make any necessary adjustments to the strokes by cutting through the shellac with a bit of alcohol, then with paint thinner, to remove and straighten out the offending stroke or strokes. Restore the surrounding area as necessary.

5. Let the layer dry, then coat it with shellac. Let the shellac dry.

6. Apply finish coat(s) as desired.

7. If you wish, apply a toning layer of oak stain/glaze over the finish. Let the stain/glaze dry.

8. Apply finish coat(s) as desired.

The top of a mucilage bottle is used to create medullary rays (other sharp-edged flexible tools can be used as well).

STRAIGHT GRAIN WITH CROSSFIRE

Crossfire, which old-timers used to call the "flower" of the wood, is the visual manifestation of interlocking grain lines. Its appearance changes in color according to the angle at which light hits the wood. This change can be quite dramatic (and unnerving when attempting to match real wood).

Crossfire may or may not have a repetitive pattern, and it can either cover the entire surface or be limited to specific areas. The easiest way to get a natural-looking crossfire is to roll, pat, or stroke some sort of tool through translucent glaze. Many tools and materials can be used, such as the back of a graining comb, the tip of a flogger, or a rag held with your fingers spread apart. While still wet, the medium is then softened and blended with a brush or cheesecloth. The process of obtaining a kind of rhythmic crossfire figure by patting bunched-up chamois in vertical lines and softening is shown in the photographs below.

The first strokes of the blending of the wet glaze should be with the direction of the crossfire. Next, you should brush across perpendicular to these mottles (this is called cross-brushing). Continue brushing, alternating directions, until no brush strokes are visible. Wipe the brush in between strokes so that the glaze is lifted from the surface rather than redeposited. Vary your pressure according to the amount of glaze that must be reduced and fused. End by brushing along the original direction.

An applied method of producing crossfire mottles would be used when a very specific pattern is needed (for example, in bird's-eye maple, pages 202–204).

Tools and their crossfire effects (from top to bottom): wavy mottler, pushed into wet medium; back edge of steel comb, slid into wet medium; pleated plastic, rolled into wet medium; crushed chamois, rolled into wet medium. After being manipulated with the tool or material, the glazes on the right half of each surface were softened by cross-brushing with a blending brush.

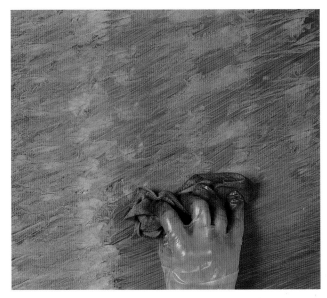

Bunched-up chamois can be used to imprint crossfire.

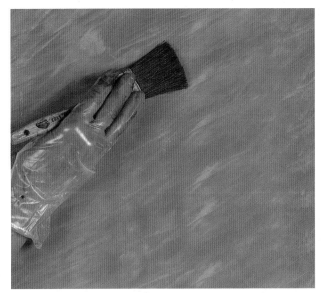

The chamois imprint is then softened with an ox-hair blending brush.

ORIENTALWOOD

Orientalwood, also called Australian walnut after its place of origin, exhibits bands of medium wood tones overlaid with darker oblique crossfire. It is used both for architectural elements and furnishings.

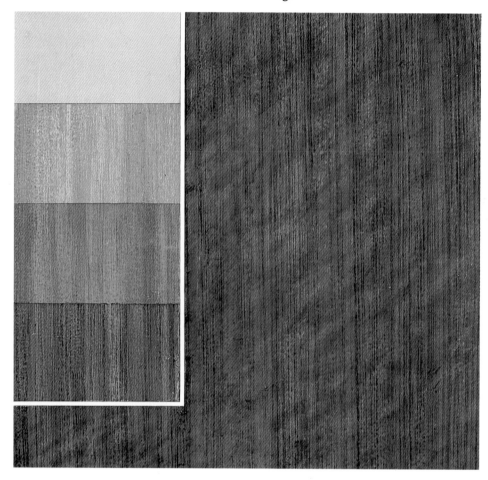

Above: *Real orientalwood.*

Left: *Stages of painting orientalwood; inset shows base-coat layer (BM 1062), pore-structure layer, interim toning layer, and figure layer.*

BASE COAT

Yellow-beige sheened alkyd interior house paint

MEDIA

1. walnut stain/glaze: 2 parts walnut nonpenetrating stain pigment, 1 part glaze medium, 1 part paint thinner

2. red mahogany stain/glaze: 2 parts red mahogany nonpenetrating stain pigment, 1 part glaze medium, 1 part paint thinner

3. dark walnut stain/glaze: 2 parts dark walnut nonpenetrating stain pigment, 1 part glaze medium, 1 part paint thinner.

4. black alkyd glaze: 2 parts black flat or sheened alkyd interior house paint, 1 part glaze medium, 1 part paint thinner

5. shellac: 1 part three-pound cut shellac, 1 part denatured alcohol

6. finish (paint-thinner- or water-soluble)

TOOLS

brush or roller

cheesecloth

flogger

1-inch (25 mm) foam or bristle brush

blending brush

TECHNIQUE

Pore-structure Layer

1. Apply walnut stain/glaze with a brush or roller.

2. Pull cheesecloth through the glaze to create straight grain.

3. Flog (see page 184).

4. Let the glaze dry and isolate the layer with shellac. Let the shellac dry.

Interim Toning Layer

1. Use cheesecloth to apply a thin film of red mahogany stain/glaze in streaks.

2. With a dry cheesecloth, reduce any heavy areas and, if desired, wipe out more long streaks.

3. Break up the texture slightly by flogging.

4. Let the toning glaze dry and isolate the layer with shellac. Let the shellac dry.

Figure Layer

1. Apply the red mahogany, dark walnut, and black glazes in random streaks with cheesecloth.

2. Pull cheesecloth through the glazes. If enough glaze was applied, there should be a texture of fine grain lines of the lower layers showing through.

3. Flog (see page 184). Note: This stage shows how a convincing imitation can be achieved simply by combining flogging with streaking in various wood colors. Note how a "cool" first layer was warmed up with the red mahogany toning and how definition was added by using black.

4. Let glazes dry and isolate the layer with shellac. Let the shellac dry.

Crossfire Layer
(In this color demonstration we used an applied method to render the crossfire.)

1. Using the 1-inch (25 mm) foam or bristle brush, apply the walnut and dark walnut stain/glazes in short, oblique strokes. These should interlock and be consistent in angle.

2. Soften the pattern by lightly stroking the blending brush over the surface, first in the direction of the strokes, then perpendicular to the strokes. Repeat if necessary, being sure to have the final brushing with the direction of the strokes.

3. Let the glazes dry and isolate the layer with shellac. Let the shellac dry.

4. Apply finish coat(s) as desired.

ENGLISH HAREWOOD

English harewood, also known as English sycamore, is a naturally white wood that in the early nineteenth century was often dyed a silvery green-gray. Today it is altered with stronger dyes as well. In addition to pale vertical markings, harewood exhibits a definite horizontal crossfire. A handsome straight grain with crossfire, harewood veneer is used both for architectural elements and furnishings.

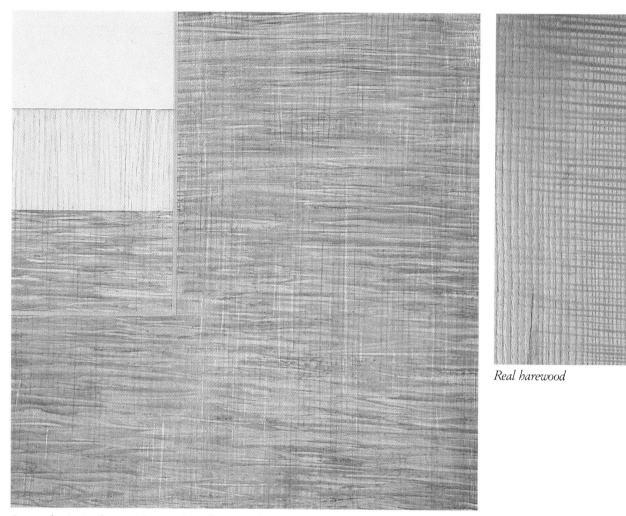

Real harewood

Stages of painting harewood; inset shows base-coat layer (BM 164), figure layer, and crossfire layer.

BASE COAT

Pale beige sheened alkyd interior house paint

MEDIA

1. fruitwood stain/glaze: 2 parts fruitwood nonpenetrating stain pigment, 1 part glaze medium, 1 part paint thinner

2. shellac: 1 part three-pound cut shellac, 1 part denatured alcohol

3. alizarin crimson acrylic

4. water-soluble finish

TOOLS

brush or roller

metal graining comb with ⅛-inch (3 mm) teeth

several cloth squares cut from old bedsheets or other absorbent cloth

blending brush (optional)

TECHNIQUE

Figure Layer

1. Apply the glaze with a brush or roller.

2. Wrap the teeth of the graining comb with the cloth and drag the comb through the glaze to create soft, straight, evenly spaced grain lines.

3. Let the glaze dry and isolate the layer with shellac. Let the shellac dry.

Crossfire Layer

1. Apply the glaze with a brush or roller.

2. Wrap the back end of the graining comb in a cloth (see page 195) and rhythmically wipe straight interlaced horizontal streaks of varying lengths. Be sure that there are areas of different strengths and densities. Some softening with a blending brush might be necessary. The overall effect should be a natural flow with no streaks out of line or character.

3. Let the glaze dry and isolate the layer with shellac. Let the shellac dry.

Toning Layer

Since this sample needed only a "hair" of toning, we used a tinted finish both to give a soft, uniform toning and for protection.

1. Mix a speck of alizarin crimson acrylic with a water-soluble finish.

2. Apply additional finish coat(s) as desired.

AMERICAN SYCAMORE

American sycamore differs from harewood in that the crossfire is lighter and less linear, with a distinctive broken pattern.

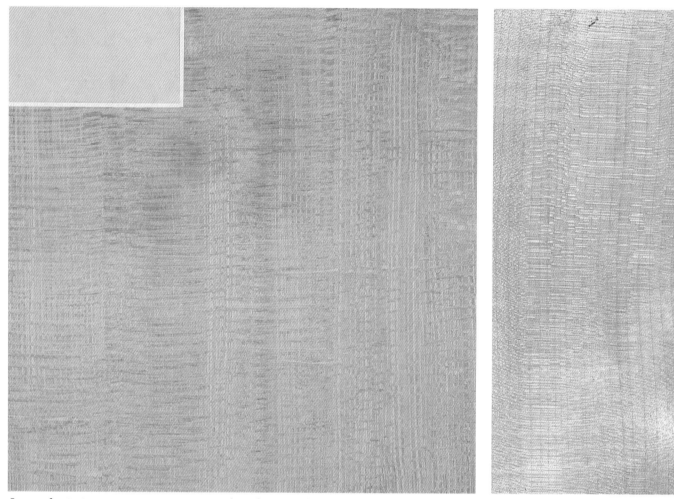

Stages of painting American sycamore; inset shows base-coat layer (BM 164).

Real sycamore

BASE COAT

Pale beige sheened alkyd interior house paint

MEDIA

1. oak stain/glaze: 2 parts oak nonpenetrating stain pigment, 1 part glaze medium, 1 part paint thinner

2. finish (paint-thinner- or water-soluble)

TOOLS

brush or roller

metal graining comb with ⅛-inch (3 mm) teeth

several cloth squares cut from old bedsheets or other absorbent cloth

sycamore roller (As its name implies, this tool is specifically designed to give the distinctive sycamore crossfire pattern. It consists of long raised-rubber lines on one side and short ones on the other. It is especially effective when used with pale colors or overglaze.)

TECHNIQUE

1. Apply glaze with a brush or roller. Uneven application of the glaze will add interest by giving variation in color depth.

2. Wrap the teeth of the graining comb with a cloth square and drag the comb through the glaze.

3. While the glaze is still wet, roll the sycamore roller along the direction of the grain lines.

4. Move the roller so that it overlaps the lines just done and then repeat the process. Overlapping will make the pattern appear intermingled. The roller can be flipped to change the direction of the slightly curved lines and/or cut to give a nonrepetitive pattern.

5. Continue rolling over the entire surface, varying the amount of overlap, the direction of the curve, and the pattern.

6. Let the glaze dry and isolate the layer with shellac. Let the shellac dry.

7. Apply finish coat(s) as desired.

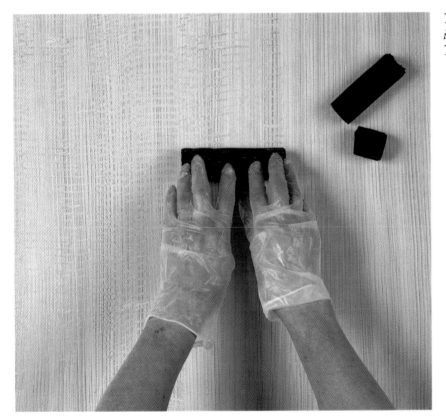

The sycamore grain pattern is imprinted into the wet media with a rubber roller. The roller can be cut, as shown.

BIRD'S-EYE MAPLE

Maple is a light wood that through the years has been fashionable in several different colors. Biedermeier maple (a maple used in early-nineteenth-century Germany) now has a strong, almost yellow-orange color (probably from the ambering of the finishes over time). Victorian maple was less brilliant. Today, because maple absorbs aniline dyes so well, it is being shown in grays, blues and other colors in addition to natural browns.

Bird's-eye maple, a variety of sugar maple, differs from regular maples by having a pronounced crossfire figure. (Curly [tiger] maple also has crossfire, but it is more regular in pattern—see page 237.) Accompanying the crossfire figure in bird's-eye maple are small areas of swirling grain (pects) scattered throughout the wood. These pects give the wood its name, as they resemble miniature eyes.

Our method of painting bird's-eye maple is unique in two ways: (1) We use an applied rather than a removal method for the crossfire (this eliminates the need for a wet edge as well as allowing us more control in forming the shapes of the crossfire), and (2) we prefer to render the crossfire figure first (permitting more selective placement of the "eyes" within the outer fringes of the crossfire, as they appear in the real wood).

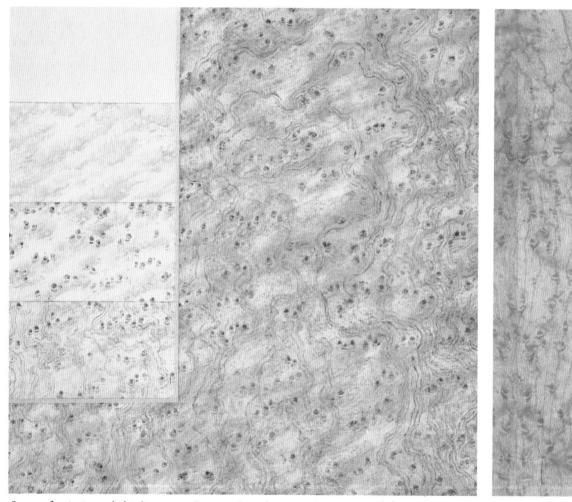

Stages of painting pale bird's-eye maple; inset shows base-coat layer (BM 164), crossfire layer, painting the "eyes," and adding grain lines.

Real bird's-eye maple, showing crossfire and pects (eyes).

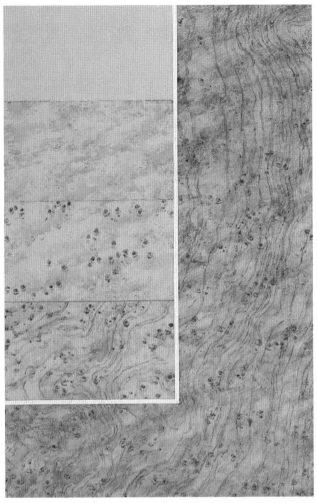

Stages of painting a darker bird's-eye maple; inset shows base-coat layer (BM 1110), crossfire layer, painting the "eyes," and adding grain lines.

BASE COAT
Pale beige sheened alkyd interior house paint
MEDIA
1. light maple stain/glaze: 2 parts light maple nonpenetrating stain pigment, 1 part glaze medium, 1 part paint thinner
2. shellac: 1 part three-pound cut shellac, 1 part denatured alcohol
3. finish (paint-thinner- or water-soluble)
TOOLS
flat, wide palette
long narrow section pulled from a natural sea wool (marine) sponge
newspaper
blending brush
cotton swabs
#0 artists' script liner brush
rubber wipe-out tool (optional)
1-inch (25 mm) bristle brush
cheesecloth

TECHNIQUE

Crossfire Layer

1. Pour the glaze into the palette.

2. Dip the long edge of the sponge into the glaze.

3. Offload any excess glaze onto the newspaper, if necessary, so that the imprint from the sponge shows clear, separated clusters.

4. Apply glaze from the lightly loaded sponge to the sheened base coat in rather rhythmic diagonal ridges. Interlace the placement instead of making long, continuous lines. An area of up to 1 foot (30 cm) square may be done at once, according to the speed at which you work.

5. While the glaze is still wet, brush the blending brush over the surface, first with and then against the direction of the crossfire. Use more pressure than usual for blending. This will lighten the tonality, diffuse the edges, and create irregular outlines. Clean the brush intermittently to maintain the light, delicate effect.

6. The pattern from the sponge will create natural places in which to paint the "eyes." If necessary, you can add other areas using a cotton swab to rub out indentations along the edges of the mottle (emphasizing the concave areas left by the marine sponge) and a few holes within some of the mottles. Placement should be random, with some single and double holes, and others nestled in groups.

Painting the "Eyes"

1. Dip the script liner brush into the stain/glaze and paint small, rather irregularly shaped circles and ovals in the "depressions" in the crossfire.

2. Paint a small arc underneath each circle or oval.

3. If necessary, clarify the line between the arc and the circle or oval by wiping out additional glaze with the back of a brush or a rubber wipe-out tool.

Adding Grain Lines

Note: this layer can be done with or without first isolating the "eyes."

1. With the script liner brush, use the stain/glaze to paint fine grain lines running from the top to the bottom of the rendition. Although the patterns of these lines should vary greatly, the following guidelines will help keep them realistic and pleasing to the eye:

- The overall pattern is often similar to heartgrain (see pages 205–209) in that there are closely spaced lines running the length of the board, curving around certain groupings in their vertical path. However, the lines themselves are much more contorted and not as regularly spaced as in most

heartgrains.

- These vertical grain lines relate to adjacent ones by following similar contours for a little while and then breaking off into almost fanciful curvy lines. The effect is similar to a topographical map.

2. Skive the lines with a cotton swab so that they are very fine. Thin lines are less obtrusive and add a subtle texture with a greater margin for placement.

3. Let the glaze dry and isolate the layer with shellac. Let the shellac dry.

Toning Layer

1. Apply glaze over entire surface with the bristle brush.

2. With cheesecloth, wipe off any excess glaze and rub out some light areas along the direction of the crossfire.

3. Let the glaze dry and isolate the layer with shellac.

4. Apply finish coat(s) as desired.

Markings are applied with a thin wedge of marine sponge.

The back end of a wooden brush is used to wipe out the light arc below each "eye."

HEARTGRAIN

Most people asked to depict wood will draw a series of V-shapes. In reality this V-formation is found in only one section of the tree—the center. It is called heartgrain (or cathedral grain) and is revealed when trees are plain-sawn (cut in parallel vertical boards across the entire width of the log).

If all trees that are plain-sawn reveal heartgrains, the only way to represent the unique character of each wood is to determine how one heartgrain differs from another. For example, the photograph below shows many veneers with heartgrain figures. Analyze the heartgrain according to the following guidelines to clarify the differences among them:

The overall contours of the V-grains. They range from wide-based, low apex forms to narrower high-apex ones with many variations in between. In addition, the manner in which they "shift" (i.e., move from wider on the bottom to narrower on top) differ. Some exhibit strong shifts, while others are more even.

The regularity of the figure. In some woods the V-grain lines are equidistant from each other, while in others the spacing between the lines is uneven.

The appearance of jogs along adjacent lines. Depending on the type of tree and whether anything disturbed the even, annual growth pattern—drought, for example, or lack of sunlight—the grain lines will exhibit changes. This means that most of the jogs will be repeated in adjacent lines.

The amount of space (the spring growth) between the V-grain lines. This can vary with the light and moisture conditions that existed while the tree was growing.

The appearance of the grain lines (the summer growth). Each specie exhibits a unique line quality. Factors that differ include whether lines look smooth or more jagged; the amount and length of the wood fibers; and how much the fibers jut out above or below a strongly defined grain line. Close examination of real wood shows that V-grains that appear from a distance to be solid diagonal lines converging into V's are actually comprised of short, parallel lines running in the direction of the length of the wood. For easy referral, we call these lines "fibers" and emphasize them as much as possible whenever "woodiness" is desired and appropriate.

The quality of the visible pore structure accompanying the heartgrain. This differs according to the type of wood—hard or soft; diffuse-porous or ring-porous—and the size and number of the pores.

The relation of the straight grain abutting either side of the heartgrain. For example, how closely does it follow the V-grain; is it narrower or wider? The straight grain itself should be analyzed as to its color, spacing, line quality, and so forth so that it matches these same qualities in the heartgrain.

The colors involved. Study the real wood carefully to see if there is more than one color in the heartgrain.

The amount of contrast in color between the light rings (spring/earlywood growth) and the dark rings (summer/latewood growth).

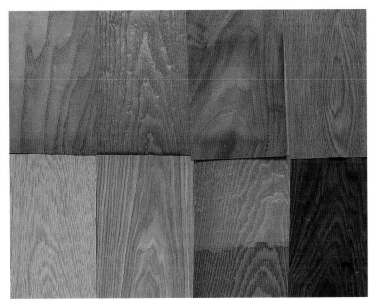

These veneers illustrate the many variations in heartgrain figure.

RENDERING HEARTGRAIN WITH A TOOL

Throughout history, whenever needs have arisen, clever people have found ways to fill those needs. Graining was so much in demand for so long that many tools were developed to make the processes quicker, more accurate, and more economical. Many of these tools have disappeared from current use.

One deceptively simple graining tool continues to be manufactured. It is made in many countries and is known by several names—among them, the heel or the rocker. It is available in two versions: as a solid rubber tool or as a thin rubber slab imprinted with a pattern and attached to a quarter cylinder of wood, which has a detachable handle. This latter type of heel usually can be found in paint and hardware stores. The most commonly available tool width is 3 inches (75 mm), although wider tools are available (one of the wider tools was quite valuable to us when we were commissioned to restore the graining on all the window- and door-frames of an 1880 horse-drawn streetcar).

It is not difficult to master the basic stroke of the heel. Just be aware that you must make two movements at once (like rubbing your stomach and patting your head at the same time). The movement is a linear one. You move the heel in strokes across your surface, while rocking the head of the heel in small increments to produce the heartgrain pattern. You also can create interesting heartgrain patterns by dragging the heel off-center down the length of the rendition, as in the bottom right photographs. To keep the figure produced crisp, clean the heel with a toothbrush or rag after one or more manipulations to eliminate excess build-up of the medium.

The heel may be used to create many heartgrains—from stark, stylized graining to natural, realistic effects. To simulate more "woodiness," after using the heel elongate the pointed ends of the V-shaped grain with a stiff-bristled brush (see *American Oak*, pages 210–11). You can then pull a rubber comb vertically through all the grain lines to break up the grain and simulate pores. To add more interest, drag the heel off-center in some boards and over the taped edge on others.

An additional factor to consider when graining with the heel is whether your base coat should be flat or sheened. A flat base coat retains some of the medium as the heel is dragged over it. This changes the base-coat color, often dramatically. A sheened base coat allows the medium to be pulled off, leaving clear base-coat color.

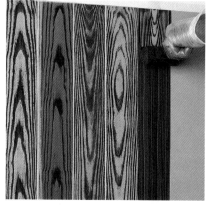

At the beginning of the stroke, the heel is held in the position shown above. It has been placed on the surface on one sharp edge (usually this is the one with the smallest arc) and is being pulled vertically down through the medium at the same time it is being turned downwards. Note that the second vertical row from the left was done on a matte surface in the same base-coat color as shown on the other rows, resulting in a difference in color.

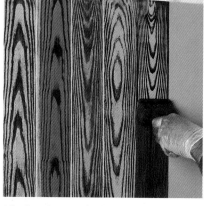

The hand turns the head of the heel as it moves down the surface. The speed at which the heel is rotated and moved will determine the figure produced.

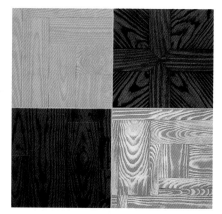

Examples of graining using the heel (clockwise from upper left): pickled wood, quarter-match veneer, stylized color combination, and pegged floor boards. Interesting heartgrains are possible when the heel is dragged off-center down the length of the rendition, as seen in the partial heartgrain in the upper left block of this photograph.

RENDERING HEARTGRAIN WITH A BRUSH

Painting heartgrain with a brush, although often more time-consuming than using the heel, has many advantages. Since each V-grain is painted individually, you have more control over the position and appearance of each grain line. The following steps will help you produce the pattern that is the basis for almost all heartgrain. To create woods not shown in this book, analyze the real wood you wish to render (using the guidelines listed on page 205), and vary colors and scale.

1. Paint an inverted V on the surface you are rendering.

2. While the paint is still wet, whisk the apex of the V with a ½-inch (12 mm) stiff-bristled brush. The motion of the brush in whisking is similar to one you would make with your fingertips if you were brushing something light away from you, like eraser rubbings or crumbs. The main difference is that this "whisking" action must be done in the direction of the apex to produce the fibers that are so characteristic in graining.

3. Repeat this whisking motion on the rest of the inverted V to add fibers to the whole grain line. If you are using two different colors for the grain lines, apply the second one directly below the first and whisk both together while they are wet. Do not use too much paint. You will know it is excessive if your whisking produces a blotchy mass instead of clear fine lines.

4. Paint more inverted V's within the first one, leaving enough room at the apex to whisk it into fibers. Make sure the apexes line up.

5. Whisk the new V's as before.

6. If desired, repeat this sequence (with the V right side up this time) directly opposite the first set of V-grains. Opposing heartgrain V's always appear within the same vertical band on any single piece of wood. Leave an opening between the apexes of the two opposing V's. (Renderings of very long pieces of wood require V's that are narrow so that the two ends of the V can continue along the entire length of the rendering.)

7. Paint straight grain on either side of the heartgrain. Lines closest to the heartgrain often follow the angle of the V's. If there are opposing V's, the grain lines nearest the heartgrain seem to be slightly curved. As more straight grain is added, the lines become straighter. Grain lines that are equidistant from the heartgrain have the same appearance because they are from the same growth ring.

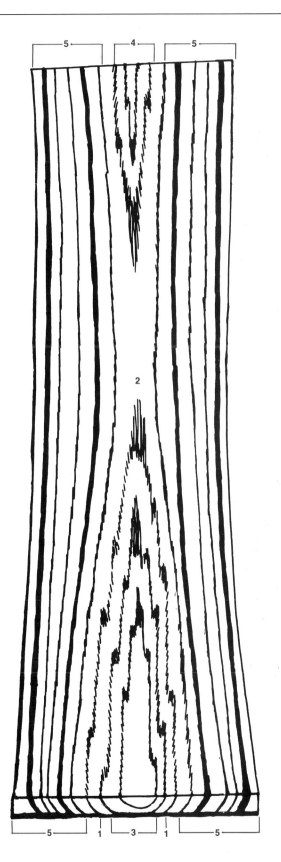

Order for rendering heartgrain

HEARTGRAIN PATTERNS: TROUBLE-SHOOTING

For graining to have a realistic look—whether rendered in exact colors of woods or in imaginative color combinations—it must have certain patterns and characteristics. If these are violated, the grain does not "ring true" to the viewer. Shown below are the most common heartgrain errors, followed by the correct rendition. In some cases errors can be fixed; however, in most cases, the rendition will need to be started anew.

Incorrect: Apexes out of line.

Correct: Apexes aligned.

Incorrect: Grain lines touch.

Correct: Grain lines are separated.

Incorrect: Grain pattern is not finished within a specific cut section of wood.

Correct: Grain pattern finished within a specific cut section.

Incorrect: Adjacent apexes appear at the same height.

Correct: All apexes appear at different heights.

Incorrect: Apex is too sharply pointed.

Correct: Apex more rounded.

Incorrect: V-grain spacing is too even and repetitive.

Correct: V-grain is spaced unevenly.

Incorrect: Jogs are too rhythmically divided.

Correct: Jogs are placed off-balance.

Incorrect: Grain lines too heavy.

Correct: Grain lines lightened.

Incorrect: Grain lines do not reach the edges of the rendering.

Correct: All grain lines reach the edges.

Incorrect: Grain lines are too splayed out at the bottom for most wood grains.

Correct: Grain lines at correct widths.

Incorrect: Jogs on the V-grains are out of line.

Correct: Jogs line up consistently.

Incorrect: Opposing V's are too evenly spaced and have insufficient space between them.

Correct: Opposing V's are less equally spaced and given more space between them.

AMERICAN OAK

American oak is the name commonly used to describe two closely related woods: white oak and red oak. Both woods have a coarse texture (with prominent, fibrous pores) and relatively light-colored spring growth, making their darker grain lines appear rather far apart. Large fibers are especially prominent at the point of each heartgrain line. White oak has slightly larger U-shaped heartgrain and less noticeable pores than red oak, but only experts can really tell them apart. All species of oak have been used architecturally and for furnishings, both in veneer and solid forms. The rendering shown below is painted as butted veneers.

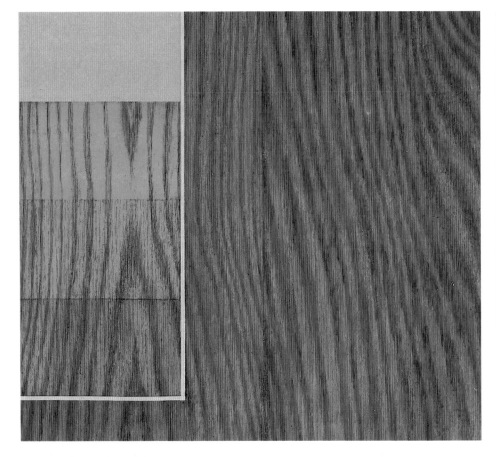

Above: *Real American oak.*

Left: *Stages of painting American oak; inset shows base-coat layer (BM 1110), figure layer, pore-structure layer, and first toning layer.*

BASE COAT

Beige-yellow sheened alkyd interior house paint

MEDIA

1. fruitwood stain/glaze: 2 parts fruitwood nonpenetrating stain pigment, 1 part glaze medium, 1 part paint thinner

2. pecan stain/glaze: 2 parts pecan nonpenetrating stain pigment, 1 part glaze medium, 1 part paint thinner

3. shellac: 1 part three-pound cut shellac, 1 part denatured alcohol

4. finish (paint-thinner- or water-soluble)

TOOLS

#0 and #2 artists' script liner brushes

one or two ½-inch or 1-inch (12 or 25 mm) stiff-bristled brushes

triangular rubber comb

1-inch (25 mm) bristle or foam brush

check-roller

paper napkins (optional)

cheesecloth

TECHNIQUE

Figure Layer

1. Apply the fruitwood stain/glaze to the surface with the script liner brushes in the V shapes required.

2. With the script liner brushes, apply the pecan stain/glaze directly above the first glaze so that there is a band of two colors adjacent to each other. The V-shaped line can be rendered as segments that join each other.

3. While the glaze is wet, whisk both colors together with the stiff-bristled brush to blend the colors into long, completely straight fibers.

4. While the glaze is still wet, comb through it vertically with the triangular rubber comb. Cross-comb as desired at an oblique angle slightly off the vertical.

5. Continue adding the V-shaped grain as desired.

6. Let the media dry and isolate the layer with shellac. Let the shellac dry.

Pore-structure Layer

1. Load the bristle or foam brush with the fruitwood stain/glaze and place it on top of the check-roller so that the brush supplies the medium for the "pores."

2. Roll the tool down the surface in straight bands, directly adjacent to each other.

3. Blot up any excess media by laying an opened paper napkin on the surface.

4. With the stiff-bristled brush, whisk out the "pores" that remain into longer, thinner streaks.

5. Let the media dry and isolate the layer with shellac. Let the shellac dry.

First Toning Layer

1. Apply pecan stain/glaze randomly with cheesecloth (see *Zebrawood*, pages 190–91) and rub off any excess.

2. Let the glaze dry and isolate the layer with shellac. Let the shellac dry.

Second Toning Layer

1. Apply fruitwood stain/glaze randomly with cheesecloth and rub off any excess.

2. Let the glaze dry and isolate the layer with shellac. Let the shellac dry.

3. Apply finish coat(s) as desired.

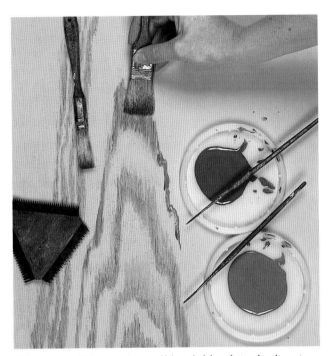

Fibers are whisked with a stiff-bristled brush in the direction of the grain.

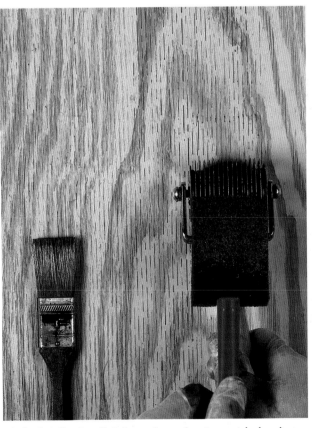

A check-roller is rolled down the surface in straight bands to create pores.

BRAZILIAN ROSEWOOD

Brazilian rosewood is one of many rosewood species, all of which are tropical woods and some of which exhibit a heartgrain figure that is quite convoluted. The rich dark red-brown and black streaks found in Brazilian rosewood often contain randomly placed "eyes" that divert the path of the grain lines. Brazilian rosewood is used for architectural elements and furnishings.

Above: *Real Brazilian rosewood.*

Left: *Stages of painting Brazilian rosewood; inset shows base-coat layer (BM 070), figure layer, and pore-structure layer.*

BASE COAT

Light brown sheened alkyd interior house paint

MEDIA

1. black alkyd glaze: 2 parts black flat or sheened alkyd interior house paint or japan paint, 1 part glaze medium, 1 part paint thinner

2. red mahogany stain/glaze: 2 parts red mahogany nonpenetrating stain pigment, 1 part glaze medium, 1 part paint thinner

3. shellac: 1 part three-pound cut shellac, 1 part denatured alcohol

4. dark oak penetrating stain

5. finish (paint-thinner- or water-soluble)

TOOLS

#0 and #2 artists' script liner brushes

½-inch or 1-inch (12 or 25 mm) stiff-bristled brush

pipe grainer or fan brush

troughlike paint holder

hair comb with finely spaced teeth

toothbrush

scrap paper

1-inch (25 mm) foam or bristle brush

cheesecloth

TECHNIQUE

Figure Layer

1. Apply the black glaze with the script liner brushes as V-shaped grain in long, thin configurations. The V's can be placed close to one another or far apart for variety; however, the straight sides of the V-shaped grain that emerge at the lower edge should be quite close together—about ⅛ to ¼ inch (3 to 6 mm) apart.

2. At the tip of the V-grain, apply a thin line of the red mahogany stain/glaze with the #0 script liner brush directly below the black line.

3. While both colors are wet, whisk them together with the stiff-bristled brush so that they both blend and form long fibers at the pointed ends of the V's.

4. With the #0 script liner brush and the black glaze, place one or two small, narrow oval "eyes" on either side of the V-shaped grain.

5. Paint a thin grain line with the #0 script liner brush and the black glaze alongside the V-shaped grain, but divert the line around the "eye." The curves should be shaped out on the left and right as if they were unevenly placed "ears" on the side of the heartgrain "head."

6. Paint one or two more grain lines (also in black), straightening each one out so that the curve around the "eye" flattens out. (For a complete discussion of grain diverting around a knot, see page 222.)

7. Load a commercial pipe grainer, fan brush, or homemade pipe grainer (made by taping as many brushes together as desired) with black glaze from the troughlike paint holder and run the comb through the brush(es) to separate the bristles. Test the brush on scrap paper. Fine clear lines result when the bristles of many types of brushes are combed through and not too much media is used.

8. Place the brush at the top edge of the rendering, allowing it to touch the surface very delicately, and pull it down the surface to the left and right of the grain lines, mirroring the angle of the V-shaped grain.

9. Continue to add rows of paint. As you add each row further away from either side of the V-shaped grain, straighten out the grain until it approaches the vertical.

10. Let the layer dry and isolate it with shellac. Let the shellac dry.

Pore-structure Layer

1. Spatter the black glaze with the toothbrush and whisk it with the stiff-bristled brush (see page 185).

2. Let the layer dry and isolate it with shellac. Let the shellac dry.

Toning Layer

1. With the foam or bristle brush, coat the surface with the dark oak penetrating stain.

2. Wipe the surface with a cheesecloth pad to reduce the stain.

3. Let the stain dry (or become tacky, see page 181) and isolate it with shellac. Let the shellac dry.

4. Apply finish coat(s) as desired.

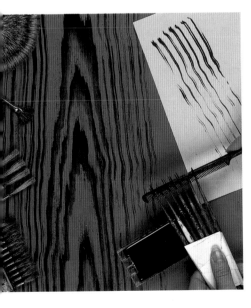

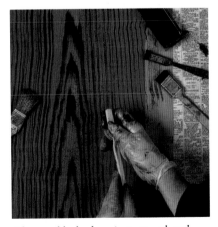

Left: Graining tools for creating straight grain (counterclockwise from upper left): three fan brushes; two pipe overgrainers; a homemade overgrainer made from script liner brushes taped between pieces of cardboard. Before use, the brush bristles are combed through to separate them. Note the paper for testing strokes and the trough holding the media. Also note the "eye" on the right side of the heartgrain.

The wet black glaze is spattered and whisked to create pores.

RING-CUT SECTIONS

The annual growth rings are the first part of a tree seen—whether it is felled with a saw or falls by itself. This is the part of wood that is called end grain. Variations in the ring patterns add to the realism and style of your renderings. To prevent the ring cut from looking like a phonograph record, consider the following:

- While the dark rings are usually thin and the lighter areas between them wider, the size and color may vary due to factors such as the amount of rainfall and sunlight, disease, and forest fires.

- When a tree grows in a leaning, rather than an upright, position, outer contours and inner growth rings become more elliptical in shape, revolving around a pith that is off-center in the tree. Growth rings are squeezed together where there is less space and spread out where there is more space.

- The center heartwood of the tree darkens over time, while the outer sapwood remains lighter.

- Some woods have radial cracks that start at the outer edge and extend through the rings, always aimed toward the heart of the wood.

The ring-cut rendering in this section is of no particular wood type. It has been fashioned into a chair merging trompe l'oeil and decoupage.

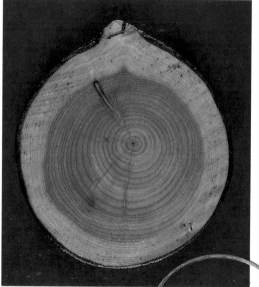

Above: *Real ring cut.*

Right: *Trompe l'oeil chair rendered in paint, raised gesso, gilding, and découpage by Ina Brosseau Marx as an homage to Isabel O'Neil*

TECHNIQUE

First Layer

1. With a foam or bristle brush, apply a solid circle of paint to an area not quite in the center of the "log." This circle should be about 3 inches (7½ cm) in diameter.

2. With single strokes of the eraser or wipe-out tool, pull through the wet paint to create rings around the center of the "log."

3. Apply a 3-inch-wide (7½-cm-wide) band of paint with the foam or bristle brush surrounding the previously painted area.

4. Pull one side of the triangular rubber comb through the paint, simulating the growth rings. Include an odd jog intermittently for interest.

5. Continue adding paint and pulling different sides of the comb through the paint. Do not cut off any previously painted rings. Each individual ring must form a continuous closed ring, following the pattern set by earlier jogs. If lines cross, paint out the unwanted ones with the script liner brush. Clarify the ring structure so that it "reads" realistically.

6. (Optional) Starting at the outer circumference, pull the back edge of the single-edged razor blade through the paint toward the center circle in 1-inch- to 3-inch-long (2½- to 7½-cm-long) straight lines to simulate radial cracks.

7. Let the layer dry and isolate it with shellac. Let the shellac dry.

Second Layer

1. With a foam brush, coat the surface with the penetrating stain (we use Minwax Jacobean stain) in a circular pattern, following the direction of growth rings.

2. With a facial tissue or cheesecloth, wipe out sections of stain along the rings in a random pattern. With a dry foam brush create transition tonalities so that lighter and darker areas fuse into each other.

3. Let the layer dry and isolate it with shellac. Let the shellac dry.

4. Apply finish coat(s) as desired.

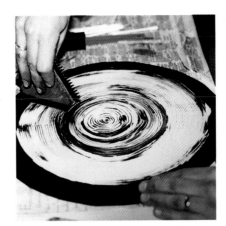

Annual growth rings are created by pulling one side of a rubber-toothed comb through the paint.

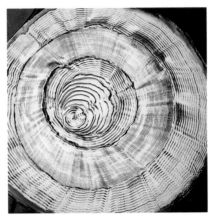

Completed first layer of a painted ring-cut rendition.

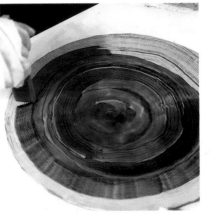

Penetrating stain is coated on the surface with a foam brush.

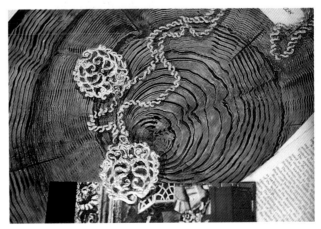

Detail of chair seat showing various techniques.

KNOTS

Knots are the cut portions of branches that are embedded in the main stem (trunk) of a tree. They show all the same growth patterns and end-grain characteristics of the ring cut. Picture a column of branchwood growing diagonally or perpendicularly within a tree. When wood is cut in parallel strips down the length of the tree, oval knots appear from diagonally growing branches and round knots appear from perpendicular growing branches. When wood is cut into the heart of the tree, knots extend across the face of the board and are called spike knots. Intergrown knots come from the live cone of branchwood, while loose knots come from a cone that has lost its nutrition. A dark outer rim develops around loose knots as the tree grows. When the tree is cut into wood, these loose knots can be pushed out, leaving knotholes.

When designing a grained surface with one or more knots, determine first where to place them. This will give you more control of the entire surface design.

Wherever there is a knot, straight grain is diverted and curves and swirls around the knot. In real woods the straight grain usually appears as regular, even, symmetrically placed curving lines on one or both sides of the knot. However, markings around knots can also

- look like golf tees above and/or below the knots, with the wider end of the tee starting at the knot; or

- look like dark smudges placed on either side of the knot. Related to the direction of the grain, they are

usually at a diagonal rather than at the top and bottom of the knot. These smudges often do not start directly next to the knot. Instead, they start after a light rim around the knot. These markings can be contained in two or more areas or they can look like crossfire streaks. (Smudges and crossfire can be created by removal techniques done by applying more medium than desired and wiping some away.) The above descriptions are illustrated in the composite photograph on the facing page.

The painted knots shown in the facing photograph were quickly done studies chosen to show different types of knots surrounded by straight grain. They are shown next to their real counterparts.

Studies 1 and 2 were done with removal techniques, 3 through 8 with applied methods. Applied methods give the grainer more control in placement, shading, size, and other design elements. Removal methods can always be used to touch up and add more precisely spaced strokes.

To improve your understanding of knots, you should collect as many different pieces of wood (and good photographs) that exhibit knots and/or graining around knots. Study the knots' sizes, shapes, ring colorations, widths, and radial cracks, as well as the grain pattern that surrounds the knot and any unique crossfire in the wood. Then try to simulate the different types of knots using both applied and removal techniques.

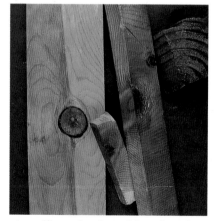

Assemblage of real wood boards with a knot on the face of one and on the edges of the others.

This veneer shows how straight grain curves around a knot.

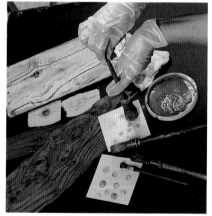

Knots are rendered with removal methods (as in the upper section of this photograph) or with applied methods (in the lower section). The "twirl" technique—twirling a glaze-coated glue brush on the surface to apply knots—is also shown.

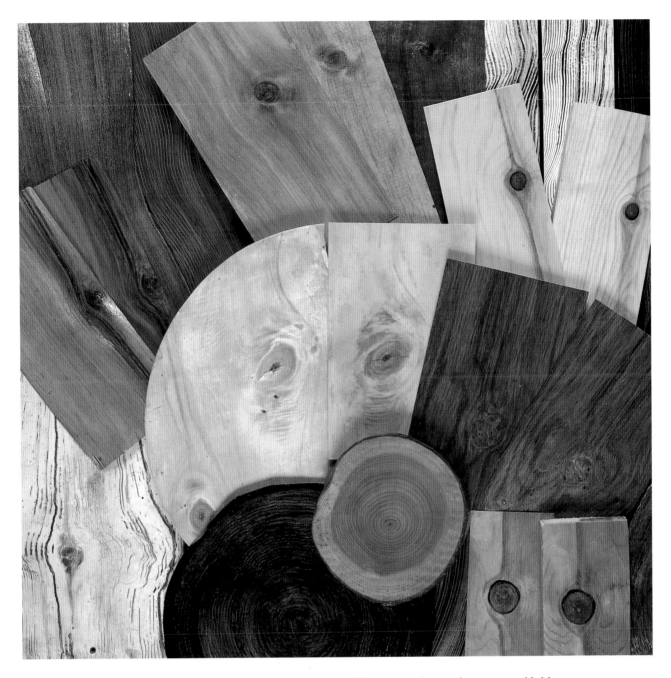

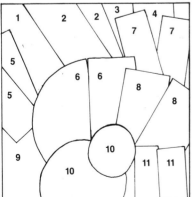

Although knots have different appearances, the ones assembled here are representative of the many ways they can look. The pieces of real wood are scrap lumber, a brie cheese box cover, purchased veneer, and a ring-cut trivet (a present from a student, sent from England). Among real woods exhibited with their painted counterparts are (1) rendered oak with an implied knot; (2) pine with a knot with dark pigmentation; (3) real oak with a knot; (4) stylized grain around an implied knot; (5) pecan with a tight knot with grain on one side only; (6) pale wood with an oval knot and crossfire; (7) pine with a tight knot with "golf-tee" markings; (8) burly English brown oak; (9) stylized grain with a knot; (10) ring cut; (11) pine with a loose knot with bark.

KNOTS SURROUNDED BY STRAIGHT GRAIN

The following techniques were used for the knots in the composite photograph on page 217 (and to the right).

STYLIZED GRAIN WITH KNOT

1. Apply flat media with a foam or bristle brush to an area small enough to be worked on at one time, but extending the full length of the wood piece being simulated.

2. While the media is wet, imprint any removal tool to simulate the knot. In this example we used a thumb covered with a piece of cheesecloth.

3. Pull an eraser through the media to create strong, dark grain lines around the knot.

4. Use a triangular rubber comb to surround both sides of the knot with grain lines, using different rubber-teeth patterns.

BURLY ENGLISH BROWN OAK

This wood exhibits sparse burl "bud" formations surrounded by grain lines.

1. Grain surface as for English brown oak, quartered (pages 193–94).

2. With script liner brushes and fruitwood, oak, and brown mahogany stain/glazes, paint clustered burl buds in a group, emphasizing an irregular distribution of the three stain/glazes in color and size (refer to *Burl*, pages 223–25).

3. With the script liner brushes, curve thin lines of oak, brown mahogany, and black stain/glazes around the clusters, ending the grain in a vertical, lengthwise direction.

PINE WITH LOOSE KNOT WITH BARK

1. With a script liner brush or with a glue brush and the "twirl technique" (see page 216), block in the knot with fruitwood stain/glaze.

2. With script liner brushes, apply oak and brown mahogany stain/glazes along the length of the surface in random areas.

3. With a cotton swab, rub out an off-center opening in the knot.

4. With the back of a single-edged razor blade, wipe out radial cracks in the knot (see page 215).

5. With a script liner brush, apply first brown mahogany stain/glaze and then black glaze around the edge of the knot (this simulates bark around a loose knot).

6. With a script liner brush, apply fruitwood stain/glaze in the design of the real wood to simulate the way grain lines and pigmentation accommodate around knots.

PINE WITH TIGHT KNOT WITH "GOLF-TEE" MARKINGS

This technique replicates the typical markings above and below knots that resemble golf tees.

1. With script liner brushes, paint in a knot with fruitwood, oak, and brown mahogany stain/glazes.

2. Surround the knot with a thin line of black paint, applied with a script liner brush.

3. Leaving a rim of base coat around the knot, use script liner brushes to paint fruitwood and oak stain/glazes in golf-tee shapes, tapering away from the marking. One edge of the golf tee should have a darker edge.

PECAN WITH TIGHT KNOT WITH GRAIN ON ONE SIDE ONLY

1. With a script liner brush, or with a glue brush and the "twirl technique" (see page 216), block in the knot with fruitwood stain/glaze.

2. Apply oak and brown mahogany stain/glazes with script liner brushes along the length of the surface in random areas.

3. With a cotton swab, rub out an off-center opening in the knot.

4. With the back of a single-edged razor blade, wipe out radial cracks in the knot (see page 215).

5. Apply fruitwood stain/glaze to the entire surface around the knot with a foam or bristle brush.

6. Wrap a piece of well-washed sheeting around a steel comb and pull it through the glaze from the top to the bottom of the rendering, curving around the knot.

7. Use script liner brushes to apply streaks of brown mahogany stain/glaze and black paint in grain lines surrounding the left side of the knot.

8. With a script liner brush, apply fruitwood stain/glaze in crescent shapes on either side of the knot near the grain lines and smudge the crescents with your finger.

PINE WITH KNOT WITH DARK PIGMENTATION

1. With a script liner brush, or with a glue brush and the "twirl technique" (see page 216), block in the knot with fruitwood stain/glaze.

2. Add radial cracks to the knot (see page 215) with the back of a single-edged razor blade.

3. Apply brown mahogany stain/glaze and black paint around the rim of the knot with script liner brushes.

4. With a ¼-inch (6 mm) foam or bristle brush, apply fruitwood and oak stain/glazes to the entire surface surrounding the knot.

5. Comb through the glaze with cheesecloth to simulate the graining around the knot.

6. With a script liner brush, add oak stain/glaze to areas as seen on the real knot to the right in the photograph.

7. If necessary, wipe out the area immediately around the knot with a cotton swab.

PALE WOOD WITH OVAL KNOT AND CROSSFIRE

1. Using a script liner brush, paint an oval knot by hand, proceeding from fruitwood to oak to brown mahogany stain/glaze as seen on the real knot to the left in the photograph.

2. Add fruitwood and oak stain/glazes in crescent shapes with a script liner brush to the areas surrounding the knot and use cheesecloth to wipe out the area directly around the knot as described in the crossfire section (see page 195).

3. With a script liner brush, apply fruitwood stain/glaze in thin lines curving around the right side of the knot to produce the depth of color seen in the photograph.

4. With a script liner brush, apply brown mahogany stain/glaze and black paint in the center of the knot to simulate the crack and heart as shown in the photograph.

Note: A good exercise would be to simulate the real knot that can be seen on the lower left of this same piece of real wood. It combines knot rings, center pith, radial cracks, and crossfire.

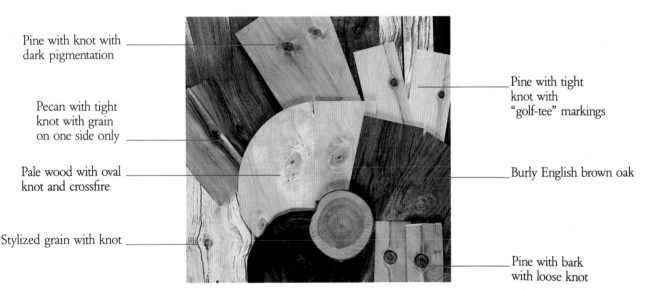

Pine with knot with dark pigmentation

Pecan with tight knot with grain on one side only

Pale wood with oval knot and crossfire

Stylized grain with knot

Pine with tight knot with "golf-tee" markings

Burly English brown oak

Pine with bark with loose knot

Once you understand the elements that make up a grain pattern, you can combine them in ways that range from rather simple to more elaborate. The following panel shows knots combined with heartgrain, straight grain, and crossfire. Note how the knots cause all of the adjacent grain lines to change their paths, going from sharp to gently curved arcs.

BASE COAT

Beige-yellow sheened alkyd interior house paint

MEDIA

1. walnut stain/glaze: 2 parts walnut nonpenetrating stain pigment, 1 part glaze medium, 1 part paint thinner

2. walnut stain/glaze: 1 part walnut nonpenetrating stain pigment, 1 part glaze medium, 1 part paint thinner

3. shellac: 1 part three-pound cut shellac, 1 part denatured alcohol

4. finish (paint-thinner- or water-soluble)

TOOLS

#2 artists' script liner brush

two 2-inch (50 mm) foam or bristle brushes (or foam roller)

steel graining comb with ⅛-inch (3 mm) teeth

piece of well-washed sheeting

cheesecloth

chamois (wet and wrung out)

TECHNIQUE

Rendering the Heartgrain

1. With the script liner brush and the #1 walnut stain/glaze, begin to paint in a few lines of heartgrain (see pages 205–209).

2. With the same brush and stain/glaze, apply knots sparsely on either side of the outer heartgrain.

3. With the same brush and stain/glaze, apply heartgrain lines outside of the knots, curving the lines around the knots. The curves should gradually straighten out as the grain gets further away from the knot. The overall appearance of this type of heartgrain will be more convoluted than usual.

4. After you have finished the heartgrain, with the script liner brush and the walnut stain/glaze, paint straight grain along both sides of the heartgrain, curving it slightly in the direction of the heartgrain.

5. Following the straight-grain line, with a 2-inch (50 mm) foam or bristle brush or foam roller, apply the #1 walnut stain/glaze to the surface outside of one side of the straight grain. Repeat this step until you have glazed an area about 7 inches (18 cm) wide.

6. Wrap the steel comb in the piece of well-washed sheeting and, following the contours of the straight grain, pull the comb through the glaze. Whenever there is a jog in the heartgrain, twist your wrist slightly to cause the straight grain you are rendering to change direction. Imagining a straight line extending out at an angle from one end of the knot through the jogs in the heartgrain can guide you in determining where to twist the comb.

7. Repeat steps 5 and 6 on the other side of the straight grain.

8. Let the media dry and isolate the layer with shellac. Let the shellac dry.

Rendering the Crossfire

1. With a 2-inch (50 mm) foam or bristle brush or foam roller, apply the #2 walnut stain/glaze over the entire surface.

2. Dab off any excess glaze with cheesecloth if necessary.

3. Bunch the wrung-out chamois into rough pleats and, starting at the lower end of your rendering, roll the chamois vertically over the surface. The crossfire pattern should correlate with the scale of the heartgrain.

4. Let the glazes dry and isolate the layer with shellac. Let the shellac dry.

5. Apply finish coat(s) as desired.

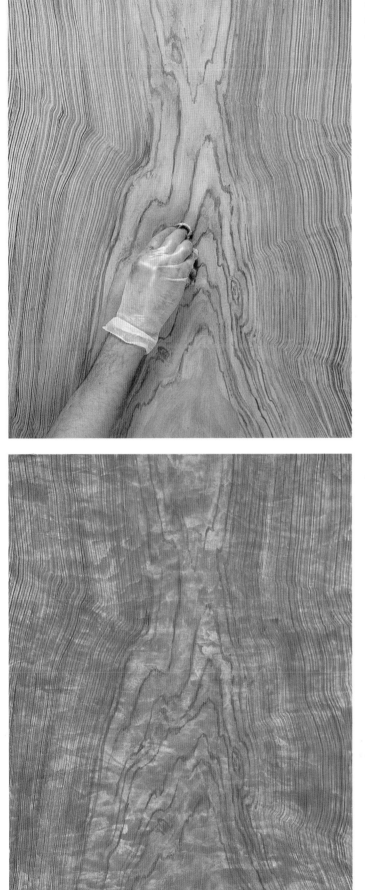

Heartgrain and straight grain rendered around a knot. The base-coat color is BM 1110.

Completed rendition of a knot surrounded by heartgrain.

GRAINING AROUND IMPLIED KNOTS

It is often more interesting and aesthetically pleasing to imply that a knot was cut off a particular board than to actually include a knot in your rendering. This effect is achieved by curving the grain pattern as if it were diverted around a knot; it is especially effective rendered with removal techniques where the tool can squeeze the grain together as it curves. The result is an alternative to all-over straight grain that can be repetitious and boring.

Although a stylized color combination was used in the demonstration, realistic wood tones can be used as well.

BASE COAT

Black sheened alkyd interior house paint

MEDIA

1. white latex flat interior house paint (thinned with water to a creamy consistency) or white alkyd glaze (1 part white flat or sheened alkyd interior house paint, 1 part glaze medium, 1 part paint thinner)

2. dark oak penetrating stain

3. shellac: 1 part three-pound cut shellac, 1 part denatured alcohol

4. finish (paint-thinner- or water-soluble)

TOOLS

tape

two 1-inch (25 mm) foam or bristle brushes

rubber graining comb

cheesecloth

TECHNIQUE

Figure Layer

1. Tape off the surface into boards of various widths.

2. Apply the white glaze with a foam or bristle brush to the first board to be grained.

3. Determine where you would want the knot were the board wider.

4. Pull the rubber comb through the glaze, rotating your wrist about ⅛ to ¼ inch (3 to 6 mm) to compress the grain lines. One or both hands may be used to hold the comb. As you pull the comb through the surface, make sure that the teeth make good contact with the surface by placing your fingertips over them and pressing firmly. At the same time you are rotating your wrist, swing the tool in a gentle curve around the area of the implied knot; then, after the curve, either return the tool to the original horizontal position or leave it rotated. Continue pulling through to finish the board.

5. Repeat the process for the rest of the boards, varying the placement of the knot and the grain pattern. Let the glaze dry.

6. If you are using an alkyd glaze, isolate the layer with shellac. Let the shellac dry. (Do not isolate latex with shellac; it may dissolve.)

Toning Layer

1. With a foam or bristle brush, apply the dark oak penetrating stain on the surface of the boards.

2. While the stain is wet, wipe it with cheesecloth to reveal varying depths of tones along the grain lines.

3. Let the stain dry (or become tacky, see page 181) and isolate it with shellac. Let the shellac dry.

4. Apply finish coat(s) as desired.

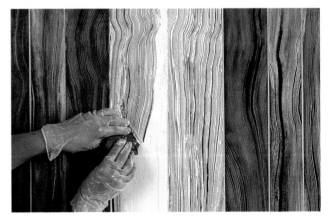

As a rubber comb is pulled through the glaze, it is twisted slightly to simulate the compression of grain lines around an implied knot. Both hands are being used here to show the diagonal position more clearly, but one-hand use of the comb is quite common.

BURL

Burls are malignancies—cells growing wild—enclosed in knoblike outer growths on tree trunks. The wood tissue of burls contains numerous bud formations of what might have been the beginnings of limbs under different growing conditions. These appear as knots when the burl is sliced into veneers.

If you keep in mind that grain (lengthwise growth rings) must divert around knots, you will more easily understand the unique visual character of burls. Picture randomly scattered single and clustered knots (oval, round, and in-between shapes), bordered in places by bandings of grain lines. This is the basic appearance of burl; however, each burl looks somewhat different. Some burls have a very graphic, linear quality, with sharply outlined knots and bandings of grain that weave in and around clusters of knots. Others exhibit clusters of knots nestled in and among diffused, mottled, watercolorlike patches of darker coloring (which bear no logical relationship to the knot clusters), with very few or no grain lines present.

The instructions that follow are for painted burl of the latter type using removal techniques, which we find the most successful for developing a rich-looking burl. The method may be done on a vertical surface; however, because this rendering requires considerable analysis, before trying it you would be prudent to experiment with the techniques on a horizontal plane, where gravity will not affect your work.

Real burl

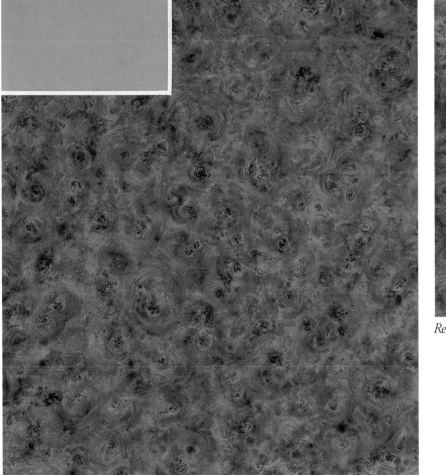

Painted burl; inset shows base-coat layer (BM 1148).

BASE COAT

Light brown sheened alkyd interior house paint

MEDIA

1. mahogany stain/glaze: 2 parts mahogany nonpenetrating stain pigment, 1 part glaze medium, 1 part paint thinner

2. darker mahogany stain/glaze: 2 parts mahogany nonpenetrating stain pigment, ½ part burnt umber japan paint, 1 part glaze medium, 1 part paint thinner

3. paint thinner

4. shellac: 1 part three-pound cut shellac, 1 part denatured alcohol

5. finish (paint-thinner- or water-soluble)

TOOLS

three 1-inch (25 mm) foam brushes

several 12-inch (30 cm) squares of 1-mil plastic

#0 artists' script liner brush

cheesecloth (optional)

TECHNIQUE

Figure Layer

1. Apply mahogany stain/glaze to the surface in short stripes with a 1-inch (25 mm) foam brush held totally perpendicular to the surface. The spacing of the stripes should be random, with strokes rather distant from each other. Do not make parallel stripes. Be sure to go across any taped edges so that the stain/glaze is deposited along the outer borders of your surface.

2. Add the darker mahogany stain/glaze to the surface in between the first set of stripes, again using a 1-inch (25 mm) foam brush. Allow the base coat to show between both sets of stripes.

3. Apply paint thinner, again with a 1-inch (25 mm) foam brush, in between the stripes, directly on top of all the areas of exposed base coat.

4. Crumple a 1-mil plastic square and roll it over the surface. This mixes the wood-colored media together,

transforming the sharp-edged lines into softer, more diffused patches.

5. Press your gloved fingertips into dark patches of glaze to simulate the oval and round knots of real burl. Aim for uneven clusters of knots (ranging from one to four knots in a cluster) with light and dark contrasts within each knot. Pressing lightly produces the preferable irregular markings in the knot; pressing too hard produces an undesirable opaque circle of base coat.

6. Add partial dark rings with the script liner brush and the dark mahogany stain/glaze around the single knots and knot clusters to replicate the dark pigment compression changes in the real wood.

7. As you work, try to achieve contrast (sparkle), many tones of brown, knots and clusters of many sizes, and both busy and calm areas. (Calm areas are particularly important to prevent the "polka dot" look of too-even circles.) Avoid all-over even color, equidistant placement of single knots, and a boring consistency of pattern. If any area is too busy and crowded, gently feed in paint thinner from the side of the script liner brush, allowing the glazes to loosen and run into each other.

8. Let the glaze dry and isolate the layer with shellac. Let the shellac dry.

Adding the "Eyes" (Optional)

Not all burls have "eyes"; however, you may wish to include them in your rendering.

1. Load the script liner brush with dark mahogany stain/glaze and lightly touch it to the surface one to four times slightly off-center within each knot.

2. Let the glaze dry and isolate the layer with shellac. Let the shellac dry.

3. If you are not adding a toning layer, apply finish coat(s) as desired.

Toning Layer (Optional)

1. Apply the dark mahogany stain/glaze to the entire surface with cheesecloth.

2. Use cheesecloth to wipe the glaze off so that only a thin layer remains.

3. Let the glaze dry and isolate the layer with shellac. Let the shellac dry.

4. Apply finish coat(s) as desired.

Mahogany stain/glaze is applied to the surface with a 1-inch (25 mm) foam brush.

The darker mahogany stain/glaze is added to the surface in between the first set of strokes.

Paint thinner is applied in between the strokes, directly on top of all the areas of exposed base coat.

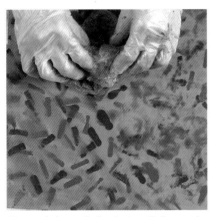

Crumpled 1-mil plastic is rolled over the surface.

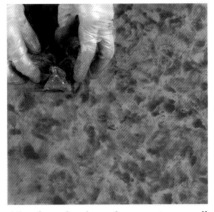

Note how the glazes fragment into small unpatterned units.

Gloved fingertips are pressed into dark patches of glaze to simulate knots.

A liner/lettering brush is swirled through the glazes.

The darker mahogany stain/glaze is applied with a script liner brush to areas adjacent to one side of a knot or knot cluster.

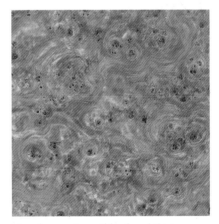

Another variety of burl, exhibiting more defined convoluted grain lines, was painted using a lighter value glaze over a still lighter value base coat.

STRAIGHT-GRAIN MAHOGANY

Mahogany is found in parts of Africa, the West Indies, Cuba, Mexico, Central America, and northern South America. Its luster and rich color, which varies from medium-value golden brown to deep, dark brown-red, have kept mahogany in demand for use on architectural elements and furnishings for many centuries. Although it is often used as solid wood, mahogany is usually associated with the dramatic designs of mahogany veneered furniture.

Rendering mahogany is different from most other graining techniques both because of the nature of the wood itself and because of the media and technique used to render it. As a mahogany tree grows, it twists first one way and then the other. When cut, the wood produces an interlocked grain pattern: interlaced light and dark tonalities seem to start and stop, rather than running as lines the whole length of the board.

While mahogany can be rendered with figure, crossfire, and toning layers, we prefer to focus on the dramatic patterns of light and dark that appear in various mahogany figures. The media we use to achieve this effect is Marglaze (see page 181). It produces quite realistic results, with shifting tonalities that create impressionistic shimmer and movement.

Real straight-grain mahogany

Two examples of painted straight-grain mahogany; insets show two different base coats (BM 1063 on the left; BM 1210 on the right).

Mahogany may be rendered in various grain patterns. The most common are straight grain and crotch figure. While either can be rendered with the technique given here, we prefer using a different technique for crotch-figure mahogany (see pages 228–30).

The straight-grain mahogany that we render is comprised of 1- to 2-foot (30 to 60 cm) interlaced light and dark streaks ranging from about ½ to ¾ inches (1¼ to 2 cm) in width.

There are two common variations of this straight-grain pattern:

Rope figure. This pattern exhibits short (3- to 5-inch [7½ to 12½ cm]) markings and often has light and dark markings with high contrast, which highlights the interlaced effect.

Diagonal figure. In this pattern, the markings start out as straight grain. They then gracefully veer up at about a 30-degree angle until they are about 4 or 5 inches (10 or 12½ cm) above the original straight grain, at which point they level off to straight grain parallel with the original. This pattern is very common on drawer fronts.

In addition, straight-grain mahogany often appears as crossbanding (1- to 2½-inch [2½ to 6¼ cm] strips of veneer). Mahogany crossbanding is very common in fine veneered furniture.

BASE COAT

Tan, orange-pink, or terra-cotta sheened alkyd interior house paint

MEDIA

1. Marglaze: 8 parts red mahogany penetrating stain, 7 parts high-gloss paint-thinner soluble finish, 5 parts asphaltum

2. shellac: 1 part three-pound cut clear shellac, 1 part denatured alcohol

3. (optional) orange shellac: 1 part three-pound cut orange shellac, 1 part denatured alcohol

4. paint-thinner-soluble finish

TOOLS

1-inch (25 mm) foam or bristle brush

facial tissue (the most absorbent you can find) or cheesecloth

TECHNIQUE

1. Apply a rather heavy coat of Marglaze to the surface with the bristle or foam brush (apply less to vertical surfaces).

2. Loosely crumple the facial tissue or cheesecloth so that there are many depressions. (Facial tissue will create a sharper, more dramatic pattern than cheesecloth; however, the softer pattern produced by cheesecloth helps prevent drips and curtaining on vertical surfaces).

3. Use the facial tissue or cheesecloth to remove the glaze from the surface with a light to medium stroke in the grain pattern or figure desired. To render straight grain, start your wiping stroke at least a hand's width outside the edge of the board being grained. Do not let the part of the stroke that removes the glaze extend from one end of the surface to the other in a long, unbroken stripe. Start your strokes from both sides of the board, as well as in the middle on longer boards; this will help create the desired interlaced effect.

To render crossbanding, start your wiping stroke at least a hand's width above where you want the crossbanding and end it a hand's width below. These markings should be kept parallel and run the full width of the strip. You should aim for a grain pattern that has randomly spaced light and dark streaks of various widths, with none thinner than ⅜ inch (9 mm). The real mahogany veneer that is chosen for crossbanding is relatively simple straight grain, so do not include interlaced or nonperpendicular markings.

When making your strokes, use your entire arm, with a straight motion generated from your shoulder rather than from your wrist or elbow. Feather out the end of each stroke by gradually lifting your hand off the surface as you follow through. As you work, keep the following characteristics of Marglaze in mind:

- The strength of your markings can vary depending on how much glaze is on the surface, how much pressure you use in your strokes, and how much tissue or cheesecloth touches the surface.

- Marglaze tends to draw together after you have wiped through it, so you should make stronger markings than you think necessary.

- The longer the wet Marglaze is on the surface, the crisper and sharper the markings will be. If the Marglaze sets up (its surface starts to dull), however, you will not be able to render diffused edges and your markings will look too harsh.

- While the Marglaze is wet, more glaze can be added to it to adjust the figure. However, once the Marglaze sets up, any additional glaze added will remain on the surface as a dark line or blot.

- If you are in doubt about depth of color, err on the light side. Marglaze is easy to darken with subsequent toning, but next to impossible to lighten.

4. Keep moving along the board wiping strokes through the Marglaze, trying not to go over any strokes more than necessary. Change the facial tissue or cheesecloth frequently.

5. If you have one or two markings that are not in keeping with the rest of the pattern, wipe them off with facial tissue or cheesecloth.

6. Let the glaze dry and isolate it *completely* with shellac (if even a small area of Marglaze is unprotected, it will be removed when more Marglaze or a paint-thinner-soluble finish is applied). If extra warmth of tonality is desired, use orange shellac; otherwise use clear shellac. Let the shellac dry.

7. If your rendering needs additional areas of glaze (see step 5), apply it with the foam or bristle brush and stroke through it as before with the facial tissue or cheesecloth. Let the glaze dry and isolate it completely with shellac. Let the shellac dry.

8. Apply four or more paint-thinner-soluble finish coats. Rub down the finish by hand.

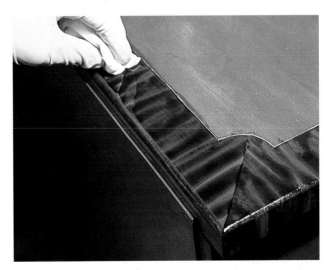

A facial tissue is stroked lightly through the glaze, perpendicular to the edge, to create straight grain for crossbanding.

CROTCH-FIGURE MAHOGANY

The crotch figure is one of the more well-known mahogany figures and has been a popular painted finish for centuries. The veneers are cut from the area where the trunk begins to fork into equal limbs. Before the forking actually develops, the tree undergoes dramatic intergrowth and twisting. This causes unpredictable compression changes that result in random dark patches interspersed throughout the usual growth pattern. Cuts made through the center of such an area produce a figure called a feather crotch, which is used both architecturally and for furnishings; outer cuts produce swirl crotch, which is not often used.

When crotch figure is used architecturally, the convention is that the figure is horizontal on wainscoting, and either vertical, horizontal, or a combination of the two on door panels. A common layout for a six-panel door would have vertical figure in the bottom four panels and horizontally bookmatched figures for the top two panels. When used vertically, the crotch figure is usually upside down, with the wider part of the figure toward the bottom.

There are many variations in crotch-figure patterns.

The following guidelines will help make your crotch-figure panels realistic:

- Crotch figure is comprised of randomly spaced light and dark streaks that emanate from an imaginary central spine (which may be either straight or slightly tilted in an S curve). Together, these streaks form a shape like a broken Gothic arch. The overall contour of the arch becomes slightly steeper the higher it appears on the spine; near the spine the curve is rather pronounced (forming a hook shape), and toward the bottom it straightens out.

- The dark markings are heavier and thicker toward the spine and taper off as they move away from the spine.

- Thin light streaks or rays often emanate from the central spine, with more appearing toward the bottom of the figure, where the markings are darkest. These rays have a pattern similar to that of a hand with outstretched fingers, and their direction shifts with any curves in the central spine.

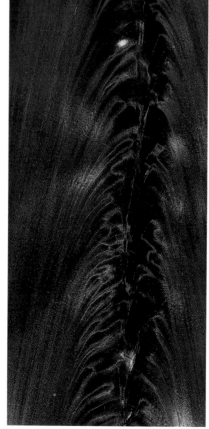

Painted crotch-figure mahogany; inset shows base-coat color (BM 1293).

Real mahogany crotch-figure veneer, shellacked.

BASE COAT

Tan, orange-pink, or terra-cotta sheened alkyd interior house paint

MEDIA

1. Marglaze: 8 parts red mahogany penetrating stain, 7 parts high-gloss paint-thinner-soluble finish, 5 parts asphaltum

2. shellac: 1 part three-pound cut shellac, 1 part denatured alcohol

3. paint-thinner-soluble finish

TOOLS

1-inch (25 mm) foam or bristle brush

facial tissue (an absorbent brand) or cheesecloth

piece of folded newspaper

TECHNIQUE

This technique includes an optional toning layer that you can use if you want a deeper mahogany.

Figure Layer

1. Apply the Marglaze with the foam or bristle brush in the pattern of the figure. This helps both to give a conception of the scale and contour of the figure and to leave light and dark streaks that can serve as a guide for the wiping.

2. Use the facial tissue or cheesecloth to wipe out light markings, following the shape of the figure. (Many people find it easier to start near the central spine and wipe out toward the edges; this allows follow-through of the stroke and helps prevent the common fault of curving the bottom of the lines back toward the central axis.) Place your strokes randomly; do not alternate markings on either side, creating a completely symmetrical design. This random placement is most easily achieved by removing the glaze in a random order (for example, wipe two markings on the lower left, then one above these on the right, then skip to a high area on the left, and so forth).

3. After the media has begun to set up, lightly dab crumpled facial tissue or cheesecloth in the dark areas near the spine to achieve a subtle mottle (do not overdo

this or the dramatic contrast between the light and dark markings and the continuity of the spine will be lost). Proceed immediately to the next step.

4. Remove glaze to render the characteristic rays by lightly touching the glaze with a 1½- to 2-inch-long (4- to 5-cm-long) edge of a piece of folded newspaper. These rays should be placed randomly, so that no repetitive or symmetrical pattern is perceived. Do not add too many rays, or they will detract from the drama of the figure.

5. If you plan to use a toning layer, at this stage lighten any areas that are very dark; otherwise you will have dark areas with little luster when the rendering is finished.

6. When there are no more shiny patches of Marglaze on the surface, coat the surface with shellac. Let the shellac dry.

7. If you are not applying a toning layer, apply four or more paint-thinner-soluble finish coats. Rub down the finish by hand if possible.

Toning Layer (Optional)

1. With the foam or bristle brush, apply a thin layer of Marglaze over the entire surface.

2. Wipe the Marglaze off the surface with facial tissue or cheesecloth, following the pattern of the underlying layer.

3. Let the media dry and isolate the layer with shellac. Let the shellac dry.

4. Apply four or more paint-thinner-soluble finish coats. Rub down the finish by hand.

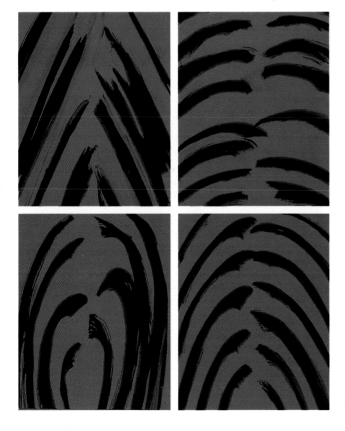

Four examples of incorrect shaping of crotch-figure mahogany.

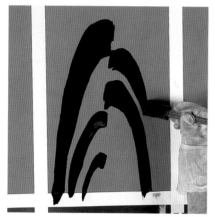

Marglaze is applied to the surface in alternate strokes. These initial strokes determine the shape of the crotch figure.

Additional strokes must follow the direction of the previously applied strokes.

All of the strokes here have been applied in correctly shaped arcs.

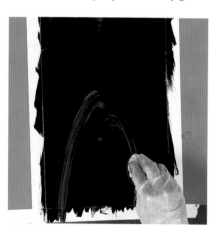

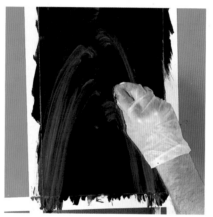

The initial "wipe-out" strokes follow the pattern set earlier.

As more glaze is wiped out, the crotch figure begins to take shape.

Practice will allow you to wipe out each subsequent stroke so that it follows the direction of the ones adjacent to it.

Sometimes glaze must be added with a brush to further refine the shape of the crotch figure.

Glaze is lifted out along the spine with a crumpled facial tissue.

The characteristic rays are added by lightly touching the glaze with the edge of a piece of folded newspaper.

SATINWOOD

Although there is an obvious color difference, satinwood and mahogany share a similar visual appearance. Both exhibit irregular widths and lengths of linear striping, a shimmer of crossfire, and exciting variations in value—ranging from light to dark.

Like mahogany, satinwood has been cut from the crotch of the tree for centuries, and steps for creating the crotch figure in satinwood parallel those given for the mahogany crotch figure. The one difference is that the figure in satinwood exhibits a narrow, rather than a wide, figure—usually about 4 to 5 inches (10 to 12½ cm) wide.

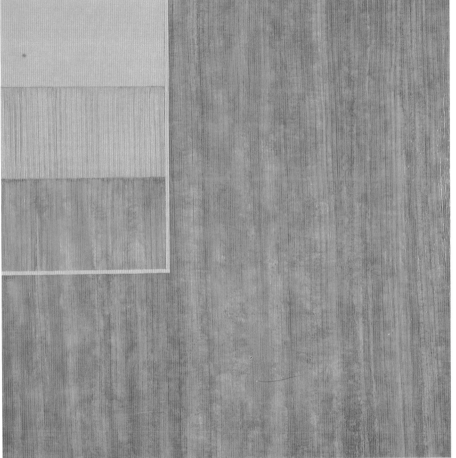

Real satinwood

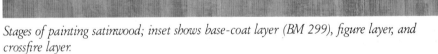

Stages of painting satinwood; inset shows base-coat layer (BM 299), figure layer, and crossfire layer.

BASE COAT

Pale yellow-brown sheened alkyd interior house paint

MEDIA

1. oak stain/glaze: 2 parts oak nonpenetrating stain pigment, 1 part glaze medium, 1 part paint thinner

2. oak with cherry stain/glaze: 2 parts oak nonpenetrating stain pigment, ½ part cherry nonpenetrating stain pigment, 1 part glaze medium, 1 part paint thinner

3. shellac: 1 part three-pound cut shellac, 1 part denatured alcohol

4. paint-thinner-soluble finish

5. (optional) raw sienna artists' tube oil color or japan paint

TOOLS

two 1-inch (25 mm) foam or bristle brushes

piece of well-washed sheeting

metal graining comb with ⅛-inch (3 mm) teeth

cheesecloth

blending brush

TECHNIQUE

Figure Layer

1. Apply the oak stain/glaze over the entire surface with a foam or bristle brush.

2. As in the instructions for harewood (see pages 198–99), wrap the sheeting around the teeth of the metal graining comb and drag it down the surface.

3. Soften a few bands of glaze by pulling cheesecloth down through them.

4. Let the glaze dry and isolate the layer with shellac. Let the shellac dry.

Crossfire Layer

1. With a foam or bristle brush, apply the oak with cherry stain/glaze in streaks running the same direction as the grain.

2. Wipe through the streaks with cheesecloth to create unevenly spaced light and dark vertical bands.

3. While the glaze is still wet, lightly "pull" and "push" the edges of the bands in short, horizontal strokes with the cheesecloth.

4. Soften the jagged edges with a blending brush held horizontally (i.e., perpendicular to the direction of the streaks). Try to vary the size, color, and quality of the various bands.

5. (Optional) If more markings are needed, let this layer dry, isolate it with shellac, let the shellac dry, and, using the same process as above, add more bands.

6. Let the glazes dry and isolate the layer with shellac. Let the shellac dry.

7. Apply finish coat(s) as desired. If a slightly darker tonality is desired, tint the finish with a very small amount of raw sienna artists' tube oil color or japan paint before applying.

While the glaze is wet, the edges of the bands are lightly "pulled" and "pushed" in short horizontal strokes with the cheesecloth.

COUNTRY GRAINING

"Through a certain stylishness and economy—cheap chic in modern parlance—painted furniture was within the reach of everyone, and everyone reached for it." So states Dean Fales, Jr., in the foreword to *Simple Forms and Vivid Colors*, the catalog of the Maine State Museum's 1983–1984 exhibition of painted furniture from 1800 to 1850.

What is quite evident in that catalog and in documentation from the early nineteenth century is that, at that time, a great deal of the painting done on furniture all over North America was a simulation of real woods. The mahogany, rosewood, satinwood, and bird's-eye maple veneered furnishings and architectural elements in the homes of the affluent of the period were mimicked in paint by urban and country artisans. Often the results were quite accurate. But just as often the excitement and joy of manipulating the medium turned these wood simulations into stylized adaptations—which became known as country graining.

That these artisans saw and understood fine cabinetry and veneering is indisputable; the evidence can be seen in the way they designed their surfaces. Both applied and removal methods were used for striped borders resembling crossbanding and for book-, diamond-, and other matches resembling sophisticated veneering. Removal methods alone were used for simulating inlay and stringing. These involved pulling a stick (or cat gut) through the medium to create a channel called a drag line, which revealed the base-coat color slightly veiled with the overcolor (our modern-day use of tape has replaced the use of a drag line).

Both removal and applied methods were used to do country graining. The results of each differed visually quite a bit. Removal techniques, which were most commonly used, made use of the glazing concepts of creating blends of color by manipulating wet media. With applied methods, the renderings had a graphic, linear, sharp-edged quality. One common use for applied techniques was for simulating real crotch-figure mahogany, which was very popular during the American Federal and Empire periods.

The colors used were derived primarily from traditional woods. The warm palette, used to render mahogany, rosewood, maple, and cherry, had a yellow ocher base coat covered with a burnt sienna glaze. The cool palette, used for nut and fruit woods like walnut, butternut, pear, and apple, had a straw-colored base coat covered with a burnt umber glaze. For the darker woods, a Van Dyke brown glaze was used over a Venetian red base coat. Nonwood colors were also used, including pale blues, greens, pinks, and reds.

MEDIA

Both paint-thinner-soluble and water-soluble media were used for country graining. The water-soluble media were made of pigments plus acidic liquids and sugars that acted as solvents and binders, enabling the media to hold a pattern. These types of media were called distemper (see page 182). Among the many substances used were beer, wine, and cider (which combine both the acidic and sugar requirements); animal and rabbit-skin glues; milk; egg white; maple syrup; wheat paste; gum tragacanth; and lye soap shavings. Pigments included organic and inorganic materials, both powdered and liquid.

We use the following formulas for country graining (three other water-soluble formulas can be found in the graining media section on page 182):

REMOVAL MEDIA (used in both removal and applied techniques)

1 part tube watercolor

2 parts apple-cider vinegar

APPLICATION MEDIA (used in applied techniques only)

1 part powdered pigment (not aniline powders)

1 to 2 parts apple-cider vinegar

½ part gum arabic

(Note: Stir the pigment and vinegar before adding the gum arabic. After adding the gum arabic, stir the mixture well and strain it if necessary. The pigment will fall to the bottom of the mixture quickly, so the media must be stirred well before each application.)

These two formulas are easily mixed, easily manipulated, very forgiving, and exciting to use. You can adjust either formula to suit the effect desired. Aim for a consistency where the medium will stay put when it is brushed on and scrubbed into the surface; the medium should not pool on the surface.

To test your medium, apply it to a matte surface with a foam or bristle brush. If the mixture is too dark and opaque, add more apple-cider vinegar. If the mixture is too pale and watery and will not hold a pattern that is imprinted into it, add more tube watercolor or pigment. Be sure to stir the media before each application.

SURFACE PREPARATION

The surface to be grained should be matte, not shiny. If the graining mixture does not adhere to your surface, wipe the surface firmly with cheesecloth. This may be enough to reduce the surface tension so that the next application of media will hold. If it does not, scrub the surface with water and a mild abrasive (whiting, household cleaner, or cornstarch); then wipe it clean with a wet cloth.

FINISH COATS

Country-graining media must have a protective coat, as the media always remain water-soluble. We recommend paint-thinner-soluble finishes, as they can be applied directly to the dried graining media without the need for an isolating layer. Matte or satin finishes, rather than gloss, are appropriate. Authentic country-graining pieces do not have glossy or fine hand-rubbed finishes (although the steel-wool-and-wax method can be used).

Left: *The painting of a blanket chest in process. The colors were taken from an authentic chest from Texas.* Below: *The finished blanket chest.*

When first applied, water media often cisses (separates into circular openings that cause the base coat to appear), as shown in the top photograph above. Whiting sprinkled on the surface and rubbed into the wet media (as shown in the bottom photograph) breaks the surface tension that is causing the cissing.

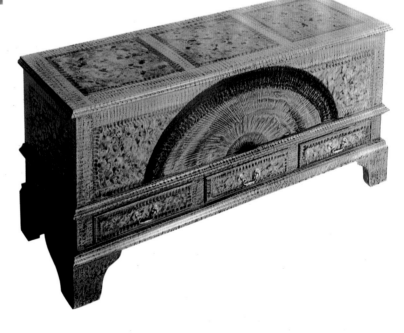

APPLIED COUNTRY GRAINING

Applied graining is done most often wet-into-wet. First, removal media is applied over a dry, matte painted base coat. While this layer is still wet, the application media is painted on in grain configurations. A unique characteristic of traditional applied designs is the addition of daubs done with bits of natural sponges or brushes. These nonprecise, rhythmically applied daubs follow the linear pattern of the grain and are used as space fillers, lending a very decorative quality to the graining.

BASE COAT

Flat alkyd interior house paint

MEDIA

1. removal media: 1 part tube watercolor, 2 parts apple-cider vinegar

2. application media: 1 part powdered pigment (not aniline powders), 1 to 2 parts apple-cider vinegar, ½ part gum arabic.

3. paint-thinner-soluble finish

TOOLS

1- or 2-inch (25 or 50 mm) foam or bristle brush

½-inch (12 mm) stiff-bristled brush

small torn pieces of marine sponge or similar substitute (optional)

newspaper (optional)

TECHNIQUE

1. With the foam or bristle brush, apply the removal media and scrub it into the surface.

2. While the media is still wet, paint linear graining patterns into it with the ½-inch (12 mm) stiff-bristled brush and the application media.

3. (Optional) Wet the marine sponge, wring it out, dip it into the application media, and offload any excess media onto a piece of newspaper. With the marine sponge, daub small dots of application media along the grain lines and filling the spaces in between them.

4. Let the media dry and apply a paint-thinner-soluble finish. Rub down to a matte or satin finish. (Note: if you do use a water-soluble finish, you must first isolate the dried media with shellac and let the shellac dry.)

A typical stylized crotch-figure panel. Ribs are painted on opposite sides of an implied tilted spine, looking like repetitive hearts. To the left is a stylized knot rendition, another very popular motif for graining. Small pieces of marine sponge were used to add ornamentation along the grain lines and to the spaces in between.

A fire screen painted with large-scale applied country graining of crotch-figure mahogany

REMOVAL COUNTRY GRAINING

Removal graining techniques are similar to glazing techniques in that they rely on the manipulation of the glaze media to create a pattern. While the techniques can be used to give a simulation of an actual wood, many of the removal techniques seen on painted surfaces of the early nineteenth century seem to be less related to grain patterns. The artisans tried to capture spontaneously the overall designs of veneered furniture rather than to realistically imitate the wood. This approach resulted from a combination of aesthetic concepts, economy, and the nature of the washy media. The effects were often rather stylized and abstract.

BASE COAT

Flat alkyd or latex interior house paint

MEDIA

1. removal media: 1 part tube watercolor, 2 parts apple-cider vinegar

2. tube watercolor paint (optional)

3. water or apple-cider vinegar (optional)

4. eggshell paint-thinner-soluble finish

5. whiting (optional)

TOOLS

1-inch (25 mm) foam or bristle brush

several #0 artists' script liner brushes (optional)

manipulation tools (many tools can be used, including toothed leather, rubber, paper, corncobs, corks, sponges, and fingertips—the most common are turkey feathers and various glazing putties)

TECHNIQUE

1. Apply the removal media with the foam or bristle brush, scrubbing the media into the surface by moving the brush back and forth with hard pressure.

2. (Optional) With a script liner brush, apply tube watercolor paint in lines. Wet a second script liner brush with water or apple-cider vinegar and touch it to the watercolor lines so they diffuse and blend.

3. Manipulate the media as described below or in ways you invent. The traditional techniques will be appropriate if you are creating pieces in the spirit of the nineteenth century.

4. (Optional) To get even more subtle blends of color, smear the initial manipulation together using feather manipulations (see below), add additional watercolor, and then manipulate again.

5. Let the media dry and coat it with a paint-thinner-soluble finish. (Note: If you do use a water-soluble finish, you must first isolate the graining media with shellac and let the shellac dry.)

At right, lines of color are applied over putty graining. At far right, a quarter-fan is being produced with a piece of putty in wet medium.

FEATHER MANIPULATIONS

For these techniques we prefer turkey feathers (available at many craft stores), which have a gentle curve. Before using feathers, the barbs (the feathery part) should be cut down to about ¼ inch (6 mm) on the convex side of the curve.

In country graining, feathers can be used to create many visual effects, with the most common being repetitive rhythmic patterns. The effects can be a crude simulation of a natural wood, such as curly maple, or a woodlike pattern, such as herringbone.

CURLY MAPLE

A particularly popular wood among country grainers, curly maple can be rendered in various color combinations. The more realistic the colors of the media, the more realistic the rendering will appear. However, nonwood colors can also be used to give a more abstract impression.

1. Place the cut end of a prepared turkey feather in the wet removal media. Hold the feather so that the heavier part (about one-third of the way up from the quill base) is on the surface (the upper part of the feather is too delicate to use; it will not imprint into the medium with enough force).

2. Push the media with the feather about ¼ inch (6 mm) to the right or left (right-handed people should push the media to the left, repeating the press-push rhythm, and left-handed people should push the media to the right). A ridge of media will form at the end of each stroke.

4. Lift the feather and repeat the motion, each time setting the feather down a little further along an imaginary row and pushing it into other ridges. Develop a repetitive rhythm, and the movement of the feather will become almost mesmerizing.

HERRINGBONE PATTERN

1. With a #2 artists' script liner brush, paint horizontal lines of two colors of watercolor into the still-wet scrubbed-in removal media.

2. Moving a cut turkey feather in a sawtooth pattern, travel across the surface, blending the two colors. (A variation is to travel across the surface moving the feather in a series of small arcs.)

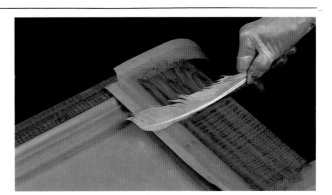

A feather is used to push the medium into curly (tiger) maple stripes on one of a pair of wood panels. Notice that the graining is proceeding exactly as it would on any other simulation of wood, governed by correct joinery practices. Painters' tape separates each section at the join where the next section changes the direction of its grain.

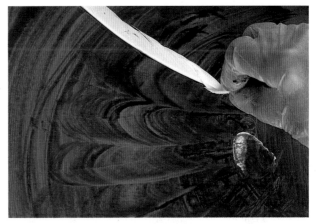

A feather is used to create the arched strokes of a fan.

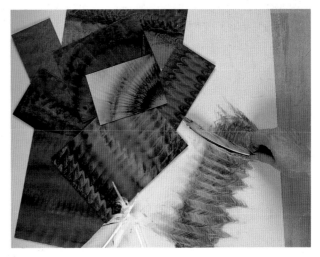

A feather is pushed up and down in a sawtooth pattern to fuse together streaks of red and blue media. Other exercises may be seen to the left.

Nineteenth-century removal techniques that used putty often exhibit an effect known as a seaweed pattern. In this pattern, the linseed oil in the putty reacted with the vinegar or beer mixture to cause the media to "crawl" on the surface, creating a miniature snakelike pattern.

Putty also was used to render the fan motif, which was popular in quarter-, half-, and full-circle shapes. This motif was a fanciful adaptation of the classic quarter-paterae found in fine veneered pieces of the English Hepplewhite and American Federal periods, in which the edges of individually shaped veneered pieces were scorched in hot coals to achieve a dimensional quality. A realistic rendering would have grained and shaded each wedge; the country rendering merely captures the essence of the design.

Besides the popular fan pattern, putty was used in two patterns that served as backgrounds for, or fillers around, other motifs. The first was roundish circles, achieved with balls of putty. The second was a random broken effect achieved from rolling various-shaped putties. When these two patterns are used together, they form a country version of burl wood.

Putty manipulations can be done with vinyl window-glazing putty as well as linseed-oil putty (do not use spackling compound). The vinyl putty is easier to handle, but does not leave a seaweed pattern. The linseed-oil putty is often too sticky to handle well; however, it can become more manageable with the addition of a small amount of whiting. Hold putty lightly but firmly when using it; both types of putty stretch from the heat of your hand.

FAN PATTERN

1. Form the putty into a 2-inch-long (5-cm-long) roll at least ⅜ inch (1 cm) in diameter.

2. Holding an end of the roll in each hand, place the putty on one corner of the surface, with one end of the roll anchored just off the corner edge onto your worktable.

3. Lift and lower the putty into the wet removal media, keeping the corner hand on the worktable to act as a pivot point and walking the other hand around in a circular pattern. Try not to print the entire impression of the putty; it looks too much like separate sausages, fingers, or flower petals. To avoid this, overlap the imprints so that a ridge is seen on only one edge.

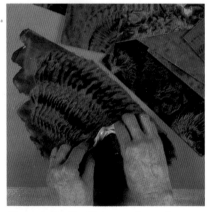

Putty is "walked" across the surface to create the fan pattern. Additional exercises may be seen above the demonstration.

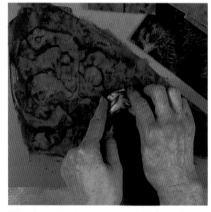

Window-glazing putty is rolled in the medium to achieve a random broken effect.

In this rendering of curly maple, the curly maple stroking has been completed; the quarter-, half-, and full fan have been rendered with feather herringbone strokes; and the putty dabbing is being done on the molding.

PART THREE
PROFESSIONAL PRACTICE

BUILDING A BUSINESS

One of the most gratifying results of our years of teaching has been hearing the many success stories of our students. Profitable decorative painting businesses, which in some cases have dramatically changed students' lives, have been launched by interior designers, conventional house painters, fine artists, homemakers, and second careerists using guidelines provided by The Finishing School. In addition to the financial rewards of their businesses, these students have also had the satisfaction of creating unique finishes in ever-changing environments.

Building a successful decorative painting business requires enthusiasm, dedication, and careful planning. Before starting a business, you should consider the reasons and requirements for starting a decorative painting business or division; how to build the business; and strategies for long-range business and financial planning. The advice that follows is based on our experiences combined with those of students who have followed our guidelines.

REASONS FOR STARTING A BUSINESS

There are two elements necessary for success in this field. The first is an appreciation and enthusiasm for painted surfaces. When people first look at our samples at school, we can usually tell if they show a certain look of excitement that they have the special love for the art needed to pursue decorative painting. Considering the effort needed to learn and perfect techniques, and the often tedious labor and constant challenges involved in job execution, there are easier undertakings for those whose motivation is solely financial.

The second element is a commitment to invest time, energy, and money to learn techniques and build the business. The implication of this is different depending on the situation. For example, a medium-sized contractor who wants to establish decorative painting as an important part of his or her business would need to make a larger investment than would a free-lance artist who wants an occasional glazing job. Consider your resources. If you have a full-time job in another field, you might not have adequate time to build a new business. Similarly, an established conventional painting contractor or an interior design firm might find it difficult to allocate the funds, personnel, and time required to launch a new, different division. However, if you are strongly motivated to build a decorative painting business, you will rearrange your priorities.

Since decorative painting encompasses elements of house painting, interior design, and fine art, we suggest that newcomers build on those skills they have while learning those they lack. For example, a house painter could start offering simple glazing while exploring the fields of color, texture, and design. Conversely, a canvas painter might start with smaller-scale, more intricate finishes while learning house-painting skills. Each aspect is important for successful results—a beautiful finish is a failure if it peels in three months or clashes with the design scheme.

Many if not most of the businesses engaged in decorative painting are individuals or small partnerships. There are two important advantages to launching a decorative painting business:

1. There can be minimal start-up costs: the costs of printing up business cards, preparing a portfolio, buying basic materials, and furnishing a home studio.

2. It is the type of business that can be started on a part-time basis.

Among established professionals, the two most likely to benefit from launching a decorative painting business are paint contractors and interior designers.

PAINT CONTRACTORS

There are many good reasons for established paint contractors to offer decorative painting services to their clients as an alternative to conventional painting and wall covering.

Decorative painting can be more profitable than conventional painting. The type of client who desires these services usually expects to pay a premium for finishes that are unique. In addition, most clients who will be requiring both conventional and decorative painting would rather use one firm. Those firms that do not offer decorative painting may actually lose commissions.

More freedom in scheduling is possible. When exteriors cannot be painted because of inclement weather, or when business is slow, decorative painting can fill the holes made in the schedule. Conversely, when the painting firm's schedule is overly filled, clients are usually amenable to waiting for a specialist in painted finishes.

A higher-quality crew of painters can be developed. This can begin with the training of current staff, continue through the hiring of relatively untrained decorative painters, and conclude with the securing of the services of more experienced free-lance decorative painters.

The firm's reputation is enhanced. Firms that offer decorative painting are perceived as sophisticated and special. Even when no decorative painting is called for on a specific job, the firm may be selected on the basis of its reputation.

However, there are also important differences between decorative and conventional painting, and their impact must be considered. For example, decorative painting

- requires much more time devoted to sample-making;

- demands more careful color decisions, particularly in selecting glazes, which involve complicated color interaction;

- is more difficult to estimate accurately as it is not as predictable as conventional painting;

- can present staffing difficulties—decorative painters who leave the firm are harder to replace than conventional painters;

- requires more decision-making responsibilities; and often requires the decorative painters to be involved in the planning stages of jobs.

Often it is prudent to develop a business in glazing, graining, and simple marbling before adding more complicated decorative painting techniques. Many successful conventional painters have improved the profitability of their businesses by offering only these simpler techniques as an addition to their regular painting. These firms can decide later whether to advance to more complicated techniques such as sophisticated marbling and graining, specialty glazing, and other faux techniques (e.g., lapis lazuli, malachite, e, tortoise-shell, and negoro nuri).

If a decorative painting firm decides to add the complete package of decorative techniques on a large scale, they must

- have a key management person who is knowledgeable in all phases of planning, estimating, and executing a decorative painting project;

- hire or develop the specialized personnel needed to do high-quality decorative painting (these employees must be aesthetically oriented and able to produce commercially viable work); and

- seek the market that desires decorative painting and be able to negotiate profitable commissions.

However, the ante goes up when these more-complicated techniques are offered; as offerings become more extensive, the time required for color research, sample development, and training and keeping skilled personnel becomes greater. For these high-level projects, the personnel in charge must have innate and trained abilities to visualize the effective uses of decorative painting, and the staff must have the skill to execute these plans. This holds true whether the project involves working with interior designers and architects or directly with private clients.

INTERIOR DESIGNERS

For interior designers, developing a special expertise in painted surfaces can be an important plus in their highly competitive field. Being able to conceptualize, paint, and/or supervise decorative-painting installations opens up a whole realm of aesthetic and problem-solving possibilities.

Interior design firms that plan to become extensively involved in this area may find it advantageous to establish their own decorative painting division. This can range from a single staff person who develops samples, acts as a liaison, and supervises free-lance decorative painters, to a permanent decorative-painting crew.

In addition to utilizing decorative painting in their own commissions, designers can serve as consultants to home-furnishing firms, corporations, and paint contractors. They can also make retail sales of painted furnishings and accessories. Furthermore, once a firm develops a recognizable style, its principles may be asked to participate in showrooms, be featured in the media, give lectures, and become involved in other activities that give the firm promotion and visibility.

HOW TO BUILD YOUR BUSINESS

In most geographic areas, selling decorative painting is easy. There are many potential markets to canvas and comparatively few decorative painters. Designers, homeowners, manufacturers, and other potential clients who have a feeling for "faux" usually welcome decorative painters.

To find and develop clients, you must

- assemble an effective portfolio;

- identify your market; and

- seek out leads through networking, advertising, and public relations.

ASSEMBLING AN EFFECTIVE PORTFOLIO

The most important selling tool for a decorative painting business is a dynamic portfolio. The portfolio should include a select group of impressive renderings (done on oak tag, railroad board, pieces of wood

baseboards, foam core, or Masonite) and photographs from completed projects (if available). All sample renderings should have appropriate finish coats, rubbed down, if necessary, as they would be on the actual surface.

The photographs should show techniques that you have done for past commissions, preferably in job conditions (e.g., on walls, fireplaces, columns, floors, furniture, and so forth). If you do not have such photographs, mock up these on-site effects in your studio. A sample should be available for each photographed technique.

You can enhance your portfolio by also including newspaper and magazine clippings featuring your work, clients' letters of appreciation, and educational accreditation.

The portfolio permits the client to make a nonverbal, visual evaluation of your work. It reflects your unique skills and aesthetic sense. If a potential client reacts positively to your portfolio, you are likely to get the commission.

A portfolio must be ever-evolving to remain dynamic. A wide range of techniques should be represented, including those incorporating the expanding new technologies in materials, tools, and supplies.

Your portfolio is your display window to the world; revise it continually—do not let it get stale. And show it at every opportunity.

IDENTIFYING YOUR MARKET

After you have developed an exciting group of samples and an interesting portfolio, you must decide which markets to pursue. Many markets are eager to hire a decorative painter who has an excellent portfolio. Consider the following potential markets:

• interior designers

• paint contractors

• builders

• architects

• homeowners

• frame shops

• window display departments

• restaurants and other commercial establishments (for walls, tables, doors)

• furniture shops (for displays, accessories, or as merchandise)

• gift stores (for boxes, frames, shelves)

• museums (for interiors, plinths, fixtures, baseboards)

• craft or flea markets (particularly in affluent areas)

• commercial photographers (for backdrops)

• consignment shops

• developers (for model apartments)

• trade-show organizers (for backgrounds)

• theater producers (for stage sets)

• unpainted-furniture shops (for displays)

• nurseries (for painted clay pots)

This list could go on and on. Any business that has an interior, fixture, or a product could find a creative use for decorative painting.

There are many ways to locate these markets. Networking is effective, as is getting names from the local Yellow Pages, show-house catalogs, and professional associations. Walk through the business district in your area scouting for potential markets. Newspapers and magazines (both general and trade) can also be a source of good marketing ideas.

SEEKING OUT LEADS

After you have decided which market to pursue, you must develop leads from that market—people with whom you can meet to show your portfolio. Leads can come from networking or cold-canvassing, advertising, or public relations efforts.

Networking and Cold-canvassing

Networking and cold-canvassing are direct methods for contacting leads, the difference being that the former is contacting a prospect using the particular name of the person who referred you, while cold-canvassing is approaching the prospect with no referral.

Although our students have had good results using both methods, they have found networking the more effective of the two. When seeking out potential clients you have a person's attention when you begin the conversation with a reference, such as "Jim or Jane Smith suggested I call you." As a general rule, telephoning is more productive than sending a letter when seeking an appointment to show your portfolio. When you do use the mail, you should also make a follow-up telephone call.

Almost everyone has architects, builders, interior designers, restaurateurs, and design professionals in his or her network. By showing your portfolio to them, you are apt to get some leads. Contact relatives, business associates, suppliers, college or high-school friends,

church or synagogue members, fraternal associates, neighbors.

In addition to finding leads by networking, you should try to reach other members of your target market by cold-canvassing. When you have identified a company that could use your services, call to get the name (with the correct spelling) of the person to contact. Send this potential client a letter introducing yourself and asking for an appointment to show your portfolio. Do whatever you can to make this mailing compelling. It is a good idea, for example, to enclose a composite photograph of your work. Include as well any interesting magazine and/or newspaper credits. Within a week follow up with a phone call to schedule an appointment.

You may find ways to show your portfolio to many possible clients at a time. Trade associations are good potential sources for such prospects. For example, the local chapter of the American Society of Interior Designers (ASID), the International Society of Interior Designers (ISID), the Painting and Decorating Contractors of America (PDCA), and the Building Owners and Managers Association (BOMA) may let you bring your portfolio to their meetings. Some of these organizations have periodic resource shows that also could prove valuable. Displaying your work at a trade show exposes your samples and portfolio to crowds of potential clients.

Advertising

Advertising enables you to reach a large number of people with relatively little time and effort. However, it has two major disadvantages: (1) it may be difficult to find the correct media to target your specific market, and (2) advertising can be ineffective in terms of cost per response.

To make an advertisement effective, multiple insertions (at least three) are essential. Therefore, if an advertisement costs $750 per insertion, you will need to invest at least $2,250. In addition to the cost of the space, the charges for designing and preparing the advertisement can be sizable.

In the early stages of promoting a new venture, be careful about spending too heavily on media advertising. Direct mailings and public relations efforts may be better ways to go.

Some of our students have used inexpensive advertisements with good results. They have placed small notices in the classified columns of local newspapers or have used the classified listings in local, regional, or national magazines. While these advertisements often result in low-end commissions, these commissions can be good for early experience.

Advertising is usually most effective for a business that is already established. As your business grows and gets more commissions, you will be able to afford a larger budget for the purchase of more costly display advertising. In addition, the longer your business has been established, the more knowledgeable you will become about your market. This acquired information enables you to advertise in those magazines, newspapers, or newsletters that will be the most effective in reaching potential clients.

Whether or not you have a sizable advertising budget, the same questions exist for an established firm as for a new firm:

- How can a specialized customer be reached without this expenditure becoming too wasteful?

- At the same cost, are there better alternatives, such as direct mail or public relations?

Advertising is unlikely to have the same impact as an article in the right newspaper or magazine. We have found the most successful advertising of our school has come from direct mailings and public-relations efforts that have led to valuable newspaper or magazine articles.

Direct mailings, if you can build or secure a quality mailing list, have distinct advantages over media advertising. They hit your target audience and can be cost-effective. Also, more information often can be included in a direct mail piece than in an advertisement.

While mailing lists can be purchased, these are almost never as effective as a list built through your own efforts. When we started our school, we put our energies into public relations efforts as a means of securing students, getting free publicity in newspaper and magazine articles, and building up our mailing list. To this day our major promotional investment is in direct mailings of our brochure and schedules.

As with any advertising effort, the direct mail piece (or pieces) should be compelling and should reflect the caliber of your work. Photography should be sharp, and all pertinent information should be presented clearly and succinctly. Be sure to proofread your copy. A sloppy mailing can dissuade potential clients from calling you.

Public Relations

An important avenue for promoting a decorative painting business is public relations. The goal of public-relations efforts is to gain the firm a reputation, or at least name recognition, through public appearances and free media exposure (in newspapers and magazines and on radio and television). Public relations can result in positive word-of-mouth about the business and inspire clients to seek your firm.

Every action that each member of the firm does is public relations. This statement dictates that the most important public relations for the business is the reputation of the business. Before considering any actions, dealing with problems, or setting policies, realize that they have public-relations implications. In addition to this indirect public relations, there are more formal efforts you can make to enhance the public image of the firm. These include sending out press releases, giving lectures and presentations, being published in newspapers and magazines, and making radio and television appearances.

Professional public-relations firms use all these tools, and more, to keep their clients' names in the news. Depending on the size of your firm, their services may be worth their sometimes substantial fees.

When we founded The Finishing School in 1984, we decided our main promotional emphasis would be on public relations rather than advertising. Our plan was to do the public relations ourselves, spending time and effort, rather than making a major financial investment. It proved to be a good decision for the school and could be for any business that wants to invest the required effort. We prepared an effective portfolio, organized color-slide presentations, designed press kits, contacted media people, arranged press meetings, and scheduled lectures and presentations to give to both public and professional groups. All these efforts were aimed at getting our name before the public. There were phone calls to make, letters to write, meetings to attend, and organizations to join. Some of these efforts were a waste of time and some resulted in rejection, but often they resulted in students attending our school.

We began promoting in our immediate area. Just as someone who wants to be an anchorperson in a major television market often starts at a small local station and moves from one larger market to another, so must many decorative painters or designers start out by lecturing about decorative painting to local organizations (in and out of the trade). By speaking before local groups, we were able to perfect our lecturing skills and go on to become major lecturers for many national conventions. These lectures, along with articles that appeared in local and professional publications, led to several valuable articles featuring us and the school in high-circulation nationally distributed decorating magazines.

Good public relations opportunities are very competitive. It takes newsworthy examples of decorative painting, effective photography, interestingly written copy, and time and effort spent researching potential promotional targets.

Photography

The potential client or student evaluates the quality of decorative painting visually. A key factor in the success of a press release, portfolio presentation, or slide lecture is the effectiveness of the photography.

Professional photographs, or professional-quality photographs, are essential when communicating with magazines. Transparencies, or "chromes," should be 4 × 5 inches (10 × 13 cm), 2¼ × 2¼ inches (6 × 6 cm), or 35mm; 8 × 10-inch (20 × 25 cm) color or black-and-white glossy prints are acceptable in many cases; 3½ × 5-inch (9 × 13 cm) snapshots, almost never. Note: Before using a photograph taken by anyone other than yourself, you must obtain a signed release from the photographer. Photographs are usually kept on file at the magazine and quite often are used months or years after they have been submitted. Make sure information about the photograph is on the back, along with your name, address, and telephone number. Retain duplicates of what you submit, as often the material will not be returned. If you want your material sent back to you, enclose a stamped self-addressed envelope to facilitate the return.

Before sending photographs to appropriate magazines, call the magazine to ask for the name of the person to whom your work should be sent. With the photographs, send a cover letter describing the project and stating any copyright information and proper credit wording (this information should also be stamped or attached to the back of the photograph).

Whenever photographs of your work are published, you should receive proper credit. This enables people who like the work to contact you. Credit wording is easy to monitor if you supply the photographs to the media; however, if someone else (a designer, for example) supplies the photographs, your contribution may not be credited. This may be because the designer has not passed along the information (although most designers do) or because the editor chose to eliminate it. You can avoid these omissions by including an appropriate clause in your letter of agreement with the designer (see pages 262–65).

The most effective credit in terms of generating commissions is "on-page" credit—credit given on the same page as the photograph. On-page credit often is given for decorative-painting photographs used to illustrate an article; for example, a collection of screens, painted floors, or furniture shown against glazed walls. Whenever possible, try to negotiate for on-page credit.

If you are lecturing or teaching, you will need to develop a color-slide collection. Lecturing at any level is

only as good as the quality of the color slides. It pays to invest in a good camera and to learn to use it to produce outstanding finished photographs. Take in-process photographs, starting with the original state of the room or object and ending with finished views. These slides will also be useful in client presentations.

Show Houses

A designer's show house is a charity effort where rooms and other spaces of an architecturally interesting large house are assigned to various interior designers to redesign. The show house is then opened to the public, offering designers and decorative painters an opportunity to display their skills to large numbers of visitors over several weeks' time. Show-house events usually include a press showing and an evening gala, which present valuable networking possibilities. In addition, a catalog is published to give to visitors, and the participating designers are each featured on a page; they also have the opportunity to buy a paid advertisement in the catalog. One room in the show house is devoted to a silent auction (donating a beautifully painted object to the silent auction is an additional way to get your name and skills before an interested, targeted audience).

To be considered for participation in a show house, contact the show-house management and/or approach participating designers. However, before making a commitment to participate, ask yourself if the show house is a better investment of time and/or money than paid advertising, seeking prospects and commissions in other ways, working on your portfolio, improving and developing your techniques, or doing paid commissions.

A decorative painter may arrange to take part in a designer's room (with appropriate credit) or to design a space of his or her own that focuses more directly on decorative painting. There are two ways to obtain your own space: You can contract with the show-house management for a room to design (at a fee) the same way a designer would; or, you can negotiate with the managers of the show house to do a public space such as a foyer, hallway, or stairway (usually paying no fee). When you have your own space, you can control the aesthetic decisions, meet the show-house visitors, and deal directly with the press.

A decorative painter, particularly an inexperienced one, can gain experience and knowledge from working on a show house with a qualified interior designer. Much can be learned by observing work being done elsewhere in the show house, and valuable networking among designers and tradespeople goes on during the

period before the show house opens. In addition, if you are allowed to meet the public, you may acquire leads that result in commissions.

A show house also can be an excellent public-relations effort; your name is listed in the catalog and on the list of credits in the room. Worthwhile media contacts can be made during the visits from the press. In addition, you sometimes can secure excellent professional photographs that will be a valuable addition to your portfolio.

Be aware, however, that show houses can also be disappointing. You may devote considerable time and energy on a finish that makes a contribution to the total effect of the room, but does not showcase your work. Furniture and other objects may obscure your work, or the painted treatments may be below eye level, limiting their visibility and restricting photographic possibilities. In addition, show-house schedules can be tight, which could result in rushed work that is not up to your usual standards—in which case participation in the show house may even be counterproductive.

A letter of agreement forces all parties to think through their responsibilities and rewards from a project (see also "Letters of Agreement," pages 262–65). A letter of agreement should be drawn up and signed by all parties involved in a show-house project. This letter should cover the following:

The nature of the work to be done. What areas are to be painted? What techniques will be used? If the committee or the owner disapproves of any part of the painting, will there be a renegotiation?

Scheduling. What is the estimated time required from the decorative painter? How is it dove-tailed with other tradespeople? Will there be any compensation if actual time greatly exceeds the estimate?

Credit. How are credits to be handled in the room and how will they be worded? If the room is to be featured in a magazine or newspaper, will credit be listed for the decorative painter?

Personal appearances. Will the decorative painter be permitted to appear in the room to talk about the work he or she has done. Are there any restrictions?

Photographic participation. If professional photographs are being taken of the room, will the negative or prints be given to the decorative painter? Will there be any charge? Are there any restrictions on how these photographs or negatives can be used?

Compensation. Are you donating your time and

expenses—or will you be paid at your usual rate, a reduced rate, or expenses only? If any of the painted objects in the room are for sale, what is the arrangement for these sales?

FINANCIAL PLANNING

Anyone going into business or operating an ongoing business should plan for and, hopefully, produce a profit. Profits can be funneled into reserves that can be used to pay for expenses during slow periods and to cover cash-flow shortages when clients are slow in paying. In addition, when you are negotiating a bank loan for expansion or capital improvements, a good profit picture is often the bank's crucial consideration in deciding whether to extend credit.

To project an annual profit, you need to determine an annual figure for each of the following:

- salaries
- fringe benefits (and other personnel costs)
- fixed overhead
- variable expenses
- planned working days
- billing rates of the painter(s)

In addition, there will be certain expenses, such as taxes, that will vary depending on the laws in your location. You should adjust your preliminary profit projection to reflect your particular tax situation. In most cases, it pays to go over your figures with your accountant before starting a business. You also may want to talk with your accountant and/or lawyer about the pros and cons of incorporation.

Every decorative painting business is different. To help illustrate how to calculate expenses for various business types, we are using three representative businesses as examples throughout this section. Most decorative painting businesses are a variation on one of these three:

A part-time decorative painter. An amateur decorative painter plans to give up his current full-time employment after a year of "testing the waters." He plans to devote two weekends a month for one year to professional decorative painting.

A two-painter decorative painting firm. A successful residential house painter who enjoys decorative painting decides to start her own business in which she will emphasize decorative painting techniques. She plans to hire one other skilled decorative painter.

An eight-painter decorative painting firm. A skilled supervisor for a leading decorative painting company decides to start his own business. He plans to do very little of the actual painting himself; rather, he will concentrate on promoting business, planning projects, creating samples, and supervising projects. He plans to hire eight painters at three different levels of experience, and to rely on subcontracting as little as possible to retain more control of each project. (Good subcontractors are usually expensive and, more important, very busy, which can make scheduling difficult. Less-skilled subcontractors will often produce work that will detract from a firm's reputation.)

SALARIES

The salaries of the painters will vary depending on their skill, the cost of living in the area where the business is located, and the market for decorative painting in that area. Salaries for management and office staff will also vary.

FRINGE BENEFITS

In addition to the salaries paid to employees, there are other personnel costs that must be paid each year. These include those that are mandated by the government, such as the company's share of social-security contribution and unemployment insurance; and those that are perquisites of the company, such as health insurance, Christmas and merit bonuses, and educational allowances.

Fixed benefits usually run from 25 to 33 percent of salaries.

FIXED OVERHEAD

Fixed overhead includes those expenditures that must be paid even if there is no income from painting commissions. Examples of this type of expenditure include the following:

- rent
- professional fees to accountants and/or lawyers (if on a retainer)
- advertising and promotion costs
- capital investments, including trucks and expensive painting equipment (such as spray and scaffolding). These investments are usually depreciated over a period of years; therefore, only the depreciation applicable to that year should be factored into fixed overhead.

- insurance on premises, trucks, and equipment

- office expenses, such as those for telephone, supplies, and printing

- sundries: donations, entertainment, dues and subscriptions, licenses, bank service charges, bad debts, collection costs, interest on borrowed funds, travel, and so forth.

Some of these expenses cannot be altered and represent an obligation regardless of the income generated—for example, rent under a lease, truck payments, and liability insurance. Others, such as advertising costs and donations, can be cut back in difficult business times. However, for planning purposes, annual estimates should be made for all of these items and they should be totaled to produce the annual planned fixed overhead.

VARIABLE EXPENSES

Those costs that vary with the amount of work a firm performs are called variable expenses. Examples of such expenses are

- supplies and materials;

- travel expenses (gas, tolls, parking);

- special inexpensive tools; and

- hiring helpers for a job.

In a decorative painting business, variable expenses tend to be a comparatively small amount, usually 10 to 15 percent of fixed expenses. Good record-keeping and experience will allow each firm to accurately set this percentage.

PLANNED WORKING DAYS

The number of planned working days can vary enormously. We have used the three sample businesses to illustrate how to obtain this figure.

Part-time Painter
This painter has a full-time job and plans to devote two weekends a month to the decorative-painting business. Planned annual working days are calculated as follows:

4 days per month × 12 months = 48 planned working days per year

Two-painter Firm
Because both the owner and the employee plan to take three weeks of vacation during the year, forty-nine weeks per year will be used in calculating annual planned working days. Four days per week is the figure

used in the calculation—this is to compensate for slow periods, time overruns on jobs, and unexpected sample-making time.

Planned annual working days are calculated as follows:

4 days per week × 49 weeks × 2 painters = 392 planned working days per year (196 working days per painter)

Eight-painter Firm
This shop also gives its employees three weeks vacation each year; therefore forty-nine weeks will be used in figuring annual planned working days. A larger shop will have more down time than a small shop because of the additional work volume required to keep more painters working, scheduling difficulties, and training time. The variety of experience of the eight painters also will result in more overruns and training time. Three and a half days per week is the figure used in the calculations.

Planned annual working days are calculated as follows:

3½ days per week × 49 weeks × 8 painters = 1,376 planned working days per year (172 working days per painter)

DAILY BILLING RATES OF THE PAINTERS

A rule of thumb when starting a decorative painting business is to charge 25 percent higher than the going rate for regular painters in the area. If the business is successful, there usually will be a profit. However, if the decorative painters are inexperienced, they must develop the skills required to justify their billing rates, which may require many hours of unbilled time.

Ideally, you would like to develop a billing rate for each painter in your firm that, if they all work the planned number of days, will both cover your expenses and give you a reasonable profit percentage. Often there are industry guidelines to help you set a planned profit percentage (10 percent is common in this industry); however, the figure you use is arbitrary. Setting it too high might jeopardize obtaining some valuable commissions.

The chart on pages 248–49 shows how to develop a daily billing rate. Again, we have used our three sample businesses to illustrate the process. It is important to note that because the daily billing rates of the painters must cover the salaries and fringe benefits of nonpainting personnel as well, those costs are added to the fixed overhead and split evenly among the painters.

Part-time Painter

The painter adds his salary ($7,200), his fringe benefits (he factors in $1,000 to pay for decorative painting seminars and books; his other job is paying his health insurance), and his fixed overhead (he estimates this at $2,500 to cover the costs of tools, equipment, and office expenses, as well as to run small classified advertisements in the local paper) to get his total fixed expenses: $10,700.

He multiplies that figure by 10 percent to get his estimated variable expenses, $1,070, which he adds to his fixed expenses to get his total expenses: $11,770.

He divides his total expenses ($11,770) by his planned working days (48) to get his daily billing rate before profit: $245. He then divides that rate by 90 percent (the reciprocal of his planned profit percentage of 10 percent) to get his actual daily billing rate: $272.

Two-painter Firm

The owner determines total fixed expenses for herself, the advanced painter, and the firm by adding salaries ($65,000 and $45,000 for a total of $110,000), fringe benefits (estimated at $20,000 for herself and $15,000 for the advanced painter for a total of $35,000), and fixed overhead (estimated at $20,000, divided equally between herself and the advanced painter). The total fixed expenses for the owner and the advanced painter are $95,000 and $70,000 respectively, for a total of $165,000.

The owner multiplies those figures by 12 percent to get estimated variable expenses ($11,400 and $8,400 for a total of $19,800), which she adds to the fixed expenses to get the total expense figures: $106,400 for herself, $78,400 for the advanced painter, and $184,800 for the firm total.

DEVELOPING A DAILY BILLING RATE*

| | | Part-time painter | Two-painter firm | | |
			Advanced	Owner	Total
A.	**Fixed expenses**				
	Salaries	$7,200	$45,000	$65,000	$110,000
	Fringe Benefits	$1,000	$15,000	$20,000	$35,000
	Fixed Overhead	$2,500	$10,000	$10,000	$20,000
	Total fixed expenses	$10,700	$70,000	$95,000	$165,000
B.	**Variable expenses**				
	Percentage	10%	12%	12%	12%
	Total variable expenses	$1,070	$8,400	$11,400	$19,800
C.	**Total expenses**	$11,770	$78,400	$106,400	$184,800
D.	**Planned working days**	48	196	196	392
E.	**Daily billing rate before profit** (C divided by D)	$245	$400	$542	$471
F.	**Planned profit percentage**	10%	10%	10%	10%
G.	**Daily billing rate** (E divided by 90%)	$272	$444	$602	$523
H)	**Annual planned profit**	$1,296			$20,384

* All figures used are on an annual basis.

The owner next divides these total expenses by the planned working days (196 for each painter) to get their daily billing rates before profit: $542 for the owner and $400 for the advanced painter, averaging at $471 for the firm. She then divides those figures by 90 percent (the reciprocal of her planned profit percentage of 10 percent) to get actual daily billing rates: $602 for herself and $444 for the advanced painter, averaging at $523 for the firm.

Eight-painter Firm

The owner determines total fixed expenses for each category of painter he has— trainee, intermediate, and advanced—by totaling salaries, fringe benefits, and fixed overhead. The fixed overhead of this business is high, as the salaries and fringe benefits of the owner and office manager come to a total of $139,650, which must be added to the standard overhead expenses. In factoring daily billing rates, the total estimated overhead—$280,000—is divided equally among each of the eight painters. Each trainee ends up with total fixed expenses of $68,000 ($25,000 salary, $8,000 fringe benefits, and $35,000 fixed overhead); each intermediate painter, $82,000 ($35,000 salary, $12,000 fringe benefits, and $35,000 fixed overhead); and each advanced painter, $95,000 ($45,000 salary, $15,000 fringe benefits, and $35,000 fixed overhead). The firm's total expenses will be $667,000 ($290,000 for salaries, $97,000 for fringe benefits, and $280,000 for fixed overhead).

The owner multiplies these figures by 12 percent to get total variable expenses ($8,160 for trainees, $9,840 for intermediate painters, and $11,400 for advanced painters), which he adds to the fixed expenses to get total expense figures of $76,160 for trainees, $91,840 for intermediate painters, and $106,400 for advanced painters. The total expenses for the firm are $747,040.

The owner next divides the total expense figures by the planned working days (172 for each painter) to get daily billing rates before profit: $443 for trainees, $534 for intermediate painters, and $618 for advanced painters, averaging at $543 for the firm. The owner then divides these figures by 90 percent (the reciprocal of his planned profit percentage of 10 percent) to get actual daily billing rates: $492 for trainees, $593 for intermediate painters, and $687 for advanced painters, averaging at $603 for the firm.

ANNUAL PLANNED PROFIT

In calculating annual planned profit, you first must determine the average daily profit per painter by subtracting the average daily billing rate before profit from the average daily billing rate. You then multiply the average daily profit per painter by the total planned working days to get the figure for annual planned profit. Using the three sample businesses, calculations are as follows:

Eight-painter firm

	Trainees (2)	Intermediate (3)	Advanced (3)	Total
	$25,000	$35,000	$45,000	$290,000
	$8,000	$12,000	$15,000	$97,000
	$35,000	$35,000	$35,000	$280,000
	$68,000	$82,000	$95,000	$667,000
	12%	12%	12%	12%
	$8,160	$9,840	$11,400	$80,040
	$76,160	$91,840	$106,400	$747,040
	172	172	172	1376
	$443	$534	$618	$543
	10%	10%	10%	10%
	$492	$593	$687	$603
				$82,560

	Part-time painter	Two-painter firm	Eight-painter firm
Daily billing rate	$272	$523	$603
Daily billing rate before profit	−$245	−$471	−$543
Daily profit per painter	$27	$52	$60
Planned working days	× 48	× 392	× 1,376
Annual planned profit	$1,296	$20,384	$82,560

THE DECORATIVE PAINTING PROCESS

Various stages are involved in taking a decorative painting commission from concept through to completion in an expeditious and professional manner. These stages are the initial meeting between the client and/or interior designer and the decorative painter; the sample-making process, including the presentation of samples; estimating; drafting the letter of agreement; and executing the commission.

Before starting on this process, however, you should understand the roles and responsibilities of the parties involved: the client, the interior designer (or architect), and the decorative painter.

ROLES AND RESPONSIBILITIES

In this section, the terms *client, designer,* and *decorative painter* are used to identify the functions performed in a decorative painting job, rather than the professions of specific people. It is our goal that readers of this book not only will be able to perform one (or all) of these roles, but also will understand how the other individuals working on a project function.

The three functions are defined as follows:

The client desires, and pays for, the decorative painting installation.

The designer plans, coordinates, and supervises the project.

The decorative painter executes the art work and may also plan and supervise the project.

The more common knowledge there is about the entire process, the more gratifying the results are likely to be. Decorative painting differs from many other aspects of interior design projects because the roles of those involved often overlap and are not as clearly defined as, for example, those of floor refinishers, drapery installers, and conventional painters.

Before getting involved in a decorative painting project, you should understand the roles and responsibilities of the client, the designer, and the decorative painter.

THE CLIENT

Before becoming the client of a designer and/or decorative painter, you should give careful thought to your needs, priorities, and budget. The more articulate you can be about these concerns, the more satisfying the final results are likely to be. Communication is essential. Before meeting with one of these professionals, you should research architectural and interior design publications, show houses, museum and historical installations, and personal contacts—both to formulate ideas and to get the names of addresses of designers and decorative painters you might want to consider for the job.

Once you have formulated your thoughts and selected a decorative painter (or several candidates), you should contact that person to set up an interview. The best place for this interview is at the job site.

When you interview a decorative painter, his or her portfolio of photographs and samples should give you a good idea of competence and range of techniques. However, you should not hire a decorative painter solely on the basis of his or her portfolio. Ask for a list of client references and call these people to get feedback on the painter's reliability and proficiency. Ask whether the decorative painter's job met expectations, and whether it was completed on time—and on budget. If the answer to any of these questions is no, ask for the reasons.

When you are working directly with a decorative painter without using a designer, you should provide the painter with all pertinent information about the environment to be refurbished, including how and when the space will be used. If you find in the decorative painter's portfolio exact samples of finishes you would like, the painter will be able to supply you with an estimate more quickly than if custom samples must be made. If you are getting samples and estimates from more than one decorative painter, make sure when you make your comparisons that the quality of work, as far as skills, craftsmanship, and technical ability, is being considered as well as the estimate.

After you have selected the finishes you want, the decorative painter should submit a proposal detailing every aspect of the job. When signed by all parties involved, this proposal becomes the letter of agreement (see *Letter of Agreement*, pages 262–66). If you hire a conventional painter to do the preparatory work for the decorative painter, you are responsible for supervising these earlier stages so that they are done according to the specifications listed in the letter of agreement.

Professional designers and craftspeople are hired for their knowledge, skills, and unique perspectives. However, you should not let these professionals intimidate you. Feel free to question their decisions. You are the one who pays the bills and must be satisfied with the final results. Bear in mind, however, that a certain protocol must be followed. For example, if the decorative painter is working for a designer or another

person in charge, you should discuss decisions and modifications directly with that person rather than with the decorative painter. Also, consider carefully before asking for even small changes; any requested changes will usually require a renegotiation of the fee.

THE DESIGNER

As a designer, you are responsible for innovating design schemes and assembling, coordinating, and supervising trades until that glorious day when all vestiges of the old scheme are gone and the new scheme is completely in place. Except in situations where fabrics, furniture, or accessories can be custom made, with standard design commissions you generally are limited by what is available within a specific budget. In contrast, decorative painting offers infinite possibilities if you have an in-depth working knowledge of how media can be manipulated to create special color and pattern effects.

A designer who has little understanding of painted finishes and how they work relinquishes to the decorative painter tremendous artistic control. It is almost as if a paper hanger were asked to "choose three wallpapers that will work with this fabric and this carpet." If the decorative painter is skillful and intuitive, the results may be wonderful. However, it can also happen that these casual forays into decorative painting by an untutored designer can lead to numerous changes, delays, and other problems.

When the designer and decorative painter working together on the planning and execution of a project are knowledgeable, they both can enter into the creative process. Armed with the knowledge of decorative painting, the designer will be able to understand the decorative painter's problems and solutions; conversely, the decorative painter who knows the effects on design of various paint techniques will be able to offer contributions to the designer to achieve his or her objectives.

It goes without saying that it is easier to work with a decorative painter you know than to start with somebody new. However, you may not know of a person who does marbling. Or there may not be a firm doing this work in your area. If you have a good working relationship with a conventional painter, you might suggest that the painter study decorative painting (keep in mind, though, that not every painter can be, or wants to be, a decorative painter). In addition, you should always be on the lookout for good up-and-coming decorative painters—they often are more innovative and open to new ideas than those who are established and in great demand (and their fees are often more reasonable).

THE DECORATIVE PAINTER

To work effectively as a decorative painter with a client and/or a designer, you need

• an understanding of the planning process;

• the skills to execute the appropriate techniques;

• the ability to adapt these techniques to the space being painted; and

• the temperament and organizational skills to complete the project in a businesslike manner.

To implement a painted finish, you need the same knowledge of materials, tools, equipment, and applications that a conventional painter has. In addition, you should understand specialized aspects of decorative painting, such as the proper preparation of a surface for the technique being used; the proper use of special tools; and a knowledge of the best media for the job. The technical problems differ for each finish. As a result, you often will spend considerable time researching and testing during the sample-making process.

Many aspects of decorative painting are similar to those of conventional painting. All of the attributes of a good paint job should be achieved, such as clean, crisp edges; no drips or curtaining; and a strong bond between coats. And, as in conventional painting, you and your crew should project a professional image. The appearance, reliability, and courtesy of any crew member—and his or her consideration of the client's property—are seen as a reflection of the person at the top: the decorative painter.

Decisions about the total design concept, the major color selections, and the choice of paint techniques are the designer's responsibilities (if one is used). However, the burden of transforming the designer's concepts into reality falls on you. You must be able to develop finishes that work within the design scheme to form a coordinated, completely integrated whole.

You should be able to estimate accurately, give viable options at various fee levels, and articulate the rationale and details of the pricing to the designer to facilitate the incorporation of the painting into the total budget.

When working directly with the client, you must translate the client's preferences and tastes into a design scheme that works. Listen carefully to what the client says, and work within the limits he or she sets as to color, scale, period, influence, and price. Suggest options without pushing unwanted choices.

To assure a good working relationship with the designer and/or client, take extra care to

• schedule appointments carefully, being sure to notify

the designer or client as early as possible if you will be late or must cancel;

- dress neatly (jeans, a painter's coverall, and/or a T-shirt with your company's name on it all add to instilling confidence); and

- be businesslike, especially regarding matters such as presentation of samples and letters of agreement.

THE INITIAL MEETING

The decorative painting process begins when a client or designer contacts a decorative painter for a specific project. During the initial telephone conversation, the uninitiated caller might ask the decorative painter a question such as, "What would you charge to glaze a twenty-by-twenty-foot room?" Rather than discussing specifics such as type of finish or who will prepare the surface, you should try to schedule a meeting. Respond with an answer such as, "I must learn more about the space and the finish(es) you would like before I can quote a price. When may I show you my portfolio?"

If the caller gives a price cap that is below what you think is reasonable, you have the option of turning the offer down or referring the caller elsewhere. However, consider first whether you might have less-expensive finishes you can offer. Do not be in a hurry to turn away business; many times a client will spend more after seeing your work.

If feasible, you should schedule the initial meeting to be held at the job site, as this tends to be most productive. Ask the client to bring to the meeting a floor plan and elevation, if available. Also, get information about the nature of the project, so you can bring along appropriate samples and magazine clippings.

This initial meeting is very important and can well decide if you will get the commission. The goal of the meeting is two-fold: to sell your ability to do the job better than anyone else and to acquire the information needed to prepare your follow-up proposal and estimate. If the meeting is on site, you should be prepared to take thorough and accurate measurements, making note of any problem areas. You may also wish to make sketches and/or take photographs.

The following topics should be discussed:

Overall design concepts.

Existing (or already selected) fabrics and carpets with which the painted surface must interact. Swatches should be made available to you for sample-making.

Problem areas, if any.

Finishes that might be appropriate. Because you have a broad knowledge of suitable finishes, you will often be called upon to supply suggestions. A well-put-together portfolio, along with magazine articles and books, can be invaluable in focusing discussion. The decorative painter should feel free to comment on whether the designer's or client's suggestions are appropriate.

The fee. Do not discuss prices for specific work. Instead, indicate which groups of finishes are more costly because they involve time-consuming detail work or require multilayer processes. Do not give estimates, either firm or "ball park," at the first meeting. You will often find in working up an estimate that it will vary from what you had expected. It is better not to set up unrealistic expectations. Indicate whether there will be a charge for any samples you prepare—and, if so, what it will be.

Scheduling. Find out approximately when the project is scheduled—and determine whether you and/or your crew are available at that time.

If the client is interested in going forward, you should promise custom samples for a date that will allow sufficient time for adequate color testing, technique development, finish-coat application, and/or drying time.

Often a client may want time to consider the samples before going forward. Usually it is better to make another visit than to leave your samples or portfolio with a client. If you feel that the client is taking advantage of your time after the initial visit, you can make a policy of charging an hourly rate for extra visits or consultations.

Ideally, you will be able to establish working relationships with one or more designers, enabling this process to be streamlined.

JOB EVALUATION

At the same time that a client and/or interior designer is deciding whether to hire you as a decorative painter, you should be evaluating whether to take the job. Consider the available budget, the scope of the project, the working conditions, the travel distance, whether the job presents an opportunity to work with a well-known designer, the value photographs of the job will add to your portfolio, and the potential for other jobs resulting from this one.

Also try to imagine what it would be like working with this client. If you feel at all uncomfortable about the client, you should have the courage to walk away from the job or ask for an unusually high fee (which, if

accepted, will compensate somewhat for the extra aggravation that may be part of the job). Difficult personalities may be harbingers of trouble ahead: multiple changes, uncooperation, slow bill-paying.

SAMPLE-MAKING

The aesthetic and financial success of a decorative painting installation is directly related to how well the client, the designer, and the decorative painter understand the importance of following prudent sample-making procedures. The creation of the tangible product, the sample, must be preceded and accompanied by an analysis of the problems to be solved and a selection from the possible solutions. Properly done sample-making

- clarifies communication among all parties;

- focuses expectations as to what will be accomplished;

- gives an indication of the final decorative effect; and

- provides information essential for realistic estimating of time and fee.

Sample-making allows the client, the designer, and the decorative painter to view and discuss decorative effects in specific visual terms, which can eliminate sometimes-costly surprises. In addition, the decorative painter finds out which media and tools work and which do not, thereby eliminating time-wasting experimentation on the job. The vast majority of problems that arise on a decorative painting job can be prevented by carefully done sample-making.

Sample-making is a time-consuming process. However, a job should never be started without making samples first, regardless of what a client might say. Also, do not allow yourself to be pushed into making "rush samples for tomorrow." Hurried samples always cause trouble; colors are off, or drying time and finish coats are inadequate. We have heard stories of rush situations where samples were submitted and accepted that had marbling or glazing done over base coats of quick-drying flat paint and coated with quick-drying finish or shellac. When the actual work was done using longer-drying media, the color was distorted and the work proved unacceptable to the clients.

Always use the same materials in preparing your samples as those you will be using on the job itself. If a time deadline forces you to prepare a rushed sample using different media, stipulate to the client that a final, properly done sample must be approved prior to your starting work on the actual job.

Neglecting thorough preparation of samples can lead to

- misunderstanding by all parties regarding desired techniques, colors, scale, and integration of the decorative painting with its surroundings;

- disappointment with color and appearance after the finish coats have been applied; and

- an inaccurate time and fee estimate given by the decorative painter for the project, leading to frustration, resentment, and possible delays.

Conversely, you should not foster excessively high expectations by submitting samples that have been refined to a degree that will be impossible to duplicate on the job. Good craftsmanship is expected, but perfection cannot be achieved any faster on site than in the studio, and job-site conditions and budgetary constraints seldom allow for numerous revisions on the job.

If sample-making is approached with the right frame of mind, it can be both creative and rewarding. All of your abilities and experience are directed toward conceiving different approaches and techniques. Variations can be tried, new possibilities explored.

RECORDING SAMPLES

You should get in the habit of recording samples, experiments, and practice pieces. List the type, sheen, and identifying number of each primer, base coat, layer coat, and finish coat. Accurately describe the techniques and materials used for each layer. Any factor that makes a sample unique should be noted (e.g., your hand was held in a certain way; the tool was dragged, not patted; the consistency of the media was very diluted). We have learned two facts concerning this recording process:

1. It takes time and is annoying. You must stop after each layer or experiment and write down every formula and process.

2. It is the only way these formulas and processes can be repeated with any consistency.

Careful recording of all formulas and processes can also be beneficial at a later date. If a touch-up is needed on a painted surface or if an additional surface must be painted to match the original, the necessary information will be available in written form.

We recommend the following method for recording samples:

1. Number all sample boards.

2. Record all primer coats, base coats, layer coats, and finish coats.

3. Record each technique (including finish methods) in as much detail as is necessary to repeat it. You might try using a tape recorder with a foot switch to record processes.

4. Time each process and record the figures carefully. They will be help you to formulate an accurate time estimate for the job.

5. Copy the information into a notebook as soon as possible after finishing the sample. Take the time to write it clearly so that the sample could be reproduced even a year or two later.

Using a notebook rather than writing information on the back of a sample both protects techniques from being copied and provides you with a source for future innovative sample-making.

We recommend that you retain all samples you do for future use. Won't you get swamped with samples? Possibly. Will you ever use all of them exactly as they are? Probably not. What you will find is that you will be building a personal file filled with techniques, visual textures, color relationships, and patterns that will be extremely valuable and time-saving in the long run. Samples drawn from this file can save time working with a client, can spark technique and color solutions, and can remind you of successful past techniques that may be adaptable to current projects.

SAMPLE-MAKING FEES

Although specific arrangements vary, decorative painters often receive a fee for executing samples (on a large job where the client invites bids, compensation for sample-making is unusual). This fee is separate from that for the job itself and is based on the time spent developing concepts, techniques, and colors. Quite often this fee does not fully compensate you for the time you spend; however, the fee indicates that the client is serious.

Decorative painters set various policies concerning these fees. Some deduct the sample-making fee if they are awarded the job; others present a certain number of samples (three, for example) at no charge, but charge for additional samples; and others bill new clients for sample-making, but waive the fee for designers and clients with whom they have working relationships. Select a policy that works for you.

Even if a fee is paid for the sample-making, unless otherwise arranged, the samples themselves usually remain the property of the decorative painter. This should be clarified with the client before you start work.

PREPARATION FOR SAMPLE-MAKING

The least complicated type of commission in decorative painting is one in which a sample chosen from your portfolio is the precise painted finish desired. It is then a simple matter for you to consult written records for the exact colors, scale, and finish coats needed to duplicate the original (if a change in any of these elements is requested, you must prepare a new sample).

What usually happens is far more complicated. The decorative painter is asked by an interior designer or private client to develop new finishes that work with specific fabrics, wall-coverings, and/or floor-coverings for a particular space. Because of the infinite optical mixes and nuances obtainable with paint media, an infinite number of samples could be prepared. Since no decorative painter has unlimited time for sample-making, the process must be made as efficient as possible.

While you can do early experiments with techniques and colors on a worktable (see pages 59–62), you should prepare your final samples (those that will be presented to the client) in conditions as close as possible to those you will have on the job. Simulate the scale, contour, and location of the surfaces to be painted. Examples of this concept include the following:

For vertical surfaces: Prepare samples for walls or other vertical planes on a vertical surface. Many of our students—particularly those working in their living areas—tape either four-millimeter-thick plastic dropcloths or a shower curtain on the wall to protect it from excess paint. Masking tape will usually be strong enough to secure the plastic to the wall—and will hold sample oak tags in place on the plastic.

For large surfaces: Make samples of a size that demonstrates the scale of the pattern and the intensity of the color. We recommend six-ply 22 × 28-inch (56 × 71 cm) art boards called oak tags (these are also known as tag boards, poster boards, or railroad boards). Another good surface for larger samples is 4 × 8-foot (1¼ × 2½ meter) untempered Masonite.

For carved or fluted moldings and columns: Acquire wooden or compositional elements with similar configurations to test your techniques. Some techniques adapt better to irregular surfaces than others.

For a decorated ceiling: Tape your board to the ceiling of your studio to test techniques, media, and fatigue factor (resulting from working in an awkward position).

In addition, duplicate as closely as possible the client's lighting conditions. This will assure that samples that match in your studio will also match at the job site. This

duplication of job-site conditions reduces problems of media manipulation on the job and also enables you to make the most accurate time estimate possible.

FINISH COATS ON SAMPLES

At the early meetings with the client, you should establish whether a finish coat on the decorative painting is desired or required. If one is selected, either for appearance or for added protection, the client should choose (from examples in your portfolio) the degree of sheen desired. Choices run from high-gloss (usually rubbed down) to mid-sheen (semigloss, satin, or eggshell) to little gloss (flat). When preparing your sample, apply the same finish you will be using on the job; however, do not cover your entire sample. Retain an unfinished portion so that you will have a reference for comparison during the job.

PREPARING A LAY-UP

For a complicated installation that is comprised of many techniques, you may want to use a sampling method known as a lay-up. A lay-up is a 2- to 8-foot-wide (½- to 2½-meter-wide) floor-to-ceiling mock-up designed to see how specific finishes will look in context. There are several options when presenting a decorative painting lay-up:

- The lay-up section can be painted as would be done on the job.

- If the job calls for solid color areas accented with decorative painting on such elements as trim, wainscoting, and fireplaces, the solid colors can be painted on the walls and the alternative decorative techniques painted on oak tags, foam core, baseboards, or other sample moldings. These elements can be taped to the walls for client selection.

- The entire lay-up can be done in pieces in your studio and then be brought to the premises and assembled on the wall. Here again, mix-and-match choices can be offered.

When you are utilizing the lay-up, the more elements of the room you can coordinate with the lay-up, the more complete the client's visualization will be. The elements can include wallpaper, drapery and upholstery fabrics, floor-coverings—virtually anything that will be in the room. By stepping back and squinting, or blocking out the rest of the room with your hands, you can get an idea from the lay-up of the full-scale relationships of pattern and color. Lay-ups are also useful in helping to determine the work order of the various painted surfaces.

PREPARING FLAT SURFACES FOR SAMPLE-MAKING

At The Finishing School, we use oak tags for preparing flat samples. They meet all the requirements for a good sample-making surface, as they

- readily accept primers, base coats, and glazes;

- attach easily to vertical surfaces because of their light weight (which is also a boon when taking them to clients and/or shipping them);

- are widely available (in our area, as in others where we have taught, they are found in art stores, stationery and card shops, drug stores—in fact, any store that carries school supplies).

These oak tags have smooth surfaces (unlike the pebbled surface of mat or illustration board) and are pliable (they can form columns for sample-making when the ends are taped together). We especially like them because they serve as the 4-square-foot

Dry cleaners' wire hangers are attached to the back (dull side) of the oak tags with 1-inch (25 mm) masking tape. (We prepare many oak tags at one time.)

(1¼-square-meter) area that Carlton Wagner, the recognized color expert, maintains is necessary to see a color, or color relationship, accurately.

At our school we have devised an effective system to facilitate the handling of oak tags when preparing, drying, and storing them:

1. Attach wire hangers (available at a dry cleaner's) to the back (the dull side) of the oak tags with 1-inch (2½ cm) masking tape. The hanger should be taped on its long side only, so it can move, and should be attached about 1 inch (2½ cm) away from the edge of the oak tag.

2. Find a rolling clothes rack or a permanent wall rack of the appropriate height for storing the boards (or suspend a bar between two padded ladders, tables, or chair backs). Note: Allow room for the height or width of the oak tag plus the height of the wire hanger.

3. When you are ready to prime the oak tag, lay it shiny side up on a table, allowing the hanger to fall over the edge of the table.

4. When you are not working on the boards, hang them up by the hangers.

Priming and Base-coating the Oak Tags

If you are using an alkyd base coat, the oak tags do not have to be primed. However, if you are using latex paint, first prime the oak tags with an alkyd primer; otherwise they will warp severely. Although unprimed oak tags do flatten out eventually, priming the oak tags allows you to start work as soon as the painted oak tags dry.

Prior to applying primer to an oak tag, wind masking tape around a napped roller (available at paint stores). When you pull the tape off, most of the excess pile will come away, thus reducing stray fibers that can mar your work. Use this roller to apply your primer to the oak tag.

After you have primed each board, pick it up by the top of the hanger and hang it from the raised bar. After the primer dries, bring the board back to the table and apply the base coat (see page 30). When the base coat is dry, you are ready to glaze.

PREPARING DIMENSIONAL SURFACES FOR SAMPLE-MAKING

While oak tags are excellent to prepare samples for flat surfaces, and even to wrap around a column, other surfaces must be found to paint effective samples for dimensional surfaces. If the sample is for an element such as a baseboard, cornice molding, or fluted door frame, you must search for a similar surface for your sample.

Several different grades of wood moldings usually are available at local lumber yards and mills: common, finger-joint, and select. At The Finishing School we use finger-joint-grade molding for baseboards because, unlike common-grade molding, it has no knots, and it is less costly than the select grade. Moldings are priced by length and usually are sold in 2-foot (60 cm) increments, up to 16 feet (5 meters). Most lumber yards will cut moldings to custom sizes for a small fee.

Specialty wooden and compositional moldings, pedestals, and other architectural elements are available at lumber yards, at mills, and through mail-order firms. In addition, you may find sources in the classified advertising sections of shelter and interior-design magazines and in the appendix of this book. These elements can be used as samples for specific jobs or to present your work in realistic and thought-provoking ways.

Prepare wooden moldings and architectural elements as follows:

1. Apply a coat of alkyd primer and let it dry.

2. Sand the moldings with 220-grit sandpaper.

3. Remove the residue from the sanding with a tack cloth.

4. Decant your base-coat paint (we usually use sheened paints) into a container (see page 30) and thin the paint, very gingerly, until it levels out to a mirrorlike surface when applied to a sample wooden board. (Alkyd paints are thinned with paint thinner; latex with water.)

5. Apply the base coat to the boards or element with a foam or oxhair brush. If the base-coat paint has been thinned properly, no additional sanding is required.

For compositional elements, follow the manufacturer's directions for surface preparation and then follow the painting procedures used for wooden elements.

PRESENTATION OF SAMPLES

Samples can be presented to clients for approval in settings that range from rather informal (e.g., in the living room of a client who wants a marbled mantel) to very formal (e.g., at a meeting of the board of a large corporation who wants faux mahogany interiors for a restaurant chain). Regardless of where you make your presentation, you should project the image of a self-assured professional who will efficiently and artistically apply the selected finishes within the time frame allotted. Try not to let any nervousness show in your

speech or mannerisms. Dress appropriately for the occasion (this may mean traditional business attire or current fashions).

Both formal and informal presentations should be carefully thought through. The presentation should be short and to the point, giving consideration to the specific nature of the company and the audience. The more research you can do on the potential client's likes and dislikes (based on his or her previous choices), the more on-target your presentation can be, and the more likely you will be chosen for the commission.

Informal Presentations

At an informal presentation, place samples where they will be installed to give an accurate approximation of light refraction, color compatibility, and scale. A presentation board of fabrics and floor-coverings combined with the selected painted finishes will allow the best visualization of the final effect. When there is no designer involved, avoid an overabundance of choices that may confuse the client. We advise showing no more than three choices at a time. If your three top candidates are not selected, you can bring out others you have in reserve; however, when you bring out a new sample, take one of the original samples away so that the client has no more than three to compare at any time.

Formal Presentations

A formal presentation may require audiovisual equipment, depending on whether you are using slides, prints, or magazine pages, or presenting a videotape or film. If you do not own the appropriate equipment, you can usually rent it on a short-term basis for about 10 percent of the purchase price.

Before giving your presentation, check the room in advance for the location of electrical outlets, and find out whether you will need any extension cords or plug adapters. The ideal arrangement is to have a dress rehearsal of the presentation to avoid unexpected equipment trouble. How well your presentation is run gives the client an impression of how well the job will be run; do not let a malfunctioning projector ruin a presentation that has taken weeks to prepare.

You may be required to present details of similar projects to substantiate your ability to direct a complicated installation. The client will want to be sure that you understand the scope of the job and that you have experience ordering supplies and hiring and supervising a crew. Be prepared to leave the client a one-page resume of professional installations and personal qualifications.

After the Presentation

If your proposal is accepted, follow the steps outlined in *Project Execution,* pages 266–272. Use the time between this acceptance and the beginning of the project time to train the people who will be involved in the project and to practice techniques so that all will go smoothly on the job.

If your proposal is not accepted, try to determine the reasons. The entire presentation exercise will have proved a valuable learning experience if you find out that your estimate was above the allocated budget, that the painted finishes were considered inappropriate, or that the presentation itself did not inspire confidence in your ability to manage and execute the job.

ESTIMATING

Marketing strategy has produced a possible client and the prospective job has been thought through. Now an estimate must be prepared.

The three methods most used for estimating and pricing are the flat-fee quote, the square-foot (square-meter) quote, and the billing-actual-time quote.

With a flat-fee quote, a total price is given for the completion of a job, with materials usually included. To convert a flat-fee quote into a square-foot (square-meter) quote, divide the total flat-fee quote by the square footage (square meterage) of the area.

With a square-foot (square-meter) quote, a specific charge per square foot (meter) is given for the technique chosen from the portfolio, with materials usually included. To convert a square-foot (square-meter) quote to a flat-fee quote, multiply the square-foot (square-meter) price by the measured square footage (meterage) of the area to be painted.

With a billing-actual-time quote, the decorative painter is paid a set fee per working day (materials may be included or billed separately). In effect, the painter is being hired on a temporary basis.

CALCULATING AN ESTIMATE

There are advantages and disadvantages to each method, as outlined on the chart on page 258.

Billing-actual-time Quote

This is the method used most often when the parameters of the job are difficult to determine, such as with an extensive restoration or in a situation where there is a special relationship between the client and the decorative painter. The fee that will be charged per day is your predetermined daily billing rate (see pages 247–49).

Square-foot (Square-meter) Quote

To come up with a square-foot (square-meter) quote, you first must determine from sample-making or on-the-job experience how many square feet (meters) of a technique can be done in an average workday (daily square-foot [square-meter] production). Divide your daily billing rate by this figure to obtain the price per square foot (meter) that can be quoted to clients.

Even after giving a square-foot (square-meter) quote, you usually will be expected to submit your final estimates in a flat-fee quote.

Flat-fee Quote

We recommend flat-fee estimates for most decorative-painting commissions. Accordingly, this method is extensively explored. If a price per square foot (meter) is requested, it can be derived by taking the flat-fee estimate and dividing it by the total number of square feet (square meters) to be painted.

The following four steps are used to reach a flat-fee estimate:

1. Developing a daily billing rate for each painter (see pages 247–49).

2. Estimating the number of days a job will take.

3. Calculating the tentative estimate by multiplying the daily billing rate by the estimated number of days.

4. Revising this estimate if there are any special circumstances in the job.

ESTIMATING TIME

Predicting accurately how many days a job will take requires taking measurements of the surface to be treated, planning the techniques to be used, adapting these techniques to the project, and, usually, adding an additional margin for safety. Take the following steps:

1. Take careful measurements of all surfaces to be painted. Use square-foot (square-meter) measurements for flat surfaces such as walls and floors; linear-foot (linear-meter) measurements for moldings (eliminate fractions). Usually, openings in walls, such as doors and windows, are not subtracted from the total square-foot (square-meter) measurement because of the extra time it takes to protect the work around them.

2. Develop techniques to be shown to the client (see *Sample-making*, pages 253–57).

3. For timing purposes, break the techniques into the processes involved. For example, a particular technique might call for priming, sanding, base-coating, applying the first decorative layer, isolating the first layer, applying the second decorative layer, isolating the second layer, and applying two finish coats. Omitting any of these processes usually will do more to throw off a time estimate than underestimating the time a particular process will take.

4. Do the final stages of technique development in conditions as close as possible to those on the job site

ESTIMATING METHODS: PROS AND CONS

Method	For the Decorative Painter	For the Client, Architect, Designer
Flat-fee quote	+ Customized planning leads to more accurate cost estimates and allows more creative input. − If job falls through, you may not be compensated fully for estimate and samples. − Your costs may exceed the flat-fee quote.	+ Customized estimate is usually well thought out. + Custom samples usually accompany the estimate. − You must wait for the estimate and samples to be prepared.
Square-foot (square-meter) quote	+ Eliminates preparing custom samples. − If technique is new, may be inaccurate. − Creative input may be restricted.	+ Allows immediate pricing of a job. − The estimate may be higher than a flat-fee quote.
Billing-actual-time quote	+ Predictable daily income. − Client may pressure you to speed up work.	+ Extent and nature of the job may be revised at client's discretion. − Job cost may be higher than anticipated. − Job cost is dependent on the integrity and competence of the painter. − Difficult to budget total costs accurately.

to realistically estimate the time each process will take (see *Sample-making*, pages 253–57).

5. Add time for peripheral tasks, such as travel, set-up, taping, dropclothing, and clean-up.

6. Add a safety factor. Our experience, and that of our students, indicates that even with careful planning most jobs run longer than expected. With experience and good record-keeping, these time overruns may lessen, but there are still apt to be surprises that result in the actual time becoming more than had been planned. To compensate for these overruns, we suggest a safety factor of 10 to 50 percent be added to the planned time.

The following list of time-wasters and time-savers will give a further idea of factors to consider.

TIME-WASTERS

- commissions where perfection of execution and finish is required
- awkward access to surfaces to be treated
- working adjacent to in-process work
- obstructions such as air conditioners, heaters, windows, or forced-air frames
- carved surfaces
- scaffold painting
- floor painting
- ceiling painting
- poor access to and/or availability of service elevators
- parking facilities located far away
- working in furnished areas, or areas with carpets and/or wall-coverings
- working with an inexperienced or indecisive client or designer

TIME-SAVERS

- flat unbroken surfaces
- using previously perfected techniques
- working in unfurnished areas
- previously primed and base-coated walls
- using subcontractors for surface preparation and base-coating
- two layers in one— tinted primers, shellac coats, or finish coats
- working with an experienced client or designer

The tentative estimate is calculated by multiplying the daily billing rate (see pages 247–49) by the estimated number of days. It is usually rounded up or down (slightly) to provide a manageable figure.

REVISING A TENTATIVE ESTIMATE

After calculating a bid, you should analyze it to determine that you have covered all expenses. Revise a tentative estimate if there are any special circumstances that would make certain changes in the estimate more advantageous to the firm.

There are many reasons to adjust the tentative estimate. You may want to raise the estimate to cover increased costs resulting from extra equipment, travel expenses, or slow-paying clients. Conversely, you might need to lower the estimate to win a desirable commission or to get work during a slow period; often, taking a job for a lower-than-usual fee may be better for the firm than not working at all.

The following examples illustrate ways revisions can be made. The daily billing rates for these examples have been taken from the Daily Billing Rate chart on pages 248–49.

Example 1: Part-time Painter Bidding for a Very Desirable Commission

A leading designer is doing a model apartment and is looking for a decorative painter to marble a fireplace. The job is valuable for two reasons: (1) important future work can come from the designer, and (2) commissions may result from the exposure in the model apartment. Others will be bidding for the job and price is a consideration. The designer has heard that other painters are reducing their usual fees to get this commission.

The number of days is estimated at three days plus a one-day safety factor for a total of four.

Estimate

4 days @ $272 = $1,088 (rounded up to $1,100)

Revised estimate

The part-time painter decides to work an extra weekend on this job at no charge. He submits the following revised bid:

2 days @ $272 = $544 (rounded up to $550)

Because these weekend days were not calculated into his annual budget, there will be no change in his annual fiscal figures (see page 249).

Example 2: Part-time Painter Bidding on a Job That Will Require Numerous Design Meetings

A small museum wants six doors to be grained. From the first meeting with the director, the painter is told that before the project and the samples will be approved there will be meetings with the architect and several required appearances at board meetings. The painter estimates that two extra days will be involved in attending meetings and redoing samples. The painting should take three days (including a safety factor).

Estimate

3 days @ $272 = $816 (rounded to $800)

Revised estimate

The painter adds the two extra days he will be spending at meetings to the three working days.

5 days @ $272 = $1,360 (rounded to $1,350)

Example 3: Two-painter Firm Bidding on a Job Requiring Scaffolding

A two-story rotunda in a residence is to be glazed. It will require renting a scaffold for a week (minimum rental time) at a cost of $525. With preparation and finish coats, the job (with a safety factor) should take two painters three days.

Estimate

Owner: 3 days @ $578 = $1,734

Advanced painter: 3 days @ $444 = $1,332

Total: $3,066 (rounded up to $3,100)

Revised estimate

The $525 cost of the scaffolding is added to the original estimate.

$3,100 + $525 = $3,625

Example 4: Two-painter Firm Bidding on a Long-term Job

A desirable restaurant job is being bid on by several leading decorative-painting companies. The commission (including a safety factor) will take the two painters six weeks (working five days a week).

Estimate

Owner: 30 days @ $578 = $17,340

Advanced painter: 30 days @ $444 = $13,320

Total: $30,660 (rounded to $30,500)

Revised estimate

It is decided to sharpen the bid as much as possible without giving up any profit. Because the firm's daily billing rate was calculated on a four-day-a-week basis, by figuring this estimate on a five-day-a-week basis, a considerably lower estimate results. Because 49 weeks of 5 planned working days totals 245 working days, this revised planned-working-days figure is divided into the owner's total expenses ($106,400) to get $434, which is divided by 90 percent, resulting in a revised daily billing rate of $482. The advanced painter's total expenses ($78,400) are also divided by the revised planned working days (245) to get $320, which is divided by 90 percent, resulting in a revised daily billing rate of $355.

Owner: 30 days @ $482 = $14,460

Advanced Painter: 30 days @ $355 = $10,680

Total: $25,540 (rounded to $25,500)

Example 5: Two-painter Firm Bidding on a Job for a Charitable Organization

The headquarters of the United Fund is to be glazed. The painters estimate that the job will take three days.

Estimate

Owner: 3 days @ $578 = $1,734

Advanced painter: 3 days @ $444 = $1,332

Total: $3,066 (rounded up to $3,100)

Revised estimate

Because this is a charitable organization, the firm decides to price the work at a reduced fee. They find a paint company to donate the paint, so no variable expenses will be included in the estimate. Both painters agree to take no profit, and to work on Saturday at no charge, enabling the job to be priced on a two-day basis.

To refigure the daily billing rate without variable expenses and profit, divide the owner's fixed expenses ($95,000) by 196 planned working days to get a revised daily billing rate of $484 (without profit). Divide the advanced painter's fixed expenses ($70,000) by 196 planned working days for a revised daily billing rate of $357 (without profit). The revised estimate is then calculated as follows:

Owner: 2 days @ $484 = $968

Advanced painter: 2 days @ $357 = $714

Total: $1,682 (rounded up to $1,700)

Example 6: Eight-painter Firm Bidding on a Job that Involves Unusual Travel Expenses

A privately owned historic residence is to be painted with an assortment of decorative painting techniques. This stately mansion is located 500 miles from the painting company and will require a crew of four (one advanced painter, two intermediate painters, and one trainee) to stay at a motel near the location of the mansion. The length of the job is estimated as ten days (including two safety-factor days).

Estimate

Advanced painter (1): 10 days @ $687 = $6,870

Intermediate painters (2): 20 days @ $593 = $11,860

Trainee (1): 10 days @ $492 = $4,920

Total: $23,650

Revised estimate

The following travel expenses must be added to the estimate:

• four round-trip airfares @ $350 = $1,400

• motel accommodations (40 days @ $70) = $2,800

• meal allowances (40 days @ 25) = $1,000

The total travel expenses will be $5,200. This figure is added to the previous estimate.

$23,650 + $5,200 = $28,850 (rounded up to $29,000)

Example 7: Eight-painter Firm Bidding on a Job for a Slow-paying Client

A government day-care center has invited bids for a cartooned decorative-painting treatment. The time estimate is six working days plus two safety-factor days for a total of eight working days. Two advanced and two intermediate painters will be used on the job. The government agency involved is known to take about 120 to 180 days to pay for completed work.

Estimate

Advanced painters (2): 16 days @ $687 = $10,992

Intermediate painters (2): 16 days @ $593 = $9,488

Total: $20,480 (rounded up to $20,500)

Revised estimate

While the firm is waiting to be paid, its expenses have to be paid. This will necessitate a $20,000 loan for six months, the cost of which is likely to be $1,400. This figure is added to the previous estimate to obtain a revised estimate.

$20,500 + $1,400 = $21,900 (rounded up to $22,000)

Example 8: Eight-painter Firm Bidding on a Job During a Slow Period

It is the twenty-fifth day of a month in a slow period and no work is scheduled for the first two weeks of the next month. A call comes for an estimate of a glazing job to start on the first of the next month. The firm estimates that with a four-painter crew (one advanced painter, two intermediate painters, and one trainee) the job should take ten days. It is known that several firms are going to bid for this job.

Estimate

Advanced painter (1): 10 days @ $687 = $6,870

Intermediate painters (2): 20 days @ $593 = $11,860

Trainee (1): 10 days @ $492 = $4,920

Total: $23,650

Revised estimate

The decision is made to make the bid low to get the job. The bid will be just enough to cover the salaries and fringe benefits of the painters. The annual working days are recalculated using a 5-day week rather than a 3½-day week to get 245 working days (as in Example 4).

The new daily billing rates are calculated as follows:

Advanced painter (1): Salary and fringe benefits ($60,000) divided by working days (245) equals a new daily billing rate of $245.

Intermediate painters (2): Salaries and fringe benefits ($47,000) divided by working days (245) equals a new daily billing rate of $192.

Trainee (1): Salary and fringe benefits ($33,000) divided by working days (245) equals a new daily billing rate of $135.

Using these new daily billing rates, the estimate is revised as follows:

Advanced painter (1): 10 days @ $245 = $2,450

Intermediate painters (2): 20 days @ $192 = $3,840

Trainee (1): 10 days @ $135 = $1,350

Total: $7,680 (rounded up to $7,700)

Note: When planning a price-cutting estimate, exercise great care. An occasional modest reduction of profit will not have great impact on your bottom line (it also will not have a significant impact on the estimate). However, a drastic reduction of profit, as shown in this example, will result in a loss for the firm, although not as large a loss as when no work is done. Again, care is stressed—no work can put a company out of business quickly; doing too many commissions at a loss will put a company out of business slowly. In addition, a company that gets a reputation of "low-balling" bids can have difficulty getting full-price bids accepted. Attempt to find creative solutions to slow periods before taking the easy road of dramatic price-cutting. The best insurance for business in tough periods is the reputation a firm establishes in prosperous periods.

LETTER OF AGREEMENT

The success of a decorative painting project is greatly dependent on how all the parties involved work together. This interaction is best formalized with a letter of agreement, sometimes called a proposal or letter of intent. On large projects, a legal contract, usually negotiated between attorneys, may be the appropriate document. For smaller jobs, a carefully drawn up, clearly stated letter of agreement generally will suffice. It is the best way to define the obvious and not-so-obvious aesthetic, practical, and financial concerns that, if not spelled out, could lead to misunderstandings and problems. The verbal discussions that precede the letter of agreement are invaluable for airing the concerns of all parties. This is the time to establish a good working relationship that will continue for the duration of the job.

We recommend that letters of agreement be custom-tailored to each project. In addition to the standard clauses all documents of this sort contain, the letter of agreement should specifically clarify working conditions and payment schedules. (We strongly suggest that the entire *Project Execution* and *Sample-making* sections on pages 266–72 and 253–57 be read for information that will be a guide in drafting the letter of agreement and will help uncover potential trouble spots.)

For each job, the letter of agreement should include as many of the following conditions as are relevant: the identity of the client and his or her responsibilities (including required sign-off procedures), details of the work, fee-related information, commencement and completion dates, responsibility for the quality of work, insurance information, and permission to photograph the work.

CLIENT RESPONSIBILITIES

For the purpose of the letter of agreement, the identity of the client is the person who pays the bills. The client must sign and date every approved sample, the letter of agreement, and a letter approving the completed project. We have heard from students who were not paid because they had not realized that the person who had authorized the samples was not the person who had the authority to do so. If the bill-payer has not seen the samples or the letter of agreement or approved the final results, he or she may disapprove and refuse to pay. To avoid this sticky situation, adopt a policy that requires all parties involved to sign the samples and letter of agreement and approve the final results.

In addition to approved samples and a sign-off procedure for the completed job, other documents and information should either be signed off or made a part of the letter of agreement. These include designers' and architects' plans, drawings, blueprints, and paint plans; subcontractors' agreements; arrangements with other suppliers; insurance certificates (see *Insurance*, pages 263–64); and local government permits. The size and complications of the project determine how many of these are required for all parties to sign.

After all documents have been signed, any subsequent changes, if there are any, should be discussed with all parties, be authorized in writing, and be signed off by all parties (including the bill-payer). Our students have found that seemingly minor changes from the original agreement can cause major problems if they are not fully discussed and approved by all parties.

The client's responsibilities also include

• supplying floor plans and elevations, if requested;

• arranging for removal and return of furnishings;

• arranging for secure receiving and storage facilities;

• designating a representative with decision-making power if the client is unavailable; and

• discussing the details of the project and signing samples, the letter of agreement, and any other pertinent documents.

DETAILS OF THE WORK

A well-written letter of agreement details specifically what is to be painted, as well as where, when, and under what working conditions. Each procedure is then listed in the order it will be done.

Having to analyze and put the processes in sequence serves also to help you to organize the order of the

work for the project itself and often reveals the need for unique supplies or unusual provisions on the job. Listing areas where work will *not* be done eliminates uncertainty and possible disappointment to the client.

On many projects, the decorative painter's work is coordinated with other tradespeople. The letter of agreement should detail what is expected of these other workers and any penalties that shall be assessed if they do not live up to these specifications. For example, if someone else is doing the preparation of surface and base-coating, and certain products, colors, and procedures have been signed off on, a penalty may be assessed if these specifications are not followed. Similarly, if another tradesperson, subsequent to completion or when the work is in process, damages your work, either that tradesperson or the client shall pay an extra fee for the repair work involved. Also, if the work of another tradesperson is late and seriously disrupts your schedule, a dollar penalty may be assessed, to be paid either by the tradesperson or the client.

FEE-RELATED INFORMATION

The letter of agreement should include the fee for the project, the amount of deposit, the fees being charged for samples, payment schedules, sales tax (if applicable), penalties (if any), terms of final payment (upon completion, upon a walk-thorough approval, net or terms for thirty days after completion [see *Estimating*, pages 257–62 for more information on fees]). In addition, the letter of agreement should address the following:

- that any changes from the original letter of agreement that affect fees should be renegotiated

- any specific, expensive materials (e.g., 23K gold leaf) that will be billed separately from the fee

- interest charges if the client fails to pay as scheduled (or other specified conditions). List what time after the due date interest will be assessed.

- special conditions; for example, if payment schedule is not adhered to, work will be suspended until payments are current

- ownership of samples and designs. Even if the client pays for the samples, they belong to the decorative painter unless other arrangements have been made. (For more information on fees for sample-making, see *Sample-making*, pages 253–57.)

- in the event that a project is suspended or abandoned, details of when and how much the decorative painter should be paid for services performed (e.g., consultations, samples, on-site renderings, in-process work)

- upon cancellation, whether the deposit is refundable, either wholly or in part

- if not included in the estimate, charges for cartage of pieces done off site

COMMENCEMENT AND COMPLETION DATES

Job beginning and ending dates may be stated in a general way. The unexpected often happens: preceding tradespeople's work is not completed on time, supplies are delivered late, you have a commitment to complete a prior job, you or an employee becomes ill, transportation presents problems, and so forth. Because of these unexpected contingencies, all parties should be reasonable when drafting penalty clauses.

RESPONSIBILITY FOR THE QUALITY OF WORK

It should be understood that the decorative painter will take responsibility for any work that does not stand up for a reasonable time (excepting if subjected to damage and/or abuse). However, work such as plastering, base-coating, and finishing done by tradespeople hired directly by the client or designer is not the responsibility of the decorative painter—unless he or she gave faulty instructions.

INSURANCE

The one type of insurance that is required by law and is essential for anyone using employees on the job is workman's compensation. A copy of the decorative painter's certificate of insurance should be attached to the letter of agreement. (Remember, this insurance problem is not exclusively a decorative painter's—any tradesperson is faced with this same problem, whether paper hanger, house painter, or plumber.)

Insurance coverage should be discussed during the initial planning discussion. The client should ascertain what his or her homeowner's policy covers and the painter should be aware of his or her insurance coverage. With current astronomical insurance rates, it is often less expensive to replace or repair any occasional breakage or damage than to rely on insurance for compensation.

Keep written documentation of safety precautions (safety reviews at the job site, safety education, hazardous material manifest, and so forth). These will

be valuable for OSHA (the federal government's Office of Safety and Health Agency) inspections and if you are involved in any litigation.

PERMISSION TO PHOTOGRAPH THE WORK

Client's permission may be requested for the use of and access to the premises for photographing the job and for the use of these photographs for publicity purposes. In the letter of agreement, the client may request that his or her name be withheld.

FINAL CHECKS

Double-check all statements in the letter of agreement before sending it to the client. Misinformation and omissions may be costly. The letter of agreement should end with a statement that requests the client to indicate acceptance by signing and returning one copy with the initial payment (if any). The client retains one copy of the letter of agreement (signed by the decorative painter) for his or her records. If the client is unwilling to sign the letter of agreement, either renegotiate the clauses in question or, if there are irreconcilable differences, do not accept the commission.

Be aware, given the litigious nature of these times, that what you do or do not say in a letter of agreement may have all sorts of legal ramifications. For a large contract, a lawyer who specializes in this type of law should draw up the contract, and, if necessary, represent you in signing of that contract. For smaller jobs, the lawyer's and court costs—plus the loss of working time—makes litigation a losing proposition, particularly if your adversary is willing to "go all out" to fight your suit. Even on a $10,000 job (assuming you have gotten half that amount before or during the job), it is not worth suing the client or designers for the balance. For jobs under $5,000, small claims court is sometimes a partial remedy for this kind of suit, and the letter of agreement is very important to win your case. Another problem with legal remedies is that even if you do win a judgment, it is difficult and sometimes impossible to collect this award.

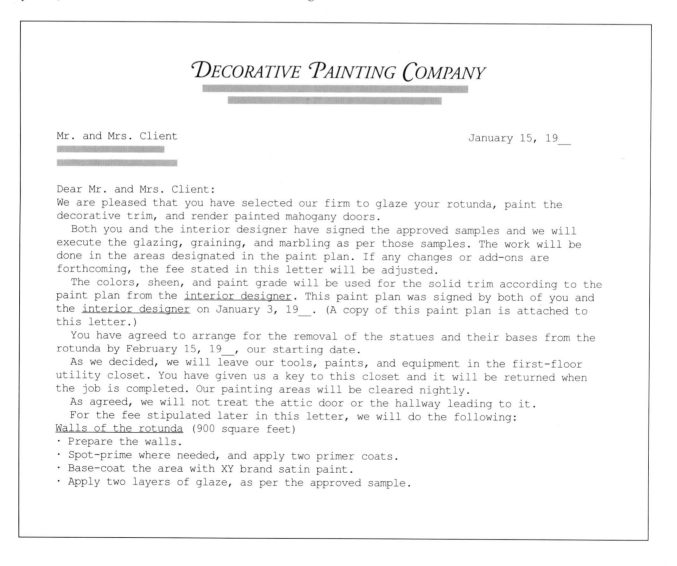

DECORATIVE PAINTING COMPANY

Mr. and Mrs. Client January 15, 19___

Dear Mr. and Mrs. Client:
We are pleased that you have selected our firm to glaze your rotunda, paint the decorative trim, and render painted mahogany doors.
 Both you and the interior designer have signed the approved samples and we will execute the glazing, graining, and marbling as per those samples. The work will be done in the areas designated in the paint plan. If any changes or add-ons are forthcoming, the fee stated in this letter will be adjusted.
 The colors, sheen, and paint grade will be used for the solid trim according to the paint plan from the <u>interior designer</u>. This paint plan was signed by both of you and the <u>interior designer</u> on January 3, 19___. (A copy of this paint plan is attached to this letter.)
 You have agreed to arrange for the removal of the statues and their bases from the rotunda by February 15, 19___, our starting date.
 As we decided, we will leave our tools, paints, and equipment in the first-floor utility closet. You have given us a key to this closet and it will be returned when the job is completed. Our painting areas will be cleared nightly.
 As agreed, we will not treat the attic door or the hallway leading to it.
 For the fee stipulated later in this letter, we will do the following:
<u>Walls of the rotunda</u> (900 square feet)
· Prepare the walls.
· Spot-prime where needed, and apply two primer coats.
· Base-coat the area with XY brand satin paint.
· Apply two layers of glaze, as per the approved sample.

<u>Baseboards and stairs</u> (85 linear feet)
· Prepare the surfaces.
· Apply one coat of tinted primer.
· Base-coat these areas with XY brand satin paint.
· Render Verde Aver marble, as per the approved sample.
· Apply two finish coats, not rubbed down, as per the approved sample.
<u>Mahogany doors</u> (3)
· Prepare the surfaces.
· Apply one coat of tinted primer.
· Base-coat doors with XY brand satin paint.
· Render painted mahogany, as per the approved sample.
· Apply five finish coats and rub them down as per the approved sample.
If during, or after completion of, this project any damage is done to our work by another tradesperson or anyone else who is not an employee of our firm, the cost to repair this damage is not included in the fee stated in this letter.

Our work is scheduled to be done between February 15, 19__ and March 25, 19__. We will be working on the premises during this period, but not for the entire period.

If we cannot begin our work by March 1, 19__, because the proposed construction is not completed, a 10% surcharge will be added to the fee stated in this letter. A 10% surcharge also will be added if, because of the work of other tradespeople, we cannot work at least three weeks of the planned six weeks.

If we do not complete our work by April 10, 19__, the final payment to us will be reduced by $1,000.

In the event that the project is terminated before completion, for any reason, we will be paid for the work completed to that point at a pro rata share of the fee, plus 25%.

We have arranged for the XYZ Scaffolding Company to handle the scaffolding required for this project. This firm was selected after contacting two other companies and deciding XYZ was best equipped for this job and was fairly priced. The basis for this choice is available to you should you so desire. The firm's price is $1,200 for delivery, installation, and removal of the scaffolding. Their letter confirming this price and giving other pertinent information is attached. They will bill you directly.

You have checked and confirmed that your insurance will cover any damage that might be done to the house and its contents. Our workers are covered by our liability insurance and state-mandated workmen's compensation. A copy of our Certificate of Insurance is attached to this letter.

You have given us permission to photograph the work being performed, both in process and as a finished area. We have agreed not to publish these pictures without written permission signed by both of you.

The fee for the decorative painting is $16,000. The $300 paid for samples will be deducted from this total.

A $5,000 deposit is due when all parties sign this letter. This deposit is refundable in full up to February 1, 19__. Between that date and the commencement of the project, a $4,000 refund will be issued if requested.

A $5,700 payment will be due March 5, 19__, if at least 50% of the work has been completed.

The final $5,000 will be paid upon completion of the project. This final payment assumes there have been no add-ons. If the final payment is not made within ten days after completing the final walk-through, a 10% interest charge will be added to this payment.

I have read this letter and agree to its contents.

_____ _____
President, Decorative Painting Company Date

_____ _____
Mr. Client Date

_____ _____
Mrs. Client Date

You may want a lawyer to review some of your first letters of agreement or those with unusual circumstances. This is not so much to avoid litigation as it is to make sure that the letter of agreement is clear, inclusive, and complete.

Screening your clients can help eliminate problems. This safeguard precedes the letter of agreement, but can be the most important step in a successful project.

The drawing up of an effective letter of agreement takes time, but its benefits to all parties far outweighs this investment of hours.

PROJECT EXECUTION

After the samples have been approved and initialed, the letter of agreement signed, and the deposit paid, the decorative painting can begin. Ideally, decorative painters would always work in a completely empty house that had no wallpaper, carpeting, or finished floors. They could do their decorative painting, protect it, and have other tradespeople follow who were so skilled and careful that no touch-ups would be required. A knowledgeable and unflappable general contractor would coordinate and schedule all work so that every tradesperson would have ample time to complete his or her job without interference.

In the real world these ideal conditions rarely occur. Decorative painting is done as part of either a renovation or new construction, or in a refurbished room. When other tradespeople are involved, there is often a conflict concerning whose work should be given priority in scheduling. Each would like to be the first one in and the first one out, as it is more difficult and time-consuming to work around already finished work. More often than not, the decorative painter (who usually is scheduled at the end of the available work period) is left with much less working time than is needed because the other tradespeople have run over their allotted time.

For these reasons, before starting work you must understand the scope of the entire job and make careful, detailed plans. The person in charge (the client, interior designer, or general contractor) should be made aware of the time you will need to do the project and the necessity of coordinating your work with other tradespeople both to increase efficiency and to minimize the possibility of damage to completed painted surfaces.

In addition, you must attend to the following:

- planning the order of work when several techniques are involved;

- scheduling around existing working conditions;

- assembling supplies;

- protecting the floors;

- organizing your workspace and supplies; and

- making special considerations for large jobs.

COORDINATING DECORATIVE PAINTING WITH OTHER TRADES

Projects vary from those where only the decorative painter is involved to those that also involve many other tradespeople. The more people there are on a job, the more planning will be required and the greater the chances for conflict and delays. For a smooth decorative painting job, coordinate the work as follows:

- All major electrical, plumbing, telephone, and other installations that could damage the surfaces on which decorative painting will be done must be completed prior to preparation of the surface and painting.

- Floors may or may not be refinished prior to surface preparation and decorative painting depending on how messy the paint technique is; how careful the floor finishers will be (floor-sanding machines often damage painted baseboards); and whether sanding dust will present a problem (finished painted surfaces can be draped with plastic to protect them).

- Surface preparation and decorative painting should be done before carpeting is laid, even though some touch-up may be needed on the baseboards afterwards.

- Painted techniques on trim should be done before wallpaper or fabric is installed on the walls. The painted technique should extend ½ inch (1¼ cm) on the wall in the event that the wallpaper or fabric does not meet the trim exactly. Many times in older homes the joints between walls and trim have been spackled so often that it is difficult to decide where the wall ends and the trim begins.

PLANNING THE ORDER OF THE DECORATIVE PAINTING

When several techniques are involved, intelligent sequencing can save time and also result in a better job. The following examples show effective sequencing and the reasons for the recommended order of processes. Use them as a guide for how to approach your unique situation.

Glazed Walls with Solid-color Trim

1. Prime the entire room (walls and trim).

2. Base-coat the walls.

3. Glaze the walls.

4. Apply finish coat(s) to the walls.

5. Paint the trim.

When you are doing a glazed technique it is difficult (and sometimes impossible) not to go over onto an adjacent surface. Taping an already painted trim is time-consuming and often permits paint seepage (which requires still more time to correct). It is relatively easy for a painter to cut in (paint) the trim without damaging the walls.

Solid Walls with Faux Mahogany Trim

1. Prime the entire room (walls and trim).

2. Base-coat, grain, and apply finish coat(s) to the trim.

3. Paint the walls.

The mahogany trim may seep onto the walls; however, the solid color will easily cover any flaws. Because the trim is protected, it will not be damaged during the subsequent painting.

Squeegeed Strié Walls with Marbled Trim (Two Different Base Coats)

1. Prime the entire room (walls and trim).

2. Base-coat and glaze the walls.

3. Let the walls dry and apply painters' tape over the glaze (unless it has finish coats, in which case it does not need additional protection).

4. Base-coat and marble the trim.

Where you are using two decorative techniques, either a finish coat (which can be cleaned of paint) or taping will be required. In either case, a flat surface (the wall) is easier to correct than a curved surface (the trim).

ORDER OF WORK WITHIN A SINGLE TECHNIQUE

When planning the work schedule, you should break each technique to be used into separate steps. For example, the steps in graining a three-panelled door would be as follows:

1. Prepare the surface.

2. Prime the entire door.

3. Base-coat the entire door.

4. Grain and isolate all panels.

5. Grain and isolate all rails and horizontal moldings.

6. Grain and isolate all stiles and vertical moldings.

7. Tone in the same sequence, or tone the door as a whole, depending on the nature of the toning required.

WORKING CONDITIONS ON THE JOB

In addition to planning the order of painting, you should gather as much information as possible about working conditions before starting on a job. Find out the following:

• What days and hours work can be done, and whether there are limitations on access through service entrances and elevators. This could be especially important if travel distance is a factor.

• Whether supplies can be left in place until the end of the job, or if they must be moved nightly. (Unusual requests should be a factor when figuring your estimate. We had one situation where all evidence of work, including scaffolding on a spiral staircase, had to be removed prior to each weekend and erected again on Monday mornings.)

• If any unusual masking, draping, or floor protection will be necessary.

• Whether paint odors will be a problem.

• The location of the parking area, supply-storage room, utility sink, trash compound, and restroom.

In addition, an agreement should be reached as to who is responsible for the necessary moving and returning of furniture, fixtures, and accessories, especially pieces that are large, heavy, breakable, and/or valuable.

GATHERING SUPPLIES

A master list similar to the one on page 268 is invaluable when gathering supplies for each particular job. Used as a checklist, it helps assure that few materials are forgotten, obviating unnecessary trips to the local paint store or your studio. Photocopy the list, and for each job label a photocopy with the client's name, address, and telephone number; the job date; and a brief description of the job (e.g., glazed rotunda, marble trim, mahogany doors). You can then check off each supply needed for that job.

Since jobs differ, go through each process mentally as a reminder of what supplies you will need. For example, on glazing projects you will need straining cloths and empty containers; on taping days you must have razor blades. If you maintain sample master lists for each

MASTER LIST OF MATERIALS, SUPPLIES, AND EQUIPMENT

Client's name_____ Date of job _____

Address _____ Job technique _____

Phone _____

Preparation Equipment
- ☐ Sandpaper
 - ☐ 80-grit ☐ 120-grit
 - ☐ 220-grit
- ☐ Wet/dry polishing papers
 - ☐ 400-grit ☐ 600-grit
- ☐ Steel wool
 - ☐ 00 ☐ 000 ☐ 0000
- ☐ Sanding block
- ☐ Palm sander
- ☐ Tack cloth
- ☐ Glue
- ☐ Epoxy
- ☐ Filling material (spackle)
- ☐ Hammer
- ☐ Screwdriver

Mixing Materials & Containers
- ☐ Plastic bucket(s)
- ☐ Quart cans and lids
- ☐ Gallon cans and lids
- ☐ Empty tin cans
- ☐ Bottles (jars) and lids
- ☐ Plastic containers and lids
- ☐ Flat aluminum-foil trays
- ☐ Straining cloths
- ☐ Rubber bands
- ☐ Paper cups (sturdy)
- ☐ Measuring spoons and cups
- ☐ Wood stirrers
- ☐ Plastic stirrers (stems from foam brushes)

Media & Solvents
- ☐ House paints (qts./gals.)
 - ☐ Alkyd ☐ Latex
 - ☐ flat ☐ flat
 - ☐ eggshell ☐ eggshell
 - ☐ satin ☐ satin
 - ☐ gloss ☐ gloss
- ☐ Japan colors
- ☐ Watercolors
- ☐ Gouache
- ☐ Tempera
- ☐ Acrylic paints
- ☐ Artists' oil tube colors
- ☐ Stains
 - ☐ nonpenetrating
 - ☐ penetrating
- ☐ Marglaze
- ☐ Casein
- ☐ Glaze medium

- ☐ Latex acrylic urethane finish (water-soluble finish)
- ☐ Powdered pigments
- ☐ Paint thinner
- ☐ Liquid sandpaper (sanding eliminators)
- ☐ Water
- ☐ Kerosene
- ☐ Linseed oil, boiled
- ☐ Flatting oil
- ☐ Driers
- ☐ Glycerin
- ☐ Wallpaper adhesive (vinyl)
- ☐ Aniline powders
- ☐ Shellac
- ☐ Alcohol
- ☐ Apple-cider vinegar
- ☐ Finishes
 - ☐ quick-dry ☐ slow dry
 - ☐ flat ☐ satin
 - ☐ high-gloss

Decorative Painting Tools & Accessories
- ☐ Graph paper
- ☐ Markers
- ☐ Pencils
- ☐ Ballpoint pens
- ☐ Ruler, straight-edge
- ☐ Template sticks
- ☐ Burnishers
- ☐ Roller cages
- ☐ Roller sleeves
 - ☐ stucco ☐ napped
 - ☐ foam
- ☐ Paint tray
- ☐ Paint-tray liners
- ☐ Roller extension
- ☐ Roller scrapers
- ☐ Check roller
- ☐ Sycamore roller
- ☐ Combs
 - ☐ hair ☐ rubber ☐ steel
- ☐ Graining heels
- ☐ Feathers
- ☐ Sponges
 - ☐ synthetic ☐ natural
- ☐ Bronze wool
- ☐ Squeegees
- ☐ Wallpaper brushes
- ☐ Glazing putty
 - ☐ vinyl ☐ linseed-oil
- ☐ Cotton
- ☐ Cotton paper

- ☐ Chamois
- ☐ Plastic
 - ☐ 4-mil ☐ 1-mil
- ☐ Rags
- ☐ Newspaper
- ☐ Erasers
- ☐ Potato
- ☐ Wax paper
- ☐ Paper napkins
- ☐ Tissue paper
- ☐ Facial tissue
- ☐ Cotton swabs
- ☐ Pastel stumps (tortillons)
- ☐ Cheesecloth

Brushes
- ☐ Foam brushes
 - ☐ 1-inch (25 mm)
 - ☐ 2-inch (50 mm)
 - ☐ 3-inch (75 mm)
- ☐ Glue/stencil brushes
- ☐ Old, broken-in brushes
- ☐ Blending brush
 - ☐ badger-hair
 - ☐ hog's-hair
- ☐ Artists' script liner brushes
 - ☐ #0 ☐ #1 ☐ #2 ☐ #6
- ☐ Fan brushes
- ☐ Stipple brush
- ☐ Stiff-bristled brushes
 - ☐ 1/4-inch (6 mm)
 - ☐ 1/2-inch (12 mm)
 - ☐ 1-inch (25 mm)
 - ☐ 2-inch (50 mm)
 - ☐ 3-inch (75 mm)
 - ☐ 4-inch (100 mm)
- ☐ 1/4-inch (6 mm) soft-bristled brush
- ☐ Toothbrushes
- ☐ Pipe overgrainers
- ☐ Wavy mottler
- ☐ Flogger

Tapes
- ☐ Masking tape
 - ☐ 1/8-inch (3 mm)
 - ☐ 1/2-inch (12 mm)
 - ☐ 3/4-inch (19 mm)
 - ☐ 1-inch (25 mm)
 - ☐ 2-inch (50 mm)
- ☐ Painters' tape
- ☐ Safe-release tape
- ☐ Long-release tape
- ☐ Specialty tapes

Cutting Tools
- ☐ Matte knife and blades
- ☐ X-acto knife and blades
- ☐ Putty knife
- ☐ Palette knife
- ☐ Razor blades (single-edge)
- ☐ Scissors

Finishing Items
- ☐ Wax
- ☐ Rottenstone
- ☐ Household oil
- ☐ Polishing compound
- ☐ Polishing cloth

On-the-Job Accessories
- ☐ Electric adapters
- ☐ Extension cords, heavy-duty
- ☐ Photographic light stands
- ☐ Light bulbs (a variety)
- ☐ Pot hooks
- ☐ Stepladder
- ☐ Rolling platform
- ☐ Planks
- ☐ Folding chair
- ☐ Collapsible worktable
- ☐ Trash bags
 - ☐ paper ☐ plastic
- ☐ Drop cloths
 - ☐ canvas ☐ plastic
- ☐ Building paper
- ☐ Plastic wrap
- ☐ Aluminum foil

Personal Amenities
- ☐ Food
- ☐ Water
- ☐ Radio
- ☐ Soap
- ☐ Hand cleaner
- ☐ Vinyl gloves
- ☐ Work clothes
- ☐ Kneepads
- ☐ Dust masks
- ☐ Respirator
- ☐ Paper towels

Client-Related Items
- ☐ Business cards
- ☐ Portfolio
- ☐ Samples
- ☐ Fan deck of paint colors

technique on file and pull the list out when assembling supplies for that technique, it will simplify the task.

When packing supplies prior to transporting them to a job, first group and label each supply category together (e.g., mixing and straining materials, tapes, tools for a certain technique, paints and their solvents). This is especially important for materials that may spill or leak; these should be packed in leakproof cartons.

For safer handling of boxes of supplies, try cutting openings into the box ends. Also, use lightweight sturdy dollies or hand trucks.

PROTECTING FLOORS

The best way to begin a job is to protect the floors before any materials are brought inside. Put down building paper or plastic (available at lumber yards, hardware stores, or home centers) in the actual working areas and on any other floors that might get paint tracked on them, such as those in hallways and adjacent rooms. Do not try to tape a plastic drop cloth directly to the carpet; it will not stick and paint may get on the carpet. A remedy to this problem is to first stick 2-inch-wide (5-cm-wide) masking tape on the carpet adjacent to the baseboards completely around the room. Then secure the plastic drop cloth by taping it to this masking tape. If paint gets on the plastic, wipe it off and place a canvas drop cloth or newspaper over the area so that no paint will be tracked to unprotected areas.

ORGANIZING YOUR WORKSPACE AND SUPPLIES

After you have protected the floors, you should set up a work area. A small collapsible table provides a comfortable height at which to mix paints, helps to keep the work area neat, and prevents the accidental spills that often occur when paints are set on the floor.

Once you have brought in supplies and tools, you must assure their security, particularly in the case of small, expensive pieces of equipment. Pilferage is all too common, even in seemingly secure environments, and tools are often borrowed—with or without your knowledge—and not returned to where they belong. To minimize this problem, unload only those supplies that are actually needed, and hide, remove, or arrange secure storage for any valuable tools or supplies. In addition to the security advantage of the "grouped items" method of packing, it also ensures organized unpacking.

PLANNING LARGE JOBS

For smaller jobs, project execution begins with organizing and taping the surface (see pages 32–40).

On large jobs, however, paint plans may be required. Paint plans are visual representations of the surfaces to be painted. They can be done on architectural plans (blueprints), interior designers' renderings, or a sketch prepared by anyone involved in the project. Once your samples have been approved, you specify exactly what materials are to be used as primer, base coat, interim protective coats (if required), and finish coats (if required). A separated plan should be made for each layer (where required). Mark each surface on each plan with a code, such as PS1, PS2, and PS3 for primer sealer; BC1, BC2, BC3 for base coats; IN1, IN2, IN3 for interim coats; and FC1, FC2, and FC3 for finish coats. A legend for each plan should accompany it, specifying the media manufacturer, the manufacturer's media number, and the degree of sheen (flat, eggshell, satin, semigloss, or gloss). You should give a complete set of plans to the general contractor (if one is involved), the interior designer and/or architect, the paint contractor, and the client.

Large jobs often require using equipment such as ladders and scaffolding. You may want to purchase ladders for your work. Scaffolding, on the other hand, is usually rented.

Ladders

Decorative painters must be familiar with different types of ladders—and know how to use them safely. The ladders most often used by decorative painters are the following:

Stepladders. These are self-supporting portable ladders that look like the letter "A" when open. They have steps on one side and often have a tray for materials. A large portion of decorative painting can be done using only a commercial-grade stepladder. Stepladders are used to work at higher levels than could be reached if standing on the floor.

Trestle ladders. These are similar to stepladders except that they have rungs on both sides. In addition, some have extensions that run straight up from the apex. Trestle ladders can be used to support a plank on which the decorative painter stands to reach high places.

Segmented ladders. These ladders are divided into short sections that can be bent at the hinges and locked into different configurations. They are useful for working in awkward situations (around obstacles or on stairways) or to form a raised horizontal level on which to stand.

Following manufacturers' safety recommendations, in addition to using common sense, will prevent most injuries. Here are a few safety rules:

- See that ladders conform to safety codes and are inspected frequently for damage (safety codes can be obtained from governmental agencies such as the Occupational Safety and Health Agency [OSHA], trade associations such as the Paint and Decorating Contractors of America [PDCA], and manufacturers and stores selling ladders). Often on the ladder itself is a statement of compliance with safety codes and other pertinent information such as maximum load and suggested use.

- Never stand on the shelf or on the top step of a stepladder.

- Your body should be in line with the ladder; only your arms should extend out.

- Never use a stepladder as a straight ladder.

- Allow only one person on a ladder at a time unless it is specifically designed for more.

- When ascending or descending, always face the ladder.

- Use extreme caution when setting up planks between ladders or on stairways.

- When working on a ladder in front of a doorway, rope off the area and place signs warning of the ladder's presence.

Scaffolding

Scaffolds are designed to bring people within comfortable working reach of elevated or inaccessible areas. The types of scaffolding most often used by decorative painters are tubular steel or aluminum sectional systems that are erected on site and dismantled when the project is completed. These units, called rolling platforms, are mounted on wheels and are an efficient way to reach ceilings, cornices, or other high areas that need detailed treatment. While the need for scaffolds on some jobs is essential, on other jobs the time that their use might save should be balanced against the cost of their rental or purchase.

Always have a knowledgeable, experienced person in charge of erecting, adapting, and demolishing tubular scaffolds (this service is usually available with scaffold rentals). Other safety considerations are as follows:

- Be sure that scaffolds are equipped with appropriate guard rails, mid-rails, toe boards (a board running along the outside of the working platform—the floor of the scaffold), and screens to prevent objects from falling off. This is especially important when platforms are more than 10 feet (3 meters) high.

- When moving rolling platforms, apply the force as near to the bottom of the platform as possible.

A final note regarding scaffolds: Do not accept any commission where difficulty with height will affect the quality of either your work or your mental health.

RECORD-KEEPING

Logs are ongoing records detailing procedures (including formulas, materials, and tools), when they were done (and how long they took to do), and by whom. Logs permit greater flexibility in scheduling since any crew member could complete a job that another had begun, after referring to the log. These logs also have many other uses, including the following:

- They can serve as a guide to estimating time to do processes for future jobs.

- They can help you evaluate the productivity of your painters when making personnel decisions such as merit salary increases or reduction of hours.

- They serve as a record of the techniques certain painters have done, which can help in assigning painters to future jobs.

- They aid in financial planning by showing how profitable one job is compared to another.

WAYS TO MAKE A PROJECT GO MORE SMOOTHLY

There are many aspects and details of decorative painting that can only be learned by doing them. To help you in the process of developing your own procedures, we offer the following tips from our experience.

- Mix too much paint rather than too little. This extra paint will come in handy if you have underestimated the amount of paint needed or if you accidentally spill paint, put the wrong solvent in the paint, or make other errors.

- Set paint cans into buckets and hang them from your ladder with pot hooks (available from paint stores) for spill-free working.

- When you are not using them, store paint-laden brushes, cheesecloth, and/or other tools in aluminum-foil household pans. These pans are portable and help keep the premises neater.

- For disposable palettes use paper plates or freezer paper.

- Kneepads (sold for carpet and masonry installers and at garden and sports shops) lessen physical strain. A low stool with or without wheels can also be helpful.

- Use a small vacuum cleaner or hand-held vacuuming unit to clean areas prior to painting and before leaving a job.

- Holes punched through the depression in the rim of paint cans with an ice pick allow excess paint to drain through and lids to fit tighter.

- Dispose of trash, particularly solvent-filled cheesecloth, all during the day (rather than at the day's end) to reduce odors. Splash cheesecloth and rags with water to minimize the chance of spontaneous combustion.

AESTHETIC CONSIDERATIONS WHILE WORKING

Although instructions for individual painted techniques differ, the following guidelines will prove helpful when actually painting any surface:

- Move away from your work frequently to critique it. Do this from the vantage point from which it will be viewed (e.g., to critique in-process cornice molding, get off your ladder and view it while standing on the floor) to double-check the scale, color, and texture of individual sections and to see how each relates to the whole project.

- Although everyone should have pride in every facet of his or her work, it is not necessary to lavish time-consuming aesthetic discrimination on a layer whose only purpose is to furnish an underlayer of color and directional flow. Study the sample to decide how much time and effort to spend on each layer of multilayered techniques. Analyze how much of any layer might be visible when viewed through a subsequent one and allocate the most time to those layers that contain dramatic and unique features of the technique (for example, veins in a specific marble).

- Take care not to "lock in" (isolate with a protective coat) any colors, patterns, or directions that call excessive attention to themselves or will need to be corrected later. Trying to build on layers with these types of problems reduces subsequent design and color options. (If you have used shellac as the isolating [protective] coat, you can remove it to correct any offending work. Use alcohol on a cotton swab to remove the shellac, then apply the proper solvent [usually water or paint thinner] to eliminate the undesirable work; then correct the area, let it dry, and shellac it again.)

- Be aware that progressive changes in daylight in a space play tricks with perception. Also, colors refract differently when seen in direct sunlight as contrasted with artificial light. You can use portable photographic light stands fitted with the correct bulbs to provide light where it is dim and to equalize unbalanced existing lighting, especially when chandeliers and other lighting fixtures may not yet have been installed.

- Maintain concentration on the job. Talking while working on difficult techniques fragments your ability to make good judgments about your painting.

- Realize that both painting technique and your perception of it change as the day progresses due to physical strain, mental fatigue, low blood sugar, and the tedium of doing the same thing hour after hour. All of these influences affect judgment and performance and can lead to uneven technique, mistakes, and repetitive patterning. Taking frequent breaks, breathing fresh air, and eating healthy snacks throughout the day will help clear thought processes and renew physical energy. Snacks should be low in sugar, like the morning carrots and afternoon almonds that we give to our students.

Throughout the painting process, keep in mind that tensions associated with decision-making can be either helpful or debilitating. Beneficial tensions keep your creative juices flowing and make you aware of potential visual problems. Harmful tensions will often stifle spontaneity, cause dissatisfaction, and necessitate constant redoing of your work.

Craftsmanship

While good craftsmanship is expected of all painters, decorative painters in particular must pay attention to details as their work is often a focal point that is viewed very critically. The marbled wall that does not quite reach the ceilings in some places and bleeds over in others does more than convey sloppiness; the entire illusion is compromised and the edge becomes visually disturbing. Even imperfections that are not readily apparent can give a subliminal feeling that things are not right. Pay particular attention to the following details:

Measurements for division of space (e.g., wall blocks, floor design). These must be accurate; horizontals must be level and verticals must be plumb.

Pencil lines. These should not be visible (unless they are part of the design).

The continuity of painted techniques. Poor taping or carelessness can result in uncovered areas of base coat or interim layers showing (these are especially likely to be found in corners and crevices and adjacent to wallpaper, cabinets, and windows).

Careless taping. Paint seepage and fuzzy-edged lines must be scraped off or touched up.

After a job is finished, it is a good policy to go over the job with the client or his or her representative to check any details, similar to those listed above. This may be a prerequisite for the final installment on the fee.

PROFESSIONAL INTERACTIONS WHILE THE JOB IS IN PROCESS

Once work has started, the interactions among the decorative painter, the designer, and the client can have a dramatic impact on the expeditious and successful completion of the job. Decorative painting is an unfamiliar and intimidating process to many clients and designers—even those with experience.

Changes

Situations may arise where clients question the appropriateness of the finish chosen and suggest changes. Since decorative painting is a service as well as an art, the client's input should not be dismissed. At the same time, as the decorative painter, you must not make any negative comments about the designer's choices, thereby putting yourself in the middle. If the client requests a change, the designer or designer's representative (one of whom should be available at all times while the decorative painter is working) should discuss with the client the reasons for the original selection. Often the fact that the finishes being applied have been chosen to work with new furnishings and fabrics, but are being seen against clashing fabrics and carpets from the old design scene can make a client panic.

If the client is adamant about the need for a change (even after having seen extensive samples and/or lay-ups) and the designer agrees it is necessary, a new sheet should be added to the letter of agreement detailing the agreed-on changes and stating the additional fee involved. All parties who signed the letter of agreement must then sign this amendment. If new samples are required, have them signed by the parties that signed the original samples.

Small add-ons while on a job can cause you large headaches. A red flag should accompany the words: "by the way, while you're here. . . ." Do not acquiesce to requests for little jobs that "won't take very long" (usually for little or no fee). State that it is company policy that every change, no matter how small, proceeds only after a sample has been approved and signed.

Working Undisturbed

While you are working, the client should try to provide a working environment in which the best artistic and technical decisions can be made. The intrusions of pets and children disrupt concentration. We have heard of instances where the decorative painter was the afternoon's entertainment, providing the client with a front-row seat at the real-life play of in-process painting. This can be unnerving, making you concerned about what the client is thinking, rather than focusing on the judgments that must be made. This is especially important when difficult processes are being done (e.g., painting exquisite veins in marble or working with quick-drying media). You should be polite but firm about "no sidewalk superintendents." You might point out that they might get paint splashed on them—accidentally, of course (an old-timer's trick, apocryphal, we're sure).

When a commission lasts for any length of time in the home of a client who is constantly on the premises, familiarity can breed not contempt, but more familiarity—especially if you take coffee breaks together. While we at The Finishing School are all for positive social interaction, we encourage keeping a professional distance when decisions about the work must be made; that way no one feels taken advantage of or awkward about speaking up.

Professional Ethics

Occasionally a client will want to bypass the designer and hire the decorative painter directly. Although there is a gray area as to what is proper, in most situations the correct behavior is clear-cut. For example, most people would agree that a treatment to another area as part of the same renovation should go through the designer if the designer brought you in. However, the same area could be done two years later without the designer's involvement (although a call asking if this would be a problem could be made if you had a continuing professional relationship with the designer). Decisions of this nature can usually be reached by combining general decency with good business practice, which, in this context, are really the same thing.

APPENDIX

SOURCES

Advance Equipment Mfg. Co.
4617-19 West Chicago Avenue
Chicago, IL 60651
(312) 287-8220
Graining tools.

Ardmore Mfg. Co., Inc.
2009 North Clybourn Avenue
Chicago, IL 60614
(312) 549-3440
Squeegees.

Bay City Paint Co.
Market Street
San Francisco, CA 94114
(415) 431-4914
Japan paints.

Benjamin Moore & Co.
51 Chestnut Ridge Road
Montvale, NJ 07645
(800) 344-0400
Finishes/varnishes (paint-thinner- and water-soluble); interior paints and glazes (alkyd and latex); stains.

Dick Blick Fine Art Co.
P.O. Box 1267
Galesburg, IL 61401
(800) 447-8192
Specialty brushes; artists' paints.

BonaKemi, USA, Inc.
14805 East Moncrieff Place
Aurora, CO 80011
(303) 371-1411
Water-soluble finishes with cross-linkers (hardeners).

Burns Paint & Equipment
900 Broadway
San Antonio, TX 78215
(512) 227-9353
Japan paints.

Chromatic Paint Corp.
P.O. Box 690
Stony Point, NY 10980
(914) 947-3210
Japan paints.

Albert Constantine & Son, Inc.
2050 Eastchester Road
Bronx, NY 10461
(800) 223-8087
Finishes/varnishes (paint-thinner- and water-soluble); japan paints; stains; veneer samples book.

Craig & Rose, plc
172 Leith Walk
Edinburgh EH65ER
Scotland
031-554 1131
Specialty brushes; finishes/varnishes (paint-thinner- and water-soluble); interior paints and glazes (alkyd and latex).

Crown
Unit I, Lyon Trading Estate
High Street
West Drayton, Middlesex
England
0895 449661
Finishes/varnishes (paint-thinner- and water-soluble); interior paints and glazes (alkyd and latex).

Crowning Touch, Inc.
8902 Rosehill Road
Lenexa, KS 66215
(913) 888-2929
Architectural ornaments.

Decorative Painting Materials
13 Cutter Mill Road
Great Neck, NY 11021
(516) 487-2270
Washed and cut cheesecloth.

The Decorative Painting Network
17 Maple Drive
Great Neck, NY 11021
(516) 487-2270
Workshops, seminars, and organizations.

Dulux, ICI Paints Division
Wexham Road
Slough, Middlesex
England
0753 31151
Finishes/varnishes (paint-thinner- and water-soluble); interior paints and glazes (alkyd and latex).

Eagle Supply Co.
327 West 42 Street
New York, NY 10036
(212) 246-6180
Japan paints.

Eastern Marble Supply Co.
P.O. Box 392
Scotch Plains, NJ 07076
(201) 322-6567
Polishing materials for real marble.

Finesse Pinstriping, Inc.
P.O. Box 1428
Linden Hill Station
Flushing, NY 11354
(800) 228-1258 (outside of New York State)
(800) 696-5699 (in New York State)
Tapes.

The Finishing School, Inc.
17 Maple Drive
Great Neck, NY 11021
(516) 487-2270
Lectures, seminars, and workshops.

Finnaren & Haley, Inc.
901 Washington Street
Conshohocken, PA 19428
(215) 825-1900
Interior paints and glazes (alkyd and latex).

Florida Sponge & Chamois, Inc.
2495 Long Beach Road
Oceanside, NY 11572
(516) 678-5600
Sponges and chamois.

Green & Stone, Ltd.
259 King's Road
London SW3
England
071-352 0837
Artists' paints.

Hamilton Brush Mfg.
Rosslyn Crescent, Wealdstone
Harrow, Middlesex
England
01-427 1405
Specialty brushes; graining tools.

F.A. Heffer & Co., Ltd.
24 The Pavement
London SW40JA
England
071-622 6871
Specialty brushes; graining tools.

Janovic Plaza
30-35 Thomson Avenue
Long Island City, NY 11101
(718) 786-4444
Alcohol-soluble aniline dye powders; specialty brushes; finishes/varnishes (paint-thinner- and water-soluble); graining tools; casein paint; interior paints and glazes (alkyd and latex); japan paints; stains; tapes.

Johnson Paint Co., Inc.
355 Newbury Street
Boston, MA 02115
(617) 536-4244
Finishes/varnishes (paint-thinner- and water-soluble); interior paints and glazes (alkyd and latex); japan paints; stains.

John T. Keep & Sons, Ltd.
15 Theobald's Road
London WC1
England
Specialty brushes; finishes/varnishes (paint-thinner- and water-soluble); graining tools; interior paints and glazes (alkyd and latex).

Langnickel
229 West 28 Street
New York, NY 10001
(800) 847-4046
Specialty brushes.

Lee Valley Tools
P.O. Box 6295
Station J
Ottawa, Ontario K2A 1T4
Canada
(613) 596-0350
Specialty brushes; finishes/varnishes (paint-thinner- and water-soluble); interior paints and glazes (alkyd and latex); stains.

Liberty Paint Corp.
969 Columbia Street
Hudson, NY 12534
(518) 828-4060
Alcohol-soluble aniline dye powders; specialty brushes; finishes/varnishes (paint-thinner- and water-soluble); graining tools; artists' paints; casein paints; interior paints and glazes (alkyd and latex); japan paints; sponges and chamois; stains; tapes.

W.D. Lockwood & Co., Inc.
81-83 Franklin Street
New York, NY 10013
(212) 966-4046
(212) 226-2878
Alcohol-soluble aniline dye powders.

Long Island Paint Co.
1 Continental Hill
Glen Cove, NY 11542
(516) 676-6600
Casein paints; interior paints and glazes (alkyd and latex).

Macbeth (Munsell)
P.O. Box 230
Newburgh, NY 12551-0230
(800) 622-2384
Neutral (LRV) Gray Scales; student charts; book of color (3 vols.)

Mann Brothers
757 North La Brea Avenue
Los Angeles, CA 90038
(213) 936-5168
Specialty brushes; finishes/varnishes (paint-thinner- and water-soluble); graining tools; artists' paints; interior paints and glazes (alkyd and latex); japan paints; sponges and chamois; stains; tapes.

Mantrose-Haeuser Co.
Division of Onyx Group, Inc.
500 Post Road East
Westport, CT 06880
(800) 344-4229
Finishes/varnishes (paint-thinner- and water-soluble).

Mark's Paint Store, Inc.
12506 Magnolia Boulevard
North Hollywood, CA 91607
(818) 766-3949
Japan paints.

McCloskey Varnish Co.
7600 State Road
Philadelphia, PA 19136
(800) 345-4530
Finishes/varnishes (paint-thinner- and water-soluble); glazing media.

McDermott Paint
35 Spring Street
Greenwich, CT 06830
(203) 622-0699
Japan paints.

Mohawk Finishing Products
Rte. 30 North
Amsterdam, NY 12020
(518) 843-1380
Specialty brushes; finishes/varnishes (paint-thinner- and water-soluble); graining tools; interior paints and glazes (alkyd and latex); japan paints; sponges and chamois; stains; tapes.

John Myland, Ltd.
80 Norwood High Street
London SW279NW
England
081-670 9161
Stains.

Pearl Paint Co., Inc.
308 Canal Street
New York, NY 10013
(800) 221-6845 (outside of New York State)
(212) 431-7932 (in New York State)
Artists' paints; casein paints; japan paints; water-soluble paints for serpentine marbling.

E. Ploton (Sundries) Ltd.
273 Archway Road
London N65AA
England
081-348 0315
Specialty brushes; graining tools; artists' paints.

Pratt & Lambert, Inc.
P.O. Box 22
Buffalo, NY 14240
(716) 873-6000
Finishes/varnishes (paint-thinner- and water-soluble); interior paints and glazes (alkyd and latex).

J.H. Ratcliffe & Co. (Paints), Ltd.
135A Linaker Street
Southport PR85DF
England
0704 37999
Specialty brushes; graining tools; stains.

Rayco Paint Co.
2535 North Laramie Avenue
Chicago, IL 60639
(312) 889-0500
Japan paints.

T.J. Ronan Paint Corp.
749 East 135 Street
Bronx, NY 10454
(800) 247-6626 (Outside of New York State)
(212) 292-1100 (In New York State)
Japan paints.

Simpsons Paints, Ltd.
122-124 Broadley Street
London NW8
England
071-723 6657
Finishes/varnishes (paint-thinner- and water-soluble); interior paints and glazes (alkyd and latex).

Star Scenic Supply
3309 Bartlett Boulevard
Orlando, FL 32811
(407) 425-1615
Japan paints.

The Stencil Shoppe, Inc.
#39 Olde Ridge Village
Chadds Ford, PA 19317
(215) 459-8362
Custom stencil-cutting.

Tru-Value Hardware Stores
(Cotter & Company)
2740 North Clybourn Avenue
Chicago, IL 60614
(312) 975-2700
Squeegees.

Carolyn Warrender
Stencil Design Ltd.
1 Ellis Street
London SW1X9AL
England
071-730 0728
Japan paints.

Whistler Brush Co.
(Lewis Ward & Co.)
128 Fortune Green Road
London NW6
England
071-794 3130
Specialty brushes; graining tools.

Winsor & Newton
51 Rathbone Place
London W1
England
071-636 4231
Artists' paints.

Wood Finishing Supply Co., Inc.
100 Throop Street
Palmyra, NY 14522
(315) 597-3743
Japan paints.

Wood-Kote Products, Inc.
P.O. Box 17192
Portland, OR 97217
(800) 843-7666
Finishes/varnishes (paint-thinner- and water-soluble); stains.

UNITED STATES/UNITED KINGDOM EQUIVALENTS

While many of the terms used in this book are similar in many countries (e.g., artists' oil tube colors, acrylics, glycerin), some vary from one country to another. The following lists terms commonly used by decorative painters in the United States and their equivalents in the United Kingdom.

US	UK	US	UK
MEDIA		**SUPPLIES**	
alkyd (paint-thinner-soluble)	flat-oil or trade eggshell (white-spirit-soluble; low lustre)	cotton, absorbent	cotton wool
		roller sleeves	roller cylinders
denatured alcohol	methylated spirit	sandpaper	glasspaper
drier	siccatif	steel wool	wire wool
finish coats	varnish coats	sword striper	dagger
gouache	designer's colour		
latex (water-soluble; matte, eggshell, low-luster [satin or semigloss], or gloss)	emulsion (water-soluble; matt, mid-sheen [silk, satin, or semi-gloss], or gloss)	**TECHNIQUES**	
		burl	burr
liquid drier	patent drier	crotch figure	feather grain
paint thinner	white spirit	removal and wiping manipulations	broken colour (e.g., colour wiping, ragging, distressing)
primer (paint-thinner- or water-soluble; may exhibit a slight sheen)	standard undercoater (white-spirit-soluble; exhibits matt surface)		
		tooth	key
shellac, orange	knot sealer, knotting, button polish		
shellac, white (clear)	white polish	**MEASUREMENTS**	
stains, nonpenetrating (termed wiping, masking, or pigmented)	oil stains	3 feet	1 meter
		1 inch	25 millimeters (mm)
stains, penetrating	oil stains	1 foot	30 centimeters (cm)
tinting colors (Universal Tinters)	colourizers (Universal Stainers)		
watercolors	watercolours		

GLOSSARY

Acrylic: A water-based painting medium that dries alcohol-soluble. Available as paints and as an ingredient in water-soluble finishes.

Alkyd: A paint-thinner-soluble painting medium made from synthetic resins. Usually (although incorrectly) called oil media.

Aniline dyes: Coal-tar dyes developed in 1856 in Germany. Alcohol-soluble aniline powders can be mixed with shellac to add toning.

Applied techniques: Putting media on a surface with a tool.

Architrave: The wooden molding surrounding a door or window. Available in a broad range of sizes.

Artists' oil tube colors: Linseed-oil-based media that are paint-thinner-soluble.

Asphaltum: A thick brown-black coal-tar derivative used since Ancient Egyptian times (in the 1930s Egyptian mummies were ground up to secure the asphaltum that had been used in the mummification process). Used as an ingredient in Marglaze, a media for rendering mahogany.

Base coat: Also called ground coat. The first coat of paint applied to a surface after the primer coat.

Binders: The part of a medium that facilitates bonding.

Body: Also called consistency or viscosity. The fluid thickness of a medium.

Bonding: The adhesion of one film to another or to a substrate.

Boxing: A method of mixing liquids (e.g., paints) for uniformity by pouring them back and forth from one container to another.

Breccia: The Italian term for the fragments in marbles that have reformed into new stones. The French term is *breche.*

Burnishing: Pressing or polishing the edges of tape so that there is no paint or glaze seepage. The term derives from the Italian word *brunir* (to make brown). When gold is polished it acquires a brown cast and is termed burnished.

Caen stone: A type of flat limestone cut into blocks. It has been used for centuries in interior and exterior architecture.

Casein: A water-based painting medium previously made from the protein milk casein and now made from soya protein. It is available in a broad range of colors.

Chroma: A term originated by Albert H. Munsell for the amount of pure pigment in a color. The Commission Internationale de L'Éclairage (C.I.E.) uses "colourfulness" as a synonym.

Color wheel: The visible spectrum arranged in a circle.

Combing: A technique of pulling toothed implements (rubber, metal, leather, plastic, or cardboard) through wet media.

Curtaining: Sagging in a paint film or finish coat, resembling the curved bottom edges of drapery swags.

Denatured alcohol: Also called denatured solvent or solvent alcohol. Alcohol that has been made unfit for drinking. Used as a solvent for all shellac-based media and dried latex and acrylic films.

Distemper: A term for water-soluble painting media that uses beer, glue-size, or cider vinegar for a binder.

Dragging; A glazing technique for achieving a subtle mixture of fine stripes by pulling a wide, long-bristled brush through wet glaze.

Driers, liquid: Paint-thinner-soluble liquid chemicals that promote drying of paints and finish coats. Japan driers and cobalt driers are two examples.

Eggshell: A finish with a low degree of gloss, resembling that of an eggshell. It is between flat and semigloss.

Electromagnetic spectrum: The entire range of electromagnetic waves, from gamma rays through the narrow visible spectrum of color to radar and radio waves.

Faux: A French term loosely defined as a simulation of a real substance. Simulating wood is called *faux bois;* simulating marble, *faux marbre.*

Film: A thin, continuous layer of liquid applied to a surface.

Finish coat(s): See also *Varnishes.* The protective coat(s) generally applied last in a decorative painting process. Finish coats may be water- or paint-thinner-soluble.

Flat: Also called matte. A finish with no sheen.

Flogging: A technique for creating a small repetitive pattern (usually of pores in graining) by slapping the flat side of a brush into a wet medium while moving along a surface, A wide, long-bristled brush called a flogger usually is used, although other brushes may be employed.

Glycerin: A colorless, syrupy liquid prepared from fats and oils. Extends media drying time in water-based media.

Glaze: A translucent film of color made from paint media. Also used to refer to the medium itself.

Glaze medium: A proprietary paint-thinner- or water-soluble medium used to make opaque pigments translucent.

Glazing: Techniques done by manipulating translucent media over dry surfaces, creating unlimited visual effects.

Gouache: A water-based painting medium that is more opaque than watercolor. It remains water-soluble after it dries.

Graining: Also called *faux bois.* Decorative painting techniques used to simulate woods.

Ground: The surface upon which media is first applied.

Hand: Individual artistic style.

High-gloss: The highest sheen of finish.

Holiday: An area that is inadvertently skipped during the application of a liquid film.

Hue: The family name of a color according to its wavelength on the visible spectrum.

Isolating coat: Also called interlayer, barrier, or protective coat. A coat used to isolate one paint layer from another to prevent interaction between them.

Japan paints: Paint-thinner- and lacquer-thinner-soluble paints with pigments dispersed in driers and flat varnish. These paints have no linseed oil.

Latex: A natural or synthetic water-based-emulsion medium that dries alcohol-soluble. Available as paints and finishes.

Lay-up: A floor-to-ceiling full-scale representation of the various paint colors and/or techniques selected for large areas. A lay-up is examined by the client for approval prior to beginning a project.

Light Reflective Value (LRV): A measurable degree of light that is reflected back from every surface. LRVs are given in percentages.

Low-luster: Also called satin. A finish with a low sheen.

Marbling: Also called *faux marbre* or marbleizing. Decorative painting techniques used to simulate marbles.

Marglaze: A formula developed at The Finishing School, Inc., in Great Neck, New York, that is used in creating painted mahogany.

Medium (pl. media): The liquid that binds pigments together and holds them (bonds them) to the surface. It also is used to refer to a particular liquid substance used in a process or technique.

Megilp: The substances that give body to glazes so that they hold an imprint without returning to a homogeneous film.

Metamerism: The change in a color when it is seen under different lighting conditions (e.g., incandescent light, fluorescent light, daylight).

Mil: Abbreviation for millimeter; used for measurements of thicknesses of plastic.

Mineral spirits: The best grade of paint thinner.

Muttoncloth: Also called stockinette. A knit fabric used for removing excess glaze and for imprinting a texture. Each side of the cloth has a different texture.

Munsell System of Color: A system for defining color by value, hue, and chroma.

Ombré: Also called grade. To graduate a color imperceptibly from light to dark or into another color.

Opacity: The degree of covering power of a media.

Optical mixes: Visual effects created by the interrelationships of color, scale, and pattern.

Paint thinner: A petroleum-based solvent used in place of turpentine in formulas and for thinning and cleaning.

Painted finishes: Paint coats that are used to enhance a surface. They may be abstract, all-over designs or simulations of real substances.

Paints: Pigments dispersed in liquid media that bond to a surface.

Pigments: Insoluble powders that are suspended in liquid (a vehicle) to make a paint or glaze medium. Pigments can be organic (from animal or vegetable sources) or inorganic (from mineral sources). They give a medium opacity and color.

Primer: Also called sealer or undercoater. The first coat of media applied to a surface to reduce absorbency and to ensure adhesion of subsequent coats.

Rag-rolling: A glazing technique that involves rolling crumpled material into wet glaze.

Removal techniques: Techniques where glazes and other media that cover a surface are lifted off or wiped out.

Rottenstone: A finely ground limestone used as an abrasive in the process of rubbing down finish coats.

Sagging: See *Curtaining.*

Satin: Any finish with a sheen between flat (matte) and high-gloss.

Scumble: A nontranslucent film that provides effects of opacity.

Sealer: See *Primer.*

Semigloss: A finish with a sheen between eggshell and high-gloss.

Shade: Any hue plus black.

Shellac: An alcohol-soluble liquid derived from stick-lac, the resinous secretion of the lac beetle. Deep orange-brown in its natural state, shellac is bleached to make clear shellac.

Solvents: Liquids used in media to adjust consistency. They evaporate after application.

Spattering: A technique for applying fine to coarse bits of media to a surface by flicking the media from the bristles of a cut-off bristle brush or toothbrush.

Sponging: A technique for producing dots of color on a surface using natural sponges.

Stains: Penetrating or nonpenetrating media used for staining woods and for making graining media.

Stippling: A technique of bouncing the bristle ends of a brush into wet glaze to even it out. A special brush with tufts of bristles or any other flat-topped brush may be used.

Strié: Techniques for creating subtle through dramatic stripe and plaid effects. May be done with a wide variety of tools and materials. The term is also used for the finished result of these techniques.

Substrate: The surface under all paint layers.

Tack cloth: Also called tack rag. A cloth (usually cheesecloth) impregnated with resins to remove dust and particles from a surface prior to coating it with a paint or finish coat.

Thinner: Also called diluent. A solvent that is acting as an agent to thin a medium.

Tinting colors: Also called colorizers or tints. Pigments used for altering the hues of all types of media. Available in a limited color range.

Tints: See also *Tinting colors.* Any hue plus white.

Tooth: Also called purchase or mechanical anchorage. Texture given to a surface by abrading it so that a subsequent coat will bond to it.

Trompe l'oeil: A French term meaning "deceive the eye." A technique in which an illusion of depth is created by emphasizing highlights and shadows as if an element is seen under a defined light source.

Undercoater: See *Primer.*

Value: The amount of light and dark in a hue.

Varnishes: Also called oleoresins. Transparent paint-thinner-soluble finishes comprised of natural resins (from fossilized or living trees) and drying oils. (All other finish-coating materials should be referred to as finish coats.)

Vehicle: The carrier of a pigment.

Walking a glaze: A Finishing School technique of bouncing cheesecloth into wet glaze and then bouncing it back and forth across a still-wet surface to equalize the amount of glaze on an entire area.

Wash: A very thin solution of a medium.

Watercolor: A thin, water-based painting medium that is made up of pigment, gum arabic, glycerin, and water.

Wet edge: The place where one section of glaze joins a still-wet, previously applied section so that no seam (or break) is visible after the glaze is manipulated.

Whiting: Finely ground calcium carbonate used as an extender in paints, as a thickener in glazes, and to make linseed-oil glazing putty less sticky and more easily handled.

CREDITS

Except as noted below, the decorative painting in this book was conceived and executed by Ina Brosseau Marx and Robert Marx, the photographs were taken by Nick Simone, and the line drawings were rendered by Marca Cameron. In addition, we would like to acknowledge the other contributors—companies, artists, photographers, and interior designers—who graciously allowed us to include their work.

COMPANIES

Benjamin Moore & Co.: All paint chips and paint numbers, the collage of red fabrics and carpets with a watercolor by Kenneth X. Charbonneau on page 49, and the Benwood Stain Chart on page 178 courtesy of Benjamin Moore & Co.

Munsell Color: The Munsell color charts and wheel on pages 53 and 55 courtesy Munsell Color, 2411 N. Calvert St., Baltimore, MD 21218.

The Hearst Corporation: The bottom photograph on page 234 is reprinted with permission from HOUSE BEAUTIFUL, copyright © August 1988. The Hearst Corporation. All Rights Reserved. Jesse Gerstein, photographer.

ARTISTS

Abby Aisenberg and Betsy Florin: p. 149.
Lori Barnaby: p. 96.
Andrea Biggs and Timothy Biggs: p. 64 (center right).
Marca Cameron: p. 96.
Sharon Cooper, Creative Art Inc.: p. 64 (top center and right).
Julie Dworschack: p. 120.
Pat Ekovich: p. 97.
James Cook Embree: p. 93 (right).
Directors and students of The Finishing School: pp. 65 (top right and bottom right), 88 (bottom), 100, 174.
Students at The Finishing School: pp. 99 (composite on left), p. 136 (bottom).
Anne G. Harris Design Studio: p. 172.
Pam Hawkins: p. 91 (bottom).
Augustin Hurtado: p. 104 (top).
Ina Brosseau Marx: pp. 37, 66 (right), 214 (bottom), 215 (all), 234 (center right and bottom).
Robert Marx: pp. 68, 112 (bottom).
Jo and Billy Mattison, Finishes by Jo Mattison: p. 40 (all).

J. Chester Mixon: p. 111 (bottom).
Mary Winsor Newman: p. 235 (bottom).
Lawrence Oliver, Jr.: p. 136 (top).
Paxwell Painting Studios, Inc., NYC: pp. 64 (bottom right), 79.
Nick Starr: p. 83 (bottom).
Jeannie Sullivan: p. 90.

PHOTOGRAPHERS

Rick Albert: p. 97 © Rick Albert 1991.
Andrew Bordwin: p. 79 © 1989 Andrew Bordwin N.Y.C.
Scott Bowron: p. 172.
Sharon Cooper: p. 64 (top three).
Michael Devonshire: p. 93 (right).
Berry Morton Eckstein: p. 64 (center two).
Courtney Frisse: p. 83 © Courtney Frisse.
Jesse Gerstein: p. 234 (bottom).
Birney Imes: p. 111 (bottom).
Warren Jagger Photography Inc.: p. 149.
Bob Kedd: p. 40 (bottom).
Jack Kotz: pp. 65 (top right and bottom right), 88 (bottom), 100, 174 © Jack Kotz 1991.
Mark Loete: p. 91 (bottom).
Jo and Billy Mattison: p. 40 (top four).
Ina Brosseau Marx: pp. 65 (bottom left), 66 (left), 98 (bottom), 99 (composite on left), 136 (bottom), 151 (right six), 214 (bottom), 215 (all), 227, 234 (center right).
Mary Winsor Newman: p. 235 (bottom).
Lawrence Oliver, Jr.: p. 136 (top).
Bill Rothschild: pp. 66 (right), 68, 112 (bottom).
Robert Ruscansky: p. 90.
Austin Trevett: p. 120.
Kenn Wells: p. 64 (bottom two).

INTERIOR DESIGNERS

George Constant: p. 64 (top center and right), p. 66 (right).
Terry Herman: p. 90.
Foster Maegher: pp. 65 (top right and bottom right), 88 (bottom), 100, 174.
Motif Designs: p. 97.
Lee Napolitano: pp. 68, designed by Lee Napolitano, Allied Member ASID.; 112, Lee Napolitano as seen in Mansions & Millionaires Inc. Designers' Showcase.

BIBLIOGRAPHY

Aronson, Joseph. *The Encyclopedia of Furniture.* New York: Crown, 1948.

Ayres, James. *The Artist's Craft.* Oxford: Phaidon, 1985.

Billmeyer, Fred W., Jr., and Max Saltzman. *Principles of Color Technology.* New York: John Wiley & Sons, 1966.

Chevreul, Michel E. *The Principles of Harmony and the Contrast of Colors.* 1854 English-language edition translated from the French edition of 1839.

Churchill, Edwin A. *Simple Forms and Vivid Colors.* Augusta, Me.: The Maine State Museum, 1983.

Constantine, Albert, Jr. *Know Your Woods.* Revised by Harry J. Hobbs. New York: Charles Scribner's Sons, 1975.

Corbella, Enrico. *The Architect's Handbook of Marble, Granite and Stone.* 3 vols. New York: Van Nostrand Reinhold, 1990.

Fine Hardwood Veneer Association. *Fine Hardwoods Selectorama.* Indianapolis: Fine Hardwood Veneer Association and American Walnut Manufacturers Association, 1987.

Fleming, John, and Hugh Honour. *Dictionary of the Decorative Arts.* New York: Harper and Row, 1977.

Gettens, Rutherford J., and George L. Stout. *Painting Materials: A Short Encyclopaedia.* New York: Van Nostrand Reinhold, 1942.

Harley, R.D. *Artists' Pigments c. 1600-1835.* London: Butterworth, 1970.

Hebblewhite, Ian. *Artists' Materials.* Oxford: Quarto, 1986.

Hinckley, F. Lewis. *Dictionary of the Historic Cabinet Woods.* New York: Crown, 1960.

Hoadley, R. Bruce. *Understanding Wood.* Newtown, Ct.: Taunton Press, 1980.

Hope, Augustine, and Margaret Walch. *The Color Compendium.* New York: Van Nostrand Reinhold, 1989.

Itten, Johannes. *The Art of Color.* New York: Van Nostrand Reinhold, 1966.

Knackstedt, Mary V., with Laura J. Haney. *The Interior Design Business Handbook.* New York: Whitney Library of Design, 1988.

Ladau, Robert F., Brent K. Smith, and Jennifer Place. *Color in Interior Design and Architecture.* New York: Van Nostrand Reinhold, 1988.

Mayer, Ralph. *The Artist's Handbook of Materials and Techniques.* New York: Viking, 1946.

Milman, Miriam. *Trompe-L'oeil Architecture.* New York: Rizzoli, 1986.

Munsell, Albert H. *A Color Notation: An Illustrated System Defining All Color and Their Relations by Measured Scales of Hue, Value and Chroma.* Baltimore: Munsell Color (Macbeth), 1988.

_____ . *A Grammar of Color.* New York: Van Nostrand Reinhold, 1969.

Nassau, Kurt. *The Physics and Chemistry of Color.* New York: John Wiley & Sons, 1983.

Painting and Decorating Contractors of America. *Painting and Decorating Craftsman's Manual and Textbook.* Falls Church, Va.: Painting and Decorating Contractors of America, 1975.

_____ . *Painting and Wallcovering: A Century of Excellence.* Falls Church, Va.: Painting and Decorating Contractors of America, 1984.

_____ . *The Business of Painting.* Falls Church, Va.: Painting and Decorating Contractors of America, 1989.

Schiffer, Nancy, and Herbert Schiffer. *Woods We Live With.* Exton, Pa.: Schiffer Limited, 1977.

Siegel, Harry, with Alan M. Siegel. *A Guide to Business Principles and Practices for Interior Designers.* New York: Whitney Library of Design, 1982.

Van der Burg, A.R., and P. Van der Burg. *School of Painting for the Imitation of Woods and Marbles.* London: Technical Press, 1936.

Varley, Helen. *Colour.* London: Marshall Editions, 1988.

INDEX